1000
Masterpieces of
Decorative Art

Authors:
Victoria Charles
With the collaboration of Eugénie Vaysse

Layout:
Baseline Co. Ltd
61A-63A Vo Van Tan Street
4th Floor
District 3, Ho Chi Minh City
Vietnam

Library of Congress Cataloging-in-Publication Data

Jacquemart, Albert, 1808-1875, author.
 [Histoire du mobilier. English]
 1000 masterpieces of decorative art / author, Victoria
Charles ; with the collaboration of Eugenie Vaysse.
 pages cm
 Summary: "From ancient Sumerian pottery to Tiffany
stained glass, decorative art had been a fundamental
part of the human experience for generations. While
fine art is confined to galleries and museums, decorative
art is the art of the every day, combining beauty with
functionality in objects ranging from the prosaic to the
fantastical. In this work, authors Albert Jacquemart and
Emile Bayard celebrate the beauty and artistic potential
behind even the most quotidian object. Readers will
walk away from this text with a newfound appreciation
for the subtle artistry of the manufactured world"--
Provided by publisher.
 ISBN 978-1-78160-217-1 (hardback)
 1. Furniture--History. 2. Decorative arts--History. I.
Bayard, Emile, 1868-1937, author. II. Charles, Victoria,
editor. III. Title. IV. Title: One thousand masterpieces of
decorative art.
 NK600.J3513 2014
 745.09--dc23
 2014006508

1000
Masterpieces of
Decorative Art

PARKSTONE
INTERNATIONAL

TABLE OF CONTENTS

INTRODUCTION

Decorative and industrial arts, like all forms of art, are an expression of life itself: they evolve with the times and with moral or material demands to which they must respond. Their agenda and means are modern, ever-changing, and aided by technological progress. It is the agenda that determines the shapes; hence technology is also part of it: sometimes they are limited by its imperfections, sometimes it develops them by way of its resources, and sometimes they form themselves. Weaving was initially invented because of the need to clothe the body. Its development has been crucial to that of textile arts. Today, market competition has created the need for advertising: the poster is a resulting development and the chromolithograph turned it into an art form. Railways could not have existed without the progress of metallurgy, which in turn paved the way for a new style of architecture.

There is a clear parallel between human needs and the technology that caters to them. Art is no different. The shapes it creates are determined by those needs and new technologies; hence, they can only be modern. The more logical they are, the more likely they are to be beautiful. If art wants to assume eccentric shapes for no reason, it will be nothing more than a fad because there is no meaning behind it. Sources of inspiration alone do not constitute modernism. However numerous they are, there is not an inexhaustive supply of them: it is not the first time that artists have dared to use geometry, nor is it the first time that they have drawn inspiration from the vegetable kingdom. Roman goldsmiths, sculptors from the reign of Louis XIV, and Japanese embroiderers all perhaps reproduced the flower motif more accurately than in 1900. Some 'modern' pottery works are similar to the primitive works of the Chinese or the Greeks. Perhaps it is not paradoxical to claim that the new forms of decoration are only ancient forms long gone from our collective memory. An overactive imagination, an over-use of complicated curves, and excessive use of the vegetable motif – these have been, over the centuries, the criticisms ascribed to the fantasies of their predecessors by restorers of straight lines, lines that Eugène Delacroix qualified as monstrous to his romantic vision. What's more, in the same way that there has always been a right wing and a left wing in every political spectrum, ancient and modern artists (in age and artistic tendencies) have always existed side-by-side. Their squabbles seem so much more futile, as with a little hindsight, we can see the similarities in the themes of their creations, which define their styles.

The style of an era is marked on all works that are attributed to it, and an artist's individualism does not exempt his works from it. It would be excessive to say that art must be limited to current visions in order to be modern. It is, however, also true that the representation of contemporary customs and fashion was, at all times, one of the elements of modernism. The style of a Corinthian crater comes from its shape, a thin-walled pottery vessel inspired by the custom of mixing water and wine before serving them. But its style also results from its decoration: the scenes painted on it depicted contemporary life or mythological scenes.

Those who think that the Jacquard loom, the lace-making machine, the great metalworking industry, and gas lighting all date from the beginning of the 19th century would be interested to learn that they were not pioneering technologies; they were only used to copy ancient silks, needle-points, or spindle laces to create imitation stone walls and light porcelain candles. Hence, it is necessary to admire those who dared to use cast and rolled iron in construction. They were the first to revive the tradition of modernism in architecture; they are the true descendants of French cathedral builders. Therefore, Antoine-Rémy Polonceau, Henri Labrouste, and Gustave Eiffel are perhaps the fathers of the 19th-century Renaissance, rather than the charming decorators who, following John Ruskin, tried to break with the pastiche and create, first and foremost, a new style using nature as a starting point.

The vision of nature, literally paraphrased and translated in the works of Émile Gallé, was not compatible with the demands of the design and the material. "A marrow", wrote Robert de Sizeranne, "can become a library; a thistle, an office; a water lily, a ballroom. A sideboard is a synthesis; a curtain tassle, an analysis; a pair of tweezers, a symbol." The research of something new borrowed from the poetry of nature, in breaking voluntarily with the laws of construction and past traditions, must have offended both common sense and good taste. To transpose nature into its fantasies rather than studying its laws was a mistake as grave as imitating past styles without trying to understand what they applied to. This was just the fashion of the time, but being fashionable does not constitute modernism.

Reviving tradition in all its logic, but finding a new expression in the purpose of the objects and in the technical means to achieve them, which is neither in contradiction nor an imitation of former shapes, but which follows on naturally; this was the 'modern' ideal of the 20th century. This ideal was subject to a new influence: science. How could it be that artists would remain oblivious to the latent, familiar, and universal presence of this neo-mechanisation, this vehicle for exchanges between men: steamers, engines, and planes, which ensure the domination of the continents and the seas, antennas and receivers which capture the human voice across the surface of the globe, cables which mark out roads awakened to a new life, visions of the whole world projected at high speed on cinema screens? Machines have renewed all forms of work: forests of cylinders, networks of drains, regular movements of engines. How could all this confused boiling of universal life not affect the brains of the decorators?

Thus, from all sides, it was an era metamorphosed by scientific progress and economic evolution, turned upside down politically and socially by the war, liberated from both anachronistic pastiche and illogical imaginings. Whilst the artist's invention reclaimed its rightful place, machines, no longer a factor in intellectual decline through its making or distributing of counterfeit copies of beautiful materials, would permeate aesthetically original and rational creations every-where. This world movement, however, was lacking the effective support and clear understanding of the public. Only these accolades would merit an exhibition. But rather than a bazaar intended to show the power of the respective production of the nations, it would have to be a presentation of excellence turned towards the future.

When the Exposition internationale des Arts décoratifs et industriels modernes, or International Exhibition of

Modern Decorative and Industrial Arts – originally planned for 1916, but adjourned because of the war – was re-envisaged in 1919 by public authorities, modifications were imperative. The 1911 classification project contains only three groups: architecture, furniture, and finery. The arts of the theatre, of the streets and the gardens, which were special sections, naturally required a new group. In its title, the new project also comprised a significant addition. The Exhibition was to be devoted to decorative and 'industrial' arts; it would affirm the willingness of a close co-operation between aesthetic creation and its distribution through the powerful means of industry. Besides the manufacturers, the material suppliers were also to be given a large space, thanks to the design which inspired the presentations of 1925. 'Modern' decorative art was to be presented in its entirety like an existing reality, completely suited to contemporary aesthetic and material needs. Ceramic tiles, hanging fabric wall coverings, and wallpaper – each has their reason for adorning particular spaces. The ideal mode of presentation was thus the meeting of a certain number of 'modern' buildings, decorated entirely inside and out, which would be placed next to stores, post offices, and school rooms, constituting a kind of miniature city or village.

Moreover, these designs had to inspire the materials they had to work with, adopted for the use of the location granted and the distribution of the works which were thoughtfully placed in their midst. That is how four principal modes of presentation were determined: in isolated pavilions, in shops, in galleries of the Esplanade des Invalides, and in the halls of the Grand Palais. The isolated pavilions, reserved for associations of artists, craftsmen, and manufacturers had to represent village and countryside homes, hotel businesses, schools, and even churches and town halls. In short, all the framework of contemporary life could be found here. Shops marked the importance attached to urban art and offered the possibility of presenting window-dressings, as well as displays, spanning one or more units. The galleries, particularly for architecture and furniture, allowed compositions connected to the Court of Trades, which were managed by the theatre and the library. They were meant to constitute the largest part of the Exhibition. At last, the interior installations of the Grand Palais were systematically categorised.

The Exhibition aroused new activity long in advance, as a consequence of the emulation it caused among artists and manufacturers. The creator's efforts were significantly encouraged by groups of 'modern' minds, which grew in number and made engaging and effective propaganda. Foreign exhibitors attach no less importance than the hosts to an opportunity that would allow most countries to compare their efforts and enrich their designs. Thus, the frame of mind of the exhibition was not a centralising narrow-mindedness, a formal modernism of the time. Far from imposing rigid and concrete specifications of style, the Exhibition of 1925 became apparent as an overview intended to reveal the tendencies in contemporary art, and to showcase their first achievements. The only stipulation was for it to be an 'original production', appropriate to the needs, universal or local, of the time. This phrase could be used to refer to any previous century, which may have only been said to be great because it was thought to be innovatory.

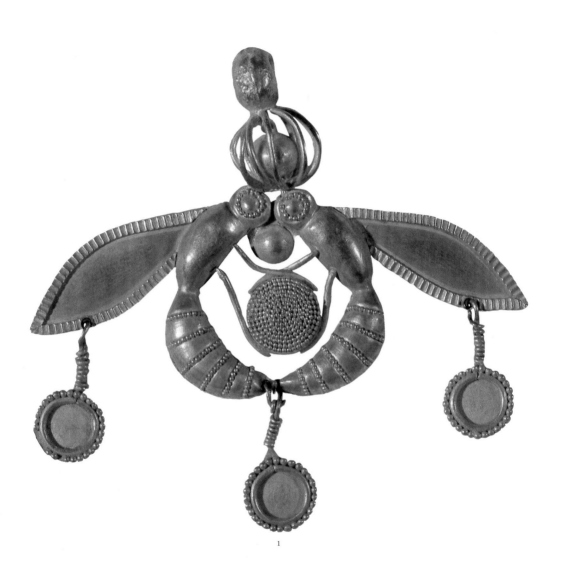

1

ANTIQUITY

It is widely accepted that the first traces of civilisation and, by extension, the first features of characteristic styles, are to be found in Egypt. The day when man determined that one substance was more precious than another, he worked on it as on a labour of love and devoted it to the embellishment of temples which he reared to his gods, or the adornment of his own person. All written records unite in proving this, Holy Scripture, Homeric poems, and even the oldest narratives of the Far East. Museums have also confirmed the fact and bear authentic testimony to this innate sentiment of luxury inherent in all people of the earth. Who has not stood astonished before the perfection of the Greek jewels displayed in the Louvre or before the first attempts of unknown people of the Americas, as barbaric and almost similar to those of Asia Minor? Is it not well-known that, among ourselves the artistic forms given to the precious metals were but a provisional garb intended to impart an agreeable appearance to the portable wealth of our ancestors? Capital accumulated in this shape was readily moveable, and, alas still more readily alienable. War, emigration, casual wants, all brought gold and silver to the smelting-pot, which had erewhile been proudly displayed in vases, furniture, and jewellery. Nor is it simply ancient times which had to undergo such vicissitudes of which we have spoken. There is not an epoch in history which has not had its hecatombs of works of art whenever the pressure of public requirements made itself sensibly felt.

Styles emerge from a mix of ideas and take on the universal cloak of timeless beauty. Whether they are cheerful or solemn depends on contemporary fashions and events as the style will pick and choose from preceding styles to satisfy current whims. Vanity, the early signs of which we discussed when describing the prehistoric cavewoman in her necklaces of coloured stones, animal teeth, and perforated shells, will now come into its own as not only the Egyptians and Assyrians, but the Hebrews and peoples throughout Asia perfected the goldsmith's arts. Egyptian tombs have yielded perfectly-chased pectorals, scarab necklaces, symbolic fish, lotus flowers, and so on. However, these cannot compete with Greek jewellery.

The goldsmith's trade was a school which produced masters. Lysippos hammered metal before he became sculptor; Alexander, third son of Perseus, king of Macedon, did not think it disparaging to make chasings in gold and silver. The large votive vase in the temple of Minerva has immortalised the name of Aristotle of Hiton. Calumis, sculptor as he was, used to embellish silver vases with bas-reliefs, which, in the days of Nero, were, at Rome and among the Gauls, an article of luxury for the rich and a subject of emulation for artists. However, magnificent works, crowns, vases, and jewellery, have honoured our museums and suffice to prove that the songs of Homer and the descriptions of Pliny were not exaggerated.

The Greeks excelled in the working of metal, which they decorated with repoussé work and did not solder, while the Egyptians were the masters of pictorial representation in jewellery.

However, we are more familiar with Roman and Etruscan gold work thanks to the excavations of the necropolis of

1. **Anonymous.**
Bee-shaped pendant, Royal Necropolis, Malia, 1700-1600 BCE.
Gold. Heraklion Archaeological Museum, Heraklion (Crete).
Greek Antiquity.

Etruria and particularly those carried out in the ruins of Herculaneum and Pompeii. Amongst other objects, the clips, earrings, hooks, mirrors, and brooches recovered there are admirable for their shape, taste, and beauty. The Romans, in fact, loved gold and precious stones and brought a delicate good taste to their jewellery which Eastern peoples, who were more preoccupied with originality than with the aesthetic aspects of their art, lacked. The Byzantine emperors, too, would further emphasise luxury and their strange heavy jewellery is often accused of lacking taste. However, Byzantium at least has the excuse of achieving real luxury and the magnificent abundance it expresses perhaps makes amends for other deficiencies. It is "a dazzling jumble of enamels, cameos, niellos, pearls, garnets, sapphires, and gold and silver indented work". (Théophile Gautier.) The Gauls and Franks seem to have been fond of the necklaces and rings made of precious metals of which so many examples have been found in their tombs. Gallo-Roman gold and silver smiths have left us many examples of bracelets and armbands in the shape of coiled snakes, necklaces, badges, brooches, and so on. Generally speaking, the style of these pieces is closely aligned with the building style and decoration of the period. We suggested earlier that a piece of furniture is a miniature architectural monument. Similarly, a piece of jewellery is a miniature monument in gold or silver. We will recognise the designs used from the pediments of temples or the columns of the time and the shape from one or other detail of a building or the curve of a typical amphora.

The list of Egyptian furniture includes chests, pedestal tables, armchairs, stools and tables which are relatively similar in shape to our own. They are decorated with metals, ivory, mother-of-pearl, and precious woods. They have brightly-coloured coverings and there are cushions on the armchairs and stools. The beds have a kind of bed base made of strips of fibres or leather which show that comfort was a consideration. The chests take the form of miniature dwellings or temples. In summary, the Egyptian style is characterised by the hieratical, monumental nature of its statuary, by its columns and capitals (palm tree or lotus), by its sphinx, by the colossi with the heads of the pharaohs and its animal-headed gods, by its obelisk and by its pyramids, by its decoratively-deployed hieroglyphs, and finally by the huge size of its buildings. Furthermore, the widely-used decorative sacred scarab motif should not be forgotten.

The weaving of textiles dates from the earliest ages of the world, and even now we are struck with amazement at the perfection of the works produced by the hands of the ancient Egyptian craftsmen. With the primitive looms and materials spun by hand, they obtained wonderful fabrics. We learn, from the description of yarn found in the Louvre, about the fine long pile and fringed material, called *fimbria* and the transparent fabric styled by the Latins, *nebula linea*, which we will again meet with in the East at Mossoul, whence it reaches us under the name of muslin.

Whether from a civil or religious point of view, the most ancient decoration of buildings and interiors consists of hangings, the accompaniment of statues, paintings, and mosaics. However far we go back into antiquity, we can trace their use; from the heroic ages, the Phrygian and Grecian women succeeded in representing flowers and human figures, not only by means of embroidery, but in the elegant fabric itself. The young girls summoned to take part in the Panathenaic procession embroidered beforehand the veil or peplum of Minerva, an enormous hanging which was used to cover the roofless area in the temple of the goddess.

2. **Anonymous.**
Armchair of Hetepheres, Dynasty IV, 2575-2551 BCE.
Gilded wood, 79.5 x 71 cm.
Egyptian Museum, Cairo. Egyptian Antiquity.

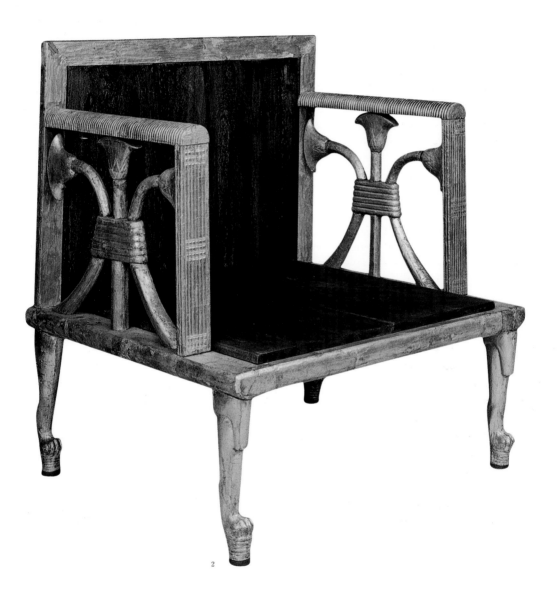

2

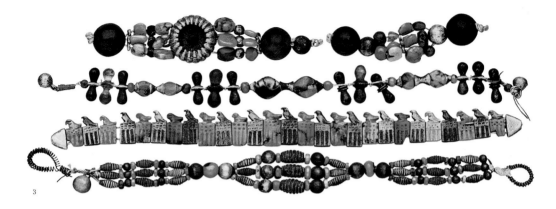

3. Anonymous.
Bracelets from the tomb of Djer, Dynasty I, 2920-2770 BCE.
Gold, lapis lazuli, length: 10.2-15.6 cm.
Egyptian Museum, Cairo. Egyptian Antiquity.

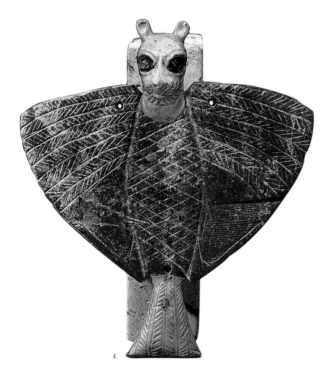

4. Anonymous.
Pendant, *Imdugud, the Lion-Headed Eagle*, Royal Palace of Mari, c. 2650 BCE.
Lapis lazuli, gold, bitumen, and copper, 12.8 x 11.8 cm.
National Museum of Damascus, Damascus. Eastern Antiquity.

5. Anonymous.
Decorative panel, Dynasty III, 2630-2611 BCE.
Limestone and stoneware, 181 x 203 cm.
Egyptian Museum, Cairo. Egyptian Antiquity.

6. Anonymous.
Labels for vases, Dynasty I, 2920-2770 BCE.
Ivory. Egyptian Museum, Cairo.
Egyptian Antiquity.

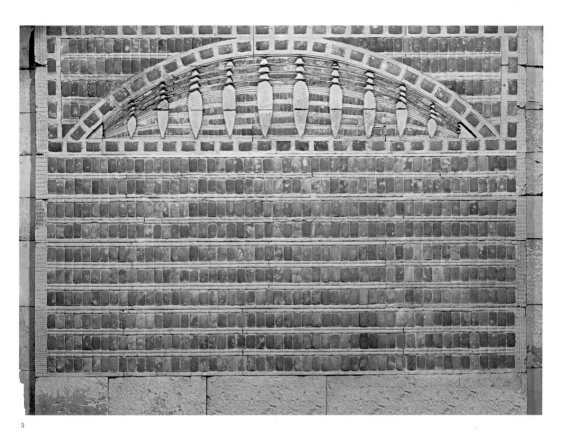

5

6

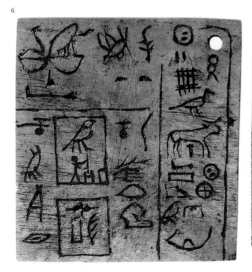

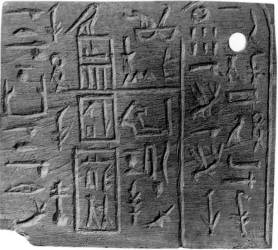

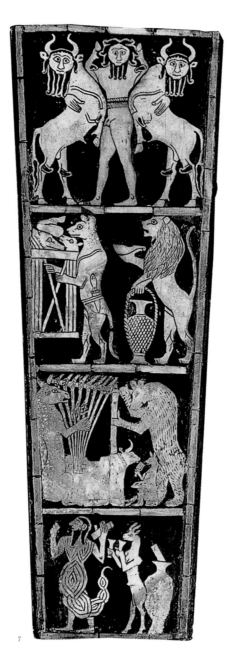

7

7. Anonymous.
Inlaid panel of a soundboard from a lyre, c. 2600 BCE.
Seashell and bitumen, 31.1 x 11.3 cm.
University of Pennsylvania Museum of Archaeology and Anthropology, Philadelphia. Eastern Antiquity.

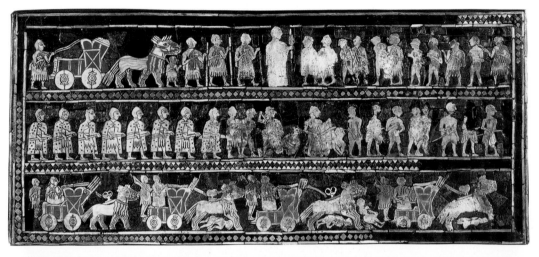

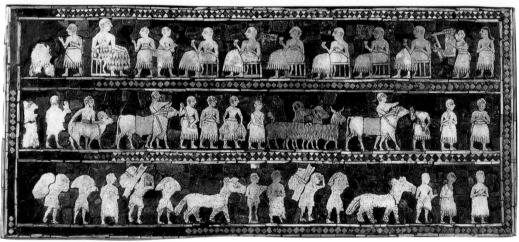

8

8. **Anonymous.**
The Standard of Ur (double-sided), c. 2600-2400 BCE.
Wood, seashell, red limestone, and lapis lazuli, 21.5 x 49.5 cm.
British Museum, London. Eastern Antiquity.

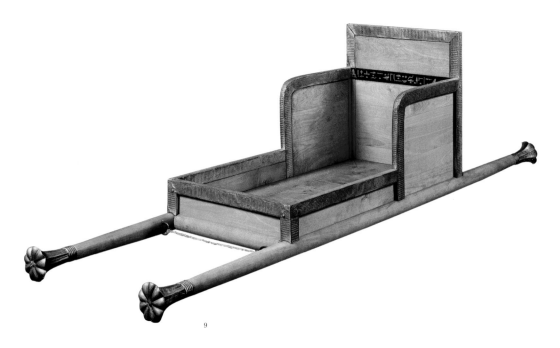

9

9. Anonymous.
Litter belonging to Hetepheres, Dynasty IV, 2575-2551 BCE.
Wood with gold leaf, height: 52 cm.
Egyptian Museum, Cairo. Egyptian Antiquity.

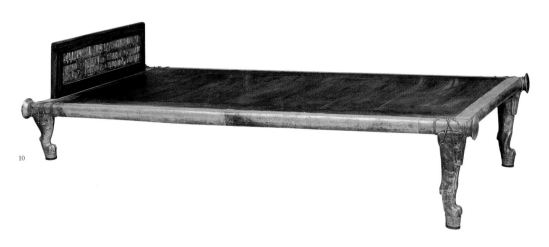

10

10. Anonymous.
Bed belonging to Hetepheres, Dynasty IV, 2575-2551 BCE.
Wood with gold leaf, 178 x 21.5 x 35.5 cm.
Egyptian Museum, Cairo. Egyptian Antiquity.

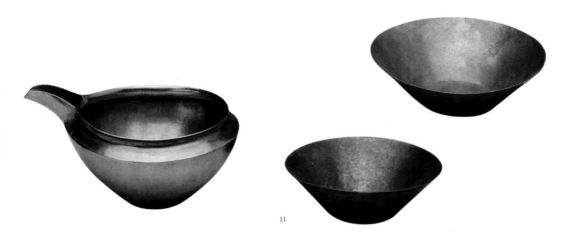

11. Anonymous.
Bowls belonging to Hetepheres, Dynasty IV, 2575-2551 BCE.
Wood with gold leaf, diameter: 8-8.5 cm.
Egyptian Museum, Cairo. Egyptian Antiquity.

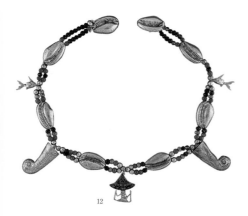

12. Anonymous.
Chains with amulets and clasp, c. 2055-1650 BCE.
Silver, lapis lazuli, glass, feldspar, electrum, carnelian,
amethyst, length: 47 cm. British Museum, London. Egyptian Antiquity.

13. Anonymous.
Earrings, Dynasty XVIII, c. 1550-1295 BCE.
Gold, diameter: 2.6 cm.
British Museum, London. Egyptian Antiquity.

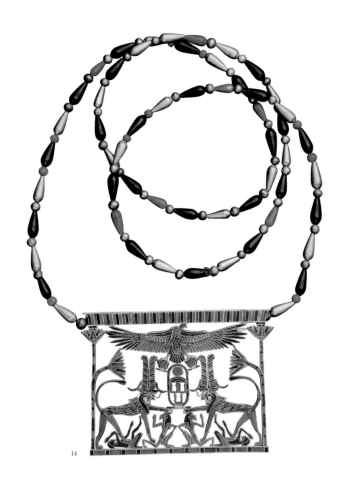

14

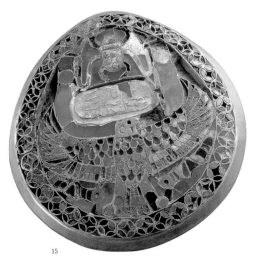

15

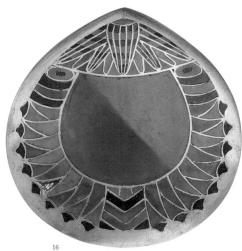

16

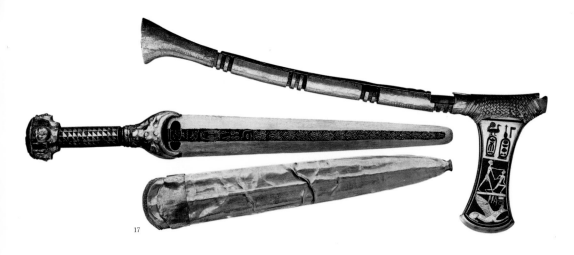

17

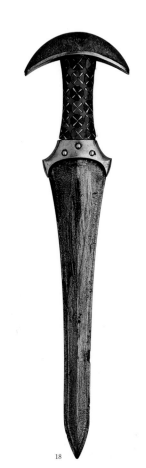

14. Anonymous.
Necklace with pectoral, dedicated to Sesostris II, Dynasty XII, 1898-1881 BCE.
Gold and semi-precious stones, height: 4.9 cm.
Egyptian Museum, Cairo. Egyptian Antiquity.

15. Anonymous.
Pendant in the shape of a shell inscribed with the name of Ibshemuabi,
King of Byblos, 2000-1500 BCE.
Gold, semi-precious stones, 7.5 x 7 cm.
Directorate General of Antiquities, Beirut. Eastern Antiquity.

16. Anonymous.
Pendant belonging to Mereret, Dynasty XII, 1881-1794 BCE.
Semi-precious stones, height: 4.6 cm.
Egyptian Museum, Cairo. Egyptian Antiquity.

17. Anonymous.
Ceremonial hatchet of Ahmose, Dynasty XVIII, 1550-1525 BCE.
Wood, copper, gold, and semi-precious stones, 47.5 x 6.7 cm.
Egyptian Museum, Cairo. Egyptian Antiquity.

18. Anonymous.
Dagger belonging to Princess Ita, Dynasty XII, 1929-1898 BCE.
Gold, bronze, semi-precious stones, length: 28 cm.
Egyptian Museum, Cairo. Egyptian Antiquity.

18

21

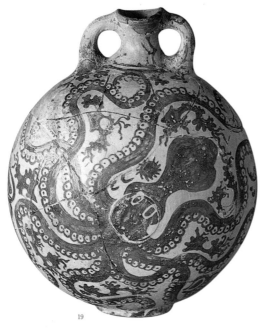

19

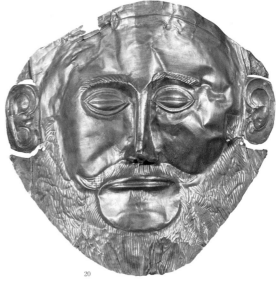

20

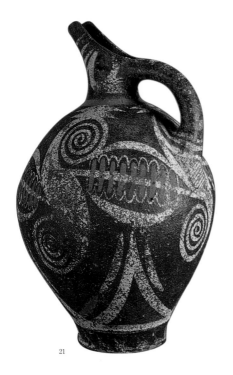

21

19. **Anonymous.**
'Octopus' Vase, Palekastro, c. 1500 BCE.
White fictile, height: 28 cm.
Heraklion Archaeological Museum, Heraklion (Crete). Greek Antiquity.

20. **Anonymous.**
Funeral mask, known as 'Mask of Agamemnon', Grave V, Mycenae, c. 1600-1500 BCE.
Gold, height: 31.5 cm.
National Archaeological Museum, Athens. Greek Antiquity.

21. **Anonymous.**
Pitcher belonging to Hephaistos, c. 1800 BCE.
Height: 27 cm.
Heraklion Archaeological Museum, Heraklion (Crete). Greek Antiquity.

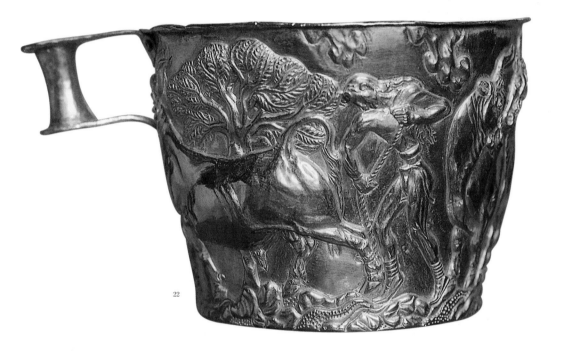

22

22. **Anonymous.**
Golden Vaphio cup, c. 1500-1400 BCE.
Gold, height: 7.5 cm.
National Archaeological Museum, Athens. Greek Antiquity.

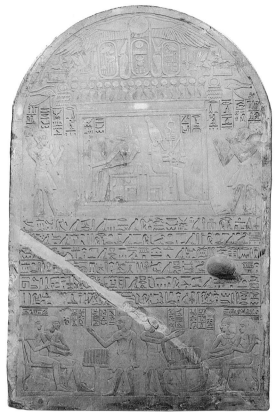

23

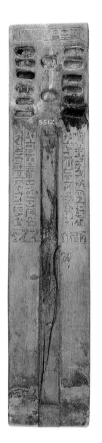

24

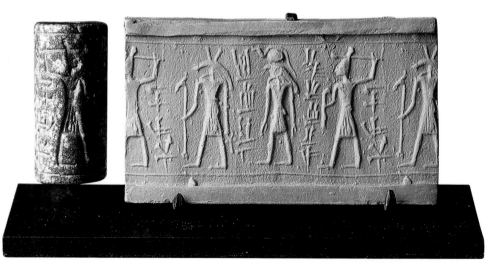

25

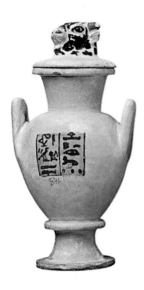

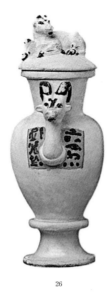

26

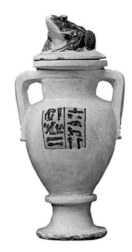

23. Anonymous.
Stele of Amenhotep, Dynasty XVIII, c. 1400-1390 BCE.
Limestone, traces of paint, height: 89 cm.
British Museum, London. Egyptian Antiquity.

24. Anonymous.
Drawing board, Dynasty XVIII, c. 1475 BCE.
Wood, plaster, ink, 36.5 x 53.4 cm.
British Museum, London. Egyptian Antiquity.

25. Anonymous.
Cylinder seal of Annipi, King of Sidon and son of Addume, c. 13th century BCE.
Blue glass (cobalt), height: 2.7 cm.
Musée du Louvre, Paris. Egyptian Antiquity.

26. Anonymous.
Vases on behalf of Yuya, Dynasty XVIII, 1387-1350 BCE.
Painted limestone, height: 25 cm.
Egyptian Museum, Cairo. Egyptian Antiquity.

27. Anonymous.
Perfume container, Dynasty XVIII, 1333-1323 BCE.
Alabaster, gold, glass paste, stoneware, 70 x 36.8 cm.
Egyptian Museum, Cairo. Egyptian Antiquity.

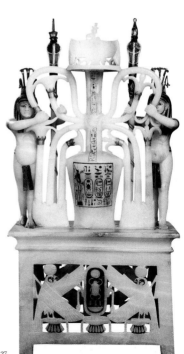

27

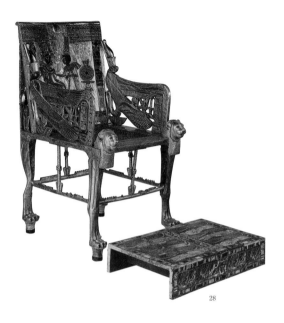

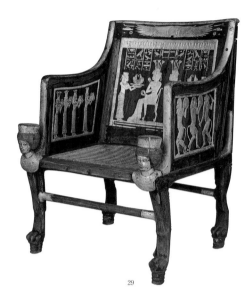

28. **Anonymous.**
Throne with footrest, Dynasty XVIII, 1333-1323 BCE.
Wood, golden leaf, silver, glass paste, precious stones, stoneware,
height of throne: 102 cm. Egyptian Museum, Cairo. Egyptian Antiquity.

29. **Anonymous.**
Chair belonging to Princess Satamun, Dynasty XVIII, 1387-1350 BCE.
Stuccoed wood, gold leaf, plant fibres, height: 77 cm.
Egyptian Museum, Cairo. Egyptian Antiquity.

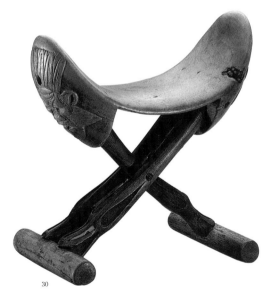

30. **Anonymous.**
Folding headrest, Dynasty XVIII, c. 1390-1295 BCE.
Wood, 19.2 x 19.4 cm.
British Museum, London. Egyptian Antiquity.

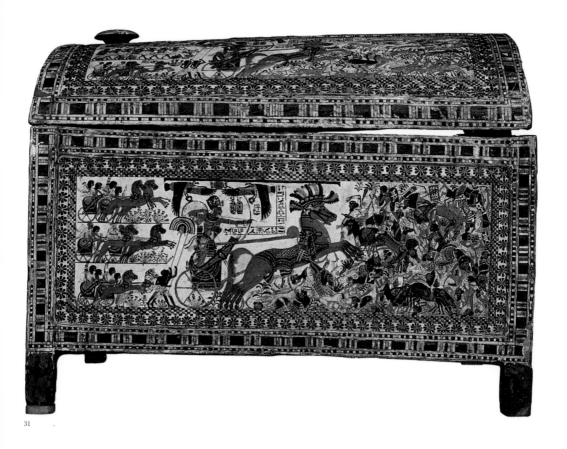

31

31. Anonymous.
Painted chest, Dynasty XVIII, 1333-1323 BCE.
Stuccoed and painted wood, 61 x 43 cm. Treasure belonging to Tutankhamun.
Egyptian Museum, Cairo. Egyptian Antiquity.

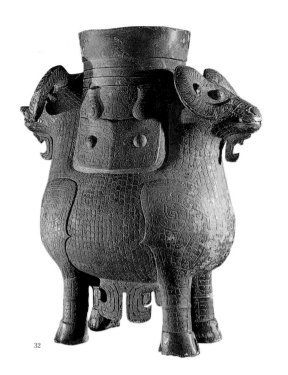

32

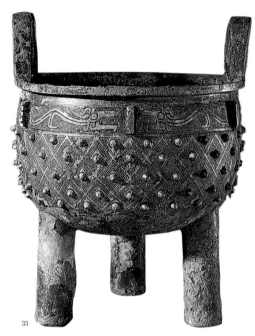

33

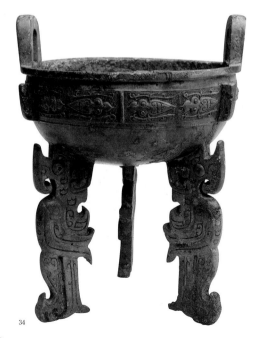

34

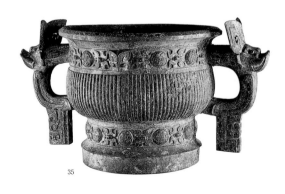

35

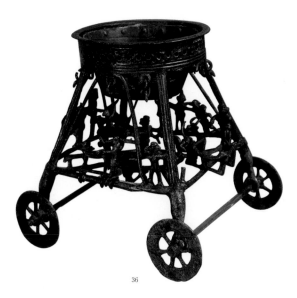

36

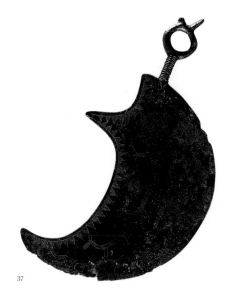

37

36. Anonymous.
Chariot for worship, Bisenzio, end of the 8th century BCE.
Bronze, wheels: 30 cm.
Museo Nazionale Etrusco di Villa Giulia, Rome. Etruscan Antiquity.

37. Anonymous.
Bronze razor, 9th century BCE.
Bronze with engraved hunting scene and geometric pattern.
Museo archeologico e d'arte della Maremma, Grosseto. Etruscan Antiquity.

32. Anonymous.
Jug, 14th-12th century BCE.
Bronze, height: 43.2 cm.
British Museum, London. Chinese Antiquity.

33. Anonymous.
Jug for rituals, 12th century BCE.
Bronze, height: 20.3 cm.
British Museum, London. Chinese Antiquity.

34. Anonymous.
Jug with bird feet, 12th-11th century BCE.
Bronze, height: 20 cm.
Shanghai Museum, Shanghai. Chinese Antiquity.

35. Anonymous.
Jug, 11th century BCE.
Bronze, height: 42 cm.
British Museum, London. Chinese Antiquity.

38. Anonymous.
Lower part of a quiver from Lorestan (Iran), 1000-750 BCE.
Bronze. Musées royaux d'Art et d'Histoire, Brussels. Eastern Antiquity.

38

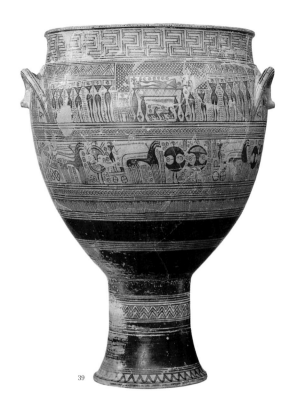

39

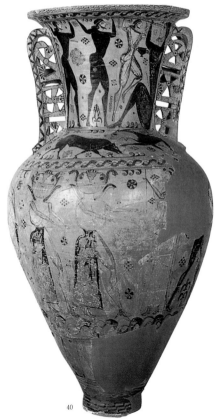

40

39. Anonymous.
Dipylon vase, from a cemetery in Dipylon, 750-735 BCE.
Terracotta, diameter: 72.4 cm.
The Metropolitan Museum of Art, New York. Greek Antiquity.

40. Anonymous.
Eleusis Amphora: *The Blinding of the Cyclops Polyphemus by Odysseus,*
c. 675-650 BCE.
Terracotta, height: 142.3 cm.
Archaeological Museum of Eleusis, Eleusis (Greece). Greek Antiquity.

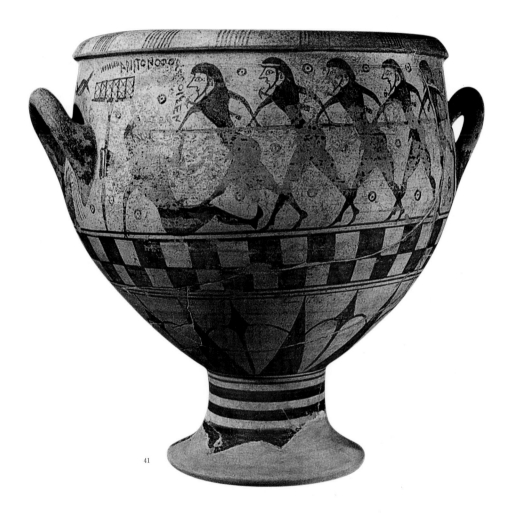

41

41. Anonymous.
Jug, c. 650 BCE.
Terracotta, 28 cm.
Museo del Palazzo dei Conservatori, Rome. Etruscan Antiquity.

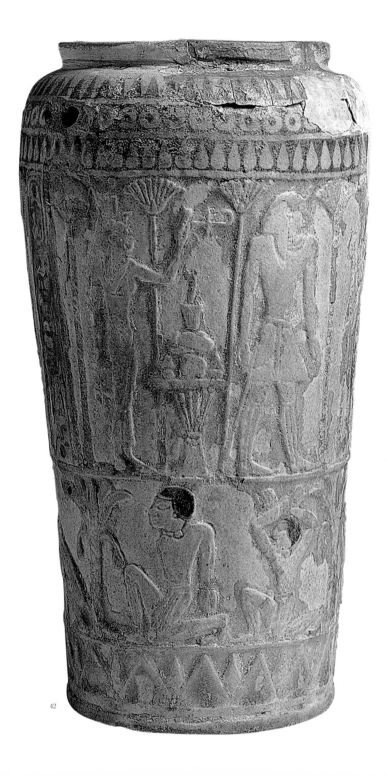

42

32

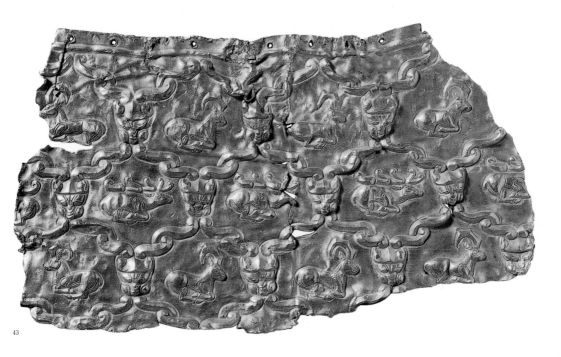

43

42. **Anonymous.**
Situla belonging to Bakenranef, c. 700 BCE.
Stoneware. Museo Archeologico Nazionale Tarquiniese,
Tarquinia (Italy). Etruscan Antiquity.

43. **Anonymous.**
Piece of a belt, probably from Ziwiye,
end of the 8th century BCE.
Gold leaf, 16.5 cm.
British Museum, London. Eastern Antiquity.

44. **Anonymous.**
Bowl from the tomb of Bernardini, 675 BCE.
Gilded silver.
Museo Nazionale Etrusco di Villa Giulia, Rome.
Etruscan Antiquity.

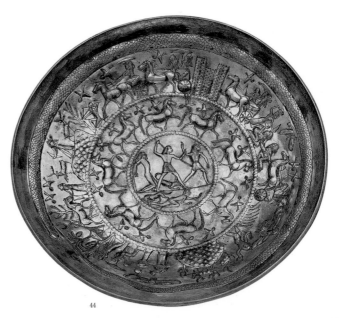

44

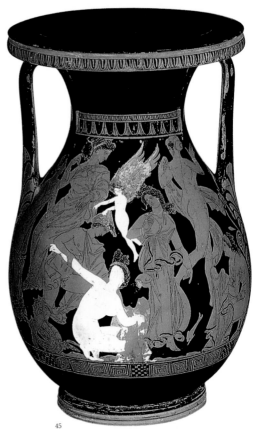

45

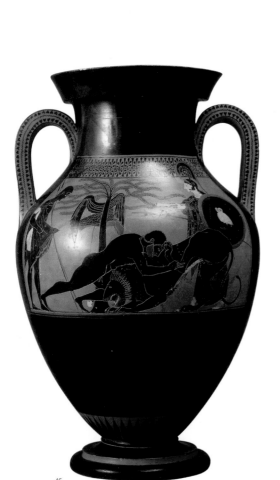

46

45. Marsyas Painter,
Peleus and Thetis, Surrounded by Other Sea Nymphs, c. 340 BCE.
Red-figured storage jar, height: 43.3 cm.
British Museum, London. Greek Antiquity.

46. Anonymous.
Hercules Strangling the Nemean Lion, c. 525 BCE.
Attic black-figured amphora, height: 45.5 cm.
Museo Civico dell'Étà Cristiana, Brescia. Greek Antiquity.

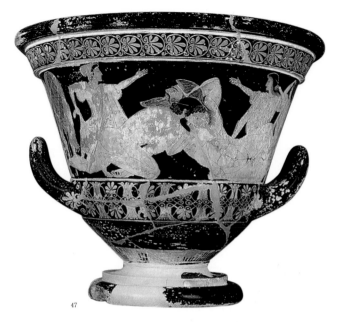

Euphronios
(Athens, end of the 6th century BCE – first half of the 5th century BCE)

As pottery maker and painter, Euphronios is one of the most well-known artists of his time, as the antiquated Greek pottery with black figures was replaced by innovative ceramics with red figures. As a forerunner in the new technique, Euphronios made several of his works recognisable through his style and his signature. He was inspired by mythological themes, by daily scenes, and by the heroic acts of Hercules, producing many large vases, amphorae, and kraters. Known for the precision of drawing naked and muscular figures, Euphronios sought opportunities to create versatile works of art, and added a hand-written note on his works.

47.

47. **Euphronios**, end of the 6th century BCE-first half of the 5th century BCE, Greek.
Hercules Wrestling Antaeus, 515-510 BCE.
Red-figured calix krater, height: 44.8; diameter: 55 cm.
Musée du Louvre, Paris. Greek Antiquity.

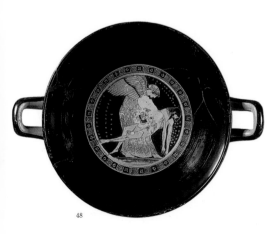

48.

48. **Douris**, 6th-5th century BCE, Greek.
Memnon Pieta, c. 490-480 BCE.
Interior from an Attic red-figured cup, diameter: 26.7 cm.
Musée du Louvre, Paris. Greek Antiquity.

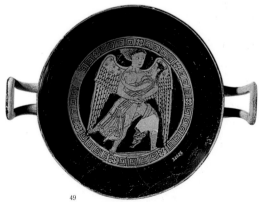

49.

49. **Anonymous**.
Red-haired Demon, c. 350 BCE.
Red-figured kylix (bowl) from Vulci.
Museo Gregoriano Etrusco, Vatican City. Etruscan Antiquity.

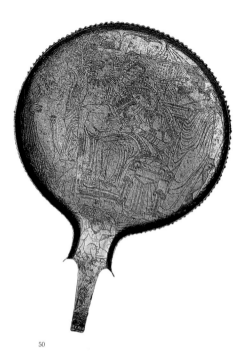

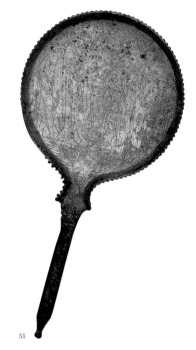

50

51

50. Anonymous.
Mirror illustrating *The Nursing of Hercules*, c. 350 BCE.
Bronze.
Museo Archeologico Nazionale, Florence. Etruscan Antiquity.

51. Anonymous.
Mirror from Tuscany, 350-300 BCE.
Bronze, diameter: 12 cm.
Museo Archeologico Nazionale, Florence. Etruscan Antiquity.

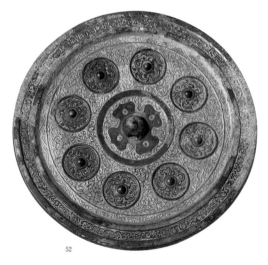

52

53

52. Anonymous.
Mirror with eight protrusions, 206 BCE – 220 CE.
Bronze, diameter: 21 cm.
National Palace Museum, Taipei. Chinese Antiquity.

53. Anonymous.
Coins from Vetulonia, c. 250 BCE.
Bronze.
Museo Archeologico Nazionale, Florence. Etruscan Antiquity.

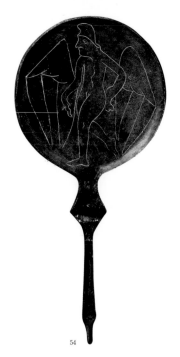

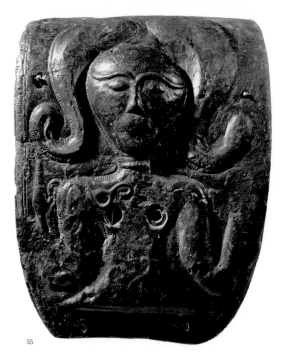

54

55

54. Anonymous.
Mirror with a winged genius, 3rd century BCE.
Bronze.
Museo Nazionale Etrusco di Villa Giulia, Rome. Etruscan Antiquity.

55. Anonymous.
Embellishment on the tomb of a woman from Waldalgesheim
(Germany), second half of the 4th century BCE.
Bronze, height: 9.5 cm. Rheinisches Landesmuseum Bonn, Bonn. Celtic Antiquity.

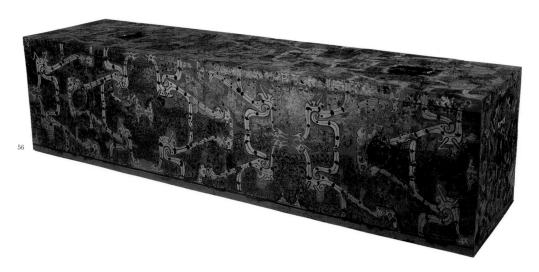

56

56. Anonymous.
Chinese lacquered coffin decorated with birds and dragons, 4th century BCE.
Wood, 184 x 46 cm.
Hubei Museum, Hubei (China). Chinese Antiquity.

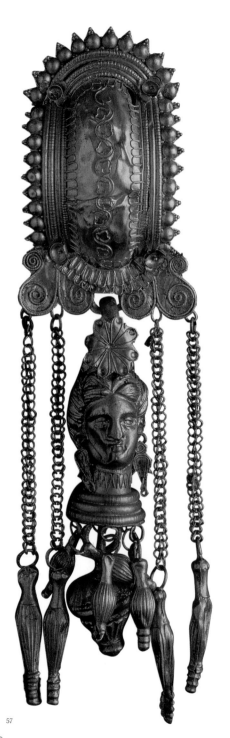

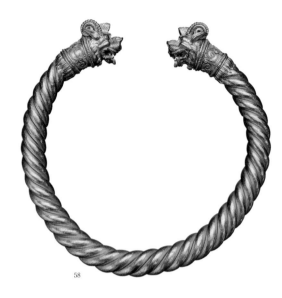

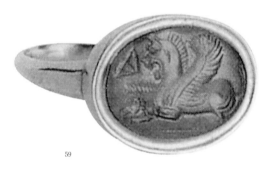

57. **Anonymous.**
Earring, c. 300 BCE.
Gold.
Museo Nazionale Etrusco di Villa Giulia, Rome. Etruscan Antiquity.

58. **Anonymous.**
Bracelet, Ptolemaic period, 305 BCE.
Gold, diameter: 8 cm.
Egyptian Museum, Cairo. Egyptian Antiquity.

59. **Anonymous.**
Signet ring, 4th-3rd century BCE.
Carnelian, diameter: 1.7 cm.
The State Hermitage Museum, St Petersburg. Persian Antiquity.

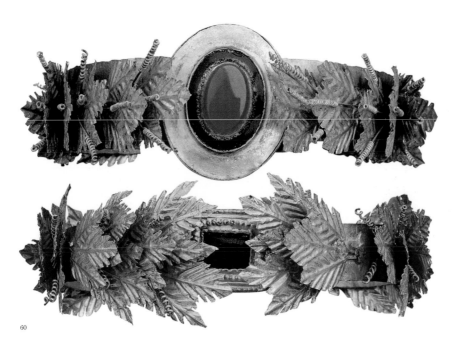

60. Anonymous.
Bracelet with an agate stone, Roman period, 117-138 CE.
Hammered gold leaf, agate, diameter: 9 cm.
Egyptian Museum, Cairo. Egyptian Antiquity.

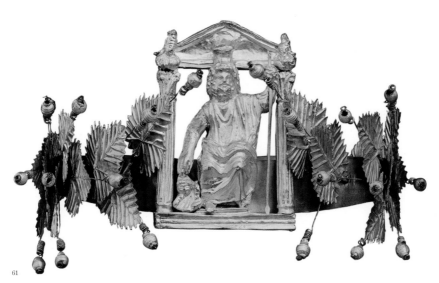

61. Anonymous.
Headpiece with a serapi figure, Roman period, 117-138 CE.
Gold, diameter: 22 cm.
Egyptian Museum, Cairo. Egyptian Antiquity.

62

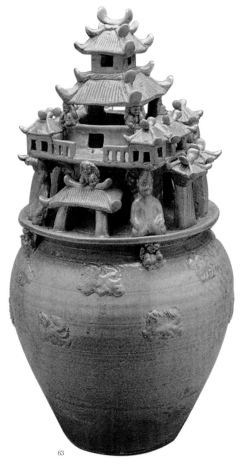

63

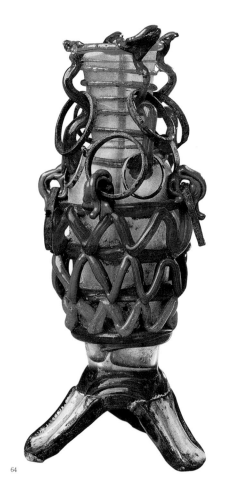

64

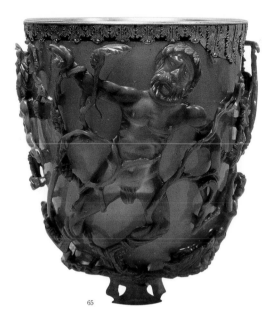

65

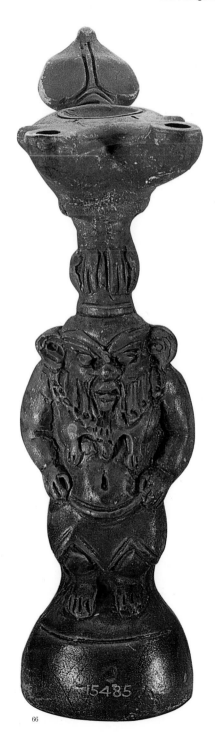

62. Anonymous.
Two adornments depicting immortals, late Han dynasty, 2ⁿᵈ-3ʳᵈ century CE.
Gold leaf and inlaid work, 2.5 x 4 cm.
Musée national des Arts asiatiques - Guimet, Paris. Chinese Antiquity.

63. Anonymous.
Incense burner in the shape of a Lian house, late Han dynasty, 20-220 CE.
Ceramic with lead glaze, height: 15 cm.
Musée national des Arts asiatiques - Guimet, Paris. Chinese Antiquity.

64. Anonymous.
Embellished vase, Roman period, 2ⁿᵈ-3ʳᵈ century CE.
Glass, bronze, and gold.
Egyptian Museum, Cairo. Egyptian Antiquity.

65. Anonymous.
Cup belonging to Lycurgus, 4ᵗʰ century BCE.
Gilded ruby, glass mixture, gold, and silver with copper highlights,
height: 16.5 cm.
British Museum, London. Roman Antiquity.

66. Anonymous.
Lamp with the figure of the god Bes, beginning of the 2ⁿᵈ century.
Terracotta, height: 21.5 cm.
British Museum, London. Egyptian Antiquity.

66

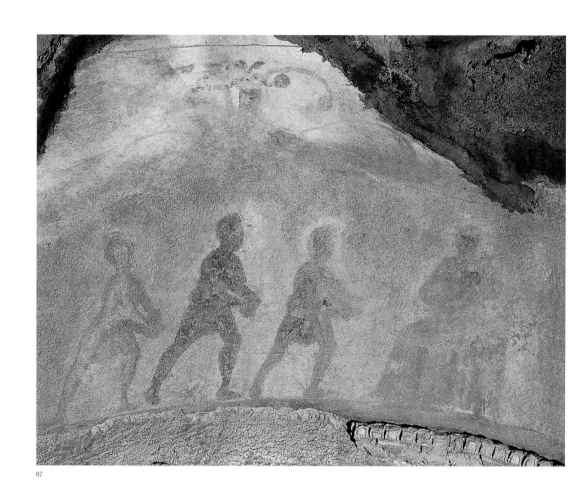

67

67. **Anonymous.**
Adoration of the Magi, c. 200.
Fresco.
Capella Greca, Catacomb of Priscilla, Rome. Romanesque.

68. **Anonymous.**
The Good Shepherd, c. 250.
Fresco.
Capella Greca, Catacomb of Priscilla, Rome. Romanesque.

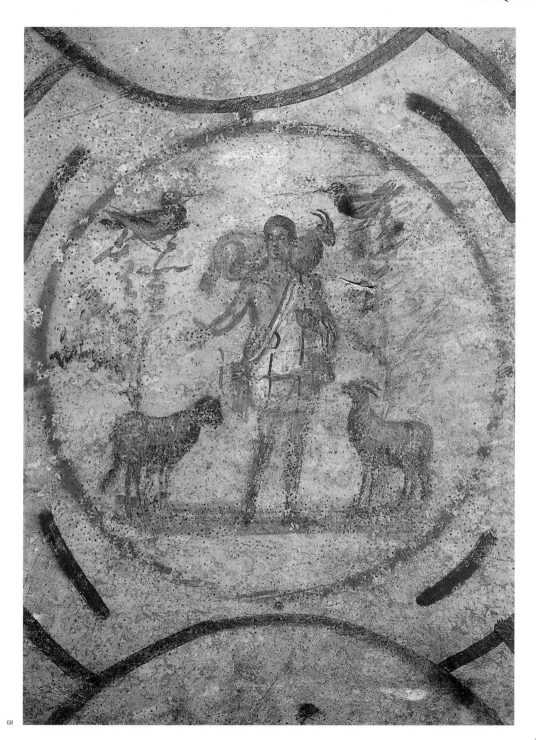

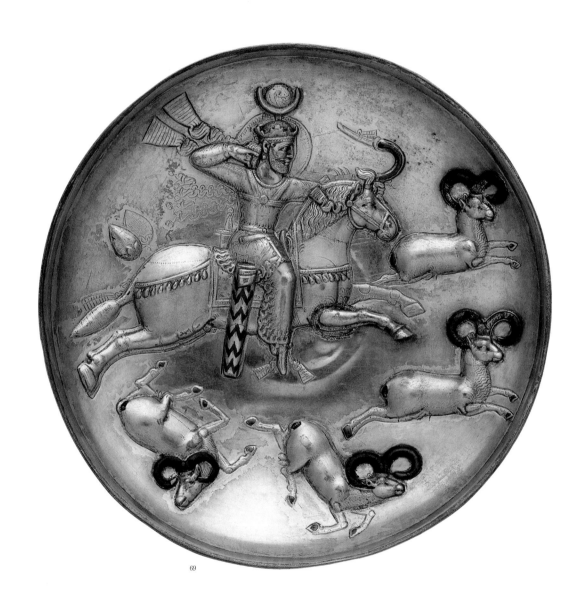

69

69. Anonymous.
King Hunting Rams, plate, 5th-6th century.
Silver, mercury gilding, niello inlay, diameter: 21.9 cm.
The Metropolitan Museum of Art, New York. Persian Antiquity.

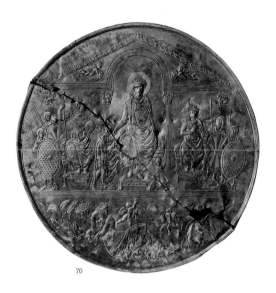

70

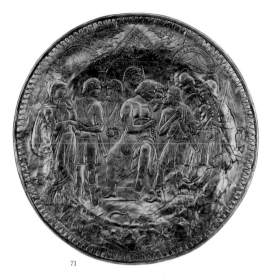

71

70. Anonymous.
The Missorium of Theodosius, 387-388.
Silver, partially gilded, diameter: 74 cm.
Real Academia de la Historia, Madrid. Byzantine Antiquity.

71. Anonymous.
Scipio's shield, end of the 4th century or beginning of the 5th century.
Silver, partially gilded, diameter: 71 cm.
Cabinet des Médailles, Bibliothèque nationale de France, Paris. Byzantine Antiquity.

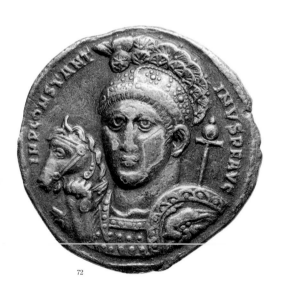

72

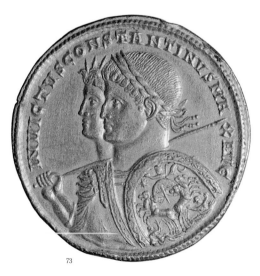

73

72. Anonymous.
Medal of Emperor Constantine the Great, 315.
Silver, diameter: 2.4 cm.
Staatliche Münzsammlung München, Munich. Romanesque.

73. Anonymous.
Medal of Emperor Constantine the Great and the sun god, Sol, 313.
Gold.
Cabinet des Médailles, Bibliothèque nationale de France, Paris. Romanesque.

74

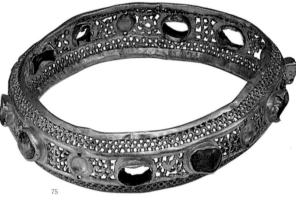

75

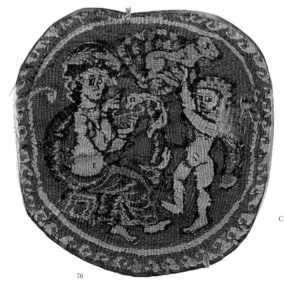

76

74. **Anonymous.**
Embellished bottle, Roman period, 4th century.
Terracotta, height: 30.5 cm.
Egyptian Museum, Cairo. Egyptian Antiquity.

75. **Anonymous.**
Bracelet, end of the 4th century or beginning of the 5th century.
Gold and coloured stones, diameter: 7.5 cm.
Cabinet des Médailles, Bibliothèque nationale de France, Paris. Byzantine Antiquity.

76. **Anonymous.**
Jason and Medea, end of the 4th century or beginning of the 5th century.
Tapestry in polychrome linen, diameter: 7 cm.
Musée de Cluny, Paris. Egyptian Antiquity.

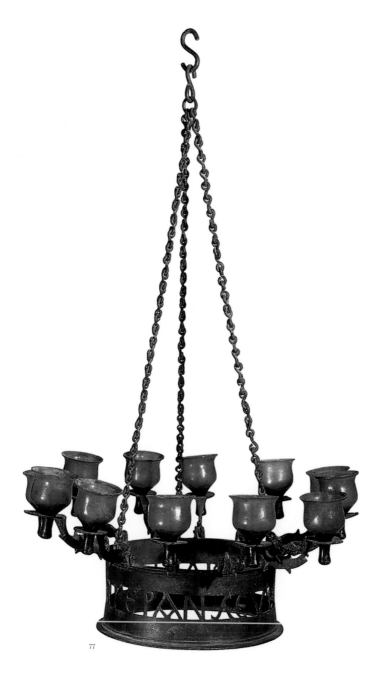

77

77. Anonymous.
Lustre, 5th-7th century.
Bronze (bobeches in modern glass), height: 18 cm; diameter: 48.5 cm.
Musée du Louvre, Paris. Byzantine.

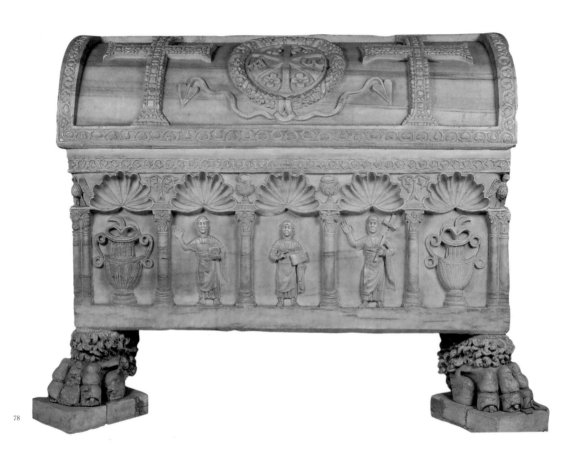

78

78. **Anonymous.**
Sarcophagus, probably belonging to Archbishop Theodor,
end of the 5ᵗʰ century or beginning of the 6ᵗʰ century.
Marble. Basilica of St Apollinaris in Classe, Ravenna (Italy). Byzantine.

MIDDLE AGES

Besides the Celtic monuments to which we have already referred (menhirs, dolmens, etc.) there is very little that is original in the style of the Gaulish period and from the Roman invasion onwards, any traces of the romantic, which were, in any case, more a result of the rudimentary nature of life at the time than of a feeling for art, are swallowed up by the culture of the victorious Romans. The bathhouses, theatres, and arenas are all attributed indiscriminately to the Gauls and the Romans, and Gaulish furniture is so similar to the furniture used in Rome as to be indistinguishable from it. Frankish style is similarly insignificant. The Franks were busy fighting and a more civilised period only begins to flourish when peace returns. The evidence of this civilisation is to be found in the Christian monasteries built beside the tombs of the saints. Clovis' reign was of no artistic importance but Dagobert had an abbey built at Saint-Denis and left us an armchair which bears his name, although there is very little to distinguish it from a curule chair! At the same time, gold and silver works with a peculiarly Byzantine flavour have been found dating from Charlemagne's reign onwards. It seems that chests attributed to the Carolingian period decorated with ivory plaques showing mythical animals and using inlaid ivory and marquetry with different coloured woods inspired the arrangements used by Italian ivory craftsmen. What we shall witness next is the arrival in the West of a new art under the auspices of new religious aspirations.

The catacombs where the early Christians took refuge from the persecution of the Roman Emperors were to be the birth-place of this Christian art, which would evolve little by little away from the old thinking. Hot wax paintings, richly-sculpted sarcophagi and a wealth of tools, receptacles and so on bear witness to the momentum of this new world view, which would be marked by a use of allegory and symbolism borrowed, in particular, from Pagan thought. However, one distinguishes in the rough execution of their work, which was of a much poorer quality than that of Rome's public buildings and imperial palaces, a thrust which was moving gradually away from those roots. When the vast Roman Empire tired of creating martyrs and inventing new forms of torture while its enemies expressed their faith through images of peace, happiness, unity, and hope, accepted the new faith, the images created in the catacombs began to decorate the walls of churches and basilicas. These images did not take on an identity entirely of their own until after the advent of Constantine when Christian art could safely develop inside these religious buildings.

At this point painting (sculpture was rather rare, found in the form of low reliefs on sarcophagi and was very similar in its themes to decorative painting) began to depict historical subjects, including Christ, the Virgin, the Apostles, Abraham and Moses, Jonah and Daniel, just as the artists of antiquity had depicted Perseus, Hercules and Theseus. It was not until basilicas had finally replaced profane buildings that Christians used images to celebrate their religion, through representations of their martyr's victory. Justinian, who had recourse to the Greek artists who imported a style of architecture which paid homage to Constantinople into the West, established the Byzantine style.

The Byzantine style is essentially an eastern style. It speaks of India, Persia, and Syria - of Asia, in fact, and celebrates the wealth of detail and the magnificence of their decoration. Although the profusion of decoration found in the Byzantine style is less than tasteful, it has great character. In painting, figures stand out against a golden background and mosaic work has never been more widely used than it was during this period. Rich fabrics from Asia were also typical. These were painted or embroidered, covered with gold or silver leaf, precious stones, cabochons and large pieces of chased metal. Favourite motifs were flowers, animals, and 'episodes from the life of Christ'. There might be up to six hundred figures on a tunic or cloak. Beds, seating, chests, vessels, and so on were made of delicately worked ebony, ivory, gold, silver, and bronze. This emphasis on luxury, seductive as it is, corrupted their taste and reflects the unusually free and pleasure-seeking manners of Byzantium. It was a time when wealth was a gateway to immorality and Byzantine art benefitted from the resulting splendour and pomp.

The Eastern peoples of antiquity were similar to modern Eastern peoples in the sense that they were content with a small range of furniture. Luxury was limited to the fine textiles that covered the frames provided with straps and webbing on which they slept. There were no chairs, tables or any of the other items of furniture we use today (except in royal palaces). Small chests and cabinets were used for all of these purposes. The lack of furniture can be ascribed to the fact that it was difficult to obtain suitable wood and to the fact that everyday life was simple as there was, at the time, very little middle ground between extravagant wealth and poverty. By contrast, at least as far as one can judge from remains and from frescoes and mosaics, the furnishings of the royal palaces were sumptuous. There were heavy solid thrones with cylindrical backs made up of a number of circles joined together, square seats with a cushion and heavy round legs and uprights. The decoration was hieratic and done in garish colours with alternating motifs. There were also mosaics and frescoes. There was an abundance of chandeliers, candelabras and worked bars. In summary, the Byzantine style was majestic. It used Greek ideas but rejected the Greek focus on simplicity and it is this difference that gives it its risky but captivating beauty. Its stylised decoration has the merit of imitating nature through routine and repetition and is an example of real beauty in an ornamental style.

The chest is an invention of the Middle Ages. Its shape, size, and the richness and quality of the decoration depend on the period when it was made. Chests may be made of wood or completely covered in painted fabric or leather. Along with the chest, the wardrobe is the other essential item of furniture, the only property that people of a certain status had. It was made of solid wood with metal fittings and its doors had a number of solid locks, giving the item the bleak appearance of a miniature fortress. Initially, joiners and carpenters made furniture. Later the task passed to wood carvers, who then became cabinet makers and did more detailed, finer woodwork. Furniture was always portable and still consisted of very few items: chest, stool, bed, and wardrobe. However, these could be used for a variety of purposes with the help of a few cushions. Non-portable furniture only began to appear in the 15th century. It was used to furnish palaces and castles, which had made do, up to that point, with chests, beds, benches, tables, and dressing tables with shelves which were transported by mule or on carts. The chests were used to store cushions and wall-hangings, painted canvases or tapestries, pieces of gold work to decorate the dressing tables and textiles which were used as floor coverings once scattering scented plants or straw on floors fell out of fashion.

To close this chapter, we should like to say something about jewellery. The invading barbarians were skilled in working precious metals. The Goths, in particular, made wonderful gold and silver work, primarily in Spain. However, in the Middle Ages, artists worked almost entirely for the church. Naturally, goldsmiths' work and jewellery in the Middle Ages, as during other periods, followed fashions in architecture and sculpture. Champlevé enamelling was used as were precious stones, but the metal setting was rounded (until the mid-13th century). Solid, heavy Romanesque art was obliged to resist the delicacy of jewellery but Gothic art would not have lived up to its reputation for elegance, delicate tracery and filigree work if it had not triumphed in the goldsmith's art as well as in architecture. We would be prepared to wager that, had more Gothic jewellery survived, we would have been able to distinguish High, Middle, and Late Gothic pieces just as we are able to recognise the equivalent architectural styles. In conclusion, let us simply remember that in the Middle Ages the jeweller's art was used primarily to embellish reliquaries, shrines, mitres, crosiers, crosses, that these objects were decorated with enamelling which is renowned to this day and that the common people were not entitled to wear jewellery. This last point, which may be aesthetically understandable, although it is certainly undemocratic, perhaps opened the way for the dreadful imitation jewellery which is so much in vogue today.

79. **Anonymous.**
St Vitale Basilica, north wall: two scenes from the life of Abraham, angels, Moses, the prophet Jeremiah, St John, and St Luke, c. 527-548.
Mosaic.
Basilica of St Vitale, Ravenna (Italy). Byzantine.

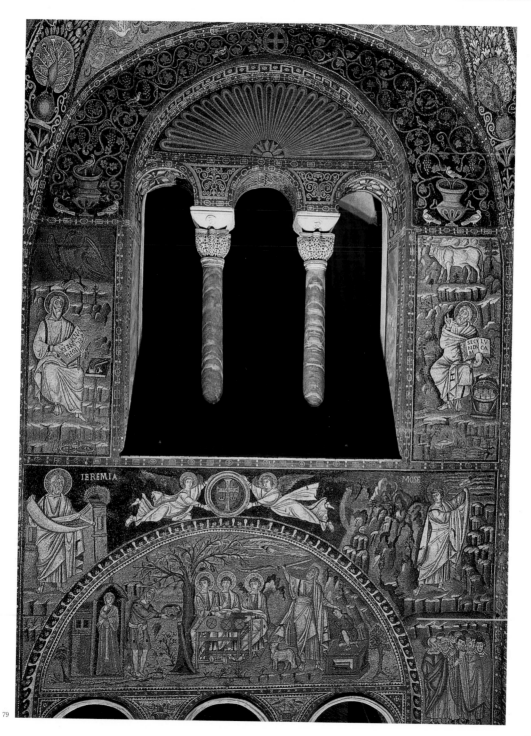

79

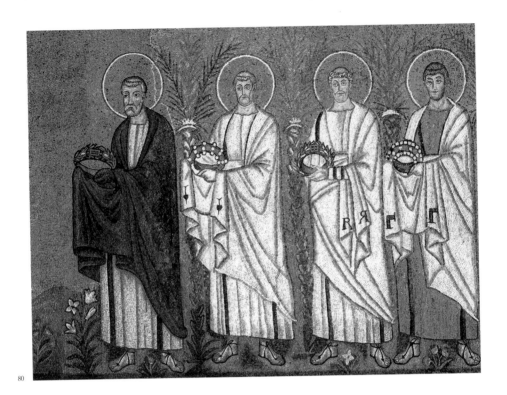

80

81

80. Anonymous.
Procession of Twenty-Six Martyrs, 493-526.
Mosaic.
Basilica of St Apollinaris in Classe, Ravenna (Italy). Byzantine.

81. Anonymous.
Miniature illustration of *Vergilius Vaticanus,*
beginning of the 5th century.
Illuminated manuscript, 21.9 x 19.6 cm.
Biblioteca Apostolica Vaticana, Vatican City. Roman Antiquity.

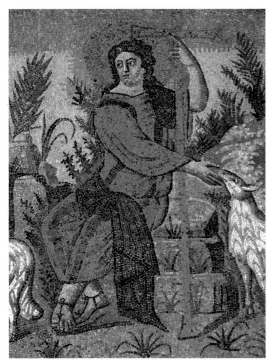

82

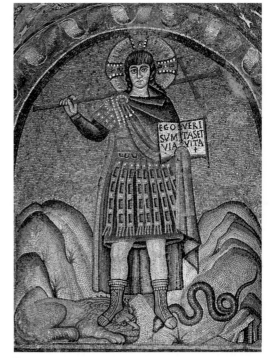

83

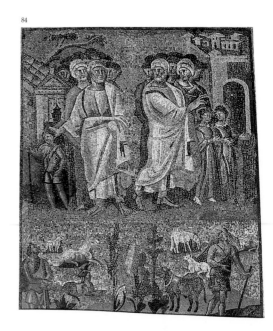

84

82. **Anonymous.**
The Good Shepherd (detail), 425-450.
Mosaic.
Mausoleum of Galla Placidia, Ravenna (Italy). Byzantine.

83. **Anonymous.**
Christ as a Warrior, c. 520.
Mosaic.
Museo Arcivescovile, Ravenna (Italy). Byzantine.

84. **Anonymous.**
The Parting of Lot and Abraham, c. 432-440.
Mosaic.
Papal Basilica of Santa Maria Maggiore, Rome. Roman Antiquity.

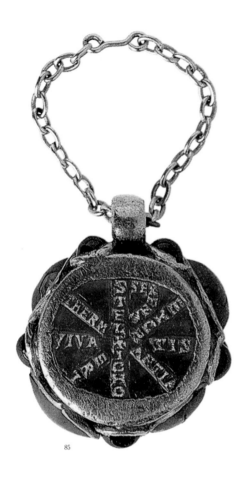

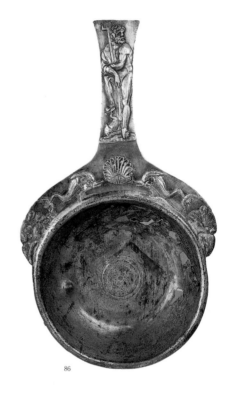

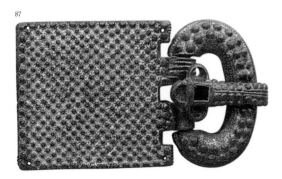

85

86

87

85. **Anonymous.**
Locket of Empress Maria, Milan (?), 398-407.
Cameo of silver, gold, emerald, and rubies.
Musée du Louvre, Paris. High Middle Ages.

86. **Anonymous.**
Patera from Cherchell, Mt Chenoua, 6th century.
Silver, partially gilded, diameter: 16 cm.
Musée du Louvre, Paris. Byzantine.

87. **Anonymous.**
Belt buckle, Visigothic Kingdom, 6th century.
Bronze and garnet, 7.1 x 12.3 cm.
Musée de Cluny, Paris. High Middle Ages.

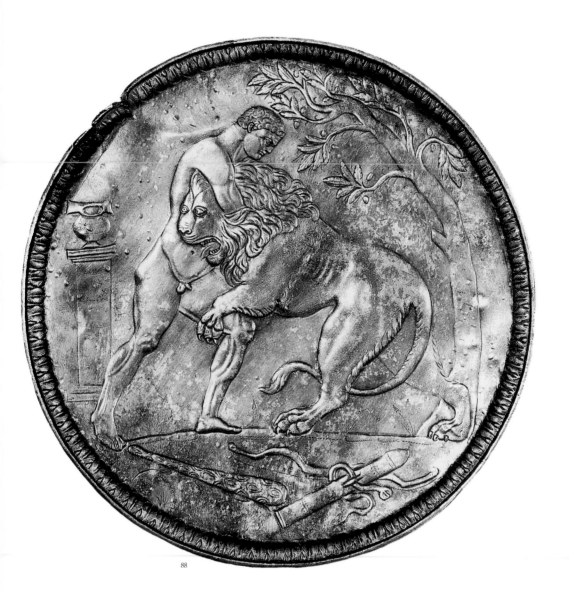

88

88. Anonymous.
Missorium, *Hercules Strangling the Nemean Lion*, 6th century.
Silver, diameter: 40 cm.
Cabinet des Médailles, Bibliothèque nationale de France, Paris. Byzantine.

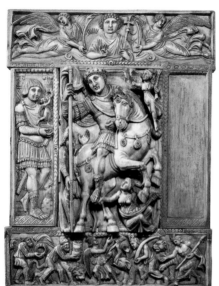

89

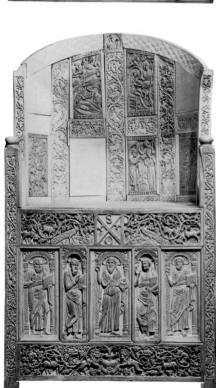

90

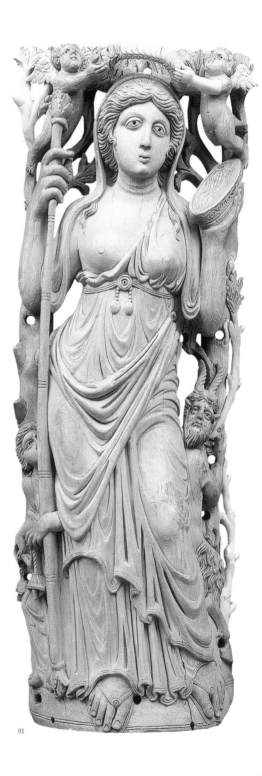

91

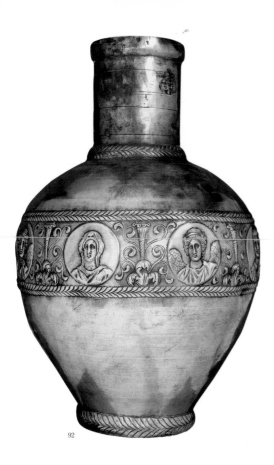

92

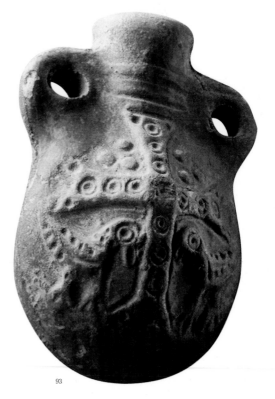

93

89. Anonymous.
Diptych panel in five parts: *The Emperor Triumphant (Justinian?),*
Constantinople, first half of the 6ᵗʰ century.
Ivory, traces of inlay, 34.2 x 26.8 cm.
Musée du Louvre, Paris. Byzantine.

90. Anonymous.
Throne of Maximilian, 546-554.
Ivory.
Museo Arcivescovile, Ravenna (Italy). Byzantine.

91. Anonymous.
Ariadne, Maenad, Satyr, and Eros, first half of the 6ᵗʰ century.
Ivory, 4 x 13.8 x 75 cm.
Musée de Cluny, Paris. Byzantine.

92. Anonymous.
Vase from Emesa (or Homs, Syria), end of the 6ᵗʰ century
or beginning of the 7ᵗʰ century.
Hammered, chased, and engraved silver, height: 45 cm.
Musée du Louvre, Paris. Byzantine.

93. Anonymous.
Ampulla with a cross, 6ᵗʰ century.
Clay, 7 x 5 cm.
Directorate General of Antiquities, Beirut. Eastern.

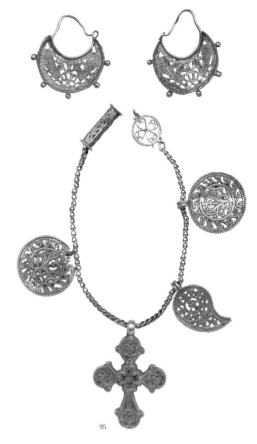

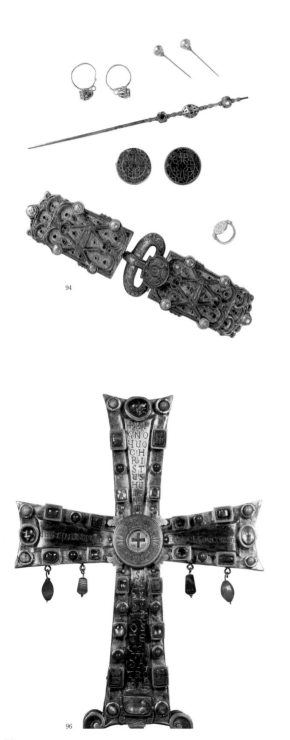

94. Anonymous.
Adornments belonging to Queen Arnegundem, Merovingian Gaul, 6th century.
Gold, garnet fragments, blue glass, silver, niello.
Musée du Louvre, Paris. High Middle Ages.

95. Anonymous.
Necklace with cross and pendants, Constantinople, 6th century.
Gold, carved and engraved.
The State Hermitage Museum, St Petersburg. Byzantine.

96. Anonymous.
Cross of Justin II (or *Crux Vaticana*), c. 568-574.
Gilded silver adorned with precious stones, 40.7 x 31.5 cm.
From the treasury of St Peter, Vatican City. Byzantine.

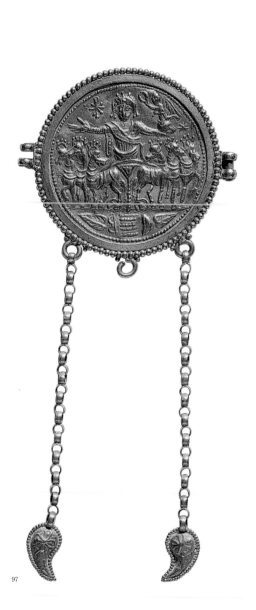

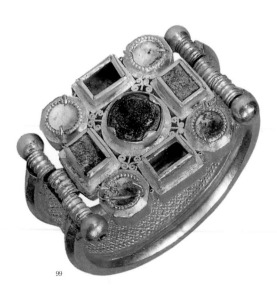

98. Anonymous.
Wedding belt, end of the 6th century.
Hammered, repoussé, and smouldered gold, granulation, length: 74 cm.
Musée du Louvre, Paris. Byzantine.

97. Anonymous.
Medallion with *The Triumph of the Emperor Qalaat al-Marqab*, 6th-7th century.
Chased gold, medallion: length: 6 cm; diameter: 5.4 cm.
Musée du Louvre, Paris. Eastern.

99. Anonymous.
Bracelet, end of the 6th century.
Gold and glass paste (partly missing), diameter: 6 cm.
Musée du Louvre, Paris. Byzantine.

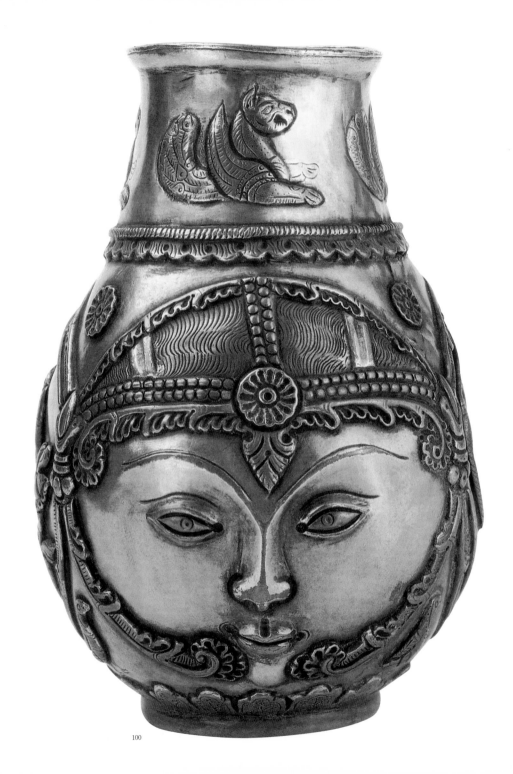

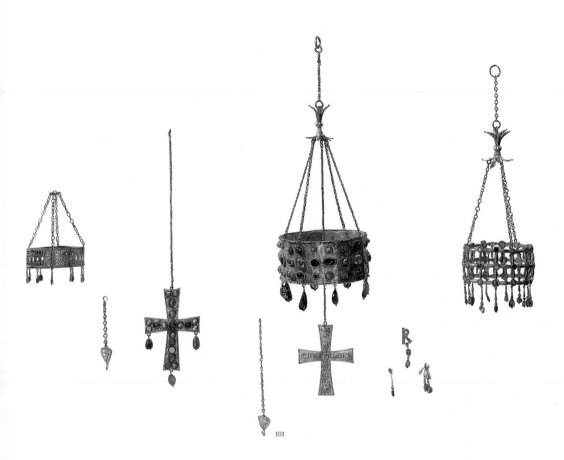

101

100. Anonymous.
Jug with the face of a goddess, 6th-7th century.
Moulded silver, neck executed separately and fixed onto the stomach,
retouched with a chisel and hollow punch, stabilising the handles of the jug.
Height: 14.5 cm; weight: 3.58 kg. The State Hermitage Museum, St Petersburg. Persian.

101. Anonymous.
Treasure of Guarrazar. Votive crowns, crosses, pendants, and suspension chains,
Visigothic Spain, 7th century.
Gold, sapphire, emeralds, amethyst, pearls, quartz, mother-of-pearl, and jasper.
Musée de Cluny, Paris. High Middle Ages.

103

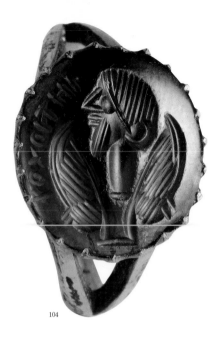

104

102. **Anonymous.**
Belt, 7th century.
Gold, 6.3 x 6.4 cm.
Musée d'Archéologie nationale, Saint-Germain-en-Laye. Byzantine.

103. **Anonymous.**
Fragment of a sheath, c. 6th-7th century.
Wood, copper, gold, niello, and stainless steel, 30 x 8 cm.
Musée de Cluny, Paris. Romanesque.

104. **Anonymous.**
Signet ring, c. 6th-7th century.
Agate, 2.6 x 2.1 cm.
The State Hermitage Museum, St Petersburg. Persian.

105. **Anonymous.**
Pitcher, 7th century.
Carnelian, height: 19 cm.
Musée du Louvre, Paris. Byzantine.

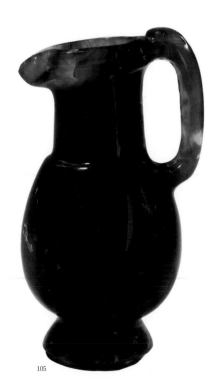

105

106. Anonymous.
Lion and Gazelle, 724-743.
Mosaic.
Hisham's Palace (Khirbat al-Mafjar), West Bank (Palestine). Eastern.

107. Anonymous.
Quadriga, 9th century.
Patterned samite, polychrome silk, 75 x 72.5 cm.
From the treasury of the Aachen Cathedral. Musée de Cluny, Paris. Byzantine.

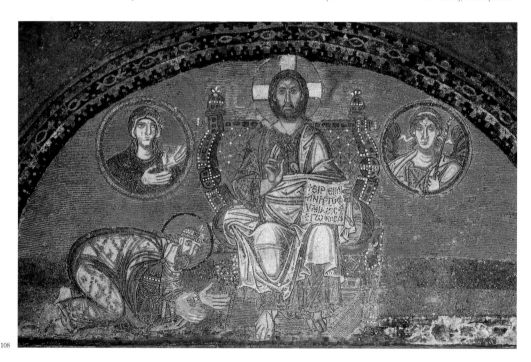

108. Anonymous.
Leo VI in Proskynesis before Christ Enthroned, 9th-10th century.
Mosaic.
Hagia Sophia, Istanbul. Byzantine.

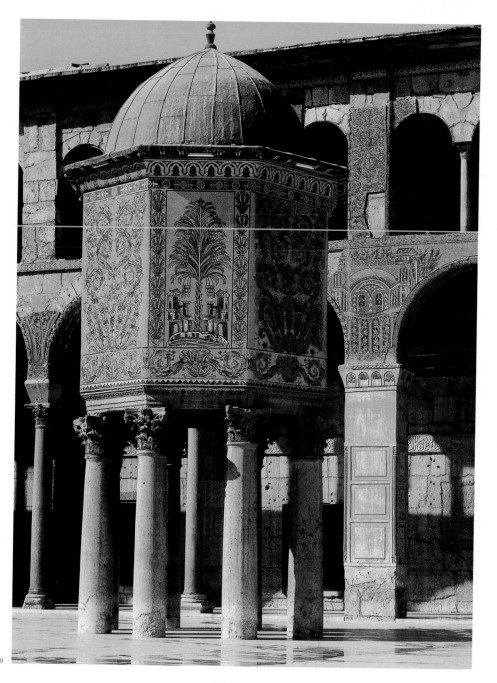

109. **Anonymous.**
Treasury, 710-715.
Mosaic.
Umayyad Mosque (or the Great Mosque of Damascus), Damascus. Eastern.

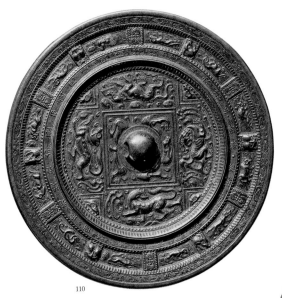

110

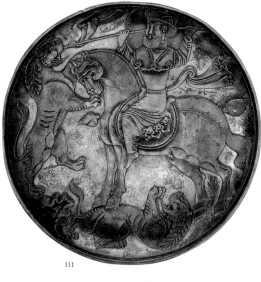

111

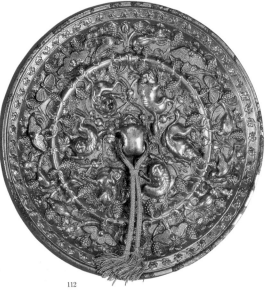

112

110. **Anonymous.**
Mirror with the twelve zodiac signs, Sui dynasty, beginning of the 7th century.
Tinted bronze, diameter: 21.5 cm.
Musée national des Arts asiatiques - Guimet, Paris. Chinese.

111. **Anonymous.**
Plate with a prince hunting lions, c. 8th-9th century.
Silver, diameter: 25.8 cm.
The State Hermitage Museum, St Petersburg. Eastern.

112. **Anonymous.**
Mirror depicting sea creatures, c. 7th-9th century.
Bronze, diameter: 17.7 cm.
National Palace Museum, Taipei. Chinese.

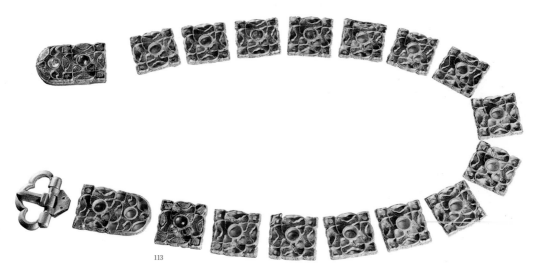

113.

113. Anonymous.
Belt in gold with precious stones, 8th century.
Gold and precious stones, 4.8 x 3 cm.
Jilin Province Museum, Changchun (China). Chinese.

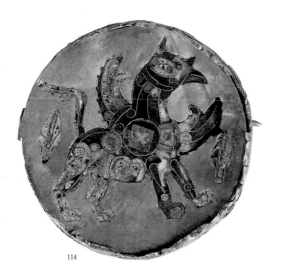

114.

114. Anonymous.
Medallion depicting a griffin, 8th-9th century.
Gold, diameter: 4.2 cm.
Musée du Louvre, Paris. Byzantine.

115. Anonymous.
Jug, decorated with a flute player and a mythical creature, 8th-9th century.
Cast bronze, height: 43 cm.
The State Hermitage Museum, St Petersburg. Persian.

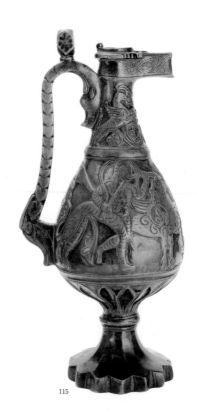

115.

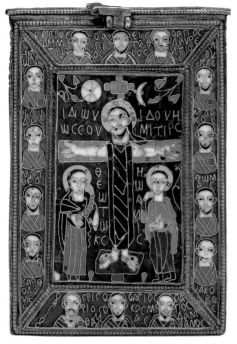

116

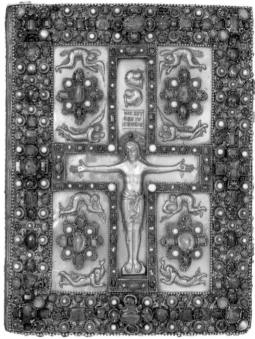

117

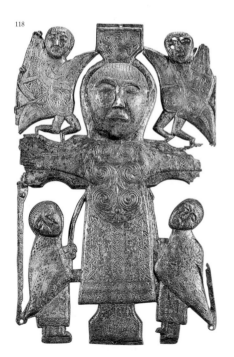

118

116. **Anonymous.**
The Crucifixion, beginning of the 9th century.
Cloisonné enamel.
The Metropolitan Museum of Art, New York. Byzantine.

117. **School of the Court of Charles the Bald**, France.
Jewelled upper cover of Lindau Gospels, c. 880.
Repoussé gold and precious stones, 35 x 27.5 cm.
The Morgan Library and Museum, New York. Romanesque.

118. **Anonymous.**
The Crucifixion, book cover (?).
Bronze, 21 cm.
National Museum of Ireland, Dublin.

119. **Anonymous.**
Majesty of Sainte Foy, 9th-15th century.
Main piece of yew wood, gold leaf, silver, enamel,
and precious stones, height: 85 cm.
Sainte-Foy Abbey-Church, Conques (France). Romanesque.

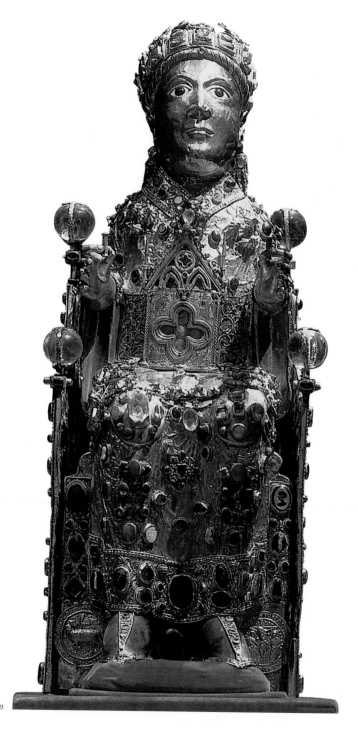

119

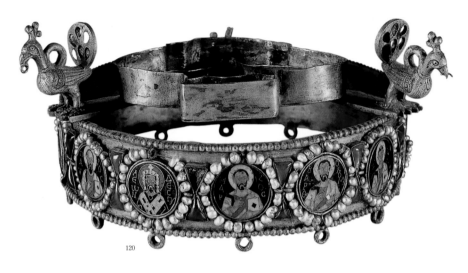

120. **Anonymous.**
Votive crown of Emperor Leo VI, 886-912.
Gold, cloisonné enamel, and pearls, diameter: 13 cm.
St Mark's Basilica, Venice. Byzantine.

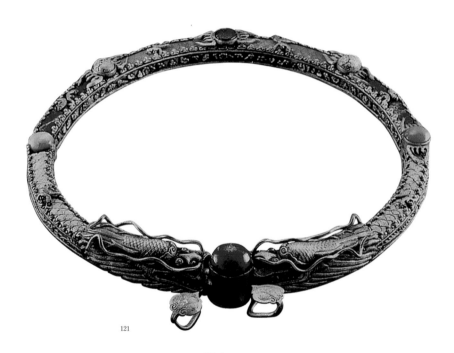

121. **Anonymous.**
Bronze-plated torque with lapis lazuli, turquoise, and coral, 9th century.
Bronze and precious stones.
Chris Hall Collection Trust, Hong Kong. Chinese.

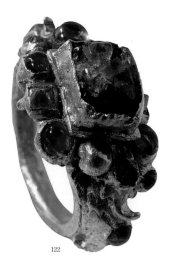

122. **Anonymous.**
Ring, 10th-12th century.
Gold, emerald, ruby, and diamonds, diameter: 2.7 cm.
Cham.

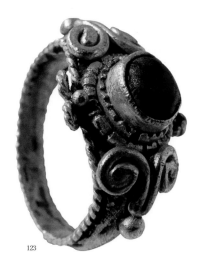

123. **Anonymous.**
Ring, 10th-12th century.
Gold and red glass beads, diameter: 2.4 cm.
Cham.

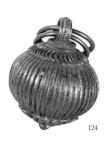

124. **Anonymous.**
Drop earrings, 10th-12th century.
Gold, height: 1.5 cm.
Cham.

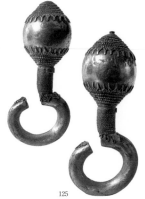

125. **Anonymous.**
Earrings, 10th-12th century.
Gold and cast iron, length: 4.6 cm.
Cham.

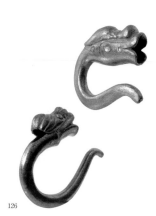

126. **Anonymous.**
Earrings, 10th-12th century.
Gold, length: 4 cm.
Cham.

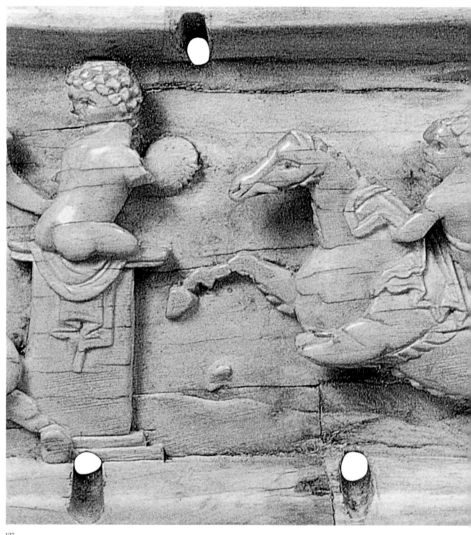

127

127. **Anonymous.** Chest plate with mythological creatures: *Playing Cherubs* (

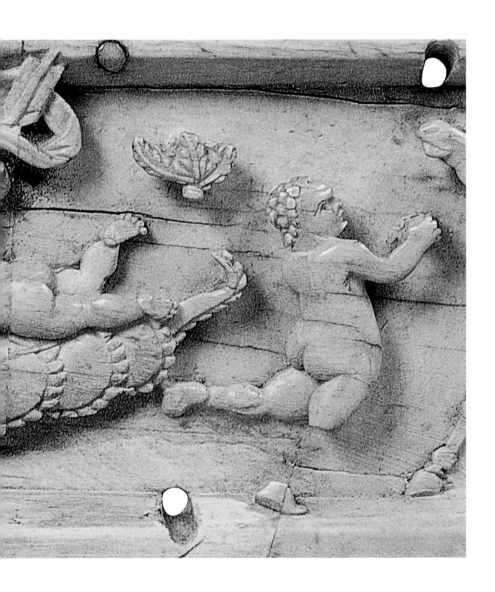

...ntinople, 10th century. Ivory, 28.2 x 4.8 cm. Musée du Louvre, Paris. Byzantine.

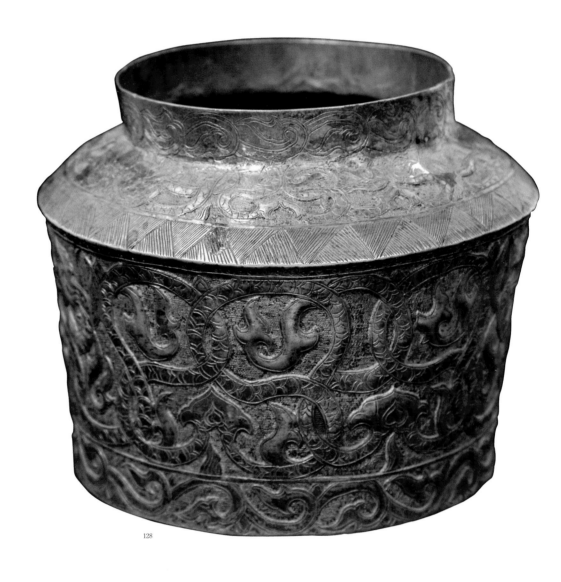

128

128. **Anonymous.**
Jug, 9th-12th century.
Silver, height: 12.5 cm; diameter: 13.5 cm.
Cham.

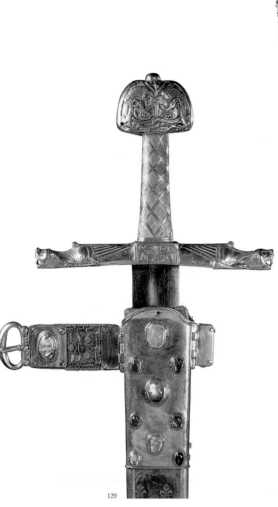

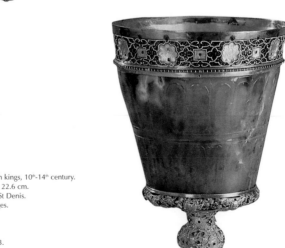

129. Anonymous.
Sword and sheath from the crowning ceremonies of the French kings, 10ᵗʰ-14ᵗʰ century.
Gold, gilded silver, and precious stones, 83.8 x 22.6 cm.
From the treasury of the Basilica Cathedral of St Denis.
Musée du Louvre, Paris. High Middle Ages.

130. Anonymous.
Chalice belonging Romanos II, 959-963.
Carnelian, height: 28.5 cm.
From the treasury of St Mark's Basilica, Venice. Byzantine.

131. Anonymous.
Vessel, 10ᵗʰ-11ᵗʰ century.
Carnelian and enamelled gold, height: 24.6 cm.
Musée du Louvre, Paris. Byzantine.

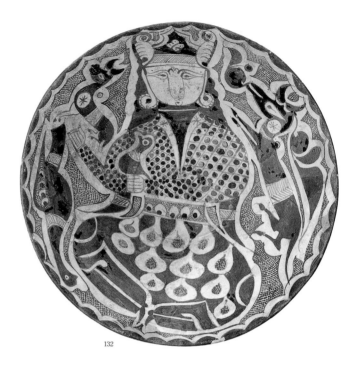

132

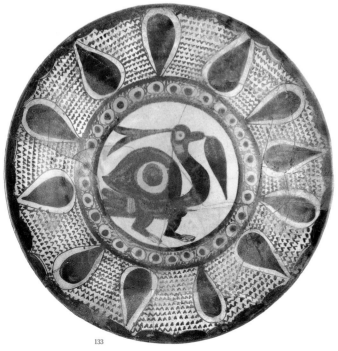

133

132. **Anonymous.**
Bowl with the figure of a seated prince, 10th century.
Ceramic, height: 10.8 cm; diameter: 36.5 cm.
Khalili Collection. Eastern.

133. **Anonymous.**
Plate with the figure of a bird, Iraq, 10th century.
Ceramic.
Private collection. Eastern.

134. **Anonymous.**
Reliquary of the True Cross, middle of the 10th century.
Gold, silver, and precious stones, height: 48 cm.
From the treasury of the Limburg Cathedral, Limburg.
Byzantine.

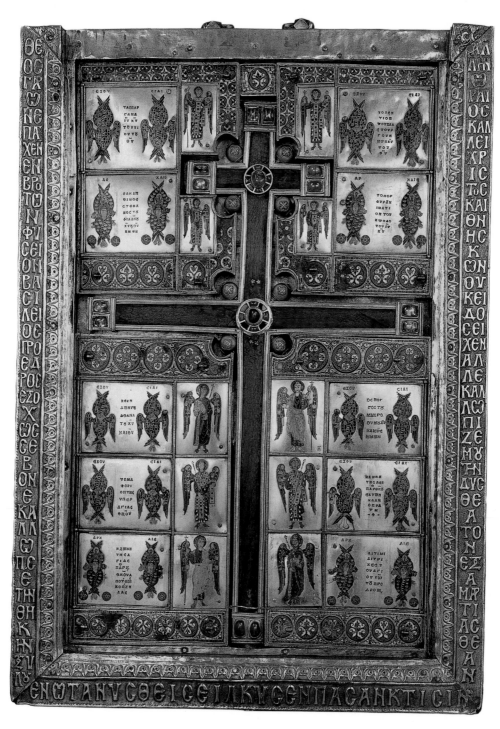

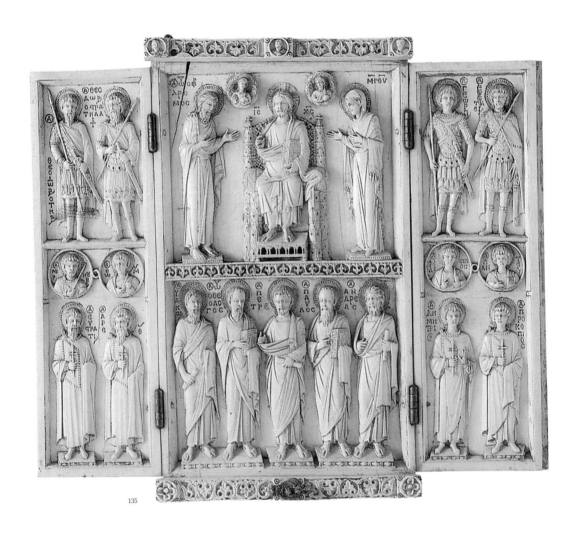

135

135. Anonymous.
Triptych, known as 'Harbaville Triptych': *Deesis and Saints*, middle of the 10th century.
Ivory and traces of polychrome, 28.2 x 24.2 cm.
Musée du Louvre, Paris. Byzantine.

136. Anonymous.
Portable altar, Fulda or Bamberg (Germany), 11th century.
Silver, partially gilded and engraved on wood, porphyry, 25.6 x 23 cm.
Musée de Cluny, Paris.

137. Anonymous.
Chest, second half of the 10th century.
Frame of wood, gilded copper, parchment paper, traces of gilding, 16 x 27 x 17.3 cm.
Musée du Louvre, Paris. Byzantine.

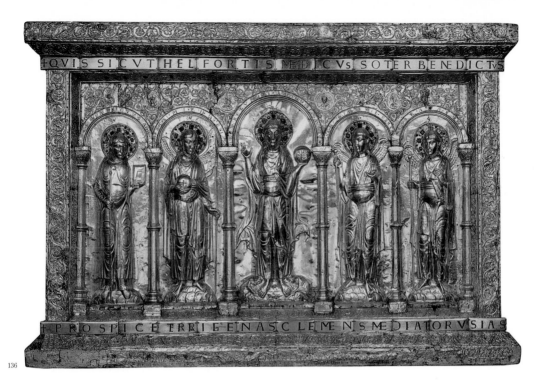

136

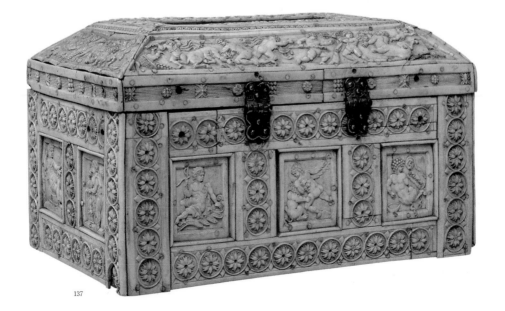

137

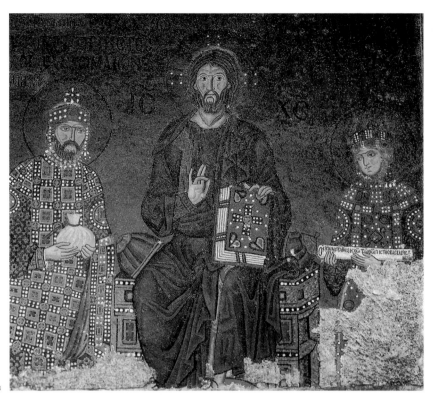

138

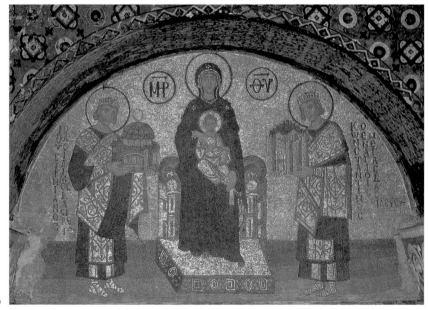

139

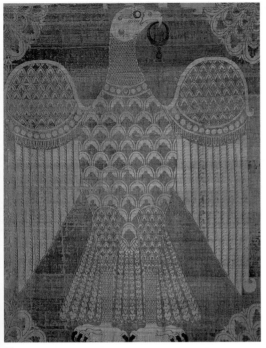

140

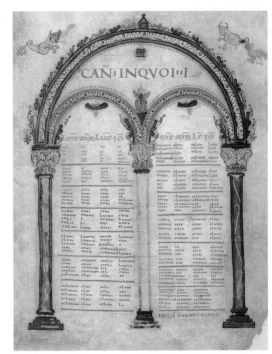

141

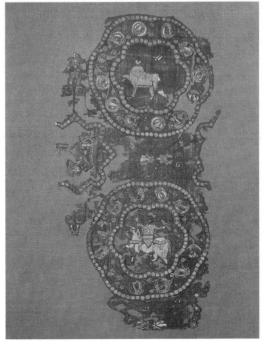

142

138. Anonymous.
Emperor Constantine IX and Empress Zoe with Christ Enthroned, 11th century.
Mosaic.
Hagia Sophia, Istanbul. Byzantine.

139. Anonymous.
Virgin Mary Holding the Infant Christ, with Constantine and Justinian, 11th century.
Mosaic.
Hagia Sophia, Istanbul. Byzantine.

140. Anonymous.
Shroud of St Germain, 11th century.
Silk, length: 236 cm.
Musée de l'abbaye Saint-Germain, Auxerre. Byzantine.

141. Anonymous.
Eusebian Canons, gospel, 10th century.
Parchment, 29.7 x 22.5 cm.
Tours. Romanesque.

142. Anonymous.
Shroud of St Lazarus of Autun, Andalusia, beginning of the 11th century.
Silk, silk threads, and gold, 55 x 30 cm.
Musée de Cluny, Paris.

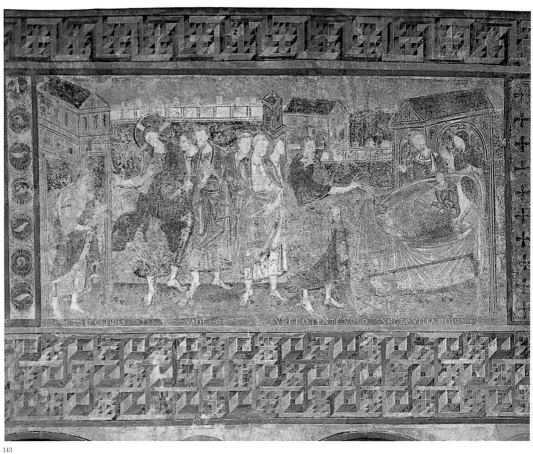

143

143. **Anonymous.**
Healing the Bleeding Woman, c. 980.
Mural.
St George in Reichenau-Oberzell, Reichenau. Romanesque.

144. **Anonymous.**
West gate, 1010-1033.
Bronze.
St Michael's Church, Hildesheim. Romanesque.

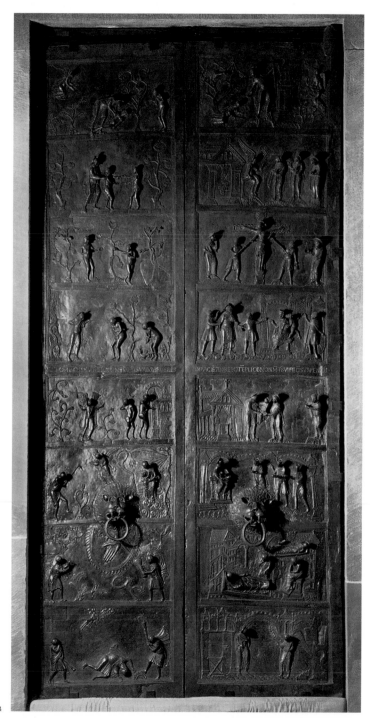

144

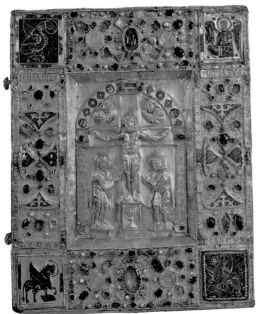

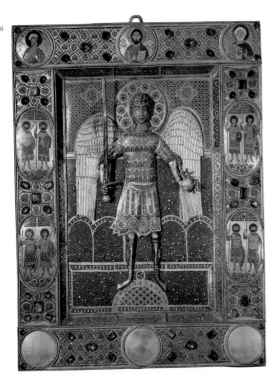

146

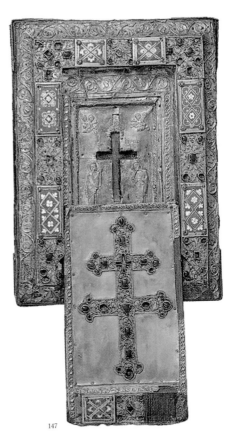

147

145. Anonymous.
Book cover: *The Crucifixion and Symbols of the Evangelists*, 11ᵗʰ century.
Gold, cloisonné enamel, cabochons, and niello over wood, 32.2 cm.
Musée du Louvre, Paris. Ottonian Renaissance.

146. Anonymous.
The Archangel St Michael, 11ᵗʰ century.
Icon.
From the treasury of St Mark's Basilica, Venice. Byzantine.

147. Anonymous.
Reliquary case of the True Cross, with sliding lid, Byzantium, 11ᵗʰ century.
Gilded silver, champlevé enamel, gems, and leather on gilded copper.
Musée du Louvre, Paris. Byzantine.

148. Anonymous.
Chest: *The Victory Parade of Two Emperors* (lid), *The Lion Hunt* (sides),
first half of the 11ᵗʰ century.
Ivory, 26.4 x 13.4 x 13 cm.
From the treasury of Troyes Cathedral, Troyes (France). Byzantine.

149. Anonymous.
Ivory chest, 11ᵗʰ century.
Ivory.
Museo Nacional del Prado, Madrid. Eastern.

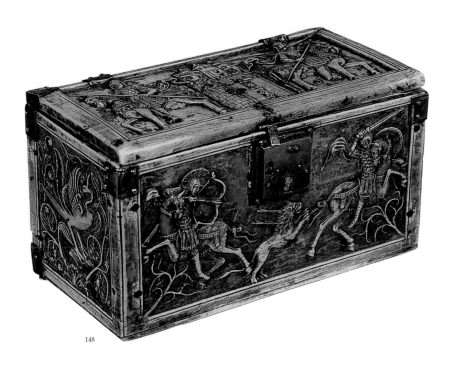

148

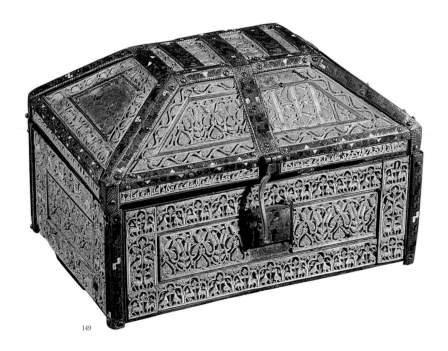

149

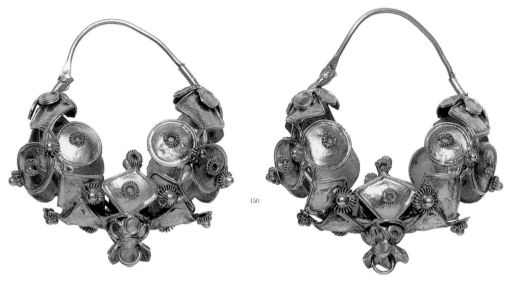

150. **Anonymous.**
Earrings, 10th-11th century.
Gold, 4.2 x 3.8 x 1.5 cm and 4.3 x 4 x 1.7 cm.
Victoria and Albert Museum, London. Eastern.

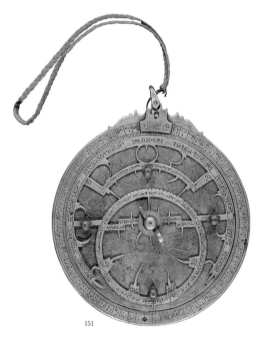

151. **Anonymous.**
Astrolabe, 1029-1030.
Bronze.
Staatsbibliothek zu Berlin, Berlin. Eastern.

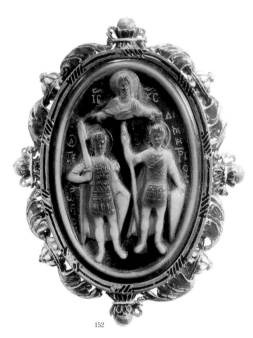

152. **Anonymous.**
St Demetius' cameo, 11th century.
Jasper and chalcedony, height: 3.25 cm.
Bibliothèque nationale de France, Paris. Byzantine.

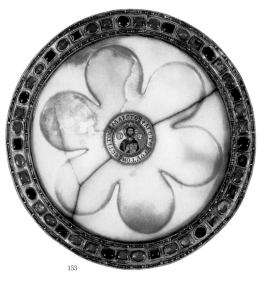

153

153. Anonymous.
Paten, with Christ blessing, 11ᵗʰ century.
Alabaster, gold, silver, diameter: 34 cm.
St Mark's Basilica, Venice. Byzantine.

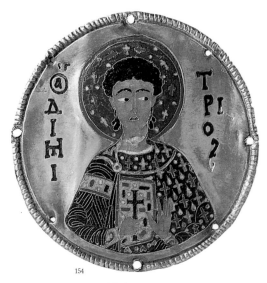

154

154. Anonymous.
Medallion: *St Demetrius*, end of the 11ᵗʰ century-beginning of the 12ᵗʰ century.
Gold and cloisonné enamel.
Musée du Louvre, Paris. Byzantine.

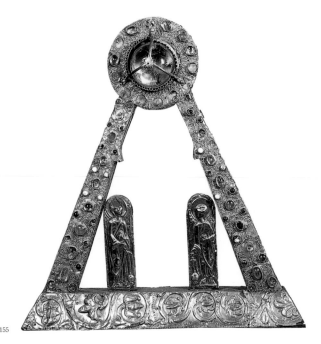

155

155. Anonymous.
Reliquary in an 'A'- shape, from Charlemagne, end of the 11ᵗʰ century.
Wood and silver.
Abbey Treasury, Conques. Romanesque.

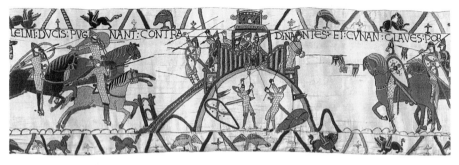

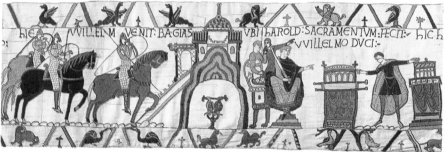

156

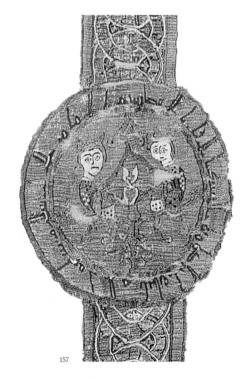

157

156. Anonymous.
Battle of Motte and Bailey Castle (top), *Harold Pledges
to Support William's Claim to the Throne* (bottom), 1077-1082.
Silk embroidery on linen, height: 50 cm; length: 70 cm.
Bayeux Tapestry.
Musée de la Tapisserie de Bayeux (with special permission of
the city of Bayeux), Bayeux. Romanesque.

157. Anonymous.
Banner for the Caliph Al-Mustali,
known as the *Veil of St Anne* (detail), Egypt, 1096-1097.
Linen, embellished with bands of tiraz and spun gold,
148 x 290 cm.
Apt Cathedral, Apt (France). Eastern.

158. Anonymous.
Initial of the second *Book of Kings*, Bible with prologue
(*Biblia Sacra cum prologis*), second half of the 12th century.
Parchment, 46.5 x 33 cm.
Weissenau Abbey, Upper Swabia.

·I· RE CV̄ II RE

¶ CAP·I·

Item recusat chusai consilii achitofel dans meli⸗
oris consilii. ut induceret dñs sup absalon malū suu.
Videns achitofel ñ finaluisse consiliū suū suspen⸗
dio interior. ipsa uoluntate licet posterior tam
sicut uida traditor. Sit se malū. scī pars.
Videnre dd exercituū trib, ducib, ipsū phibent
ipsi exire parū dantes consilii competens & sa
lubri tam egredientes duces pietas patris deman
dat. seruate in pueru absalon. scauirre.
interitus absalon filii dauid. Et exercituū nec reuer
uxit dauid filiu suū absalon mmrs. Et uolebat in
Moab dux aggredit dauid ꝙ luges hunuliauit omnē
A bisq̇. uoto oñis ipli isrl ñ audebat ad dauid reuerti
in luerlin precede regis ol morte quã sibi elegerat absalon.
Clementia regis dauid circa semer l cesos q̇ maledixe
ranr pgenti afacie absalon ol quū respondit hortan
Beneficia berzellai circa regē q̇uolunt reddē uicē. si se
neer eī impeditur. I consentiebat cū filio boehriscimo
Iurgiū inr ibū iuda q̇ consentiebat cū dd. & isrl q̇ui
Siba filii boehri cognauit malū cont regē quē conse
cit' e ioab incunnate & obsidebat q̇ subuerte uireba
r' nisi mulier p murū postullasset pro cunctis habiran
tib, fari. saluans ciuitate. Et ionathe & sepulti in sepul
Omar cū dd fame inrimendos oñis ppt saul. q̇ esulnt
dñm & dedit remediū & placat' e recollecti ossib, saul.
Bella .iiii. ab regib̄ s' statura̅ pceri.
Canticū dd q̇d cantauit dño in die q̇ llibauit cū de ma
nu omniū inimicou ei. de ros quos miifecit.
Alloquit dauid ipsm. ina que e inberhlee iuxta portā
Sitiens inspelunca posir' dd desiderauit aq̇m de cister
A bisai fr̄ ioab qui eleuauit hastā cont trecentos ui
Indignat̄ dd cont isrl ira ut dinumerari uiberet
dauid isrl & iuda. & ꝑ demmuratione uiber dd
eligere sib tres dies delatione plagarū pestil. fam̄.

Explicit liber Regnorū PRIOR9S.
INCIPIT SECVN
DV̄S.

A
CTU
EST
AV·
TE POST
QVAŌ. MOR.
TV. VS ES?
SAVL. ET VARIŌ
REVERT E REŌ
acede amalech & maneret
in sicelech dies duos. In die
aū tercia apparuit homo
ueniens de castris saul. ueste
concissa & puluere aspersus
caput. Et ut uenit ad dauid
cecidit sup faciē suā & ado
rauit. Dixitq̇. ad eū dauid. Unde uenis?
Qui ait ad eum. De castris isrl fugi. Et ait
ad eū dauid. Quod e uerbii q̇d factū est.
indica m̄. Qui ait. fugit ppls ex prelio. &
multi corruentes ex ipso mortui sunt. S;
& saul & ionathas filius ei interierunt. Di
xitq̇. dd ad adolescentē qui nūntiabat ei.
Unde scis quia mortuus e saul & ionathas
filius ei. Et ait adolescens q̇ narrabat ei.
Casu ueni in monte gelboe. & saul incūbe
bat sup hastā suā. Porro currus & equites
apppinquabant ei. Et conuersus post tergū
suū uidensq̇. me uocauit. Cui cū respon

158

89

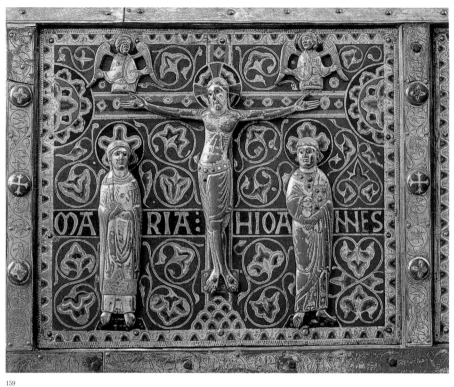

159

160

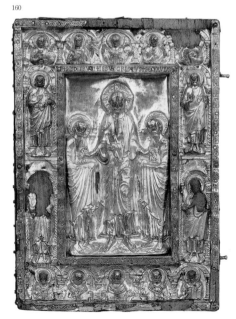

161

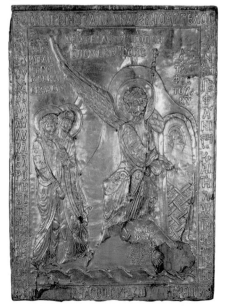

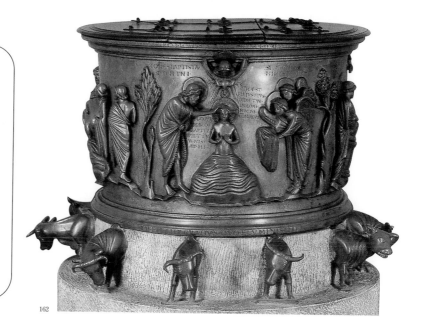

162

159. Anonymous.
The Crucifixion, St Calminius reliquary (detail), beginning of the 12ᵗʰ century.
Embossed enamel and copper.
Mozac Abbey, Mozac (France). Romanesque.

160. Anonymous.
Cover of the gospel, northern Italy, beginning of the 12ᵗʰ century.
Embossed silver, engraved and partially gilded, and niello on wood,
parchment, 28.3 x 2.4 cm.
Musée de Cluny, Paris. Byzantine.

161. Anonymous.
Reliquary plate from the stone of Christ's tomb:
The Holy Women, 12ᵗʰ century.
Gilded silver and wax on wood, 42.6 x 33.1 cm.
From the treasury of Sainte-Chapelle.
Musée du Louvre, Paris.

162. Renier de Huy, 12ᵗʰ century, Belgian.
Baptismal font, 1107-1108.
Bronze.
St Bartholomew's Church, Liège. Romanesque.

163. Anonymous.
Icon in lapis lazuli, 12ᵗʰ century.
Gold, pearls, and precious stones; height: 8.3 cm.
Musée du Louvre, Paris. Byzantine.

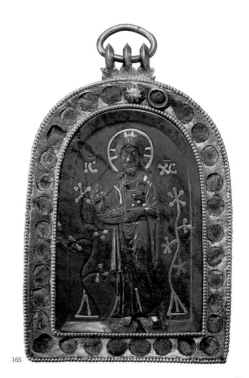

163

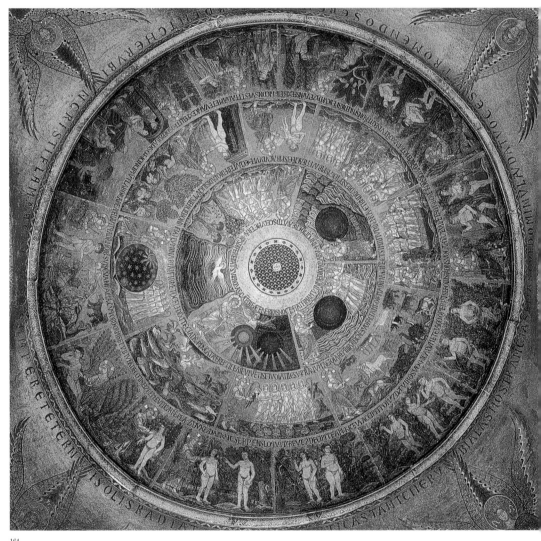

164

164. **Anonymous.**
Cupola, with Genesis, c. 1120.
Mosaic.
Narthex, St Mark's Basilica, Venice. Romanesque.

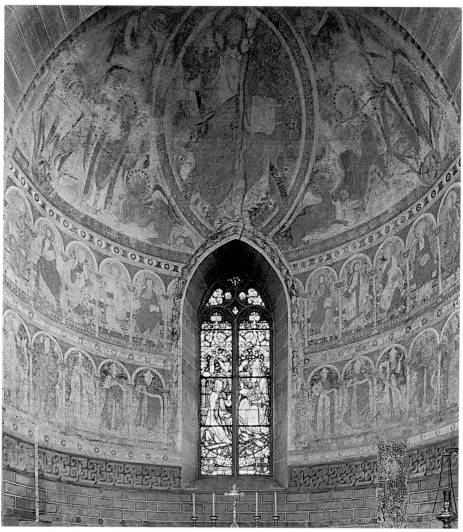

165

165. **Anonymous.**
Mural, *Christ in Glory*, 1120.
St Peter and Paul in Reichenau-Niederzell, Reichenau. Romanesque.

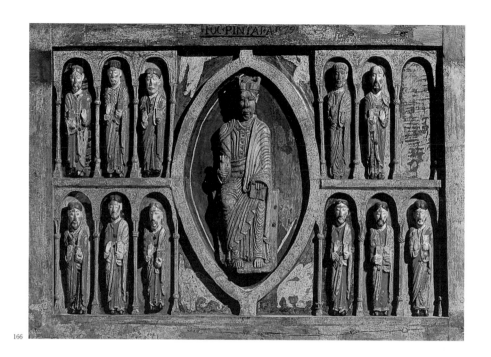

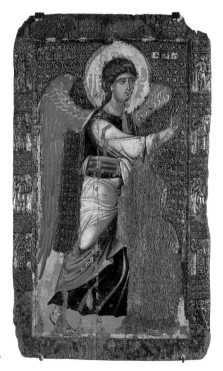

166. **Anonymous.**
Altar of Santa Maria de Taüll, 1123.
Carving from pinewood and polychrome tempera, 135 x 98 cm.
Museu Nacional d'Art de Catalunya, Barcelona. Romanesque.

167. **Anonymous.**
The Archangel Gabriel, beginning of the 12ᵗʰ century.
Icon, height: 11 cm.
Church of St Clement of Ohrid, Skopje (Macedonia). Byzantine.

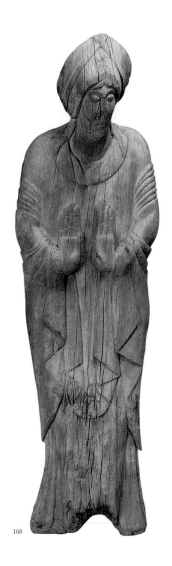

168

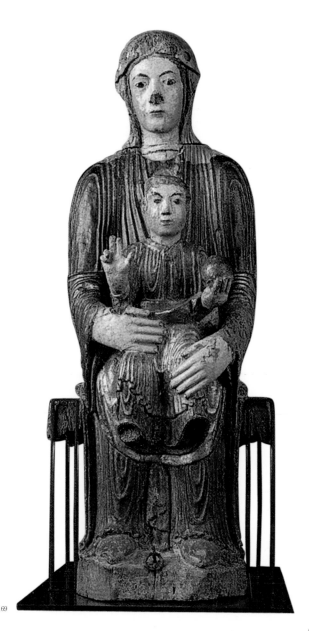

168. Anonymous.
A Holy Woman, Catalonia, c. 1125-1150.
Pearwood with traces of polychrome, 133 x 31 x 38 cm.
Musée de Cluny, Paris. Romanesque.

169. Anonymous.
Enthroned Virgin Mary, Auvergne, last quarter of the 12th century.
Polychrome wood, 80 x 30 cm.
Musée de Cluny, Paris.

169

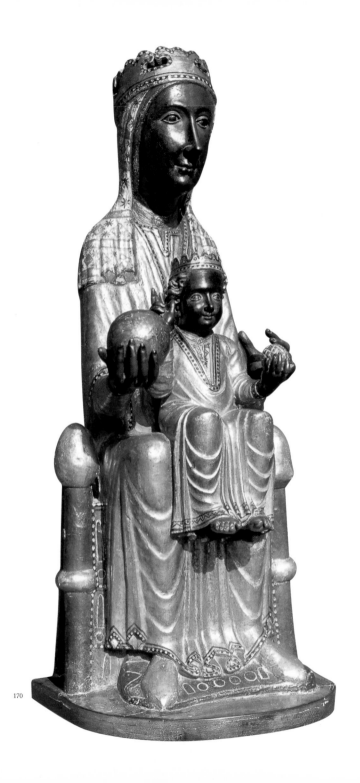

170

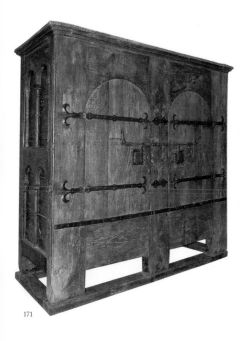

171

170. **Anonymous.**
The Virgin of Monserrat or *Black Madonna,*
beginning of the 12ᵗʰ century.
Wood.
Santa Maria de Montserrat Abbey, Montserrat (Catalonia). Romanesque.

171. **Anonymous.**
Aubazine cabinet, 12ᵗʰ century.
Oak and iron.
Aubazine Abbey, Aubazine.

172. **Anonymous.**
Qur'an stand, 12ᵗʰ century.
Wood.
Museum für Islamische Kunst, Staatliche Museen zu Berlin, Berlin. Eastern.

172

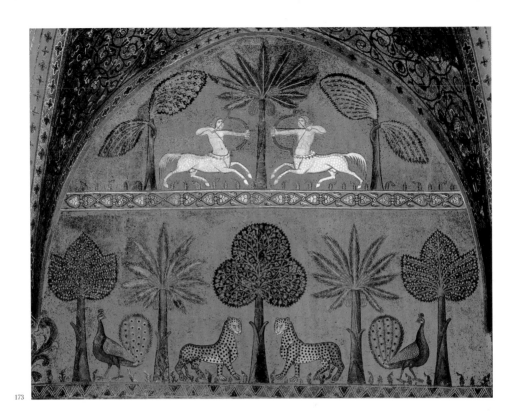

173

174

DS INMISIT·DNS·SOPOREM·INA
DAM·ET·TVLIT·EVĀ·DECOSTIS
EIVS

EVA

173. **Anonymous.**
Leopards and Centaurs, Hall of Roger II, 12th-13th century.
Mosaic.
Palazzo dei Normanni, Palermo. Byzantine.

174. **Anonymous.**
The Creation of Eve, 1130-1143.
Mosaic.
Palatine Chapel, Palermo. Byzantine.

175. **Anonymous.**
Martorana Dome, *Christ Pantocrator Surrounded
by Four Archangels,* 1149.
Mosaic.
The Church of Santa Maria dell'Ammiraglio, Palermo. Byzantine.

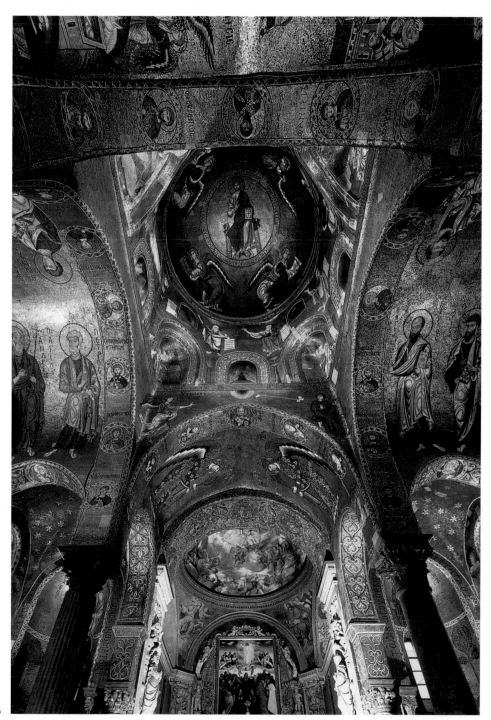

175

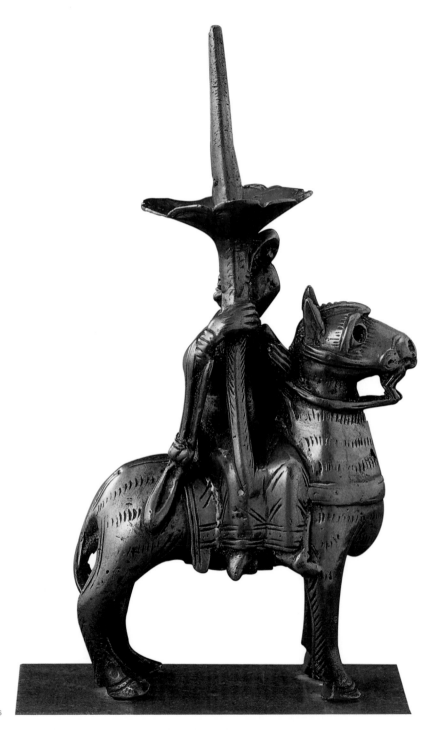

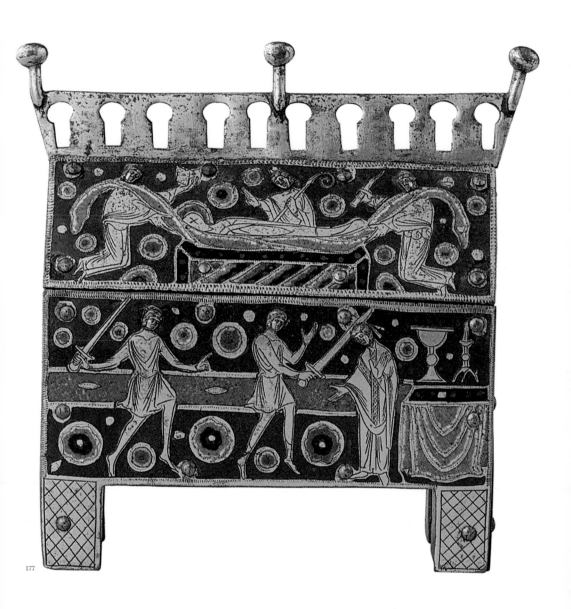

177

176. Anonymous.
Candlestick: *Woman Horseback Riding*, Magdeburg (?), middle of the 12ᵗʰ century.
Gilded bronze, height: 20 cm.
Musée du Louvre, Paris. Romanesque.

177. Anonymous.
Reliquary casket of St Thomas Becket, c. 1190-1200.
Champlevé copper, engraved, enamelled, and gilded, 15 x 16.6 cm.
Musée de Cluny, Paris. Romanesque.

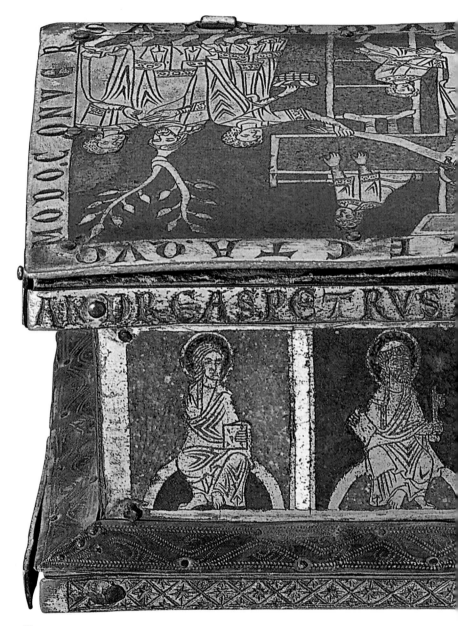

178

178. **Anonymous.** Portable altar: *Crucifixion and the Twelve Apostles*, Westfalen, c. 1170

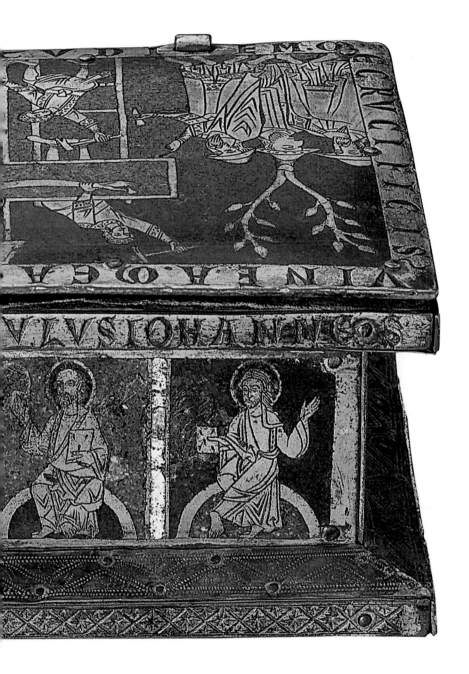

copper, engraved and champlevé enamel, 8.6 x 14 x 21 cm. Musée du Louvre, Paris. Romanesque.

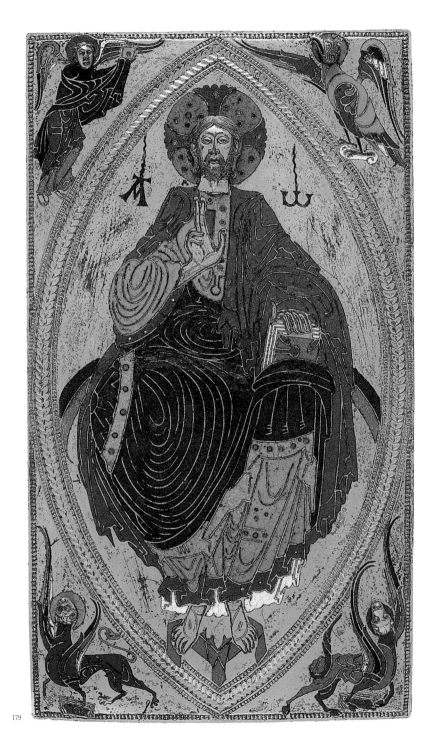

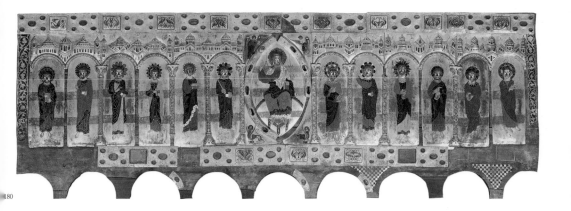

180. **Anonymous.**
Shrine of St Dominic of Silos, front plate, 1160-1170.
Enamel and copper.
Museo de Burgos, Burgos. Romanesque.

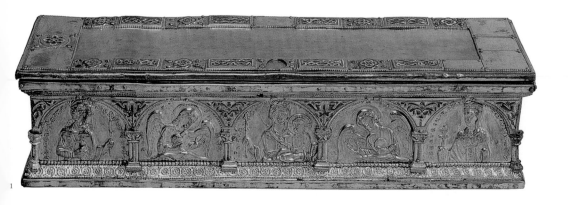

179. **Anonymous.**
Book cover: *Christ Enthroned*, meridional workshop (Limousin or Spain?),
third quarter of the 12ᵗʰ century.
Champlevé and cloisonné copper, enamelled, and gilded, 23.6 x 16.6 cm.
Musée de Cluny, Paris. Romanesque.

181. **Anonymous.**
Reliquary of Charlemagne's arm, Liège, c. 1165-1170
Champlevés enamel on copper, gilded silver on wood, 54 x 13.6 cm.
Musée du Louvre, Paris. Romanesque.

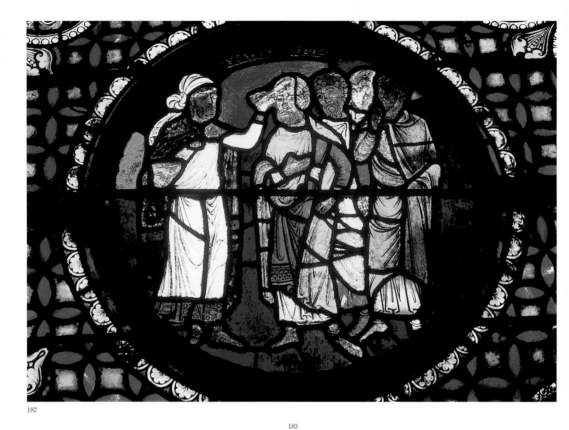

182

183

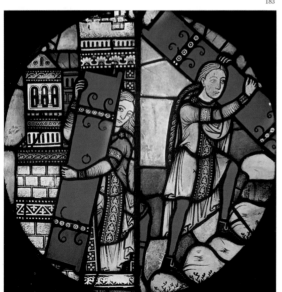

182. **Anonymous.**
Stained glass window depicting the *Passion of Christ* (missing),
1140-1144.
Originally in the ambulatory in the Basilica
Cathedral of St Denis, Saint-Denis.
Romanesque.

183. **Anonymous.**
Samson Carrying the Gate of Gaza, 1180-1200.
Stained glass window from Alpirsbach Abbey.
Landesmuseum Württemberg, Stuttgart. Romanesque.

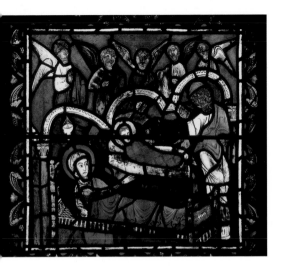

184. Anonymous.
Stained glass window depicting the *Nativity*, detail from *Life of Christ*, 1140-1145.
Ambulatory in the Basilica Cathedral of St Denis, Saint-Denis. Gothic.

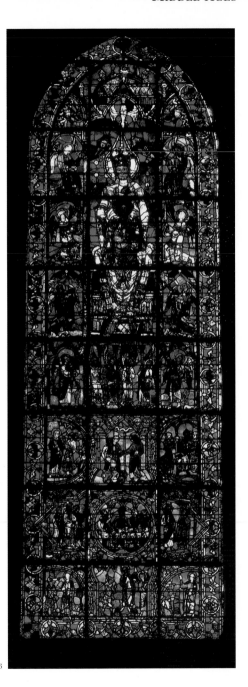

186

185. Anonymous.
St Eustace: The Sacred Tools for Hunting, c. 1200-1210.
Stained glass window.
North aisle, Chartres Cathedral, Chartres. Gothic.

186. Anonymous.
Our Lady Queen of Heaven, c. 1170.
Stained glass window, 427 cm.
Chartres Cathedral, Chartres. Romanesque.

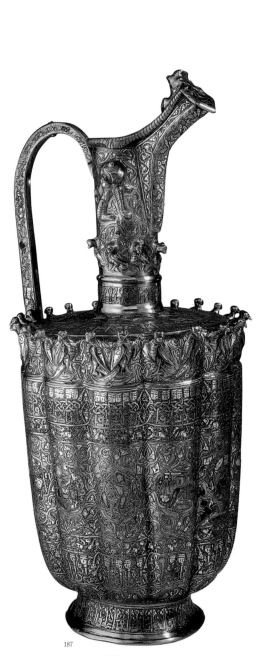

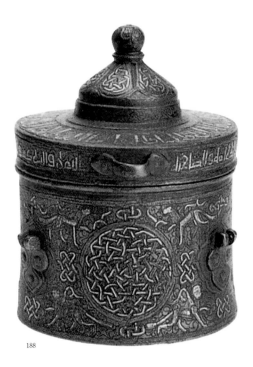

188. Anonymous.
Ink bottle, second half of the 12th century-beginning of the 13th century.
Bronze (brass) cast and engraved, coated with copper and silver,
height: 10.5 cm; diameter: 8.2 cm.
The State Hermitage Museum, St Petersburg. Persian.

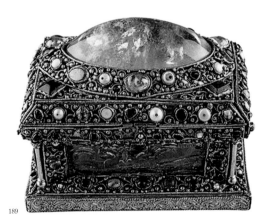

187. Anonymous.
High-spouted ewer, Herat (Afghanistan), 1180-1200.
Sheet brass inlaid with copper, silver, and gold and with repoussé decoration
including signs of the zodiac, height: 40 cm.
British Museum, London. Eastern.

189. Anonymous.
Chest, France, c. 1200.
Gilded silver, gems, pearls on wood, quartz, 11.3 x 14.8 x 9 cm.
Musée de Cluny, Paris.

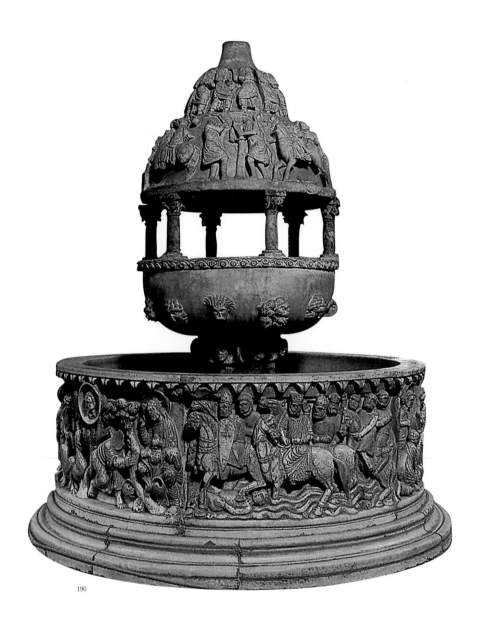

190. **Master Roberto**, Italian.
Baptismal font, c. 1150.
Basilica of San Frediano, Lucca. Romanesque.

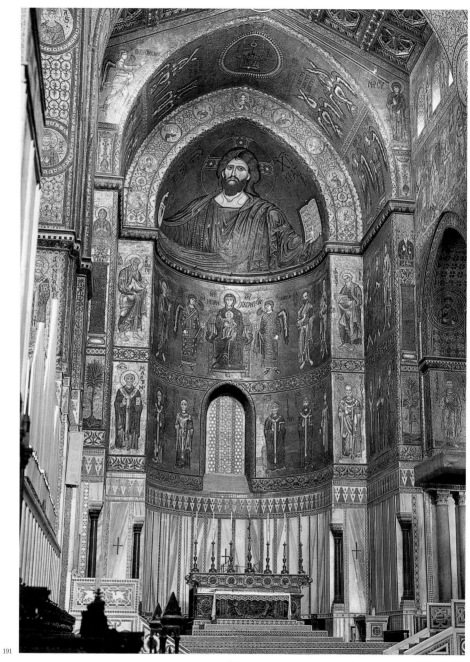

191. **Anonymous.**
Apse in the Cathedral of Monreale: *Christ Pantocrator, Virgin and Child,*
Archangel, Apostle, and Saints, 1175-1190.
Mosaic.
Cathedral of Monreale, Sicily. Byzantine.

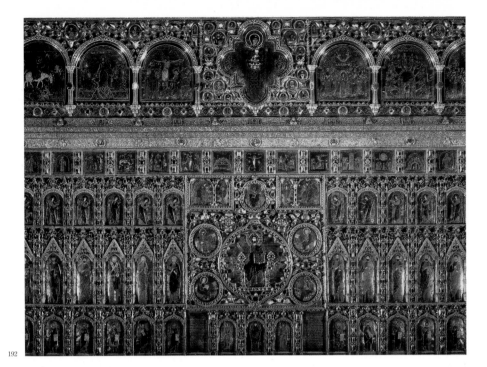

192

Nicolas de Verdun
(Verdun, 1130 – Tournai, c. 1205)

Nicolas de Verdun is one of the greatest goldsmiths of the Middle Ages. With him, the transition from the Romantic to the Gothic occurred. The genius artist was the cause for the Aesthetic Revolution of the 12th century, and he enjoyed a distinguished European distinction. The following three works are masterpieces of his creativity: in year 1181, he created the pulpit with an enamelled triptych of fifty religious peoples and a biblical scene for the Klosterneuburg Monastery. In 1184, he made the shrine of the *Three Magi* for the Cologne Cathedral and in 1205 the shrine for Tournai Cathedral. The significance of Nicolas de Verdun's works lies in his personalised style, as well as in the return of the antique design vocabulary, and, although still early, the transition to Gothic.

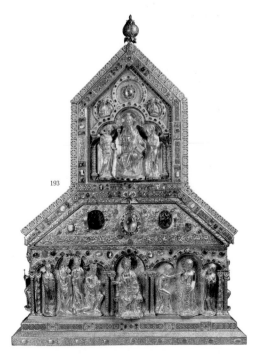

193

192. **Anonymous.**
Pala d'Oro, 12th-13th century.
Gold, silver, and precious stones, 212 x 334 cm.
St Mark's Basilica, Venice. Byzantine.

193. **Nicholas of Verdun**, 1130-c. 1205, Austrian.
Shrine of the Three Kings, 1191.
Oak, gold, silver, copper, gilding, champlevé and cloisonné enamel,
precious stones, and semi-precious stones, 153 x 110 x 220 cm.
Cologne Cathedral, Cologne. Romanesque.

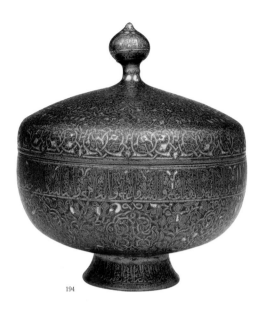

194

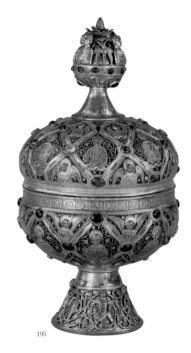

195

194. Anonymous.
Cauldron, Herat (Afghanistan), 12th century – beginning of the 13th century.
Bronze with inlaid work in silver and copper, height: 18.5 cm.
The State Hermitage Museum, St Petersburg. Eastern.

195. Master Alpais (?). Master Alpais' ciborium, Limoges, c. 1200.
Gilded copper, champlevé enamel, glass cabochons, height: 30 cm.
Musée du Louvre, Paris.

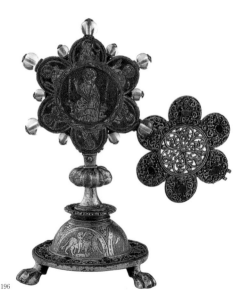

196

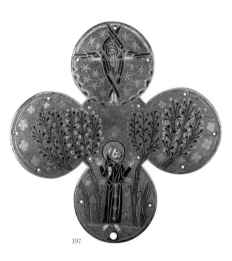

197

196. Anonymous.
Reliquary from Notre-Dame de Termonde, Flanders, c. 1220-1230.
Gilded silver and niello on a wooden core, precious stones,
and quartz, 24.1 x 13.4 cm. Musée de Cluny, Paris.

197. Anonymous.
Reliquary of St Francis of Assisi, Limoges, c. 1228-1230.
Gilded copper, champlevé enamel on gilded copper, crystals, 20 x 20 cm.
Musée de Cluny, Paris. Gothic.

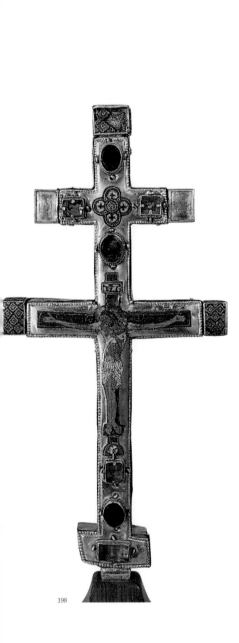

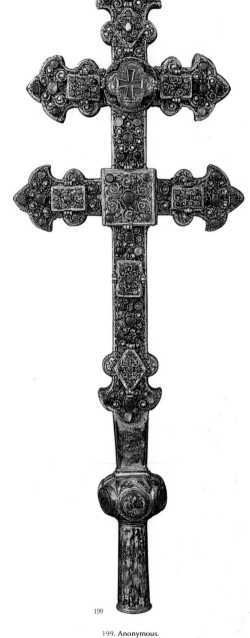

198. Anonymous.
Cross-shaped reliquary of the True Cross, southern Italy (?),
end of the 12th century or c. 1200.
Gilded silver, opaque cloisonné enamel on gilded silver, wood, glass beads, 24 x 11.7 cm.
Musée des beaux-arts de Dijon, Dijon. Byzantine.

199. Anonymous.
Cross-shaped reliquary of the True Cross, Limousin, 13th century.
Gilded copper on wood, jewels, 57.3 x 21.4 cm.
Musée de Cluny, Paris. Romanesque.

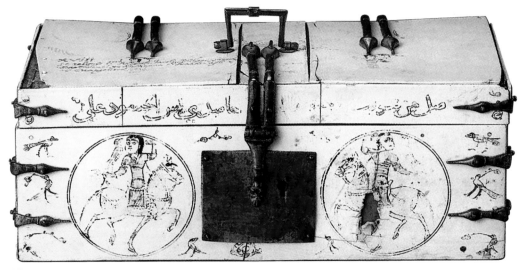

200

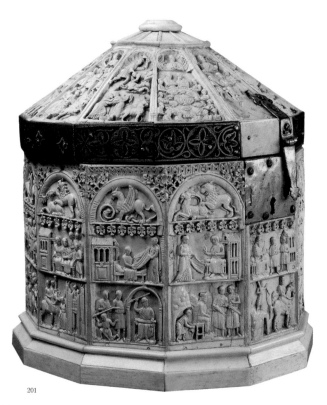

201

200. **Anonymous.**
Chest, Sicily, end of the 12th century.
Lacquered and gilded ivory on wood,
gilded bronze, 11 x 31 cm.
Musée de Cluny, Paris.

201. **Anonymous.**
Chest, known as 'The Holy Reliquary', 12th-13th century.
Ivory and enamel, height: 35 cm; diameter: 32.5 cm.
From the treasury of the Sens Cathedral, Sens (France). Byzantine

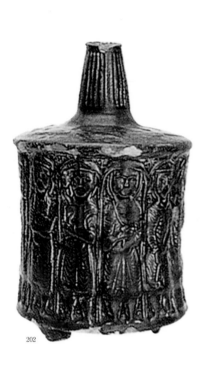

202

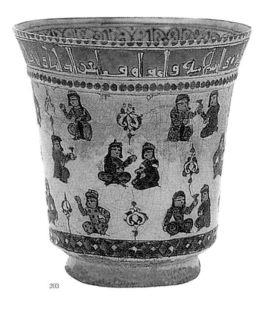

203

203. **Anonymous.**
Pitcher, 13ᵗʰ century.
Enamelled stoneware, burnt twice, height: 7.8 cm; diameter: 18 cm.
The State Hermitage Museum, St Petersburg. Persian.

202. **Anonymous.**
Jug, beginning of the 13ᵗʰ century.
Stoneware, height: 28 cm.
Museum of History of the People of Uzbekistan, Tashkent. Persian.

204. **Anonymous.**
Dishes, Iran, 12ᵗʰ and 13ᵗʰ centuries.
Ceramic and turquoise glass.
Private collection. Eastern.

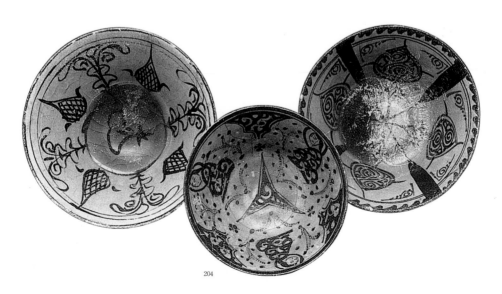

204

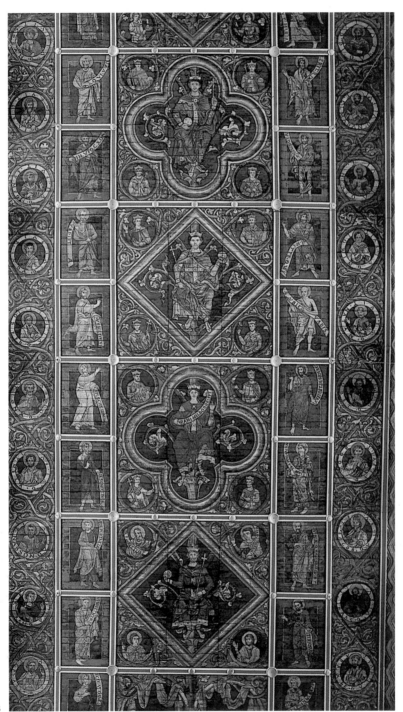

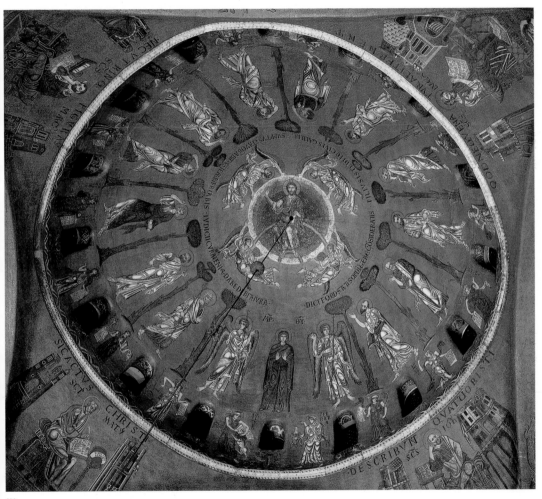

206

205. **Anonymous.**
View of a ceiling made of wood, 1214-1230.
St Michael's Church, Hildesheim. Romanesque.

206. **Anonymous.**
Ascension of Jesus, 13th century.
Mosaic.
St Mark's Basilica, Venice. Byzantine.

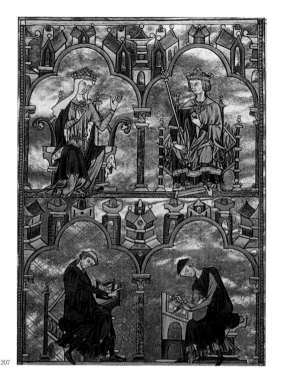

207

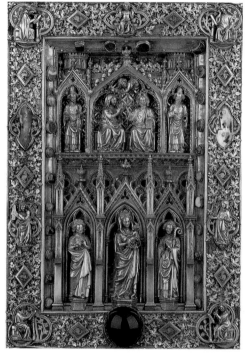

208

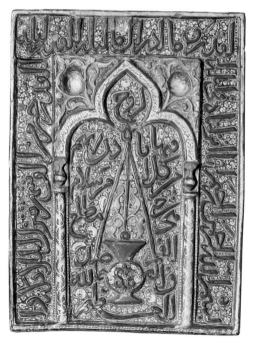

209

207. Anonymous.
Moralised Bible: *Blanche of Castile and King Louis IX of France;*
Author Dictating to a Scribe, France, c. 1230.
Ink, 37.5 x 26.2 cm.
The Morgan Library and Museum, New York. Gothic.

208. Anonymous.
Cover of a book belonging to St Blaise, Strasbourg (?), 1260-1270.
Gilded silver, 38.7 x 27.3 cm.
St Paul im Lavanttal, The Lavanttal. Gothic.

209. Anonymous.
Prayer niche (Mihrab), 13ᵗʰ-14ᵗʰ century.
Ceramic, 63 x 47 cm.
Museu Calouste Gulbenkian, Lisbon. Eastern.

210. Anonymous.
Adam, c. 1260.
Polychrome stone, 200 x 73 x 41 cm.
Musée de Cluny, Paris. Gothic.

211. Anonymous.
Virgin and Child from Sainte-Chapelle, c. 1265-1270.
Ivory and traces of polychrome, 41 cm.
Musée du Louvre, Paris. Gothic.

212. Nicola Pisano, 1206-1278, Italian.
Lectern, 1266-1268.
Marble, height: 460 cm.
Cathedral of Santa Maria Assunta, Siena. Gothic.

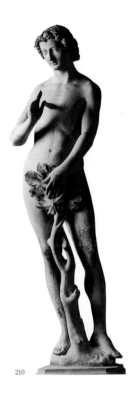

210

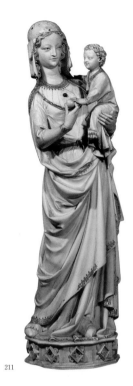

211

Nicola Pisano
(Apulia, 1206 – Pisa, 1278)

Italian sculptor and architect, Nicola Pisano heads the tradition of Italian sculpture. As early as 1221, he is said to have been summoned to Naples by Frederick II, to do work in the new Castell dell'Ovo. In 1260, as an incised inscription records, he finished the marble pulpit for the Pisa Baptistry. The next important work of Nicola in date is the Arca di San Domenico, in the church at Bologna consecrated to that saint, who died in 1221.

Nicola's last great work of sculpture was the fountain in the piazza opposite the west end of the Perugia Cathedral. Nicola Pisano was not only pre-eminent as a sculptor but was also the greatest architect of his century and a skilled engineer.

Nicola Pisano died at Pisa, leaving his son Giovanni, a worthy successor to his great talents both as an architect and sculptor.

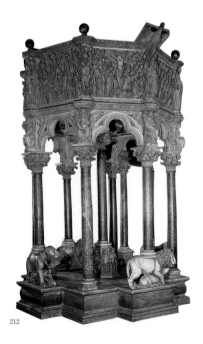

212

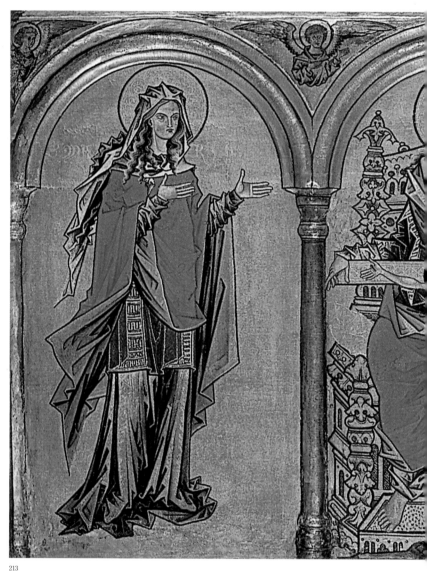

213

213. **Anonymous.** Altarpiece from the Church of St Maria zur Wiese, *The Holy Trinity, Virgi*

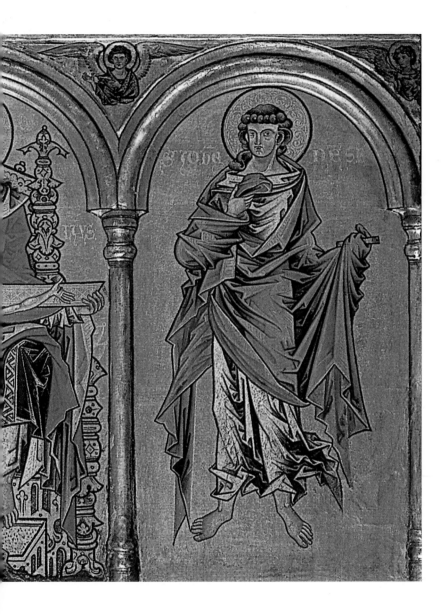

...n the Baptist, c. 1250. Paint on wood. Staatliche Museen zu Berlin, Berlin. Romanesque.

214

215

214. Anonymous.
Bowl, decorated with two princes observing a pond with two fish, 13th century.
Ceramic, height: 9 cm; diameter: 21.7 cm.
Khalili Collection. Eastern.

215. Anonymous.
Plate, Syria, middle of the 13th century.
Bronze and silver, forged and decorated, diameter: 43.1 cm.
The State Hermitage Museum, St Petersburg. Eastern.

216

217

216. Anonymous.
Cup on a pedestal, second half of the 13th century.
Cast bronze (brass), coated with silver and gold, height: 14.3 cm; diameter: 17.7 cm.
The State Hermitage Museum, St Petersburg. Persian.

217. Anonymous.
Cup, Yuan dynasty, 1279-1368.
Stoneware, porcelain, height: 16.4 cm.
National Palace Museum, Taipei. Chinese.

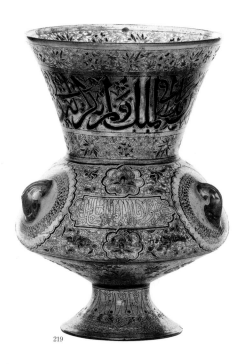

219

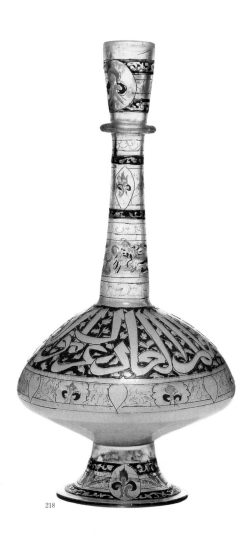

218

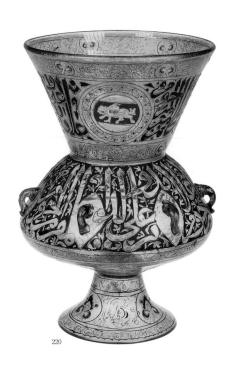

220

218. Anonymous.
Bottle, Egypt, 14th century.
Hand-blown glass, embellished with enamel and gilded, height: 48 cm.
Musée des Arts décoratifs, Paris. Eastern.

219. Anonymous.
Lamp from a mosque, 1309-1310.
Colourless glass, enamelled and gilded, height: 30 cm; diameter: 21 cm.
Musée des Arts décoratifs, Paris. Eastern.

220. Anonymous.
Lamp from a mosque, 14th century.
Enamelled glass, height: 35 cm; diameter: 31 cm.
Musée des Arts décoratifs, Paris. Eastern.

221

The Latin text within image 1:

in consilio impiorum: & in uia pec
catorum non stetit: & in cathedra pe
stilentie non sedit.
Sed in lege domini uoluntas eius:
& in lege eius medirabit die ac nocte.
Et erit tanquam lignum qd plan
tatum est secus decursus aquarum:

222

223

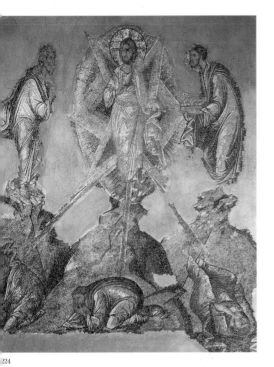

224

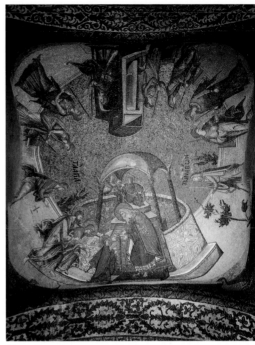

225

221. Anonymous.
Windmill Psalter: Psalm I (*Beatus Vir*), c. 1270-1280.
Ink, pigment, and gold on vellum, 32.3 x 22.2 cm.
The Morgan Library and Museum, New York. Gothic.

222. Gautier de Coinci.
The Miracles of the Blessed Virgin Mary, a representation of the story
of the damnation of a money lender and the redemption of a beggar
who accompanied the Blessed Virgin Mary, end of the 13ᵗʰ century.
Parchment, 27.5 x 19 cm.
Bibliothèque nationale de France, Paris. Gothic.

223. Yves, monk of the Abbey of St Denis, French.
The Life of St Denis: The Entrance of St Denis into Paris, c. 1317.
Miniatures on parchment, 27.5 x 19 cm.
Bibliothèque nationale de France, Paris. Gothic.

224. Anonymous.
The Transfiguration of Jesus, 14ᵗʰ century.
Mosaic.
Church of the Holy Apostles, Thessaloniki. Byzantine.

225. Anonymous.
Presentation of the Virgin in the Temple, 1315-1321.
Mosaic.
Kariye Camii (Chora Church), Istanbul. Byzantine.

226. Anonymous.
St George and the Dragon, first half of the 14ᵗʰ century.
Portable mosaic.
Musée du Louvre, Paris. Byzantine.

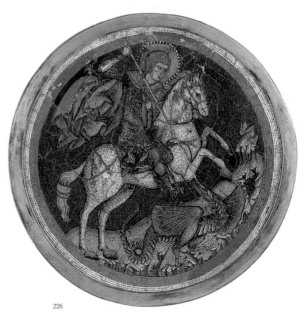

226

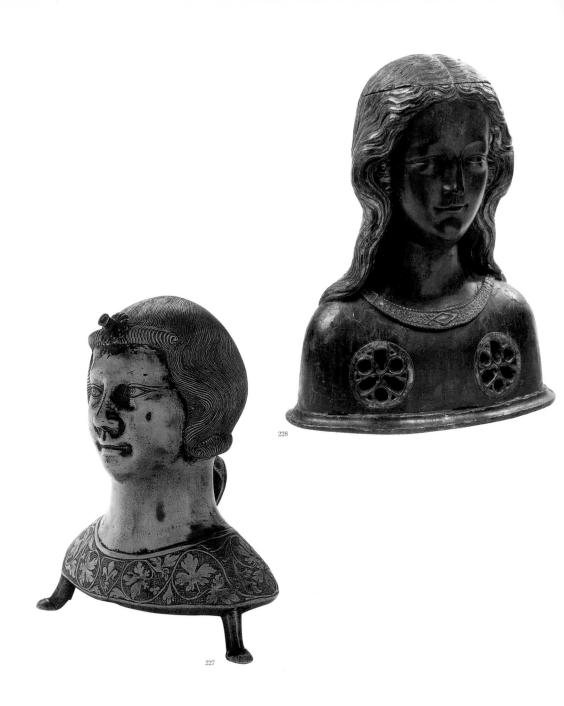

227. Anonymous.
Aquamanile, northern Germany, beginning of the 14ᵗʰ century.
Molten and engraved bronze, 22 x 19 cm.
Musée de Cluny, Paris. Gothic.

228. Anonymous.
Reliquary bust of a companion of St Ursula, Cologne, c. 1340.
Coloured limestone, gilded, height: 47.5 cm.
Musée de Cluny, Paris. Gothic.

229

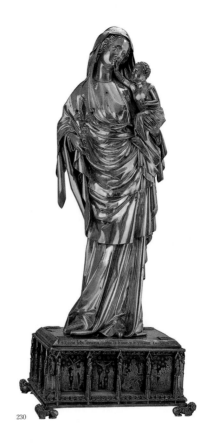

230

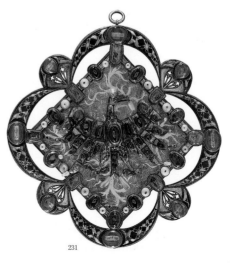

231

229. Minucchio da Siena, 14th century, Italian.
Golden rose, Avignon, 1330.
Gold and coloured glass, length: 60 cm.
From the treasury of the Basel Minster. Musée de Cluny, Paris. Gothic.

230. Anonymous.
Reliquary figure: *Virgin and Child of Jeanne d'Évreux*, Paris, c. 1324-1339.
Gilded silver, basse-taille enamels on gilded silver, stones and pearls, height: 68 cm.
From the treasury of the Basilica Cathedral of St Denis.
Musée du Louvre, Paris. Gothic.

231. Anonymous.
Clasp of a reliquary, Bohemia (?), middle of the 14th century.
Engraved silver, partially gilded, enamel, jewels, pearls, 18.5 x 18.5 cm.
Musée de Cluny, Paris. Gothic.

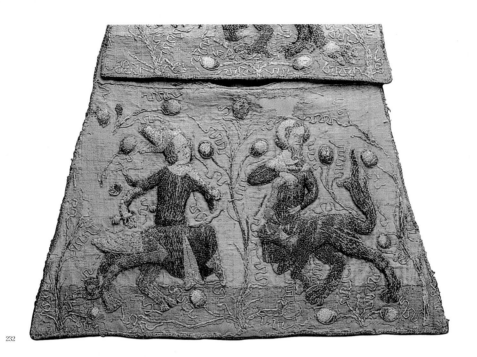

232

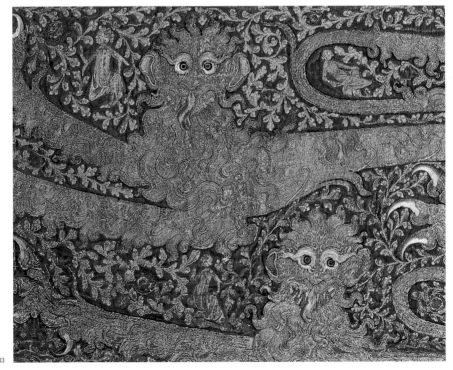

233

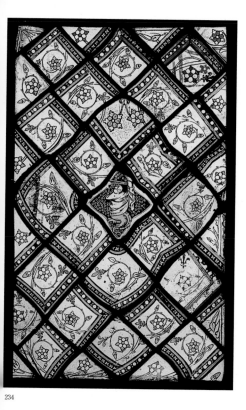

234

235

232. Anonymous.
Pouch, known as 'Countess of Bar', France, 14th century.
Leather, gold and silver threads, 36 x 32 cm.
Musée de Cluny, Paris.

233. Anonymous.
Embroidery with Leopards, c. 1330-1340.
Velvet, silver threads, partially gilded, cabochon, pearls, 51 x 124 cm.
Musée de Cluny, Paris. Romanesque.

234. Anonymous.
Grisaille panel, c. 1324.
Glass, grisaille, yellow silver, lead, 64.5 x 42 cm.
Musée de Cluny, Paris. Gothic.

235. Anonymous.
Stained glass window with maple leaves and crucifixion, c. 1330.
Glass, grisaille, and lead, 107 x 105 cm.
Musée de Cluny, Paris. Gothic.

236. Anonymous.
St Paul, Normandy, c. 1300.
Glass, grisaille, and lead, 71 x 58.5 cm.
Musée de Cluny, Paris. Gothic.

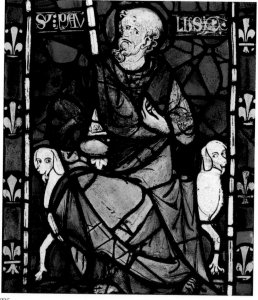

236

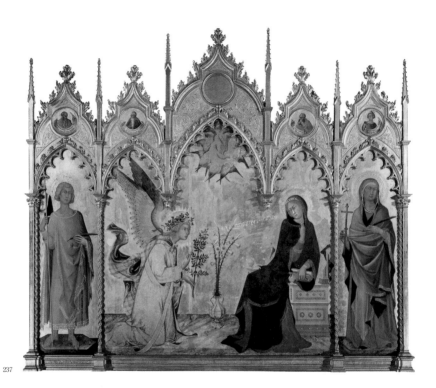

237

238

237. **Simone Martini** and **Lippo Memmi**,
1284-1344 and 1291-1356, Italian.
Altarpiece of the *Annunciation*, 1333.
Tempera on wood, 184 x 210 cm.
Galleria degli Uffizi, Florence. Gothic.

238. **Ugolino di Vieri**, 1329-1380/1385, Italian.
Reliquary of the Corporal of Bolsena, 1337-1338.
Gilded and enamelled silver, height: 139 cm.
Orvieto Cathedral, Orvieto (Italy). Gothic.

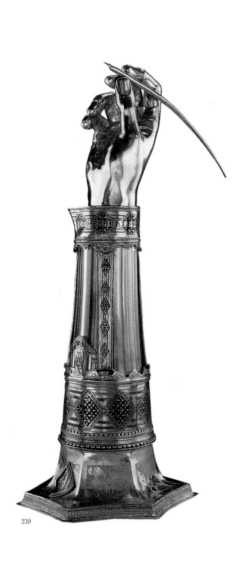

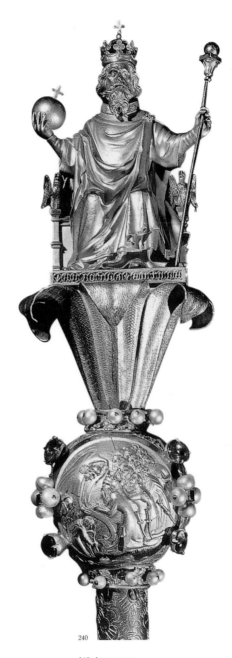

239. **Anonymous.**
Arm reliquary of St Louis of Toulouse, Naples, c. 1337-1338.
Quartz, gilded silver, and champlevé enamel, height: 48 cm.
Musée du Louvre, Paris. Gothic.

240. **Anonymous.**
Sceptre of Charles V, Paris, 1365-1380.
Gold, enamelled repeatedly, gilded silver (shaft), rubies, coloured glass, pearls, length: 60 cm.
From the treasury of the Basilica Cathedral of St Denis.
Musée du Louvre, Paris. Gothic.

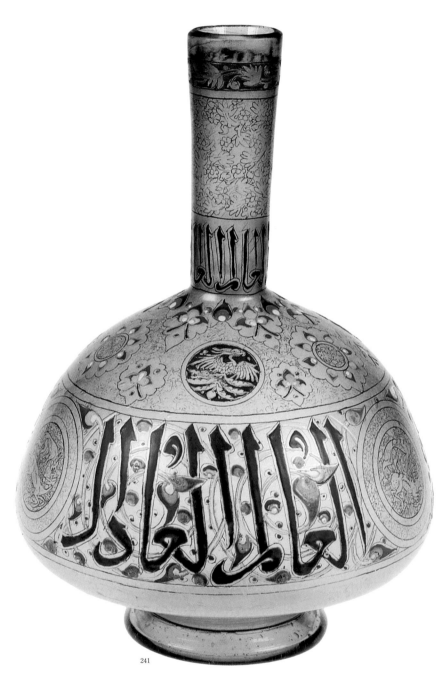

241

241. **Anonymous.**
Bottle, Mamluk dynasty, middle of the 14ᵗʰ century.
Enamelled glass.
Museu Calouste Gulbenkian, Lisbon. Eastern.

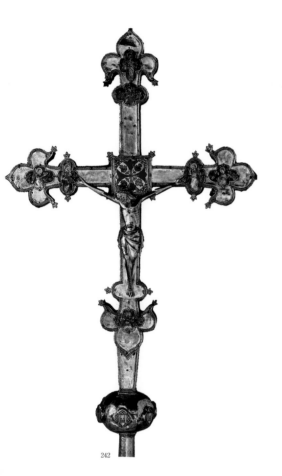

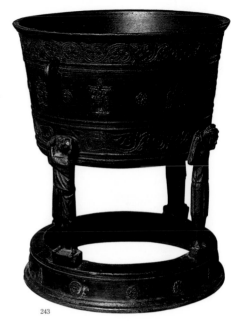

243

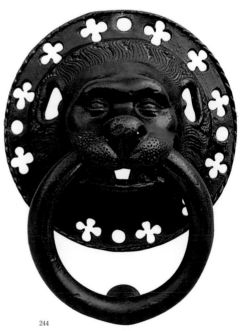

242. **Anonymous.**
Cross, 14th century.
Silver and enamel, 82.5 x 44.5 cm.
Musée de Cluny, Paris. Gothic.

243. **Anonymous.**
Baptismal font, Germany, 14th century.
Bronze, 80.5 x 87 cm.
Musée de Cluny, Paris. Gothic.

244. **Anonymous.**
Door knocker with lion, Germany, 14th century.
Bronze, 19.5 x 8.5 cm.
Musée de Cluny, Paris.

244

245. **Guyart des Moulins**, 1251-1322, French.
Bible Historiale: *Enthroned Holy Trinity* (introductory leaflet), third quarter of the 14th century.
Parchment, 45.5 x 31.5 cm.
Bibliothèque nationale de France, Paris. Gothic.

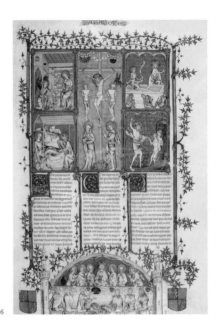

246. **Guyart des Moulins**, 1251-1322, French.
Bible Historiale: *New Testament* (frontispiece), third quarter of the 14th century.
Parchment, 45.5 x 31.5 cm.
Bibliothèque nationale de France, Paris. Gothic.

247. **Jean le Noir, Jacquemart de Hesdin, Maître de la Trinité, Pseudonym-Jacquemart**
and **Limbourg Brothers**, French. *Turin-Milan Hours (or Belles Heures of Jean de France,
Duc de Berry)*: *The Birth of John the Baptist and the Baptism of Christ*, 1375-1390.
Illuminated manuscript, 22.5 x 13.6 cm.
Bibliothèque nationale de France, Paris. Gothic.

248. **Giovanni de'Grassi**, 1350-1398, Italian.
Breviarium ambrosianum, known as *Il Beroldo*, c. 1390.
Biblioteca Trivulziana, Milan. Gothic.

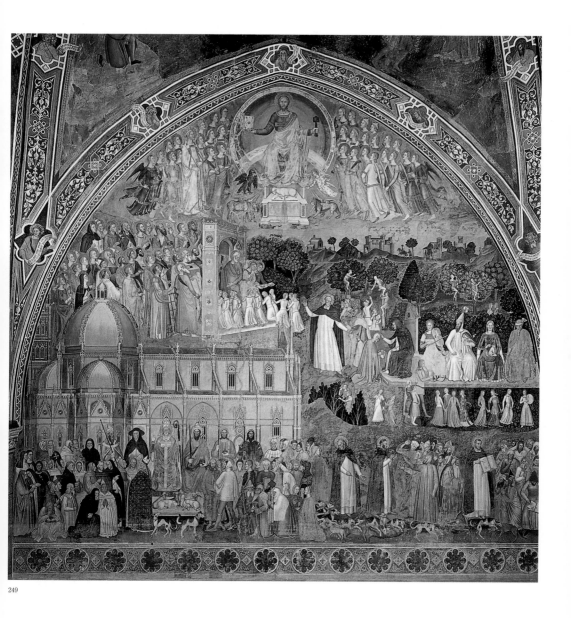

249. **Andrea Bonaiuti**, known as **Andrea da Firenze**, 1343-1377, Italian.
Exaltation of the Work of the Dominicans, c. 1365-1367.
Fresco.
Basilica of Santa Maria Novella, Florence. Gothic.

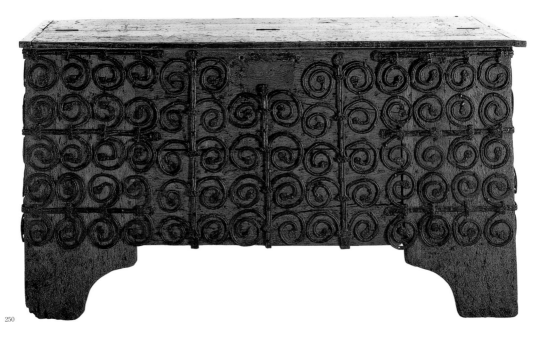

250

250. **Anonymous.**
Hinged chest, France, 14th century.
Oak and wrought iron, mortise and tenon joint, 89 x 165 x 79 cm.
Musée des Arts décoratif, Paris.

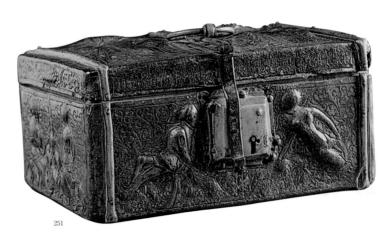

251

251. **Anonymous.**
Chest, end of the 14th century.
Repoussé leather, engraved, painted, and gilded, on wood, brass fittings, 12 x 26 x 18 cm.
Musée de Cluny, Paris.

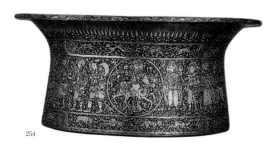

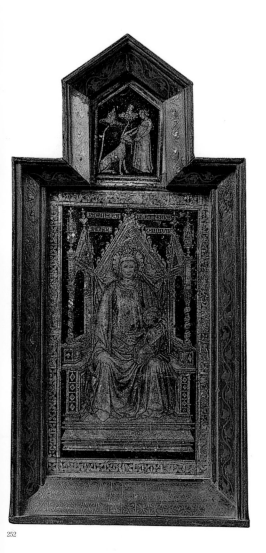

253. **Anonymous.**
Chest, end of the 14th century.
Repoussé leather, engraved, painted,
and gilded on wood, brass fittings, 12 x 26 x 18 cm.
Musée de Cluny, Paris.

252. **Anonymous.**
Plate: *Virgin and Child, Unicorn*, c. 1370.
Glass, gilded, engraved, and painted, wooden frame, 32.5 x 15 cm.
Musée de Cluny, Paris.

254. **Anonymous.**
Baptismal basin of St Louis (Louis IX), Egypt or Syria, c. 1320-1340.
Hammered brass, decoration inlaid with silver, engraved, with gold and black
paste, height: 22.2 cm; diameter: 50.2 cm.
Musée du Louvre, Paris. Eastern.

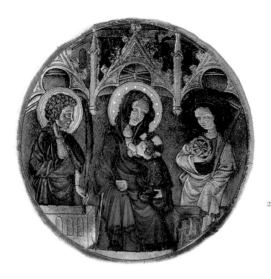
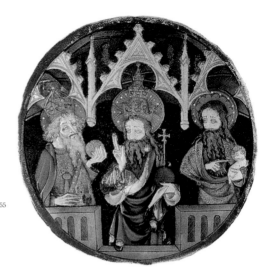

255. **Anonymous.**
A pair of mirrors: *The Virgin between St Catherine and John the Baptist and Christ between John the Baptist and Charlemagne*, before 1379.
Gold, translucent enamel on basse-taille, diameter: 6.8 cm.
Musée du Louvre, Paris. Gothic.

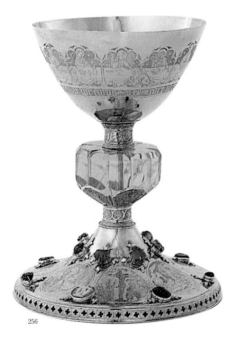
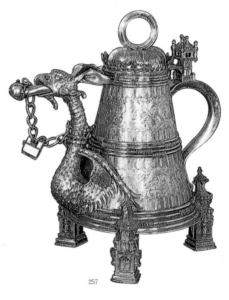

256. **Anonymous.**
St Bernard's goblet, end of the 14ᵗʰ century.
Pure gold, height: 22.5 cm; diameter: 15.2 cm.
From the treasury of St Mary's Cathedral, Hildesheim. Gothic.

257. **Anonymous.**
Water pitcher from a reception in Katzenelnbogen, beginning of the 15ᵗʰ century.
Gilded silver, height: 40 cm.
Hessisches Landesmuseum, Kassel. Gothic.

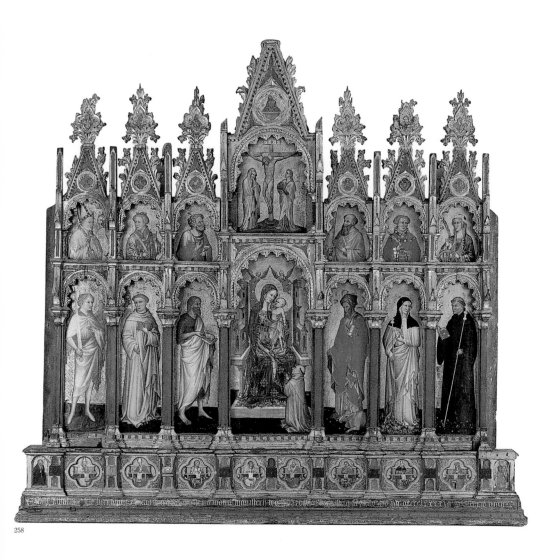

258

258. **Antonio de Carro**, 1392-1410, Italian.
Polyptych, *Virgin and Child Surrounded by Saints*, 1398.
Tempera on wood, golden background, 228 x 236 cm.
Musée des Arts décoratifs, Paris. Gothic.

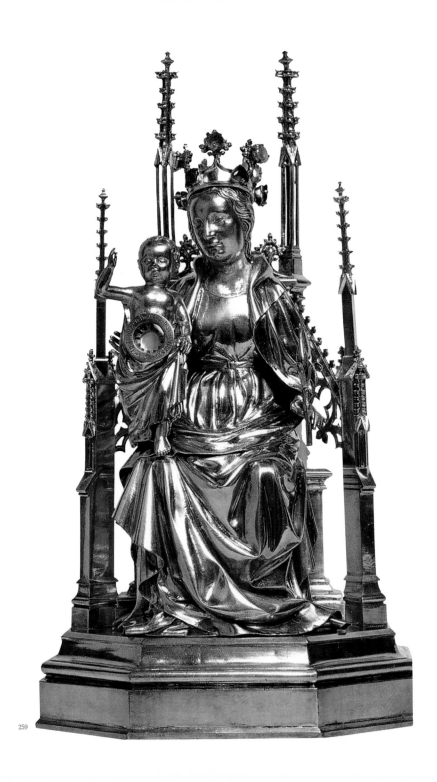

259

RENAISSANCE

In the 14th century and early years of the 15th, elegant luxury was primarily displayed in rich fabrics and tapestries made to cover furniture, seats, and benches. The flowing draperies of the beds partook of this taste, which originated with the Crusades, and was initially inspired by the sight of the magnificent fabrics of the East. Sculpture, nevertheless, continued its progress, and even Italian woodwork began to show Oriental derivation. This age also corresponds with the complete expansion of Gothic architecture and furniture. The furniture is divided into flamboyant Gothic cloisters, crowned by fine needle-shaped sticks and flourishing leaves; their niches contain elegantly-quaint figures, and the panels, with their bas-reliefs, rival the perfection of altarpieces and religious triptychs of intricate workmanship. Accordingly, no part of these articles of furniture was covered so that the artist's ingenious conceptions could be easily viewed, unless a covering was absolutely necessary. Much of this furniture served only for luxurious display, while that which was destined for travelling remained simple in form and was modestly concealed in those parts of the dwelling reserved for private life.

In the next section, we look at Renaissance furniture. H. Havard (*Les Styles*) writes:

"All furniture whose shape is not entirely determined by everyday use takes on certain characteristics of the appearance of a palace; chair legs become more rounded and column-like; cupboards, sideboards, cabinets and credence tables begin to look like small slim buildings crowned with pediments, decorated with niches and pilasters, escutcheons and entablatures."

Whatever variations the artist uses, however, no piece of furniture escapes the general trend. Everywhere furniture is becoming broader, horizontal lines take on unprecedented importance. It is the horizontal lines which invest the item with meaning and importance both in terms of its structure and its decoration.

Let us go on with our list of the identifying features of Renaissance furniture generally, the elegance and distinction of which will only increase as the style develops its own personality. Two-part cupboards covered in marquetry, cabinets in the classical style, church stalls decorated with arabesques above which there is a row of images of sibyls, angels, and chimaera in marquetry holding floating scrolls under porticos with columns. Above the images are low reliefs surrounded by columns and mouldings and above them is a cornice which forms a canopy with pinnacles and tracery on its outer edges. Narrow panels decorated with low reliefs, above which are pointed arcades supported on small columns. The panels are divided down the middle by a column and there is beading and tracery above them. Friezes, in the middle of which, one comes across a mascaron with rinceaux of light foliage emerging from it. Rows of caryatids holding flowers and fruit, separated by niches with figures represented at the back of the niche. Two-part wardrobes with four folding doors inlaid with marble or richly decorated with low reliefs on a gilt background. Chests with carved figures which are separated by pilasters with grotesque figures on them and a small spirit or genie at the top, classical mouldings: with balusters, gadroons, tracery, egg, and dart patterns, etc.

One particularly popular piece of furniture in the 16th century was a large cabinet consisting of a kind of round-topped chest which was raised on four legs and full of small drawers which could only be seen when the large wooden doors which made this piece essentially a wardrobe and which hid the drawers were open. There were also roll-tops, etc. As far as chairs and panelling are concerned, while during the Gothic

period they were made of carved wood, during the Renaissance they were upholstered in either tooled or stamped leather from either Spain or Flanders. Even the chimney pieces and roofs were elegantly shaped and carefully decorated. This is typical of the Renaissance when the aim was always to embellish.

Were it not for the extremely original nature of their carving, in various degrees of relief, French Renaissance furniture (unlike Italian Renaissance furniture which was characterised by its strange mosaics of coloured stones and copper figurines) would be rather monotonous given that it was made of a single wood and was, therefore, one colour only. The range of furniture available remained limited and, though beautiful, it was not especially comfortable. In a word, the Renaissance marked the heyday of cabinet-making, tooling and binding, gold and silver work, stained glass, enamelling used as if it were paint (Limoges enamel), ceramics as practised by Lucca della Robbia in Italy and Bernard Palissy in France, faïence work from Oiron and the anonymous master-pieces from Urbino.

This was the period when jewellery, locks, woven and stitched fabrics with light, graceful patterns in soft, shimmering colours were at their height. Finally, this was the period when Du Cerceau's drawing and engravings were in fashion and disseminated the most characteristic decorative motifs for both buildings and furniture. Where jewellery was concerned in particular, decorative value was beginning to be an end in itself, in other words, the precious materials were no longer the be all and end all. There follows a list of remarkable sculptors of the Renaissance: Jean Goujon (who was also one of the architects who designed the Hôtel Carnavalet); Ligier Richier, to whom we owe the famous Holy Sepulchre group in Saint-Mihiel; Michel Colombe, sculptor of the Duke of Brittany's mausoleum (in Nantes cathedral); Germain Pilon, Jean Goujon, who popularised the use of the low relief for general decoration, Jean Juste of Tours, sculptor of Louis XII's tomb; Pierre Bontemps, etc. Étienne de Laulne and François Briot are two goldsmiths who are worthy of mention.

Renaissance art was characterised by the fusion of different styles. The renewal was a result of artists' relaxed approach, of the uninhibited love of luxury which artists, architects, and sculptors all worshipped and served. Statues and ornaments are no longer made in barbarian traditions. They have better models in nature and their makers embellish them with lifelike representations. Indeed, nature alone is not sufficient to fire the imagination of the artists of the period and they turn to the world of myth and story or to combinations of human and animal figures. Perfectly-lifelike fruits and flowers are also included in the works of these artists who are fervent admirers of all life's great creations. Note that, aside from the character of the styles, independently of the patinas and the original colours having faded over the centuries, it is the easiest task in the world to tell real antique furniture apart from a copy! All one has to do is run one's hand lightly over the mouldings and the carvings and the feel of them is conclusive. The enthusiast will not be deceived because no-one has ever been able to fake the fine touch of such furniture, any more than a flower can be faked. The secret lies in the reliefs, which have been gradually worn by time and use, and in the wood which turns into velvet. Furthermore, velvet, silk, and satin were everywhere during this fascinatingly fresh, gay period of intellectual creativity. It was a period which turned the excessively flamboyant tracery of the most exuberant Gothic style into a kind of lace, this time without ornamental apertures, which was used profusely on all kinds of woodwork. However, it seems that even the Renaissance eventually fell into decadence, a period marked by a similar exuberance.

Renaissance jewellery, was worthy of the beauty and decorative creativity prevalent in architecture at the time. It was light, with delicate openwork and the images that were the chief source of its charm were embellished with harmoniously-coloured enamels, the like of which had never been seen before. Furthermore, towards the end of the 16th century the art of cutting precious stones added brilliance to jewellery varying its design and increasing prices. The name of Pericles is linked to the great art of ancient Greece, the names of the Medicis, of Pope Julius II, and of Pope Leo X are bound up with the Italian Renaissance and the name of Francis I, second only to that of Charlemagne, is equally gloriously connected to the history of French art.

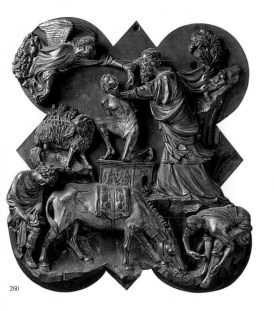

260

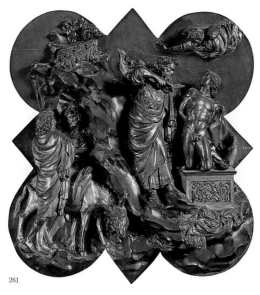

261

Lorenzo Ghiberti
(Florence, c. 1378-1455)

Italian sculptor, Lorenzo Ghiberti learned the trade of a goldsmith under his father Ugoccione, known as Cione, and his stepfather Bartoluccio. In the early stages of his artistic career Ghiberti was best known as a painter in fresco. In Rimini, he executed a highly prized fresco in the palace of the sovereign Carlo Malatesta. Informed that a competition was to be opened for designs of a second bronze gate in the baptistery, Ghiberti returned to Florence to participate. The subject for the artists was the sacrifice of Isaac, and the competitors were required to observe in their work a certain conformity to the first bronze gate of the baptistery, executed about 100 years before by Andrea Pisano. Of the six designs presented by Italian artists, those of Donatello, Brunelleschi, and Ghiberti were pronounced the best; Brunelleschi and Ghiberti tied for first. The thirty-four judges entrusted the execution of the work to the two friends, but Brunelleschi withdrew from the contest. The first of his two bronze gates for the baptistery occupied Ghiberti twenty years.

To his task Ghiberti brought deep religious feeling and a strive for a high poetical ideal absent from the works of Donatello. The unbounded admiration called forth by Ghiberti's first bronze gate led to his receiving from the chiefs of the Florentine guilds the order for the second gate, of which the subjects were likewise taken from the Old Testament. The Florentines gazed with special pride on these magnificent creations. Even a century later they must still have shone with all the brightness of their original gilding when Michelangelo pronounced them worthy to be the gates of paradise. Next to the gates of the baptistery Ghiberti's chief works are his three statues of St John the Baptist, St Matthew, and St Stephen, executed for the church of Orsanmichele.

He died at the age of seventy-seven.

260. **Filippo Brunelleschi**, 1377-1446, Italian.
Sacrifice of Isaac, 1401.
Bronze, 47 x 40 cm.
Museo Nazionale del Bargello, Florence. Early Renaissance.

261. **Lorenzo Ghiberti**, c. 1378-1455, Italian.
Sacrifice of Isaac, 1401-1402.
Bronze, 45 x 38 cm.
Museo Nazionale del Bargello, Florence. Early Renaissance.

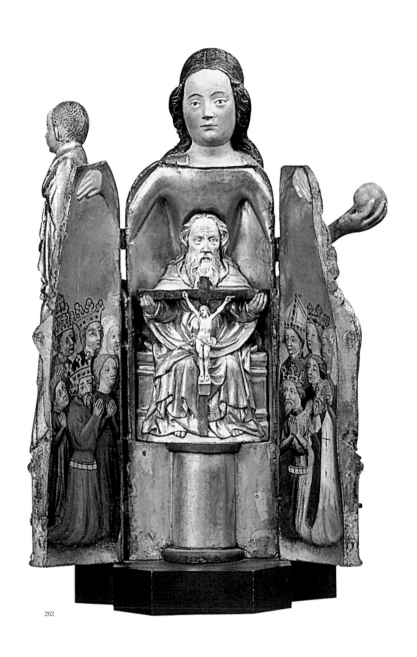

262

262. Anonymous.
Virgin, opened, West Prussia, beginning of the 15th century.
Polychrome wood (linden), 20 x 45 cm (opened).
Musée de Cluny, Paris. Gothic.

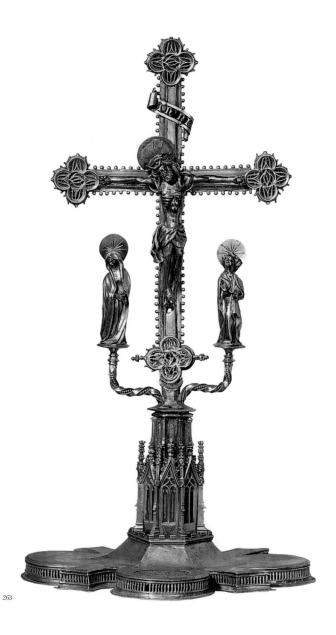

263

263. **Hector Rayronie**, 1449-1481, French.
Pedicle cross, Rodez, 15th century.
Gilded silver, translucent enamel, 38.5 x 17.6 cm.
St Gerald's Church, Salles-Curan (Aveyron).

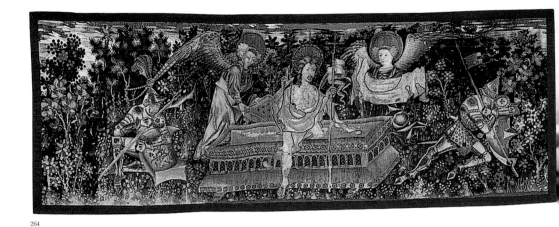

264

264. **Anonymous.**
The Resurrection, Flanders, c. 1410-1420.
Tapestry with silk and silver threads, 77 x 240 cm.
Musée de Cluny, Paris. Renaissance.

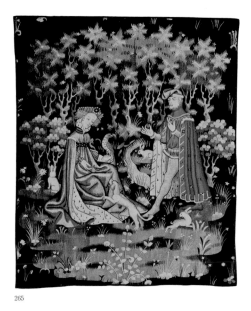

265

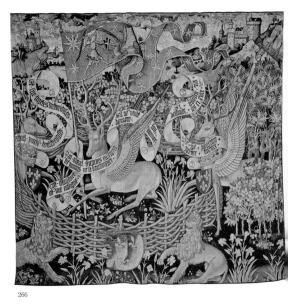

266

265. **Anonymous.**
The Offering of a Heart, c. 1400-1410.
Tapestry, wool, and silk, 247 x 210 cm.
Musée du Louvre, Paris. Gothic.

266. **Anonymous.**
Winged Stag, 1453-1461.
Wool, 347 x 380 cm.
Musée départemental des Antiquités, Rouen. Gothic.

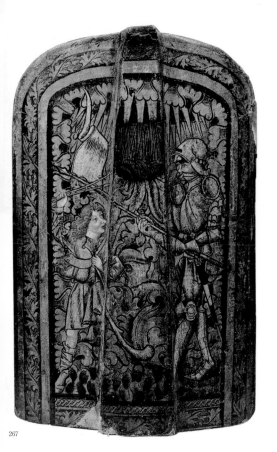

267

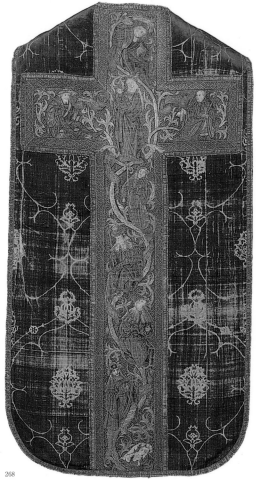

268

267. Anonymous.
Shield: *David and Goliath*, Bohemia, 15th century.
Wood, linen, silver leaf, and painting, 90 x 55.5 cm.
Musée de Cluny, Paris. Gothic.

268. Anonymous.
Tunicle, *The Tree of Jesse*, 15th century.
Silk and gold thread, 120.5 x 64 cm.
Musée de Cluny, Paris.

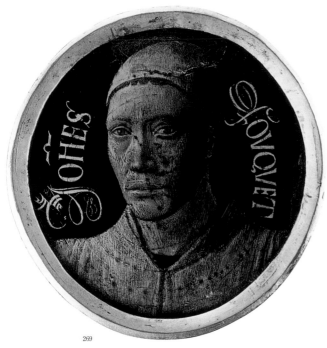

269

JEAN FOUQUET
(TOURS, C. 1420-1480)

Painter and illuminator, Jean Fouquet is considered as one of the most important French painters of the 15th century. Little is known of his life, but it is almost certain that he created the portrait of the pope Eugene IV in Italy.

When he returned to France, he introduced elements from the Italian Renaissance into French painting. He was the official painter to the court of the king, Louis XI.

Whether it is in his miniatures that elaborate even the smallest detail or in his large formatted paintings on wood panel, the art of Fouquet always possesses monumental character.

His subjects articulate themselves on large surfaces with defined lines of brilliant purity.

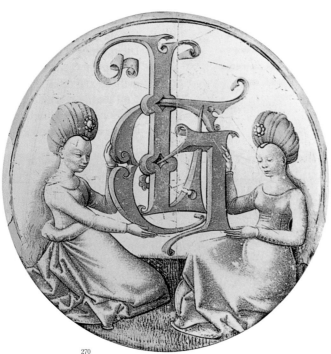

270

269. **Jean Fouquet**, c. 1420-before 1480, French.
Medallion: *Self-Portrait*, c. 1450.
Painted enamel on copper, diameter: 7.5 cm (with border).
Musée du Louvre, Paris. Early Renaissance.

270. **Jean Fouquet**, c. 1420-before 1480, French.
Rondel, monogrammed with 'LG', c. 1460.
White glass, yellow silver, and lead, diameter: 19.5 cm.
Musée de Cluny, Paris. Early Renaissance.

271. **Anonymous.**
Virgin with Child: *Notre Dame de Grasse*, 1451-1500.
Limestone, 75 x 112 x 38 cm.
Musée des Augustins, Toulouse. Gothic.

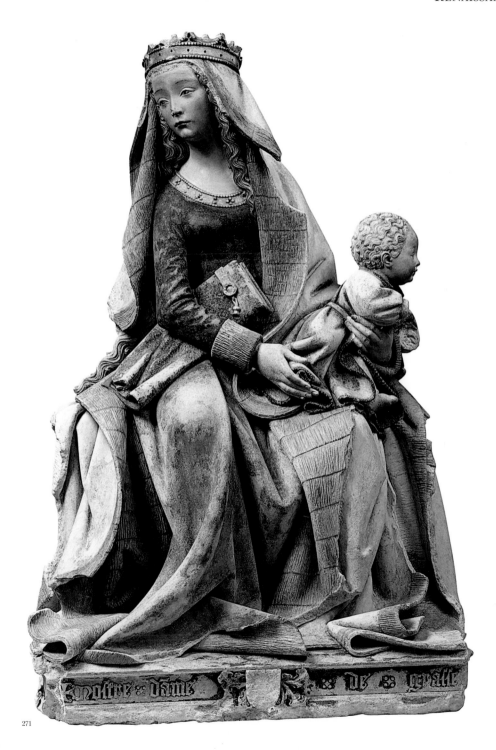

271

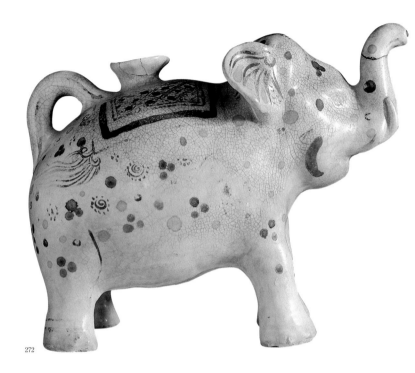

272

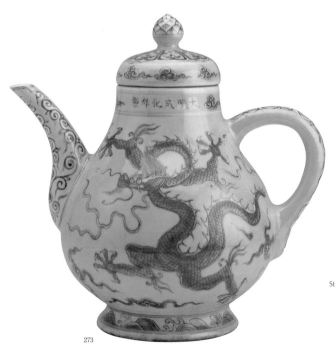

273

272. Anonymous.
Jug in the shape of an elephant, 15th-16th century.
Stoneware, decorated with polychrome enamel, length: 21 cm.
Private collection. Vietnamese.

273. Anonymous.
Water pitcher, decorated with a dragon, 1465-1487.
Porcelain, height: 21.6 cm.

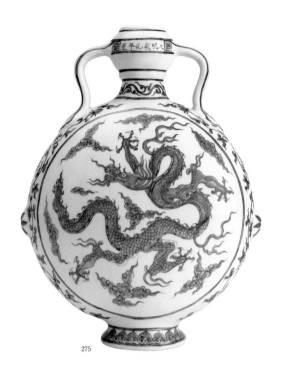

275

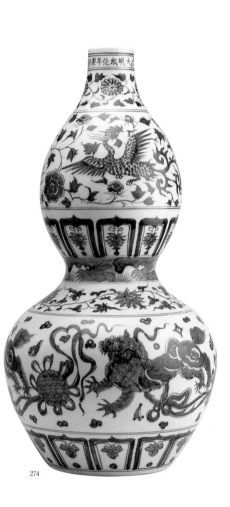

274

274. Anonymous.
Double gourd-shaped bottle, 1465-1487.
Porcelain, height: 45 cm.
Private collection. Chinese.

275. Anonymous.
Moon-shaped jug with a painting of a dragon, 1465-1487.
Porcelain, height: 27.4 cm.
Private collection. Chinese.

276. Anonymous.
Blue plate, 1465-1487.
Porcelain, diameter: 27.4 cm.
Private collection. Chinese.

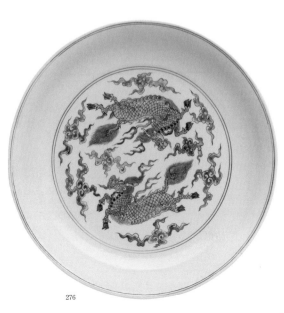

276

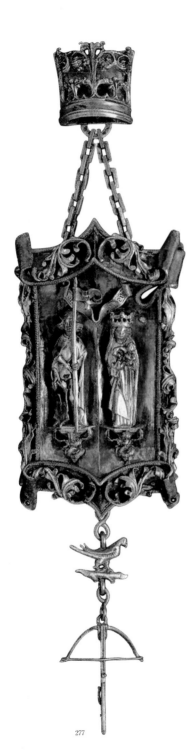

277

278

277. Anonymous.
Enseigne à l'arbalète: Vierge et Saint Hermès
(*Crossbow emblem: Virgin and St Hermes*), Rheinland, 1480-1500.
Silver, partially gilded, 30 x 6 cm.
Musée de Cluny, Paris. Renaissance.

278. Anonymous.
Portable altar, second half of the 15th century or end of the 16th century.
Amethyst, gilded, repoussé, filed, and engraved silver, niello, wooden core, 23.8 x 27.3 cm
Musée du trésor de la Cathédrale St-Jean, Lyon. Byzantine.

279. Apollonio di Giovanni, 1415/1417-1465, Italian.
Wedding chest, *Tournament in the Piazza Santa Croce in Florence*,
middle of the 15th century.
Poplar wood, carved and gilded, decorated with oil colours.
National Gallery, London. Early Renaissance.

280. Giovanni di ser Giovanni, known as **Scheggia, and Workshop,**
1406-1486, Italian.
Tiberius Gracchus and Cornelia, 1465-1470.
Poplar wood, base of slabs, 45 x 174.1 x 1.8 cm.
Musée national de la Renaissance, Château d'Écouen, Écouen. Early Renaissance.

281. Guidoccio Cozzarelli, 1450-1516, Italian.
Cupboard panel, *Odysseus' Departure*, 1480-1481.
Poplar wood, base of slabs, 34 x 121.5 x 2.5 cm.
Musée national de la Renaissance, Château d'Écouen, Écouen. Early Renaissance.

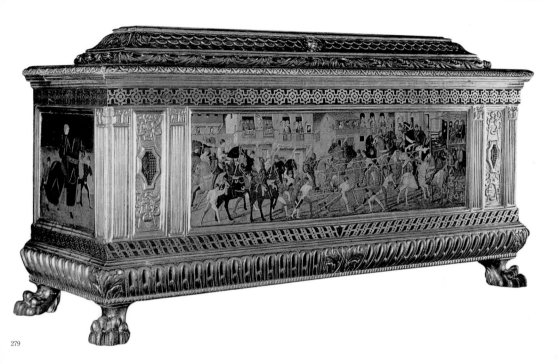

279

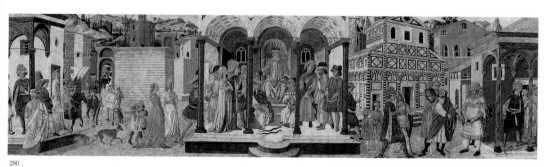

280

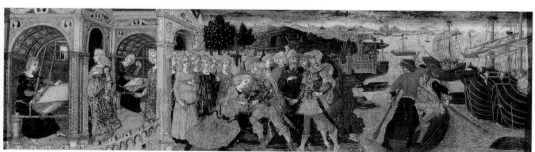

281

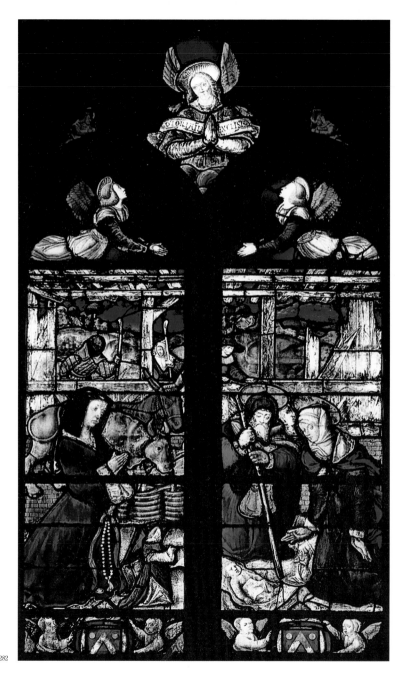

282

282. **Anonymous.**
Stained glass window: *The Nativity*, c. 1490-1500.
After a sketch from Jean Poyer, 220 x 142 cm.
Private collection, Paris.

283

283. **Jean I Pénicaud**, c. 1490-after 1543, French.
Christ Blesses the Praying Virgin, c. 1480.
Enamel painted on copper, 33 x 24.5 cm.
Musée de Cluny, Paris. Early Renaissance.

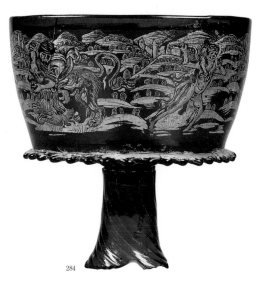

284

284. **Anonymous.**
Illustrated cup, *The Labours of Hercules*, c. 1480-1500.
Enamelled blue glass, height: 16.5 cm.
Musée national de la Renaissance, Château d'Écouen, Écouen. Early Renaissance.

155

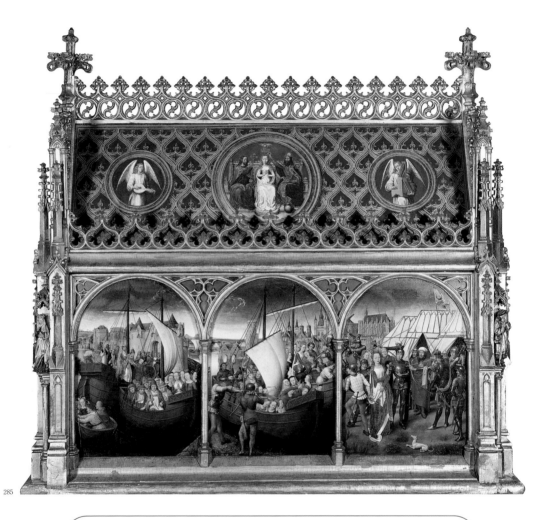

285

VEIT STOSS
(HORB AM NECKAR, C. 1450 – NUREMBERG, 1533)

German sculptor and wood carver Veit Stoss is considered, with Tilman Riemenschneider, as the greatest wood carver of his age. In 1477, he went to Krakow, where he was actively engaged until the end of the century. It was here that he carved the high altar for St Mary's Basilica, between 1477 and 1489. On the death of King Casimir IV in 1492, Stoss carved his tomb in red marble for the Wawel Cathedral in Krakow. To the same date is ascribed the marble tombstone of the archbishop Zbigniew Ollsnicki in the cathedral at Gnesen (Giezno). In 1496, he returned to Nuremberg, where he did a great deal of work completing altars. His best-known sculpture is the Annunciation for the Church of St Lorenz in Nuremberg, from 1518, carved in wood on a heroic scale and suspended from the vault.

285. **Hans Hemling**, 1435/1440-1494, Flemish.
Shrine of St Ursula, 1489.
Oil colours on wooden panel and gilding, 87 x 33 x 91 cm.
Memling in Sint-Jan – Hospitaalmuseum, Bruges. Renaissance.

286. **Veit Stoss**, c. 1450-1533, German.
St Mary's Altar: *Dormition of Mary* (centrepiece), 1489.
Linden, oak, and larch, 11 x 13 cm.
St Mary's Basilica, Krakow. Late Gothic.

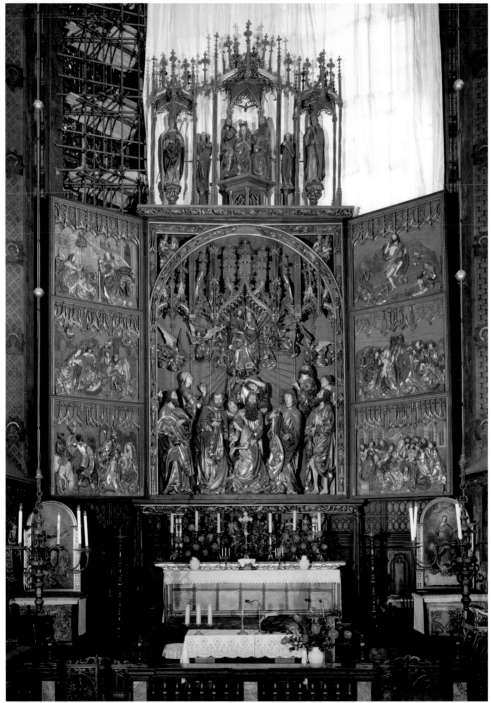

286

287

287. Anonymous.
Main reliquary of St Stephen of Muret, c. 1495-1507.
Gilded silver, bust of wood, height: 27 cm (head only).
Saint-Sylvestre Church, Saint-Sylvestre-Cappel.

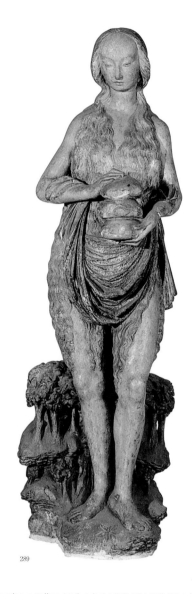

289

288

288. Bartolomeo Bellano (attributed to), 1437/1438-1496/1497, Italian.
St Jerome and the Lion, c. 1490-1495.
Bronze, 25 cm.
Musée du Louvre, Paris. Early Renaissance.

289. Anonymous.
Mary of Egypt, c. 1490.
Polychrome limestone, height: 130 cm.
Church of Saint-Germain-l'Auxerrois, Paris. Gothic.

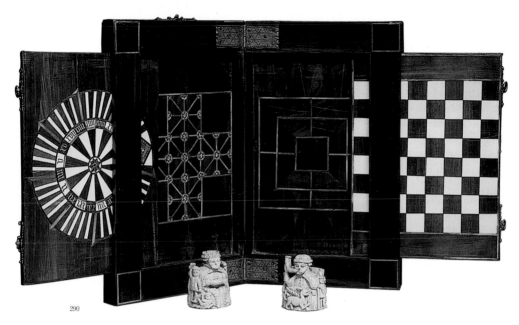

290

290. Anonymous.
Box with games, end of the 15ᵗʰ century.
Ebony, stained walnut, and ivory, 39 x 24 cm (closed).
Musée de Cluny, Paris.

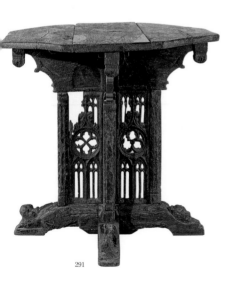

291

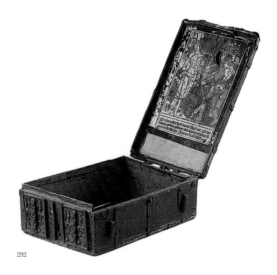

292

291. Anonymous.
Octagonal folding table, c. 1480-1500.
Oak, 75 x 90.5 x 79 cm.
Musée de Cluny, Paris. Late Gothic.

292. Anonymous.
Box with print depicting the *Martyrdom of St Sebastian*, end of the 15ᵗʰ century.
Wood, leather, iron, and fabric. Coloured xylography, done with a stencil, 21 x 34 x 13 cm.
Musée de Cluny, Paris. Late Gothic.

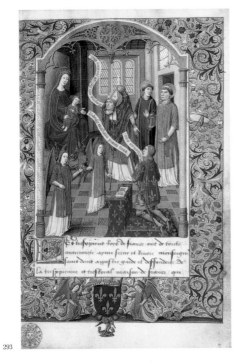

293

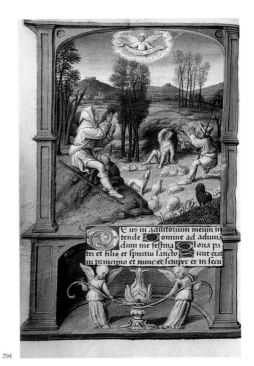

294

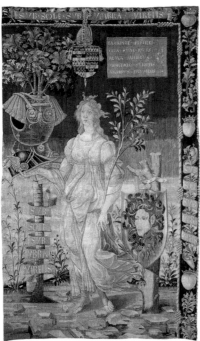

295

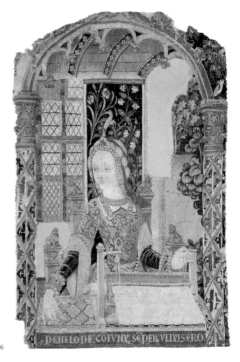

296

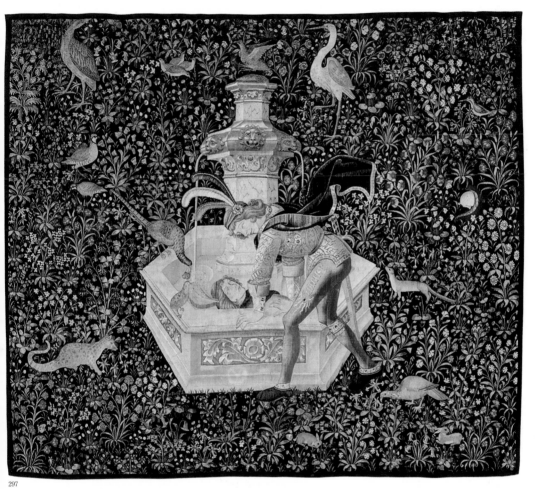

297

297. Anonymous.
Narcissus, Paris, c. 1500.
Wool and silk, 282 x 311 cm.
Museum of Fine Arts, Boston.

293. Anonymous.
Compilation in honour of St Denis, 1495-1498.
Illuminated manuscript, 26 x 17.5 cm.
Bibliothèque nationale de France, Paris. Early Renaissance.

294. Anonymous.
Book of Hours of Anne of Brittany and Mary Tudor, Tours, c. 1498.
Vellum, 13.1 x 8.9 cm.
Bibliothèque municipale, Lyon. Early Renaissance.

295. Anonymous.
Minerva, France (?), after 1491.
Tapestry, wool, and silk, 257 x 156 cm.
Private collection. Early Renaissance.

296. Anonymous.
Fragment of a curtain from *The Stories of Virtuous Women:
Penelope at Her Loom*, c. 1500.
Wool and silk, 100 x 150 cm.
Museum of Fine Arts, Boston.

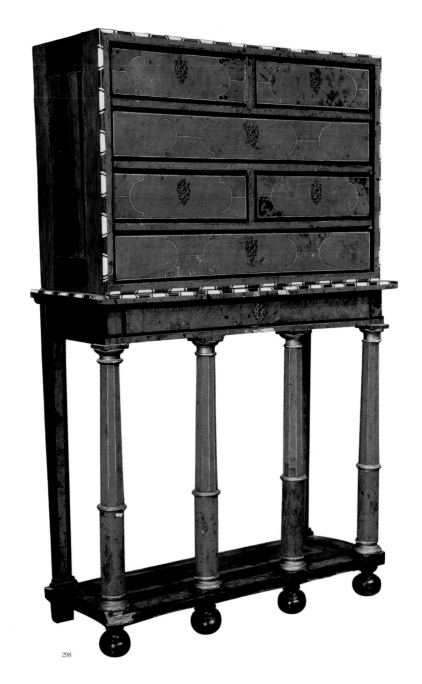

298. **Anonymous.**
Cabinet, Italy, 16th century.
Plated red tortoiseshell with ivory.
Château de Blois, Blois. High Renaissance.

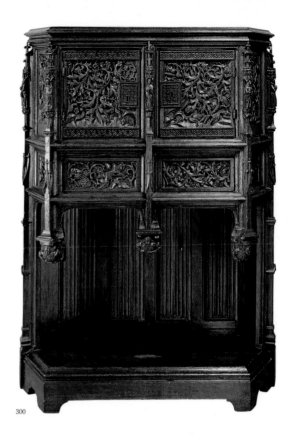

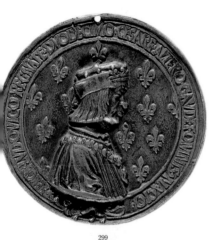

299

300. **Anonymous.**
Serving cabinet with plant detail, France, end of the 15th century.
Oak and iron, 162 x 118 cm.
Musée du Louvre, Paris. High Renaissance.

299. **Anonymous.**
Medallion of Louis XII (recto) and Anne of Brittany (verso),
Lyon, 1499.
Bronze, diameter: 17 cm.
Musée national de la Renaissance, Château d'Écouen,
Écouen. Early Renaissance.

301. **Anonymous.**
Choir stalls, Beauvais, 1492-before 1500.
Oak, height: 87 cm.
Musée de Cluny, Paris. Gothic.

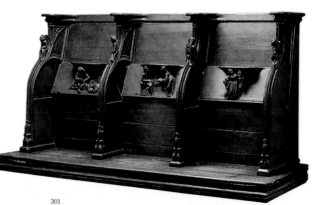

301

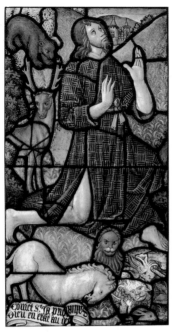

302

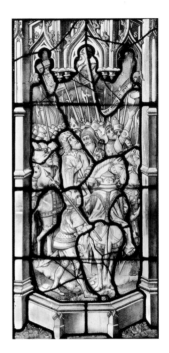

303

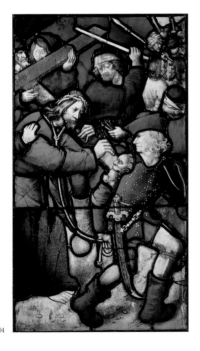

304

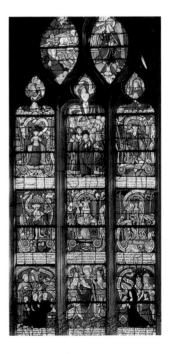

305

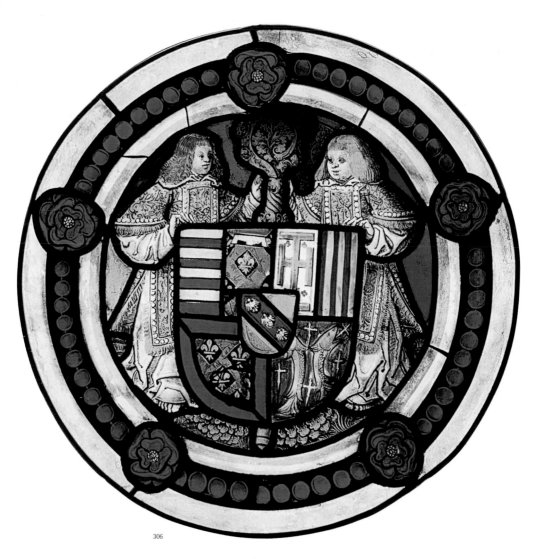

306

306. Anonymous.
Stained glass window with the crest of Jean de Lorraine, c. 1505-1518.
Stained glass window, diameter: 42 cm.
Musée Lorrain, Nancy.

302. Anonymous.
St John the Baptist Praying in the Wilderness, Rouen, c. 1500-1510.
Stained glass window, 114 x 61 cm.
Victoria and Albert Museum, London.

303. Jean Barbe (attributed to), French.
The Crucifixion: Roman Captain Recognises the Divine Nature of Christ, 1502 (?).
Grisaille stained glass window, 86 x 53 cm.
Archiepiscopal complex of Rouen, Rouen.

304. Anonymous.
Bearing of the Cross, Paris, c. 1500.
Stained glass window, 73 x 41 cm.
Musée de Cluny, Paris.

305. Anonymous.
Stained glass window with *The Great Triumphs of Petrarch*:
The Triumph of Chastity and *The Triumph of Death*, Troyes, 1502.
Stained glass window, 112 x 61 cm.
Church Saint-Pierre-ès-Liens, Ervy-le-Châtel (France).

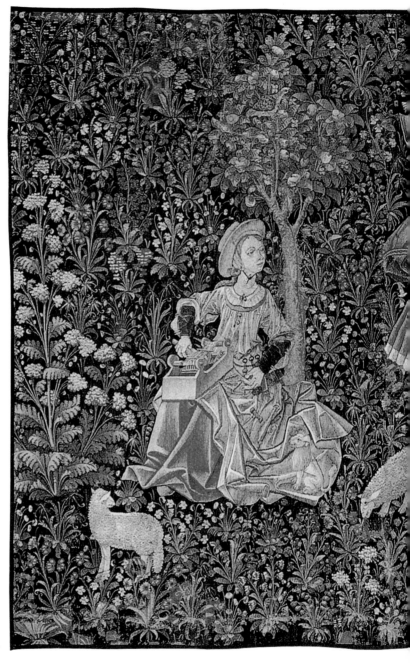

307

307. **Anonymous.** *Steps in Processing Wool,* beginning of the 16th

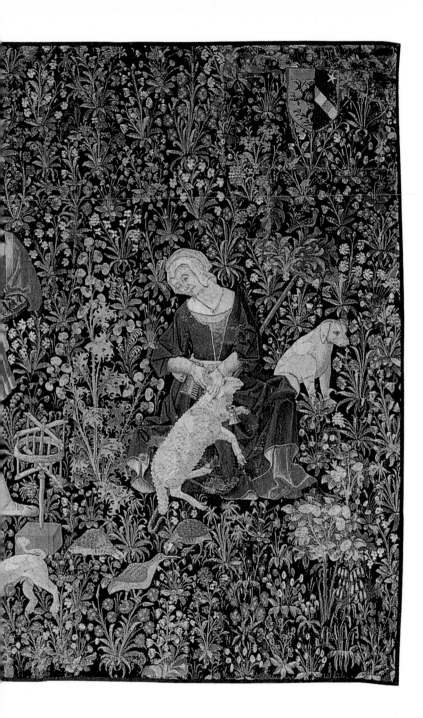

wool, and silk, 220 x 319 cm. Musée du Louvre, Paris.

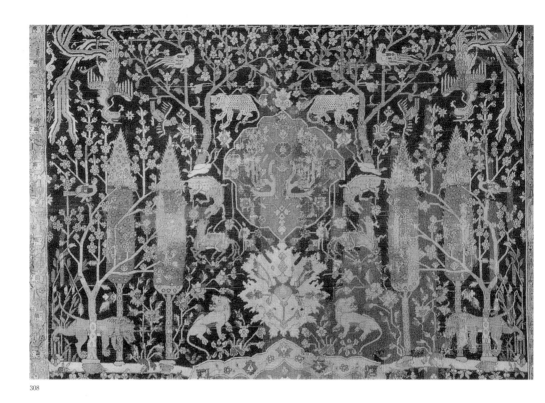

308

309

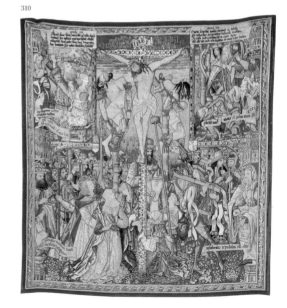

310

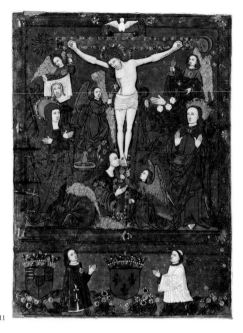

311

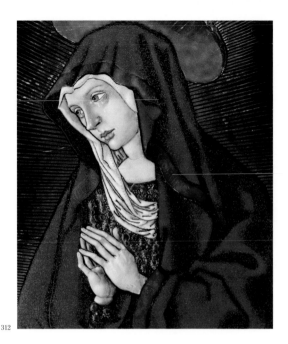

312

311. **Léonard, known as Nardon Pénicaud**, unknown - c. 1542, French.
The Crucifixion, 1503.
Painted enamel on copper, 33.5 x 25.5 cm.
Musée de Cluny, Paris. Late Gothic.

312. **Master of the Triptych of Louis XII**, French.
The Sorrowful Virgin, c. 1500.
Painted enamel on copper, 30 x 21 cm.
Musée du Louvre, Paris. Late Gothic.

Léonard, known as Nardon Pénicaud
(Date unknown – c. 1542)

Nardon Pénicaud was a French enamellist and founder of the first dynasty of enamellers from Limoges. The only dating for his works comes from the date on *The Crucifixion* from 1503 (currently at Musée de Cluny). The enamels used by Pénicaud were polychrome; he applied dark colours that he deposited onto gold or silver leaf. Pénicaud only presented religious scenes and was inspired by northern and eastern woodcuts. Although his will is dated 1541, his workshop was continued during the 16th century by his parents, Jean I, Jean II (most likely one of his sons) and Pierre (another son).

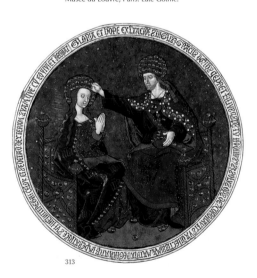

313

308. **Anonymous.**
Tapestry (fragment), beginning of the 16th century.
Wool, 258 x 250 cm.
The State Hermitage Museum, St Petersburg. Persian.

309. **Anonymous.**
Tapestry representing *The Life of St Stephen: The Miracle of Mules* (detail), c. 1500.
Wool and silk, 166 x 396 cm.
Musée de Cluny, Paris. Late Gothic.

310. **Anonymous.**
The Crucifixion, c. 1501-1518.
Wool and silk, gold and silver threads, 343 x 343 cm.
La Chaise Dieu Abbey, La Chaise Dieu. Late Gothic.

313. **Master of the Triptych of Louis XII**, French.
The Coronation of the Virgin, c. 1500.
Painted enamel on copper, diameter: 23 cm.
Musée du Louvre, Paris. Late Gothic.

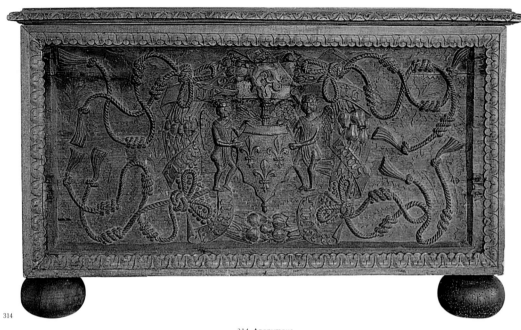

314

314. Anonymous.
Chest belonging to Bishop François d'Estaing of Rodez, 1501-1529.
Carved and painted linden, 43 x 72.2 x 42.6 cm.
Rodez Cathedral, Rodez.

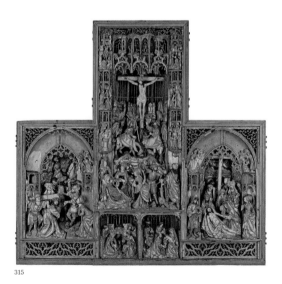

315

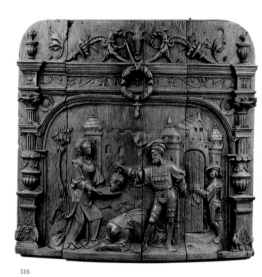

316

315. Anonymous.
Altarpiece with the *Passion and Childhood of Christ*, c. 1500-1510.
Polychrome oak, 235 x 214 x 26 cm.
Musée du Louvre, Paris. Late Gothic.

316. Anonymous.
Three backrests from the choir stalls of the Château de Gaillon, c. 1508-1510.
Oak, 55 x 58 cm.
Musée national de la Renaissance, Château d'Écouen, Écouen. High Renaissance.

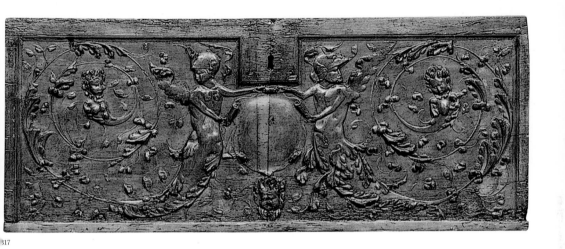

317. **Anonymous.**
Chest, 16th century.
Carved wood, 150 cm.
Musée national de la Renaissance, Château d'Écouen, Écouen. High Renaissance.

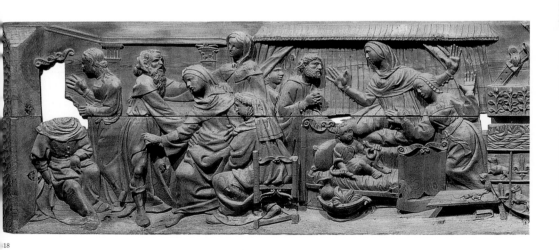

318. **Anonymous.**
Frieze from the Castle of Vélez Blanco: *The Birth of Hercules*, Spain, 1505-1520.
Carved pine, 90 x 605 cm (with frame).
Musée des Arts décoratifs, Paris.

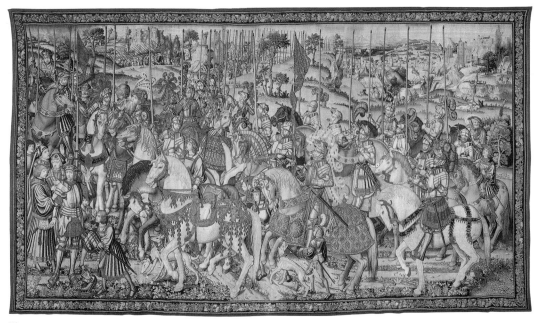

319

320

321

322

323

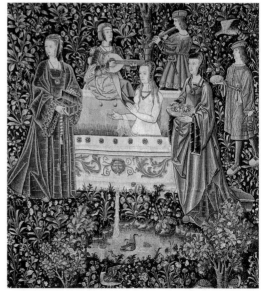

319. Anonymous.
Gallery of *Psyche*, *David's Army Gathers Strength for the Siege of Rabbah*
(detail from the third component), tapestry of *David and Bathsheba*, 1510-1515.
Musée national de la Renaissance, Château d'Écouen, Écouen. Renaissance.

320. Anonymous.
Gallery of *Psyche*, tapestries of *David and Bathsheba*, 1510-1515.
Musée national de la Renaissance, Château d'Écouen, Écouen. Renaissance.

321. Anonymous.
Gallery of *Psyche*, *David Orders Jacob to Assemble the Army*
(detail from the second component), tapestry of *David and Bathsheba*, 1510-1515.
Musée national de la Renaissance, Château d'Écouen, Écouen. Renaissance.

322. Anonymous.
The Tapestry of the World, part of the cycle *The World is Driven by Vice
and Protected by Virtue*, Brussels, 1510-1525.
Tapestry, wool, and silk, 390 x 345 cm.
Musée des Arts décoratifs, Paris. Renaissance.

323. Anonymous.
The Departure of a Hunting Party, part of *The Splendid Life*, southern Netherlands,
c. 1510-1520.
Tapestry with wool and silk threads, 285 x 285 cm.
Musée de Cluny, Paris. Renaissance.

324. Anonymous.
The Bath, part of *The Splendid Life*, southern Netherlands, c. 1510-1520.
Tapestry with wool and silk threads, 285 x 285 cm.
Musée de Cluny, Paris. Renaissance.

324

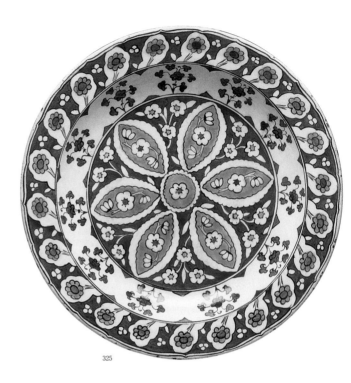

325

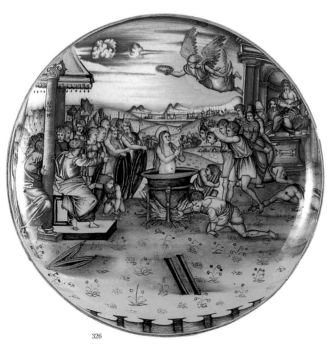

326

325. Anonymous.
Dish with turquoise rosettes, Turkey, 1530-1535.
Porcelain, blue and turquoise adornment
on white background, diameter: 37.5 cm.
Private collection. Oriental.

326. Casa Pirata Workshop.
Bowl with the *The Martyrdom of St Cecilia*, Italy, c. 1525.
Majolica, diameter: 25.4 cm.
Musée des Arts décoratifs, Paris. Mannerism.

174

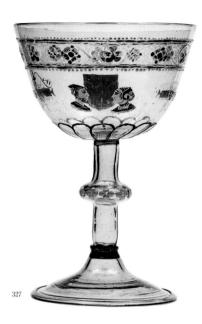

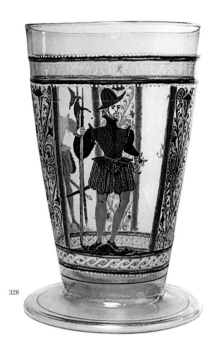

327

328

327. Anonymous.
Jug with the crest of Pierre Tallon, 16ᵗʰ century.
Engraved, gilded, and painted glass, 21 cm.
Musée national de la Renaissance, Château d'Écouen, Écouen. Renaissance.

328. Anonymous.
Stone jug 'with halberdier', 16ᵗʰ century.
Engraved, gilded, and painted glass, 17 cm.
Musée national de la Renaissance, Château d'Écouen, Écouen. Renaissance.

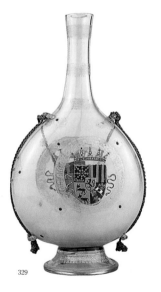

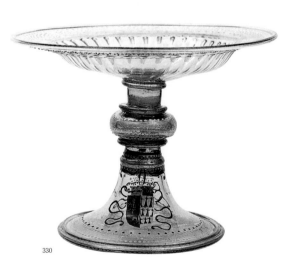

329

330

329. Anonymous.
Pitcher with the crest of Catherine de Foix, Venice, before 1517.
Handblown transparent glass, polychrome enamel, gold, 37 cm.
Musée du Louvre, Paris. Renaissance.

330. Anonymous.
Jug with the crest of Anne of Brittany, 16ᵗʰ century.
Enamelled glass, 21 cm.
Musée national de la Renaissance, Château d'Écouen, Écouen. Renaissance.

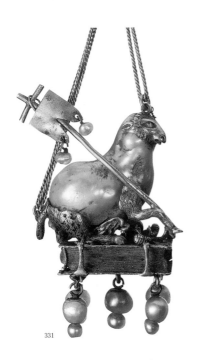

331

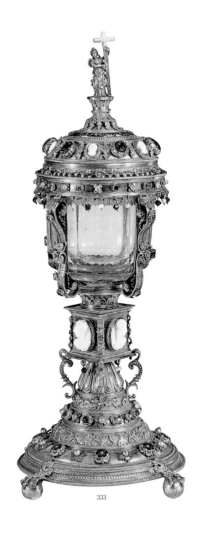

333

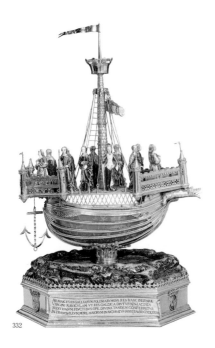

332

331. **Anonymous.**
Passover Lamb pendant, France, 16th century.
Gold, baroque pearls, 3.5 x 3 cm.
Musée des Arts décoratifs, Paris. Baroque.

332. **Anonymous.**
Ship of Anne of Brittany's heart, 1514.
Gold alloy, repoussé, guilloché, and enamelled, 15.6 x 13.1 x 6.4 cm.
Musée Dobrée, Nantes.

333. **Anonymous.**
Ciborium from the treasury of the Order of the Holy Spirit, Paris, c. 1530.
Quartz, gilded and enamelled silver, pearls, garnet, agate and mussel cameos, 33 cm.
Musée du Louvre, Paris. Mannerism.

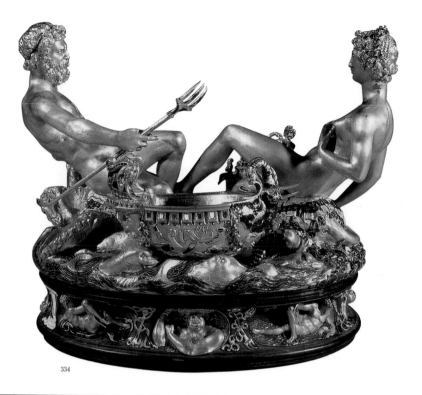

334

Benvenuto Cellini
(Florence, 1500-1571)

Italian artist, metalworker, and sculptor Benvenuto Cellini was the third child of Giovanni Cellini, a musician and artificer of musical instruments. When he reached the age of fifteen his father reluctantly consented to his being apprenticed to a goldsmith. He had already attracted notice in his native area when he was banished for six months in Siena, where he worked for a goldsmith; from there he moved to Bologna, where he progressed further in the trade. After visiting Pisa and after twice resettling for a short time in Florence, he left for Rome. He was nineteen. His first attempt at his craft there was a silver casket, followed by some silver candlesticks, and later by a vase for the bishop of Salamanca, which introduced him to the favourable notice of Pope Clement VII. In the attack upon Rome by the constable de Bourbon, which occurred immediately after, in 1527, the bravery and address of Cellini proved of particular service to the pontiff. From Florence he went to the court of the Duke of Mantua, and then again to Florence and Rome, where he was employed not only in the working of jewellery, but also in the execution of dies for private medals and for the papal mint.

Between 1540 and 1545 he worked at the court of Francis I at Fontainebleau and in Paris, where he created his famous salt cellar of gold enriched with enamel. After approximately five years of laborious and sumptuous work, the intrigues of the king's favourites led him to retire to Florence, where he employed his time in works of art, and exasperated his temper in rivalries with the uneasy natured sculptor Vaccio Bandinelli. During the war with Siena, Cellini was appointed to strengthen the defences of his native city, and, though rather shabbily treated by his ducal patrons, he continued to gain the admiration of fellow citizens by the magnificent works he produced. He died in Florence in 1571, unmarried, leaving no posterity, and was buried with great pomp in the church of Annunziata.

Besides the works in gold and silver, previously mentioned, Cellini executed several pieces of sculpture on a grander scale. The most distinguished of these is the bronze *Perseus*, a work first suggested by Duke Cosimo de' Medici. The casting of this great work gave Cellini the utmost trouble and anxiety; and its completion was hailed with rapturous homage from all parts of Italy.

334. **Benvenuto Cellini**, 1500-1571, Italian.
Francis I's salt shaker, 1540-1543.
Ebony, gold, partially enamelled, 26 x 33.5 cm.
Kunsthistorisches Museum Wien, Vienna. Mannerism.

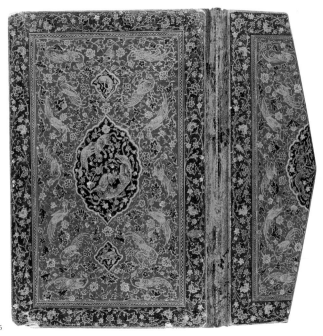

335

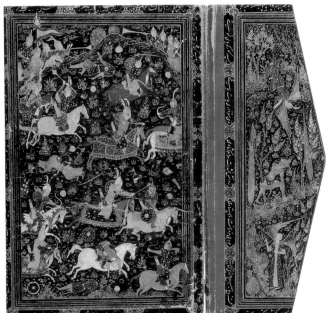

336

335. **Anonymous.**
Book cover with flaps, end of the year 1520.
Leather, lacquered, painted, and gilded papier-mâché,
19.6 x 18.8 cm (cover); 29.6 x 9.2 cm (flaps).
National Library of Russia, St Petersburg. Persian.

336. **Anonymous.**
Book cover, 16th century.
Lacquered, painted, and gilded papier-mâché and leather,
and accented gold, 41.6 x 28 cm (cover); 41.5 x 14 cm (flaps).
National Library of Russia, St Petersburg. Persian.

337. **Anonymous.**
Fabric with warriors and prisoners, Iran, 16th century.
Silk, 128 x 67 cm.
Musée des Arts décoratifs, Paris. Eastern.

338. **Anonymous.**
Tapestry with medallion, 16th century.
Silk, 248 x 199 cm.
Khalili Collection. Eastern.

339. **Anonymous.**
Velvet tunicle, 16th century.
Silk and silver, 118.5 x 33 cm.
The State Hermitage Museum, St Petersburg. Persian.

340. **Anonymous.**
Prayer mat, known as 'Bellini', 16th century.
Silk, 156 x 100 cm.
Musée des Arts décoratifs, Paris.

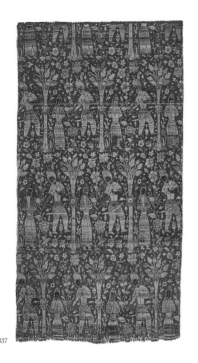

337

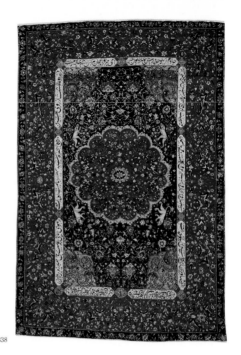

338

339

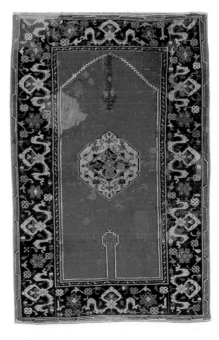

340

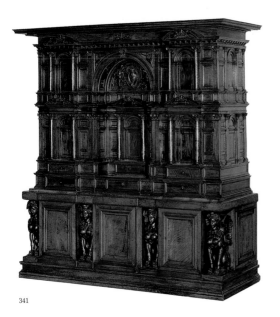

341

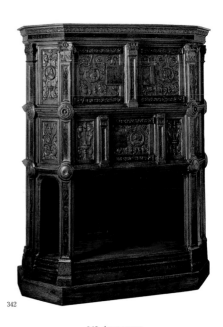

342

341. Anonymous.
Farnese cabinet, middle of the 16th century.
Walnut, 230 x 213 cm.
Musée national de la Renaissance, Château d'Écouen, Écouen. Renaissance.

342. Anonymous.
Serving cabinet from Joinville, 1524.
Oak, 144 x 129 cm.
Musée national de la Renaissance, Château d'Écouen, Écouen. Renaissance.

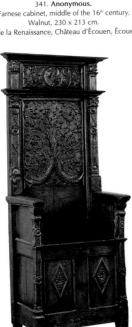

343

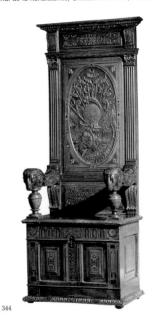

344

343. Anonymous.
Chayère (chair for royals, nobles, or ecclesiastics), first half of the 16th century.
Stained wood, height: 147 cm.
Musée national de la Renaissance, Château d'Écouen, Écouen. Renaissance.

344. Anonymous.
Chayère (chair for royals, nobles, or ecclesiastics), Île-de-France, c. 1550.
Stained walnut. Renaissance.

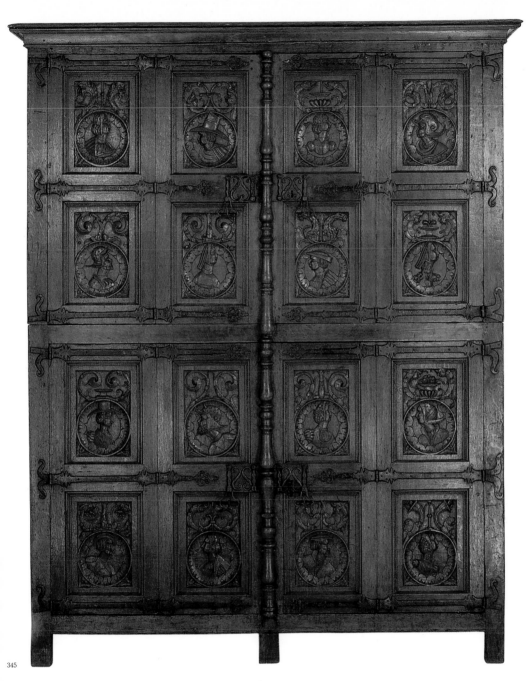

345

345. Anonymous.
Wardrobe with four doors and sixteen medallions with profiles, c. 1515-1520.
Stained oak, 232 x 176 x 70 cm.
Musée des Arts décoratifs, Paris. Renaissance.

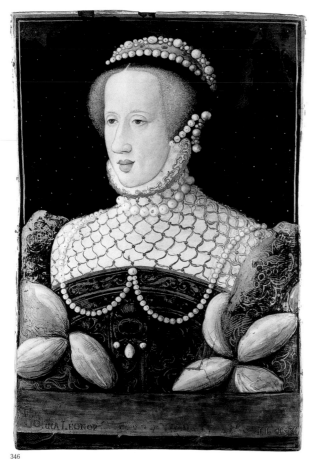

346

347

Léonard Limosin
(Limoges, c. 1505 – between January 1575 and February 1577)

Léonard Limosin was a French painter, enameller, illustrator, and engraver from the 16th century. Little is known about his life during his early period, probably he was a student of Léonard Pénicaud. In 1530, he was Painter to the King and completed several enamel pieces for churches and a number of pottery and glazed boards.

As his portraits were greatly beloved, he painted in 1544 the Queen of France, the wife of Francis I. In 1548, he was appointed servant of the king's chamber.

His enamelled pieces are sensational; Limosin devoted himself with a wide colour palette and coated his objects with purple or blue glaze. Through the certainty of his designs, the influences from the School of Fontainebleau, and his effortless execution, Leonard Limosin stands as the leading enameller of Limoges.

346. **Léonard Limosin**, c. 1505 - between January 1575 and February 1577, French.
Portrait of Eleanor of Hapsburg, 1536.
Painted enamel, 36 cm.
Musée national de la Renaissance, Château d'Écouen, Écouen. Renaissance.

347. **Léonard Limosin**, c. 1505 - between January 1575 and February 1577, French.
Peter the Apostle, c. 1535. Painted enamel, 22.8 cm.
Musée national de la Renaissance, Château d'Écouen, Écouen. Renaissance.

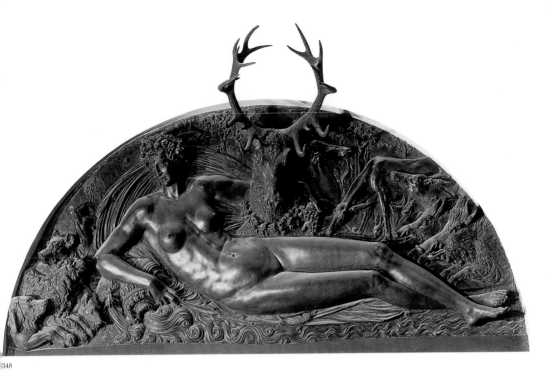

348

348. **Benvenuto Cellini**, 1500-1571, Italian.
Relief customised for the Palace of Fontainebleau gates, *The Nymph of Fontainebleau*, 1542-1543.
Bronze, 205 x 409 cm.
Musée du Louvre, Paris. Mannerism.

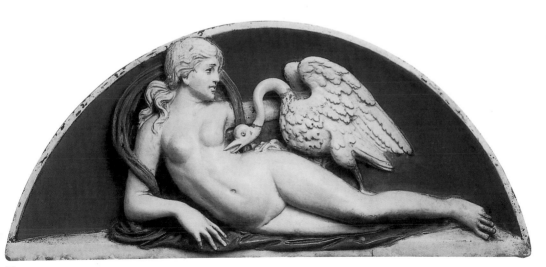

349

349. **Girolamo della Robbia**, 1488-1566, Italian.
Leda and the Swan, c. 1540.
Lacquered terracotta, 26 x 66 cm.
Liebieghaus, Frankfurt am Main. Mannerism.

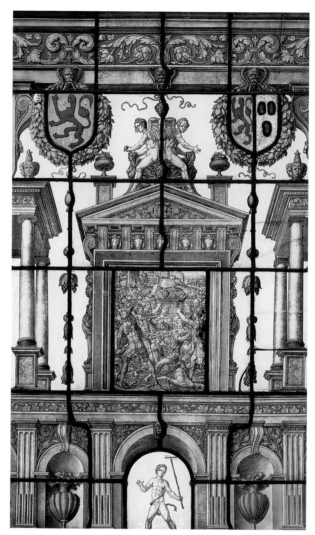

350

Dirck Crabeth
(1501-1574)

Son of a family of painters, Dirck Crabeth was a Dutch stained-glass painter, designer of tapestries and cartographer. With the establishment of his reputation, Crabeth received numerous commissions for stained glass windows. He executed one of his most important projects from 1555-1571. Completing eight windows for the grand St John Church in Gouda (Netherlands), it now belongs to the UNESCO heritage list. One of the first stained glass windows portrays the baptism of Jesus by John the Baptist, installed in 1555.
A number of original drawings by Crabeth for church windows are still conserved.

350. **Dirck Crabeth** and **Workshop**, 1501-1574, Dutch.
Stained glass window depicting *The Taking of the Ark*, 1543.
Grisaille, yellow silver, glass, and lead, 109.5 x 64.8 cm.
Musée des Arts décoratifs, Paris.

351

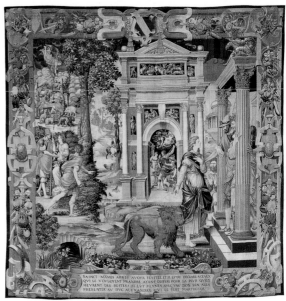

352

351. Anonymous.
The Worship of the Golden Calf (detail), middle of the 16th century.
Threads of silk and silver, 34 x 51 cm.
Musée national de la Renaissance, Château d'Écouen, Écouen. Renaissance.

352. After Jean Cousin the Elder, c. 1490/1500 - after 1560, French.
Tapestry with the *Story of St Mammes*: *St Mammes Giving Himself up to the Court of the Governor of Cappadocia*, 1544. Tapestry, wool, and silk, 440 x 450 cm.
Musée du Louvre, Paris.

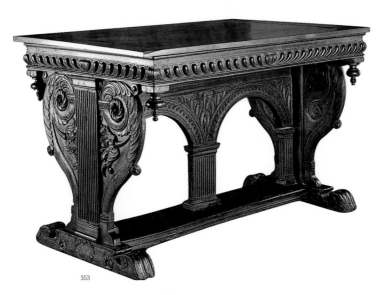

353

353. Anonymous.
'Fan' table, second half of the 16th century.
Stained wood, 82 cm.
Musée national de la Renaissance, Château d'Écouen, Écouen. Renaissance.

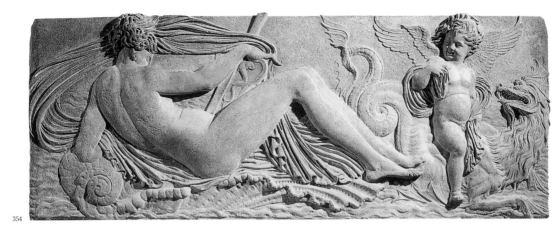

354

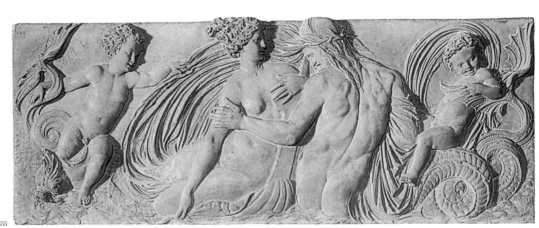

355

JEAN GOUJON
(Normandy c. 1510 – Bologna c. 1566)

The first mention of his name occurs in the accounts of the Church of Saint-Maclou in Rouen in the year 1540. On leaving Rouen, Goujon was employed by Pierre Lescot, the celebrated architect of the Louvre, on the restorations of Saint-Germain l'Auxerrois. In 1547, appeared Martin's French translation of Vitruvius, the illustrations of which were due, the translator tells us in his dedication to the king, to Goujon.

We learn from this statement not only that Goujon had been taken into the royal service on the accession of Henry II, but also that he had been previously employed under Bullant on the Château d'Ecouen. Between 1547 and 1549 he was employed in the decoration of the Loggia ordered from Lescot for the entry of Henry II into Paris, which took place on 16 June 1549. In the late 18th century, Bernard Poyet reconstructed Lescot's edifice into the Fontaine des Innocents, a considerable variation from the original design. At the Louvre, Goujon, under the direction of Lescot, executed the carvings of the southwest angle of the court, the reliefs of the Escalier Henry II, and the Tribune des Caryatides. Associated with Philibert Delorme in the service of Diana of Poitiers, Goujon worked on the embellishment of the Château d'Anet, which rose between 1548 and 1554.

Unfortunately, the building accounts for Anet disappeared. Goujon executed a vast number of other works of equal importance destroyed or lost in the great Revolution. In 1555, his name appears again in the Louvre accounts, and continues to do so every succeeding year up to 1562, when all trace of him is lost. In the course of that year an attempt was made to release from royal employment all those suspected of Huguenot tendencies. Goujon has always been claimed a Reformer; consequently, it is possible he fell victim to this attack.

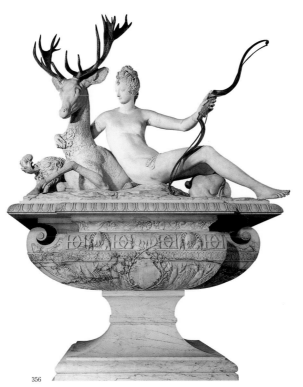

356

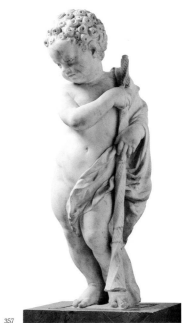

354. Jean Goujon, c. 1510-1566, French.
Relief, *Nymphs*, 1549.
Stone, 74 x 195 cm.
Musée du Louvre, Paris. Mannerism.

355. Jean Goujon, c. 1510-1566, French.
Nymph and Triton, 1549.
Stone, 73 x 195 x 12 cm.
Musée du Louvre, Paris. Mannerism.

356. Anonymous.
Fountain of Diana, middle of the 16th century.
Marble, 211 x 258 x 134 cm.
Musée du Louvre, Paris. Mannerism.

357. Germain Pilon, c. 1529-1590, French.
Funerary spirit, 1558.
Marble, 85 cm.
Musée national de la Renaissance, Château d'Écouen, Écouen.
Mannerism.

357

358

359

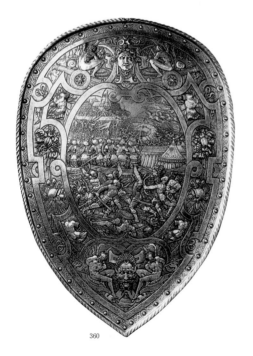

360

358. **Anonymous.**
Plaque of the harness of a horse of Henry II (detail), *The Death of Cleopatra*, c. 155
After a drawing by Étienne Delaune.
Iron, 40 cm.
Musée national de la Renaissance, Château d'Écouen, Écouen. Mannerism.

359. **Anonymous.**
Armour belonging to Henry II (detail), c. 1559.
Polished and chiselled iron.
Musée du Louvre, Paris. Mannerism.

360. **Anonymous.**
Shield belonging to Henry II, c. 1555.
Iron, partially coated with gold and silver.
Musée du Louvre, Paris. Mannerism.

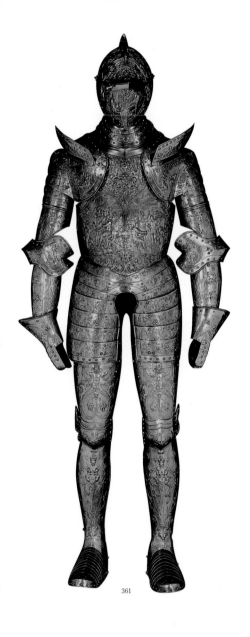

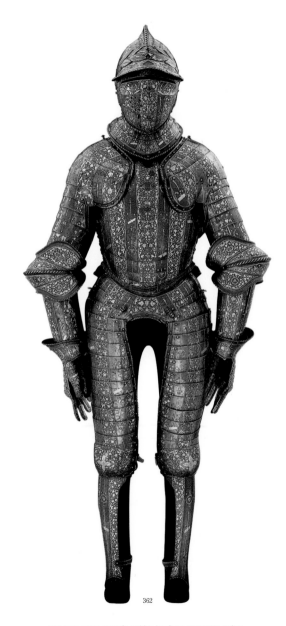

361. Anonymous.
Armour belonging to Henry II, c. 1559.
Polished and chiselled iron.
Musée du Louvre, Paris. Mannerism.

362. **Francesco Negroli and his brothers**, 1510-1579, Italian.
Armour of Henry's heir apparent, later Henry II, c. 1536-1547.
Iron coated with silver, 181 x 67 cm; weight: 19.7 kg.
Musée de l'Armée, Paris. Mannerism.

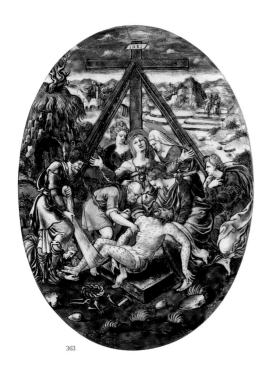

363

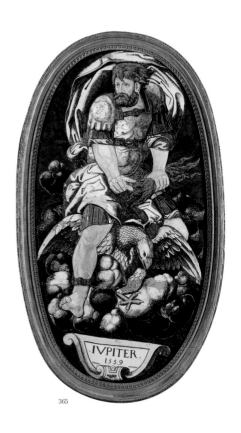

365

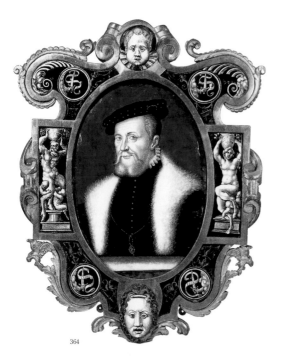

364

363. **Léonard Limosin**, c. 1505 - between January 1575 and February 1577, French.
The Descent from the Cross, 1557.
Painted enamel, 33.5 cm.
Musée national de la Renaissance, Château d'Écouen, Écouen. Mannerism.

364. **Léonard Limosin**, c. 1505 - between January 1575 and February 1577, French.
Portrait of the High Constable of Montmorency, Limoges, 1556.
Painted enamel on copper, giltwood mount, 75 x 54 cm.
Musée du Louvre, Paris. Mannerism.

365. **Pierre Courteys**, 1520-1591/1602, French.
Jupiter, 1559.
Painted enamel, 16.5 cm.
Musée national de la Renaissance, Château d'Écouen, Écouen. Mannerism.

367

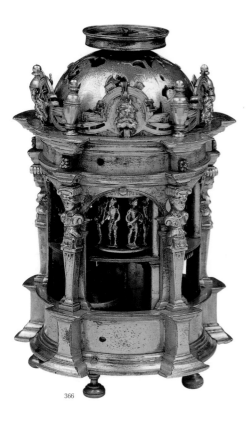

366

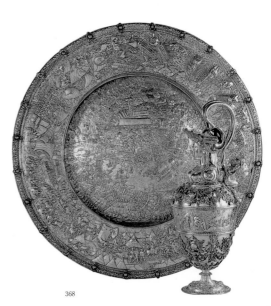

368

366. Anonymous.
Table clock, Blois, c. 1560.
Silver, gilded brass, iron from Abbeville, 12 x 8 cm.
Musée national de la Renaissance, Château d'Écouen, Écouen.

367. Anonymous.
Bottle with the crest of Catherine de' Medici, c. 1560.
Opaque glass, gilded and painted, 19.5 cm.
Musée national de la Renaissance, Château d'Écouen, Écouen. Mannerism.

368. Anonymous.
Ewer and basin, said to have belonged to Charles V, Antwerp, 1558-1559.
Basin: *Conquest of Tunis in 1835.*
Ewer: *The Embarkment of the Troops of Charles V after Battle.*
Gilded silver and partially enamelled.
Musée du Louvre, Paris.

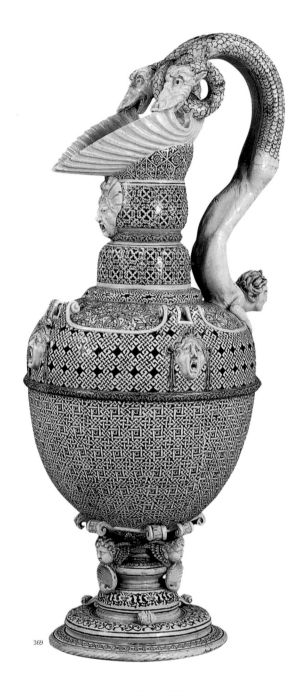

369. **Saint-Porchaire's Workshop**, French.
Ewer with the letter G, c. 1550.
Ceramic from Saint-Porchaire, height: 37.2 cm.
Musée du Louvre, Paris. Mannerism.

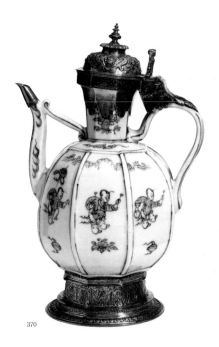

370

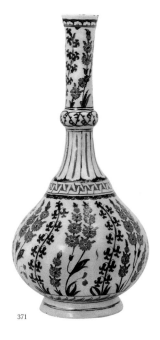

371

370. Anonymous.
Wine jug from the reign of Elizabeth I, 1560-1585.
White and blue porcelain, silver-plated mount, height: 25.6 cm.
Victoria and Albert Museum, London. Chinese.

371. Anonymous.
Bottle with plum blossoms, c. 1560.
Ceramic.
Khalili Collection. Eastern.

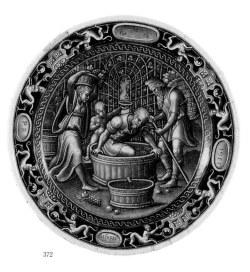

372

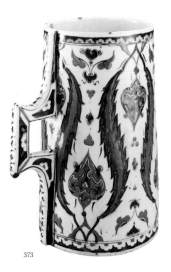

373

372. Pierre Reymond, 1513-1584, French.
Plate with *Month of September, the Harvest*, Limoges, 1561.
Painted enamel on copper, grisaille, diameter: 18 cm.
Musée des Arts décoratifs, Paris. Mannerism.

373. Anonymous.
Beer jug decorated with carnations and leaves, last quarter of the 16th century.
Ceramic, 26 x 14.5 cm.
Musée national de la Renaissance, Château d'Écouen, Écouen. Eastern.

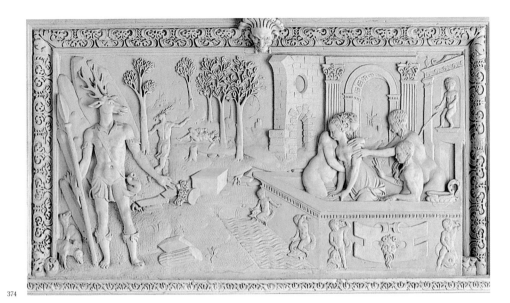

374

374. **Anonymous.**
Mantle piece detail, *Diana and Actaeon*, 1562.
Stone.
Musée national de la Renaissance, Château d'Écouen, Écouen.

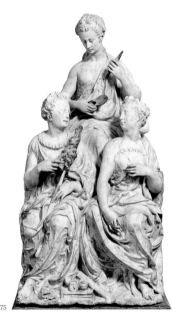

375

AlessandRo VittoRiA
(TReNto, 1525 – VeNice, 1608)

Alessandro Vittoria was a sculptor, engraver, medallist, and architect. Born in Trento, he worked from 1543 to 1547 in Sansovino's Workshop in Venice. After a few trips to Vicenza, Padua, and Brescia, he finally relocated to Venice, where began his artistic career.

His style, expressive, dramatic, and elegant, secured him a place amongst the European mannerist sculptors. He was influenced by Sansovino and realised a magnificent work in Venice, including the caryatides at the Piazza di San Marco, Scalad'Oro at Doge's Palace, and many monumental altars, bronzes, and busts.

Vittoria worked with Palladio on the Villa Pisani and with Veronese.

He died in 1608 in Venice.

375. **Germain Pilon**, c. 1529-1590, French.
The Fates, 1586.
Marble, 162 cm.
Musée national de la Renaissance, Château d'Écouen, Écouen. Mannerism.

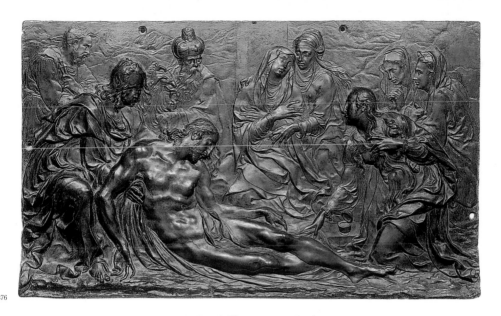

376. **Germain Pilon**, c. 1529-1590, French.
The Lamentation of Christ, 1580-1585.
Probably adorned the altar at the Church of Sainte-Catherine-du-Val-des-Écoliers, in Paris.
Bronze, 47 x 82 cm. Musée du Louvre, Paris. Mannerism.

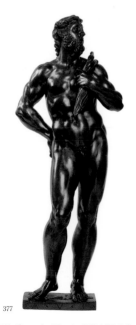

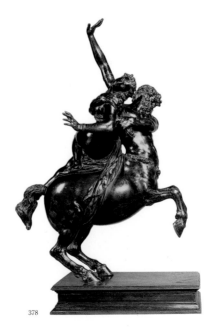

377. **Alessandro Vittoria**, 1525-1608, Italian.
Jupiter, c. 1560.
Bronze, 72 cm.
Musée national de la Renaissance, Château d'Écouen, Écouen. Mannerism.

378. **Jean Boulogne**, 1529-1608, Flemish.
Nessus and Deianeira, Florence, c. 1580.
Bronze with red-brown patina, height: 42.1 cm.
Musée du Louvre, Paris. Mannerism.

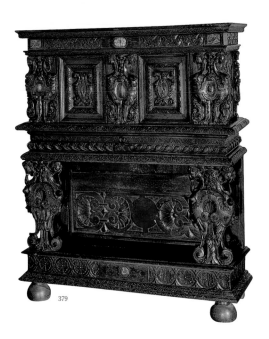

379

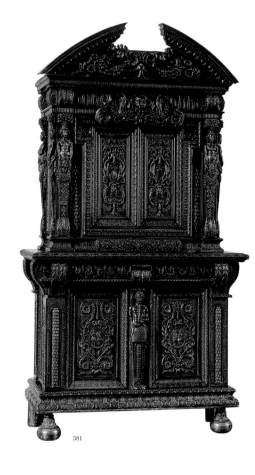

381

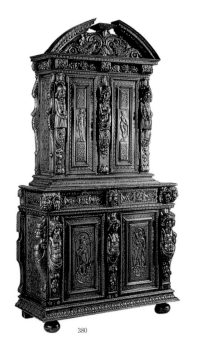

380

379. **Anonymous.**
Dresser with harpies, 1570.
Walnut, 147 x 130 cm.
Musée national de la Renaissance, Château d'Écouen, Écouen. High Renaissance.

380. **Anonymous.**
Two-piece sideboard, end of the 16ᵗʰ century.
Light walnut. High Renaissance.

381. **Anonymous.**
Wardrobe, said to be from Clairvaux, c. 1570.
Walnut, 246 x 136 cm.
Musée national de la Renaissance, Château d'Écouen, Écouen. High Renaissance.

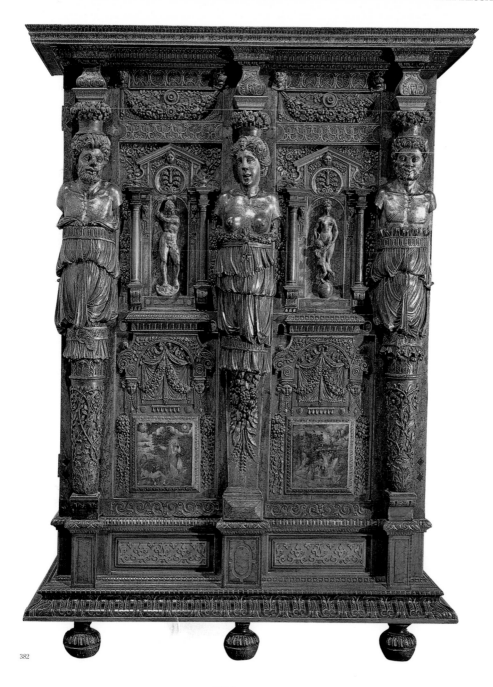

382

382. Anonymous.
Wardrobe, said to be by Hughes Sambin, c. 1580.
Walnut and oak, partially gilded and painted, 206 x 150 cm.
Musée du Louvre, Paris. High Renaissance.

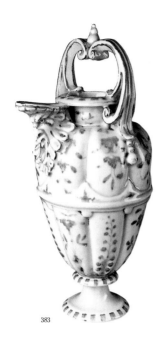

383

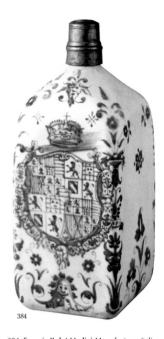

384

383. Anonymous.
Fluted ewer, Florence, end of the last quarter of the 16th century.
Medici porcelain, height: 26 cm.
Musée du Louvre, Paris. Mannerism.

384. Francis II de' Medici Manufactory, Italian.
Wine bottle, 1581.
Fine Medici porcelain, decoration in blue cameo, 27.7 x 11.3 cm.
Musée national de la Céramique, Sèvres.

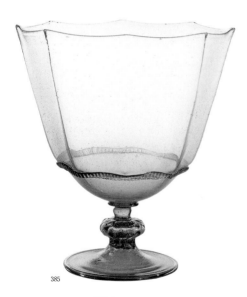

385

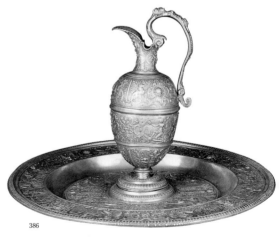

386

385. Anonymous.
Glass chalice, probably from France, end of the 16th century.
Handblown glass shaped whilst hot, height: 16.4; diameter: 15.3 cm.
Musée des Arts décoratifs, Paris. High Renaissance.

386. François Briot, c. 1550 - after 1616, French.
Basin and ewer, c. 1585.
Molten tin, diameter: 45 cm (basin), 28 x 13.5 cm (ewer).
Musée national de la Renaissance, Château d'Écouen, Écouen. Mannerism.

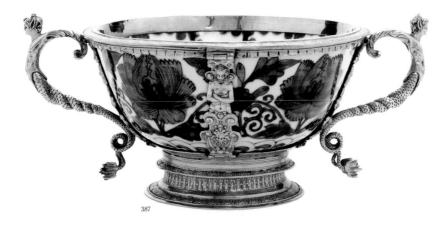

387. **Anonymous.**
White and blue drinking bowl, 1599-1600.
Porcelain, height: 13.9 cm; diameter: 23.6 cm.
Victoria and Albert Museum, London. Chinese.

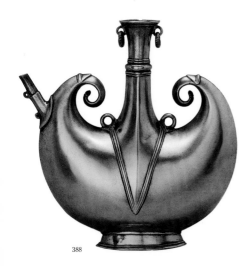

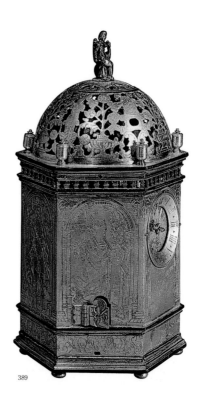

388. **Anonymous.**
A pilgrim's water pitcher, Deccan Plateau (India), 15th century.
Bronze, height: 30.5 cm.
Khalili Collection. Eastern.

389. **Anonymous.**
Table clock, end of the 16th century.
Silver, gilded brass, iron, 15 x 10 cm.
Musée national de la Renaissance, Château d'Écouen, Écouen. Mannerism.

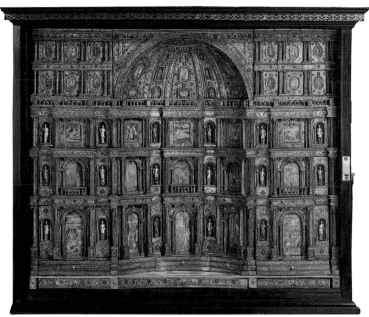

390

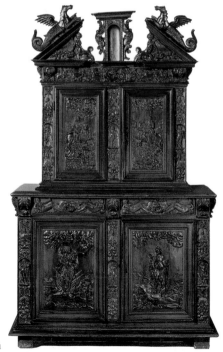

391

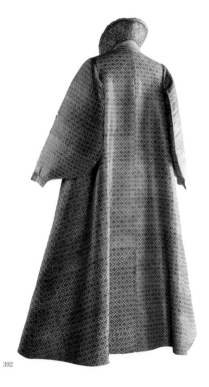

392

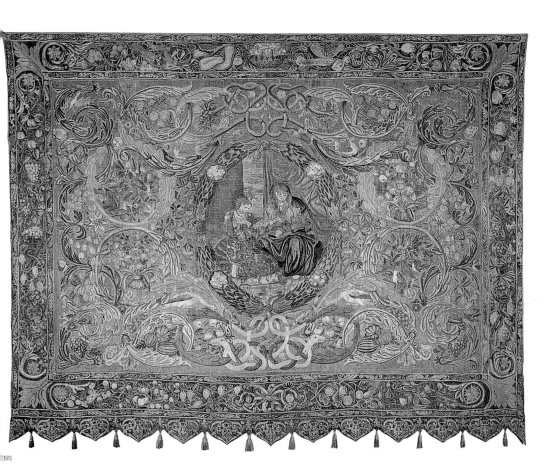

393

390. **Anonymous.**
Venetian cabinet, c. 1600.
Wood with ivory and mother-of-pearl, painted, 96 x 107 cm.
Musée national de la Renaissance, Château d'Écouen, Écouen. High Renaissance.

391. **Anonymous.**
Cabinet 'with riders', 1615-1620.
Stained wood, 264 x 142 cm.
Musée national de la Renaissance, Château d'Écouen, Écouen. High Renaissance.

392. **Anonymous.**
Dressing gown, c. 1600.
Silk, 129 cm.
Musée national de la Renaissance, Château d'Écouen, Écouen. High Renaissance.

393. **Anonymous.**
Mystical Marriage of St Catherine, c. 1610.
Framework of cloth, threads of silk and gold, 400 x 495 cm.
Musée national de la Renaissance, Château d'Écouen, Écouen. High Renaissance.

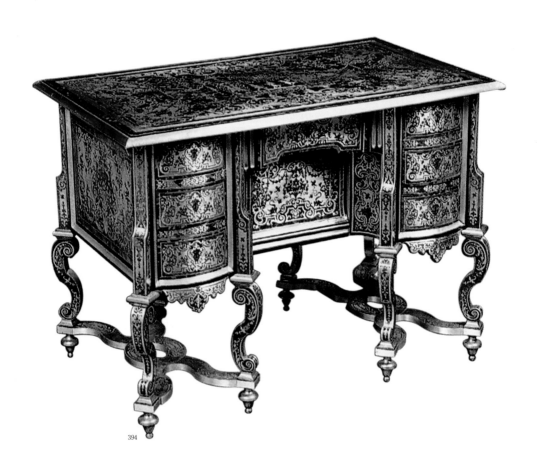

394. **Anonymous.**
Mazarin desk with seven drawers, 17th century.
Boulle-style marquetry, background in red-tinted tortoiseshell, inlay.
Châteaux de Umailles et de Trianon, Umailles. Baroque.

BAROQUE

Of all sovereigns, Louis XIV is certainly the monarch who best knew how to surround the royal majesty with the most dazzling splendour. He required sumptuous buildings for his habitation, and if Versailles as a palace realised his dreams, he still required that the furniture destined to fill those galleries with glittering mirrors, gildings, paintings, and sculptures, should be worthy of such companionship and should exhibit a magnificence unknown until that day. Logical in his conceptions, the king understood that he must entrust the manufacture of the carpets, furniture, and silverware to real artists. In order to gather the most talented, he initially granted apartments in the Louvre to each of those who had distinguished themselves by works of uncommon merit.

This magnificence is also due to superbly-framed tapestries, to shimmering brocades, in which the cities of Lyon, Tours, and Venice excelled, to immense paintings by Le Brun and Van der Meulen.

On the other hand, wallpaper imitating leather and silk appeared and its unexpected cost-saving seemed appreciated. This period coincided unexpectedly with the end of rich stained glass windows, because transparent glass windows began to resemble our own modern variety. Indeed, the heavy and exuberant ceramic works of Bernard Palissy are spurned in favour of Chinese porcelain, earthenware from Rouen and Nevres, and this movement towards simplicity, both in shape and decor, was in conjunction with the contractions above.

Now we will delve more deeply into its recognisable traits. Boulle furniture: cased clocks, cupboards, drop-front tables, desks, corner cabinets, commodes, mirrors, etc., in ebony and black shell marquetry encrusted with engraved brass arabesques, decorated with chiselled bronzes. Decor: suns, flowerets, foliage, cartouches, scrolls, shells, and caps

placed in the axis, fleurs-de-lis alternating with the royal cipher, etc. Beds without posts with velvet and feather curtains with heavy canopies. Canopies, boxes in trimmed silk and tablecloths. Ceilings, panelled with mouldings and white and gold ornaments. Decorated with complex pelmets of unequalled wealth and strength.

The silverwork tends to assault the modesty of the wood. Furthermore, the idea of bulbous furniture, with wonderful commodes with practical drawers, first appeared under the Sun King, as did the idea of large desks replacing earlier counters and tables. Moreover, we should not forget that the art of cabinetmaking reached its peak at this time with its learned veneers, and the little pieces of furniture that would abound later, such as corner cupboards, shelves, consoles, which are nothing more than pieces derived from earlier commodes and desks. Indeed, the balconies and gates speak of the triumph of ironwork in general, and the way these pieces are covered in chiselled appliqués and giving them marble tablets dates from Louis XIV. Cabinet making would become clearer and the next period would play with the elements of form it had just recovered.

If, finally, under Louis XIV and Louis XV, the art of jewellery-making reaches its peak, under the Sun King, jewellery was as solemn and as noble in its splendour as it was fanciful and graceful under Louis XV.

True Louis XV style, according to the experts, is marked by a revival of the classical spirit and a rejection of the convoluted Régence style. J.F. Oëben, Madame de Pompadour's cabinetmaker, refocused on cabinets, reacting against the oppressive profusion of bas-reliefs and bronze ornaments in the tradition of C.A. Boulle. Another master cabinetmaker was Riesener. Riesener accents the rigid transformation of the Louis XV style. Gold working remained under the spell of the unique, contorted shapes expressed in

Meissonnier, Oppenord, and Prieur's designs until François Germain, Auber, Fayolle, etc. returned to Greek simplicity.

Louis XV jewellery invokes the same spirit of simplicity and sobriety of details that pervades the entire style, although pieces were somewhat heavy and formal.

In the realm of tapestry, the Gobelins' activity never slowed down after the Great King's passing, although the solemnity of their projects diminished during the century of grace and lightness.

Although frames had expanded and acquired ornamental extravagances, the subjects of the paintings they held were 'amusing' and of small dimensions. Examples would be Charles-Antoine Coypel's depiction of Vie de Don Quichotte, Claude Audran's paintings of the seasons and the elements, and Boucher's images of the gods' great loves.

As is always the case, the jewellery created in the 18th century reflected the tastes of the times. The precious, undulating, contorted Rocaille genre of jewellery falls into the same system of ornamentation governing friezes and tympana, ceilings and panels, that goes all the way down to miniatures set in meticulously-gilded frames. The same pastoral and romantic scenes decorated medallions, buckles, and broaches often enhanced by a variety of gems or pearls. Likewise, eccentrically-shaped rings made from precious metals reflected the capricious ideal and grace of the period.

This was the age of Riesener's furniture and its precious marquetry enhanced by Gouthière's exquisite carvings, the age of large-scale nudity, of faded, subdued decorations with supple fabrics made in Lyon, and of white paint accented by a narrow sliver of gold. And it was still the age of fine fluting, garlands, ribbons, and hunting and fishing motifs and trophies.

Metalwork was inspired by goldsmith masters such as Gouthière and Germain. The latter was responsible for many of the most remarkable masterpieces of the 18th

century, while the former was more closely associated with gilded bronze work. At the time, coloured crystal was mixed with metal for a clear, transparent reflection like that of silver to create a bright ensemble and to liven up the simple shapes that followed the previous, more torturous ones. Blue crystal was preferred. Silver and its lovely motifs were used for salt shakers, teapots, and centrepieces supported by trays with discreet feet and decorated with acanthus leaves and bacchante heads among the usual garlands. The fever for metalwork produced a slew of small objects and cases: candy dishes, flasks, snuffboxes, etc. And of course, there was that familiar Louis XVI knick-knack, the fan. Decorative fans were made from perfumed wood and ivory and trimmed with gold. They depicted the romantic subjects of the era: pastoral scenes and Chinese images, and they were embedded with beautiful ornaments. The snuffboxes and candy dishes cannot be overlooked with their cameos (a very fashionable piece of jewellery following the discovery of Pompeii), their enamels, their mosaic and their rare miniatures.

During Louis XVI's reign and through the early years of the French Revolution was the most impressive artistic period for the Sèvres factory in terms of both form and decoration. Chemistry had miraculously created regal blues, turquoises, violets, daffodil yellows, and corals to be used in decorating cups, glasses large and small, vases, and any other piece of tableware, much to the delight of enthusiasts. The Pajous, Falconets, and Clodions created exquisitely-slight, unglazed porcelain sculptures for Sèvres that nicely complemented the enormity of the large table pieces. The Louis XVI vase by Sèvres is generally Classical, with a handle formed by scrolls or laurel leaves and other foliage.

The era we have just outlined ended in revolution, but only after taking advantage of a necessary and engaging evolution in good taste, subtlety, and distinction to create a welcome diversity of styles.

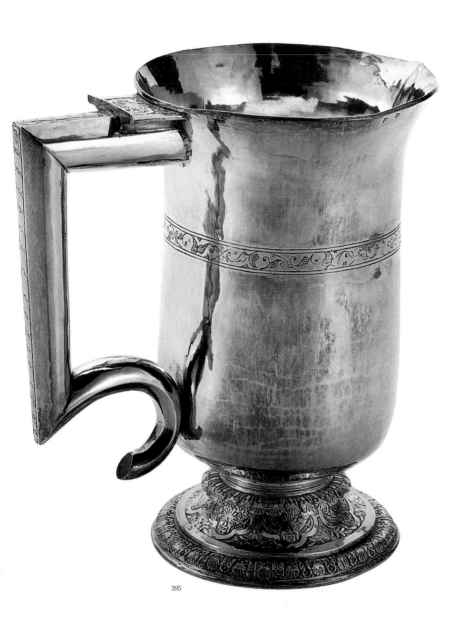

395

395. Anonymous.
Pitcher, Paris, 1603-1604.
Silver, 18 x 18.2 cm.
Musée des Arts décoratifs, Paris. Mannerism.

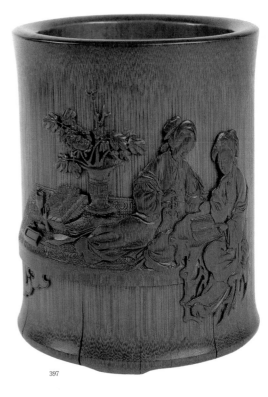

397

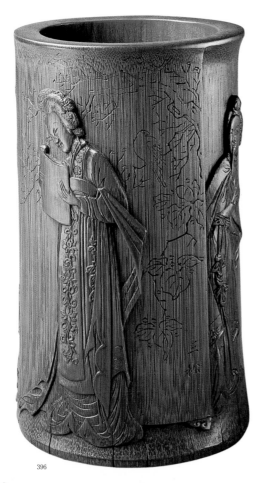

396

396. **Anonymous.**
Pencil holder, 17th century.
Bamboo, height: 13.5 cm.
National Palace Museum, Taipei. Chinese.

397. **Anonymous.**
Pencil holder, 17th century.
Bamboo, height: 15.4 cm.
Shanghai Museum, Shanghai. Chinese.

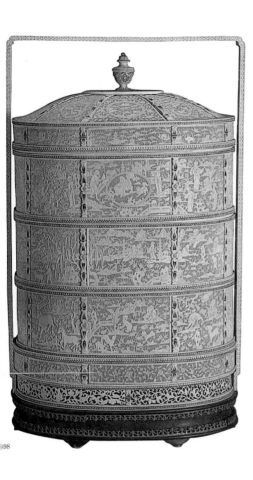

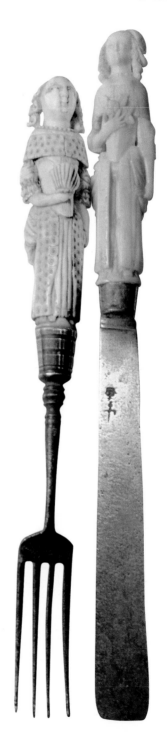

398. **Anonymous.**
Jug, 17th-19th century.
Ivory, height: 45.4 cm.
National Palace Museum, Taipei. Chinese.

399. **Anonymous.**
Knife and fork, 17th century.
Figures made of ivory.
Sexmuseum Amsterdam, Amsterdam.

399

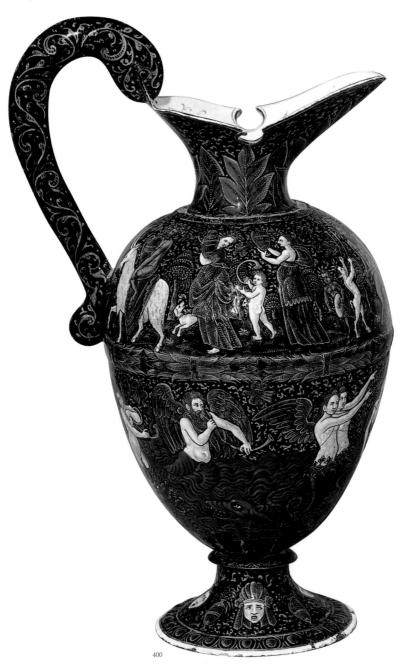

400

400. **Jean I** or **Jean II Limosin**, active beginning of the 17ᵗʰ century, French.
Water pitcher: *Triumphal Procession of Bacchus, Amphitrite,
and Poseidon,* c. 1600-1620. Painted enamel, polychrome, height: 27.8 cm.
Musée national de la Renaissance, Château d'Écouen, Écouen. Mannerism.

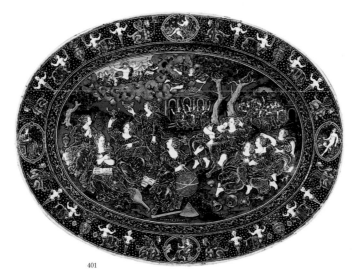

401. **Suzanne de Court**, 1575-1625, French.
Plate with *The Clever Virgins and the Foolish Virgins*, beginning of the 17th century.
Painted enamel on copper, 38.5 x 49.5 cm.
Musée du Louvre, Paris. Mannerism.

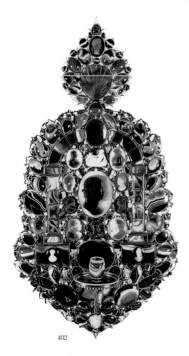

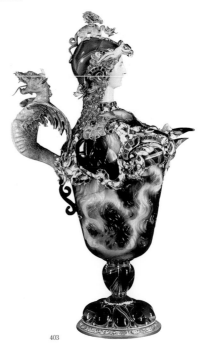

402. **Anonymous.**
Wall light of Maria de' Medici, c. 1630.
Gilded silver, cameos, carnelian, 45 cm.
Musée du Louvre, Paris. Mannerism.

403. **Pierre Delabarre** (mount), recognised master in 1625, French.
Water pitcher, c. 1630 (mount).
Carnelian, enamelled gold, 28 cm.
Musée du Louvre, Paris. Mannerism.

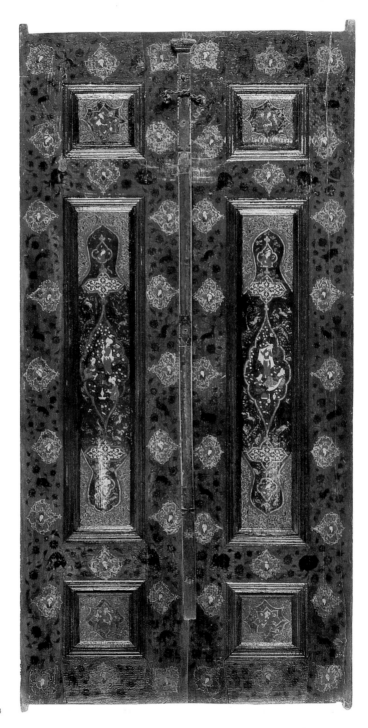

404

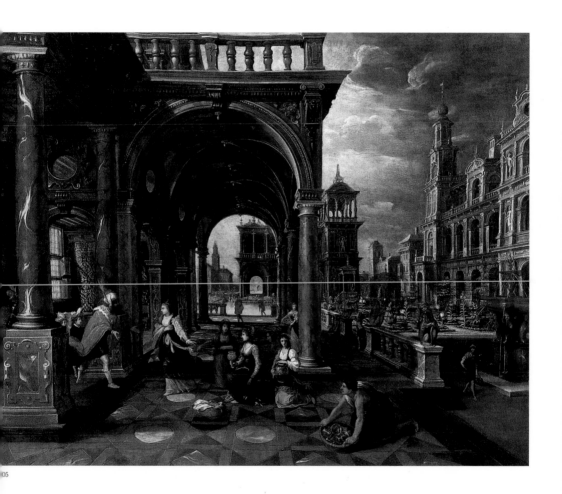

05

404. **Anonymous.**
Ornate door, 17th century.
Carved wood, 191 x 48 cm.
Musée des Arts décoratifs, Paris. Eastern.

405. **Paul Vredeman De Vries** and **Adriaen van Nieulandt**,
1567 - after 1630 and 1587-1658, Flemish.
Solomon and the Queen of Sheba, c. 1610.
Oil on canvas, 158 x 198 cm. Musée des Arts décoratifs, Paris. Mannerism.

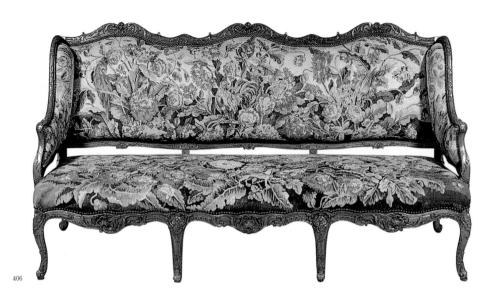

406

406. Anonymous.
Ear sofa, beginning of the 17ᵗʰ century.
Natural wood with leaf and shell carvings. Baroque.

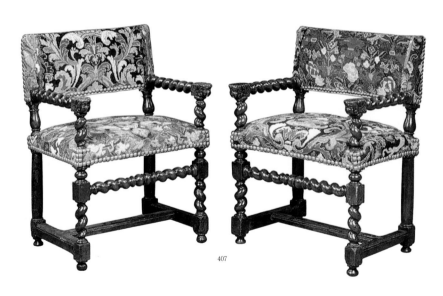

407

407. Anonymous.
Chairs with arms, beginning of the 17ᵗʰ century.
Wood and fabric cover.

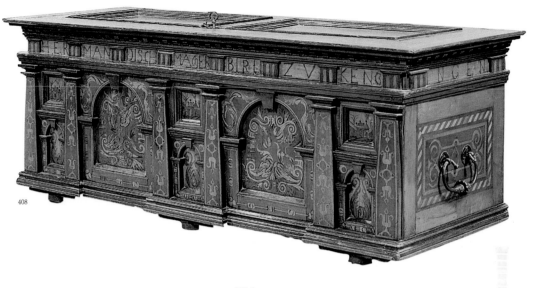

408. **Anonymous.**
Alsatian chest, 17th century.
Walnut, intarsia decoration.

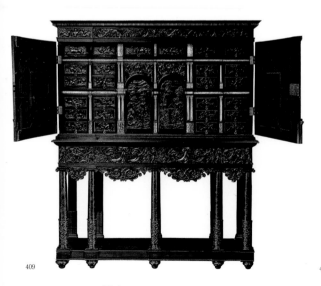

409. **Anonymous.**
Cabinet, Paris, c. 1645.
Ebony on oak frame and poplar veneer, blackened fruitwood base, 184 x 158.5 cm.
Musée du Louvre, Paris.

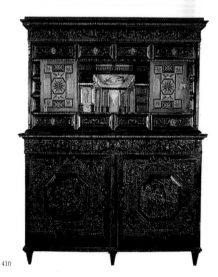

410. **Anonymous.**
Cabinet of ebony, first half of the 17th century.
Ebony.
Musée Saint-Loup, Troyes.

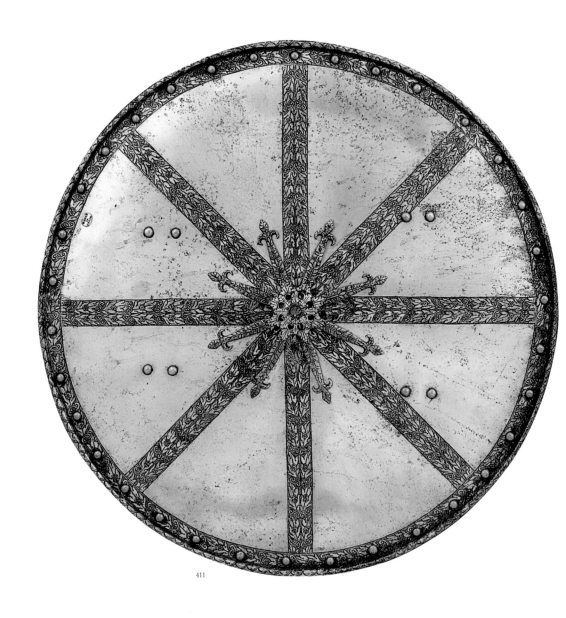

411

411. Anonymous.
Round shield for young Louis XIII, c. 1610.
Molten, engraved, and gilded iron, velvet, weight: 2.1 kg.
Musée de l'Armée, Paris. Baroque.

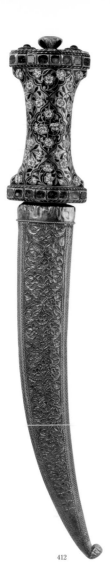

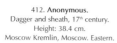

412

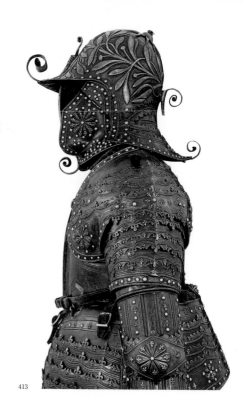

413

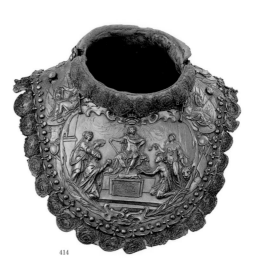

414

412. **Anonymous.**
Dagger and sheath, 17th century.
Height: 38.4 cm.
Moscow Kremlin, Moscow. Eastern.

413. **Anonymous.**
King Louis XIII's armour, c. 1620-1630.
Blackened iron, gilded copper, linen, leather, 140 x 74 cm, weight: 26.8 kg.
Musée de l'Armée, Paris. Baroque.

414. **Anonymous.**
Louis XIII's colletin, c. 1630.
Molten, repoussé, chiselled, and burnished silver, velvet,
satin trimmed with gold, 18 x 35 x 12 cm, weight: 1.3 kg.
Musée de l'Armée, Paris. Baroque.

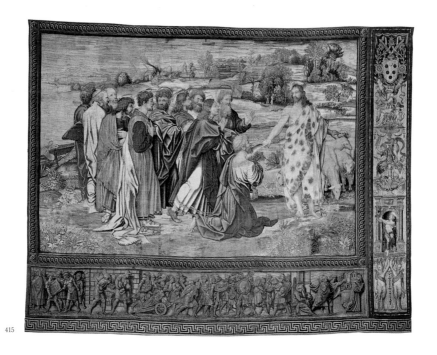

415. **Mortlake Manufactory**, 1619 - end of the 17th century, English.
Tapestry with the cycle of *The Four Horsemen of the Apocalypse:*
Christ's Charge to Peter (after Raphael), c. 1640.
Wool, silk and metal threads, 410 x 610 cm.
Mobilier national, Paris. Classisism.

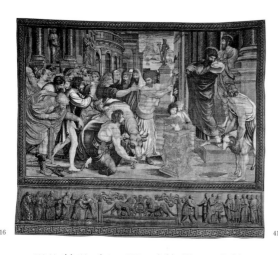

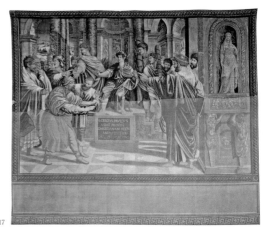

416. **Mortlake Manufactory**, 1619 - end of the 17th century, English.
Tapestry with the cycle of *The Four Horsemen of the Apocalypse:*
The Sacrifice at Lystra, c. 1640.
Wool, silk and metal threads, 420 x 650 cm. Mobilier national, Paris. Classisism.

417. **Mortlake Manufactory**, 1619 - end of the 17th century, English.
Tapestry with the cycle of *The Four Horsemen of the Apocalypse:*
The Conversion of the Proconsul or *The Blinding of Elymas*, c. 1640.
Wool, silk and metal threads, 405 x 645 cm. Mobilier national, Paris. Classisism.

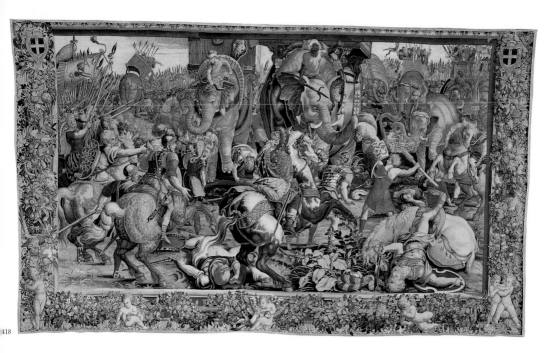

418. **After Jules Romain**, 1499-1546, Italian.
The Battle of Zama, tenth tapestry from the set of the *Hunts of Maximilian*, 17th century.
Tapestry, wool and silk, 435 x 740 cm.
Musée du Louvre, Paris. Classisism.

420. **Mortlake Manufactory**, 1619 - end of the 17th century, English.
Tapestry with the cycle of *The Four Horsemen of the Apocalypse:*
The Miraculous Draught of Fishes, c. 1640.
Wool, silk and metal threads, 493 x 440 cm. Mobilier national, Paris. Classisism.

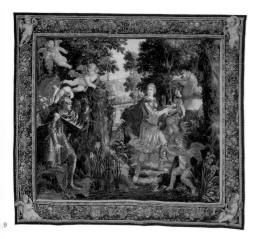

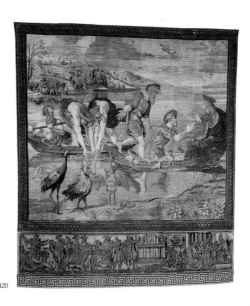

9. **Raphael de La Planche** and **Michael I von Corneille**, c. 1601-1664, French.
Tapestry with *The Story of Clorinda and Tancred:*
The Meeting of Clorinda and Tancred, c. 1645-1660.
Wool and silk, 312 x 385 cm. Musée des Arts décoratifs, Paris. Classisism.

420

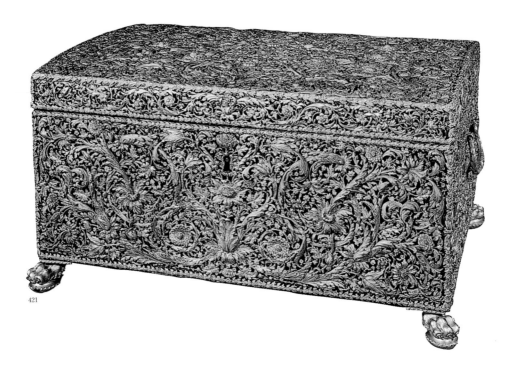

421

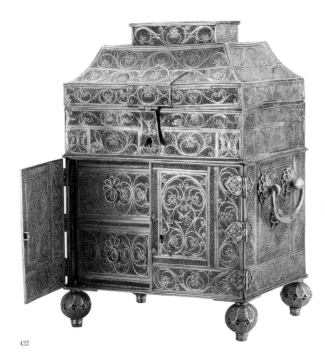

421. Anonymous.
Golden chest belonging to Anna of Austria,
middle of the 17th century.
Gold, wood covered with blue silk, 25.2 x 47.5 x 36.2 cm.
Musée du Louvre, Paris.

422. Anonymous.
Box, Goa, India, 17th century.
Silver, 57 x 40 x 32 cm.
Private collection. Eastern.

423. Anonymous.
Canopy bed from the Castle of Effiat, c. 1650.
Natural walnut, carved Genoa velvet, trim with
silk embroidery, 295 x 192 x 165 cm.
Musée du Louvre, Paris.

422

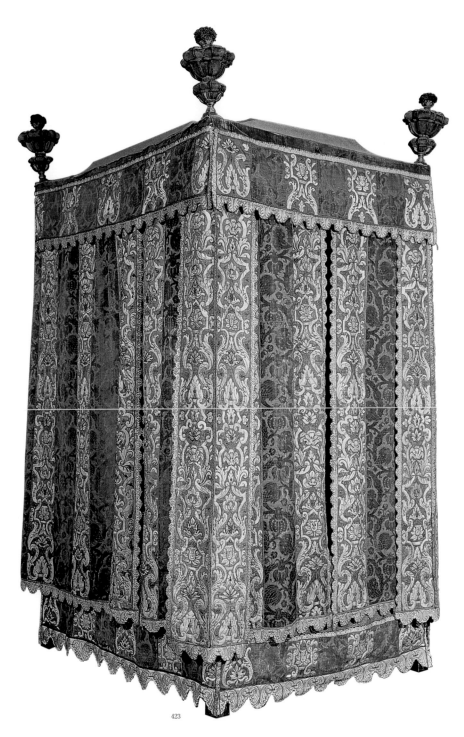

423

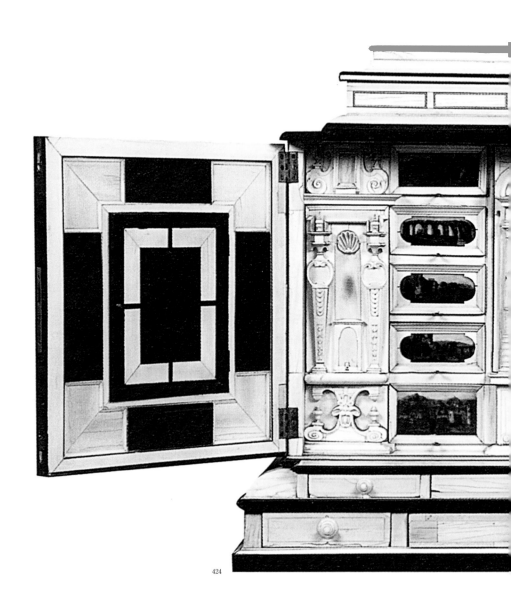

424

424. **Melchior Baumgartner** and **Hans Lencker** (attributed to), German

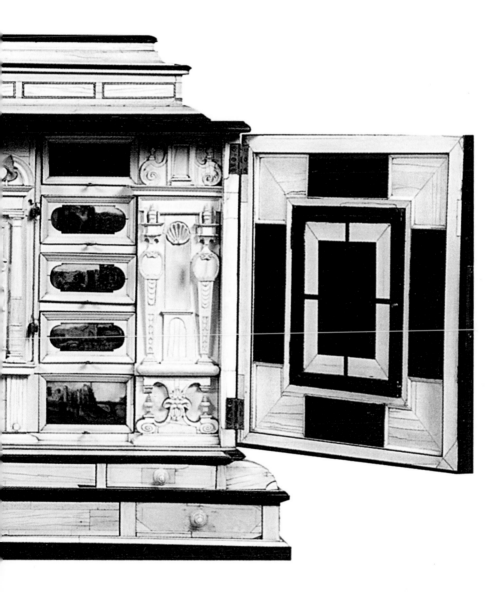

c. 1650. Ivory, silver, and gilded silver, 70 x 88 x 42 cm. Private collection.

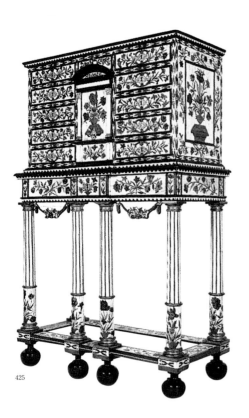

425

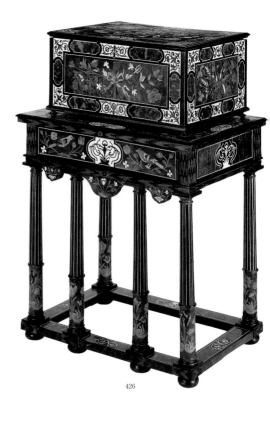

426

425. **Pierre Gole**, c. 1620-1684, Dutch.
Cabinet on stand, 1661-1665.
Veneered in ivory and tortoiseshell, ebony mouldings and brass mounts, on a pine carcase, with walnut drawers, 126 x 84 x 40 cm.
Victoria and Albert Museum, London. Louis XIV style.

426. **Pierre Gole** (attributed to), c. 1620-1684, Dutch.
Casket and cabinet, Paris, c. 1655.
Softwood, veneered in tortoiseshell, ivory, stained ivory, ebony, kingwood, walnut pear, yew, barberry, wood, casket: 23.8 x 47.7 x 34 cm; base: 63.2 x 60 x 40 cm.
Musée des Arts décoratifs, Paris. Louis XIV style.

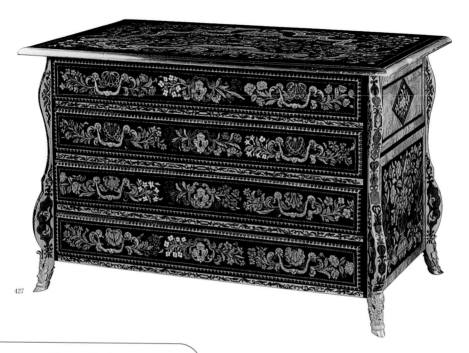

427

THOMAS HACHE
(1664 - 13 March 1747)

The Hache family is a family of cabinetmakers from
Grenoble. Thomas Hache began as journeyman in
Chambéry and learned of Italian decor. Later, he entered
the workshop of the cabinetmaker Michel Chevalier. In
1721, he received a patent for the furniture of the
Duchess of Orléans. The commission for furniture and
wood carvings increasingly grew. At the end of his life,
Thomas Hache worked in collaboration with his son
Peter and his grandson Jean-François in a workshop.
Jean-François Hache would become the most famous
cabinetmaker in the family dynasty and had acquaintance
with Jean-François Oeben, eventually inheriting the
workshop from his father.

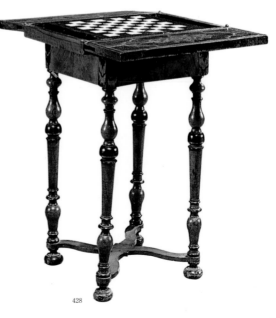

427. **Thomas Hache**, 1664-1747, French.
Commode, Grenoble, end of the 17th century.
Wood inlay, native colour.

428. **Anonymous.**
Game table from the baroque period, end of the 17th century - beginning
of the 18th century.
Fruitwood, 69.5 x 45 cm.
Private collection.

428

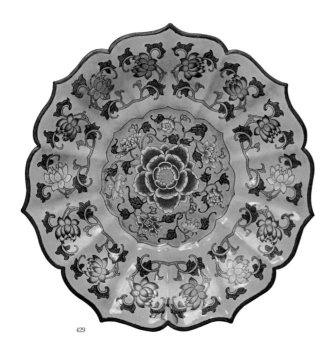

429

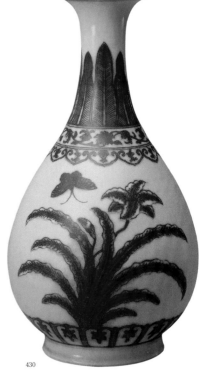

430

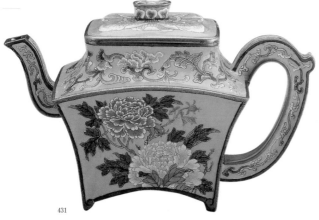

431

429. **Anonymous.**
Plate painted with twelve colours, 1660-1722.
Enamel, diameter: 17.2 cm.
The Palace Museum, Beijing.

430. **Anonymous.**
Pear-shaped vase, 17th century.
Porcelain, height: 34 cm.
The Palace Museum, Beijing. Chinese.

431. **Anonymous.**
Tea kettle, 1662-1722.
Porcelain, height: 8.8 cm.
National Palace Museum, Taipei. Chinese.

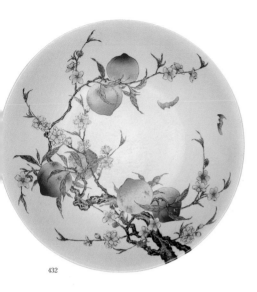

432

432. Anonymous.
Plate with butterflies and peachtree branches, 1680-1735.
Porcelain, 36 cm.
The Palace Museum, Beijing. Chinese.

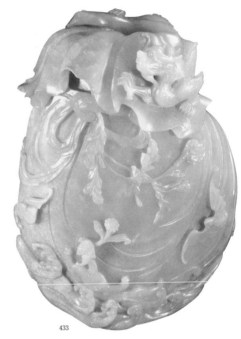

433. Anonymous.
Vase decorated with dragons and insects, 17th-18th century.
Jade, height: 28.8 cm.
Tianjin Museum, Tianjin. Chinese.

433

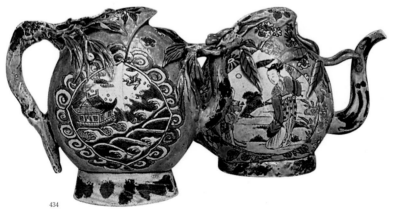

434

434. Anonymous.
Two fish-shaped alcohol tankards, Qing dynasty, Kangxi period (1662-1722).
Green porcelain, polychrome embellishment, 15.5 x 21.5 cm.
Musée national des Arts asiatiques – Guimet, Paris. Chinese.

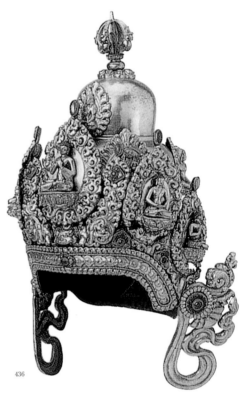

436

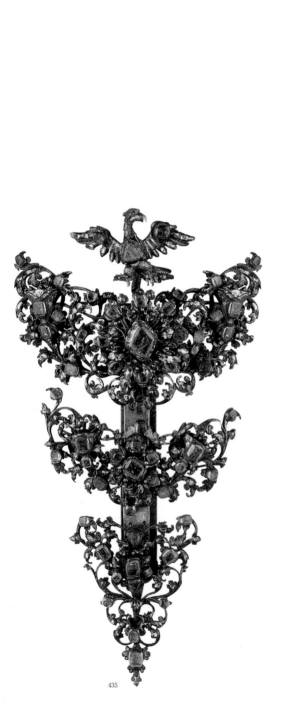

435. **Anonymous.**
Ornate corsage, France or Spain, end of the 7ᵗʰ century.
Silver, gilded silver, gold, rose-cut diamonds,
emeralds, amethyst, height: 20 cm.
Musée des Arts décoratifs, Paris. Baroque.

436. **Anonymous.**
Ritual crown, Nepal, 1677.
Gilded copper and precious stones, height: 76 cm.
Victoria and Albert Museum, London. Indian.

435

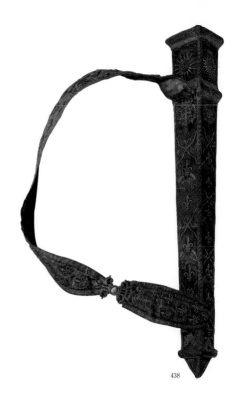

438

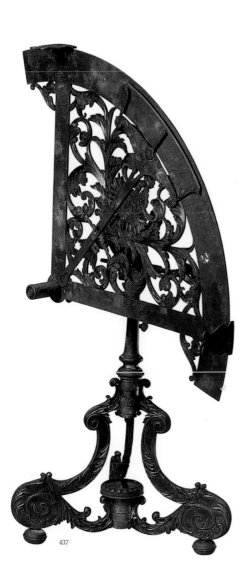

437

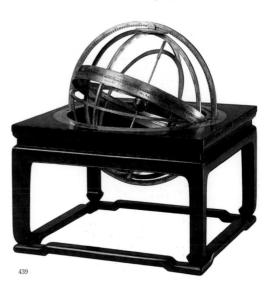

439

438. Anonymous.
Quiver with the crest of the Duke of Burgundy, second half of the 17th century.
Blue velvet, decorated with gold and silver, 79 x 12 cm; weight: 1.2 kg.
Musée de l'Armée, Paris.

437. Anonymous.
Arc quadrant, end of the 17th century.
Bronze, height: 66 cm.
The Palace Museum, Beijing. Chinese.

439. Anonymous.
Armillary sphere, 1669.
Silver plated, sandalwood, height: 37.5 cm.
The Palace Museum, Beijing. Chinese.

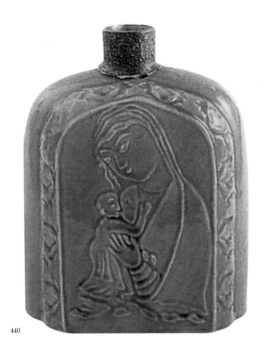

440

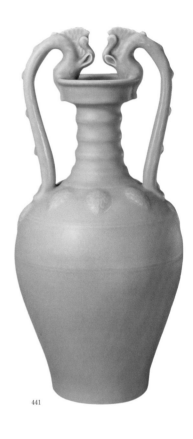

441

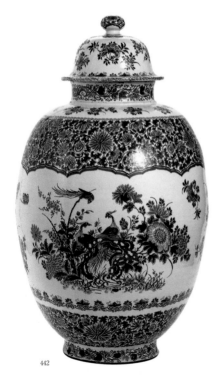

442

440. **Anonymous.**
Bottle, end of the 17th century.
Faience with molten decoration, height: 18 cm.
The State Hermitage Museum, St Petersburg. Persian.

441. **Anonymous.**
Amphora in Tang style, 1680-1735.
Porcelain, height: 51.8 cm.
The Palace Museum, Beijing. Chinese.

442. **'De Grieksche A' Manufactory.**
Porcelain vase, Delft, c. 1710.
Faience; height: 77 cm; diameter: 46 cm.
Musée des Arts décoratifs, Paris.

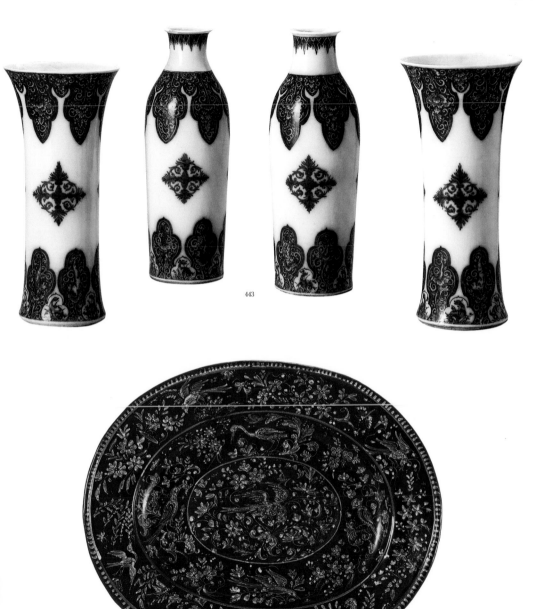

443

444

443. **Saint-Cloud Manufactory**, 1674-1766, French.
A pair of funnel-shaped vases and a pair of water pitchers, c. 1700.
Soft-paste porcelain, decorated with blue glass, funnel-shaped vases:
height: 20.8 cm; diameter: 9.8 cm. Water pitchers: height: 21 cm; diameter: 9.8 cm.
Musée des Arts décoratifs, Paris.

444. **Autruche Manufactory** (attributed to), French.
Navel-shaped plate, Neum, c. 1660.
Faience, tin-glazed, kiln-baked after decoration, 6.7 x 50.2 x 51.3 cm.
Musée des Arts décoratifs, Paris.

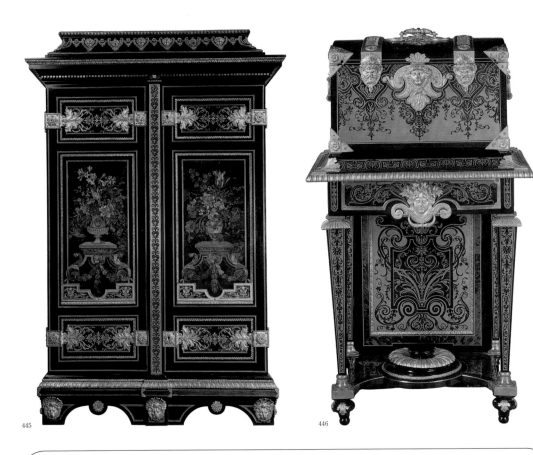

445

446

André-Charles Boulle
(Paris, 10 November 1642 – Paris, 29 February 1732)

The royal carpenter André-Charles Boulle was the first to decorate furniture with gilded bronze, making him the greatest French cabinetmaker of the 17th and 18th centuries. He was also the maker of numerous furnishings for Louis XIV, his family, and the royal estate. Initially, his father educated him on the artistic techniques regarding sculpture, drawing, painting, and gilding. Thanks to the young artist, the family workshop gained considerable recognition.

In May 1672, he receives an assignment at the Louvre.

From 1684-1692, the king commissions the panelling and the flooring of his study at Versailles, disappeared since the 18th century.

The brass- and tortoiseshell-inlaid marquetry by Boulle were such great successes, that they would be henceforth known as 'boullework'. The artist was as innovative with his bronze application and in his form of leafs as in his furniture pieces, including the creation of new models, such as the 'commode', conceptualised by him in 1708. The beauty of his furnishings was recognised not only in France, but also throughout Europe.

In 1700, he received a commission from the Duchess of Burgundy to design the furniture for the Château de la Ménagerie. Jules Hardouin-Mansart later commissioned him to complete two commodes for the Grand Trianon in Versailles.

Boulle's technique spread across France and the rest of Europe, and his model would be reproduced throughout the middle of the 18th century and the Second Empire.

445. **André-Charles Boulle**, 1642-1732, French.
Wardrobe, c. 1700.
Veneered in ebony, kingwood, polychrome wood inlay, brass, tin,
tortoiseshell and horn on oak frame, gilded bronze, 255.5 x 157.5 x 58 cm.
Musée du Louvre, Paris. Louis XIV style.

446. **André-Charles Boulle**, 1642-1732, French.
Chest on a console base, c. 1690-1695.
Archives Galerie Steinitz, Paris. Louis XIV style.

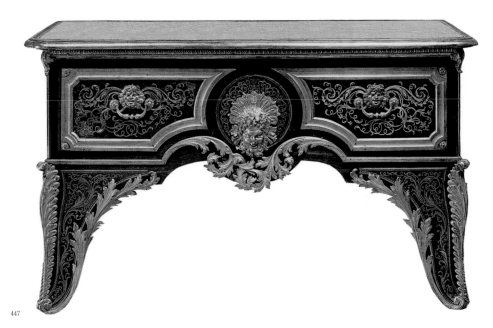

447

448

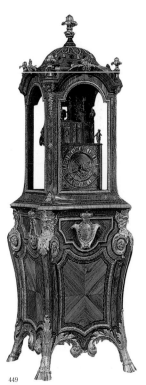

447. **André-Charles Boulle** (attributed to), 1642-1732, French.
Commode, c. 1710.
Veneered in ebony, brass and tortoiseshell inlay, gilded bronze, marble portor, 86 x 148 cm.
Musée du Louvre, Paris. Louis XIV style.

448. **Anonymous.**
Small table, Mughal, 17th century.
Gold with enamel and precious stones, 23.7 x 23.7 x 10 cm.
The State Hermitage Museum, St Petersburg. Eastern.

449. **Antoine Morand**, 1674-1757, French.
Automaton clock, 1706.
Rose and palisander wood inlay, chiselled and gilded bronze, 275 x 82 x 82 cm.
Mercury Salon, Palace of Versailles, Versailles.

449

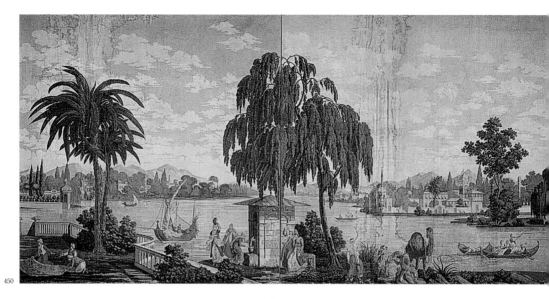

450. **Anonymous.**
Large panoramic image depicting the Bosphorus shore, 18ᵗʰ century.
Paper painted in the Dufour Manufactory, Paris.

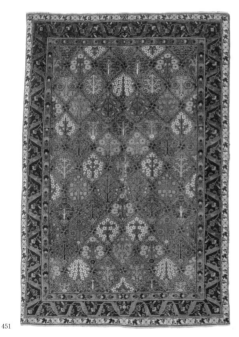

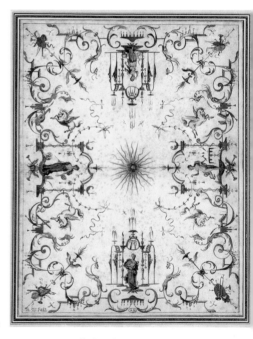

451. **Anonymous.**
Tapestry, 18ᵗʰ century.
Wool, 152 x 216 cm.
The State Hermitage Museum, St Petersburg. Persian.

452. **Claude Audran III**, 1657-1734, French.
Project for a ceiling painting, c. 1700.
Gouache on paper.
Musée des Arts décoratifs, Paris.

FRANÇOIS BOUCHER
(PARIS, 1703-1770)

Boucher is typical of the artist, whose ambitions are clearly defined and exactly proportioned to his capacity: he desired to please his contemporaries, to decorate walls and ceilings for them, and, in his better moments, realised perfectly what he set out to do. He bore the weight of an immense output, illustrating a book, or finishing off a fan as aptly as he rumpled the draperies of complaisant goddesses or peopled sky and wave with rosy and golden nudes. As a decorator he had gifts in no way inferior to those of his fascinating contemporary Tiepolo; he could also paint excellent portraits, or render intimate scenes with brilliance and deftness.

453

453. **Anonymous.**
Detail of a ceiling painting from the state house of the Countess of Verrue in Paris, c. 1715.
Musée des Arts décoratifs, Paris.

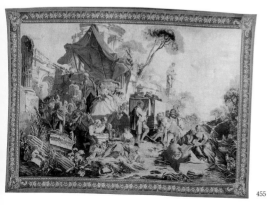

454. **François Boucher**, 1703-1770, French.
Le Montreur d'images. Fêtes Italiennes tapestry (Italian Village Scenes), 1736.
Tapestry.
Manufacture royale de Beauvais, Beauvais.

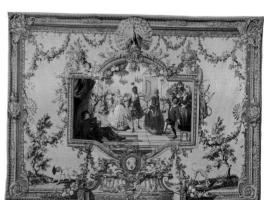

455

455. **Anonymous.**
Don Quixote: The Ball in Barcelona, c. 1732-1736.
Tapestry, wool and silk, 360 x 505 cm.
Musée du Louvre, Paris. Rococo.

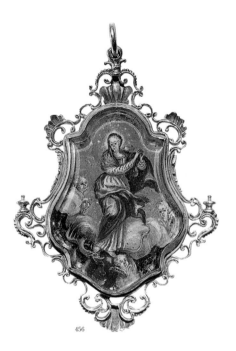

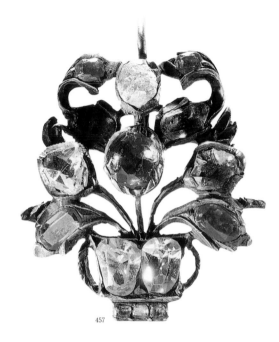

456. Anonymous.
Pendant depicting *The Assumption of the Virgin Mary*, 18th century.
Gold, crystal, glass painting, 7 x 5 cm.
Musée des Arts décoratifs, Paris. Rococo.

457. Anonymous.
Earring, France, 18th century.
Silver, emeralds, aquamarine, rubies.
Musée des Arts décoratifs, Paris. Rococo.

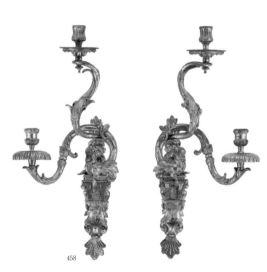

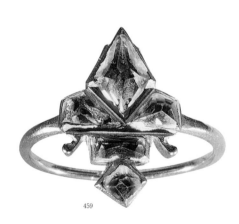

458. André-Charles Boulle (attributed to), 1642-1732, French.
Pair of sconces, Paris, c. 1715-1720.
Gilded bronze, 52 x 23 cm.
Musée des Arts décoratifs, Paris. Rococo.

459. Anonymous.
Ring with a fleur-de-lis, France, 18th century.
Gold, quartz.
Musée des Arts décoratifs, Paris. Rococo.

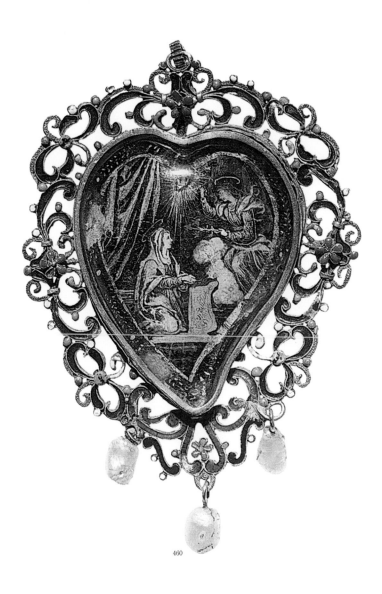

460

460. Anonymous.
Pendant with *Annunciation* and *Nativity*, 18th century.
Blue, red, white, and green enamel on gold, baroque pearls, 8.2 x 5 cm.
Musée des Arts décoratifs, Paris. Rococo.

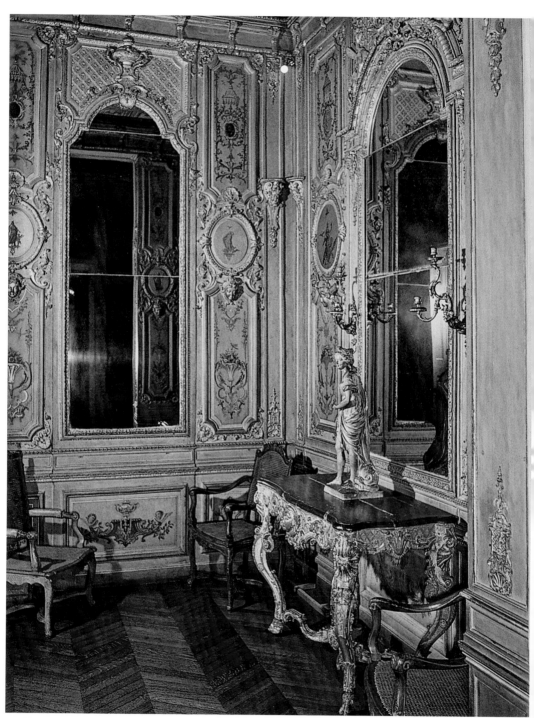

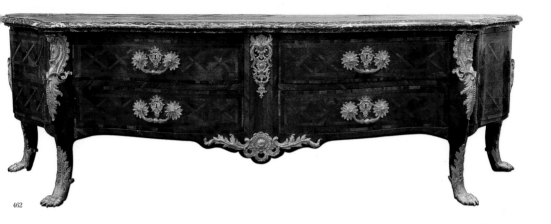

462

Charles Cressent
(Amiens, 1685-1768)

Charles Cressent, the son of the royal cabinetmaker François Cressent, was born in 1685. Educated by his father at first, he later studied at the Académie de Saint-Luc in Paris, before going to work at the workshop of sculptor Joseph Poitou, André-Charles Boulle's rival.

Following the death of the latter, Cressent became the cabinetmaker regent. His commissioners include famous names, such as King Louis XV, John V, King of Portugal, and the Duke of Richelieu, etc. Cressent made commode with rich decoration, also referred to as 'palmes à fleurs', on high feet, made of two drawers and on a gilded bronze pedestal with floral motifs.

His most important work was done between 1725-1745, during which he created fixed forms for the desk and the commode of Louis XV.

Some of his furniture was seized twice during trial proceedings between 1722 and 1725, and again in 1748, 1756, and 1765.

Cressent completed various clocks of great fantasy, leading to the birth of Rococo.

He was without a doubt one of the most brilliant creators of the first half of the 18th century.

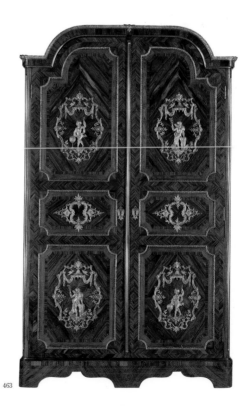

461. Anonymous.
Gilded chamber in the Rochegude mansion in Avignon, c. 1720.
Panelling, carved from lime and softwood, painted and gilded.
Musée des Arts décoratifs, Paris. Regency style.

462. Anonymous.
Double commode with corner mountings, Paris, c. 1725.
Oak and conifer wood, veneered in palisander and gilded walnut, gilded bronze, marble, 84 x 282 x 82.5 cm.
Musée des Arts décoratifs, Paris. Regency style.

563

463. Joseph Poitou (attributed to) and **Charles Cressent** (bronze),
1680-1719 and 1685-1768, French.
Wardrobe, c. 1715-1720.
Oak, veneered in violet-coloured wood, gilded bronze, 275 x 163 x 56 cm.
Musée des Arts décoratifs, Paris. Regency style.

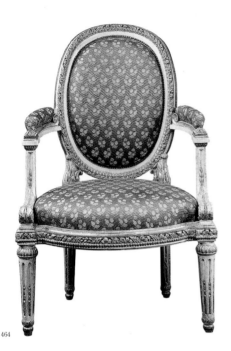

464

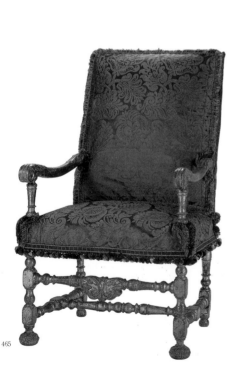

465

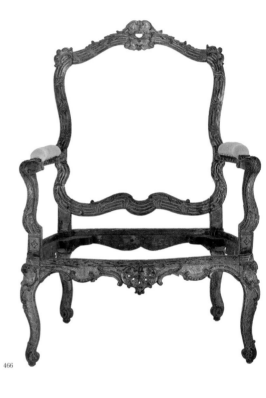

466

464. **Anonymous.**
Armchair with frame, back in curved medallion shape, 18th century.
Gilded wood, silk.

465. **Anonymous.**
Chair, c. 1670-1680.
Chiselled and gilded beechwood, modern trimming, 114.7 x 70 x 80 cm.
Musée des Arts décoratifs, Paris.

466. **Anonymous.**
Chair, Paris, c. 1720.
Chiselled and gilded beechwood, 112 x 76 x 63 cm.
Musée des Arts décoratifs, Paris. Regency style.

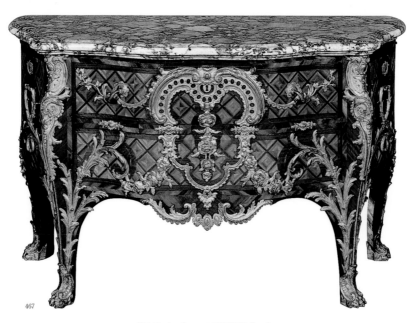

467. **Charles Cressent**, 1685-1768, French.
Commode, c. 1730-1735.
Veneered in satinwood and kingwood, gilded bronze, Sarrancolin marble, 90 x 143 x 64 cm.
Musée du Louvre, Paris. Regency style.

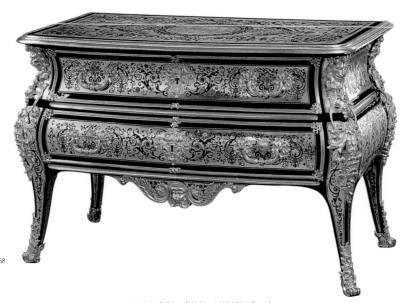

468. **Noël Gérard**, before 1690-1736, French.
Ormolu polychrome mounted Boulle commode with two drawers, c. 1730.
Veneered in ivory, tin, copper, 134.6 x 87.6 x 66 cm.
Victoria and Albert Museum, London. Regency style.

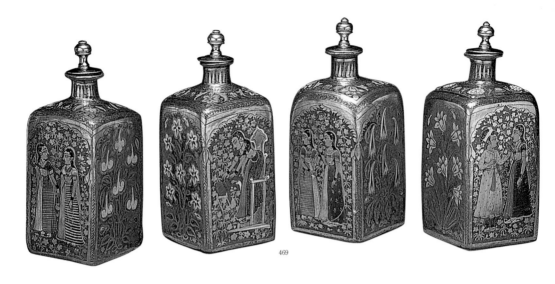

469. Anonymous.
Four glass vials, second half of the 18th century.
Colourless and transparent glass, gilded bottleneck and stopper, copper, height: 15 cm.
Private collection.

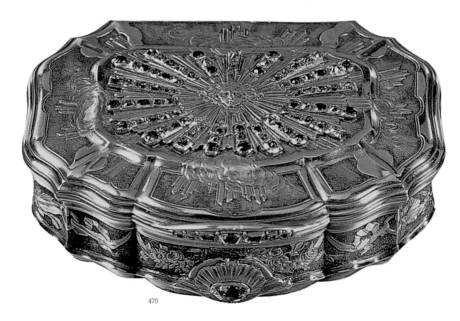

470. **Daniel Govaers**, known as **Gouers**, Master in Paris in 1717 - active until 1736.
Snuff box, 1726-1727.
Gold, diamonds, emeralds, 2.8 x 8.2 x 6.2 cm.
Musée du Louvre, Paris.

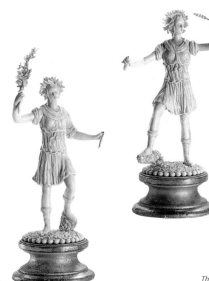
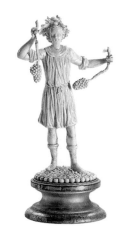

471

471. Anonymous.
The Four Seasons, 18th century.
Enamelled white and opaque glass on a metal stand,
base of gilded turned wood, height with base: 17 cm.
Musée des Arts décoratifs, Paris.

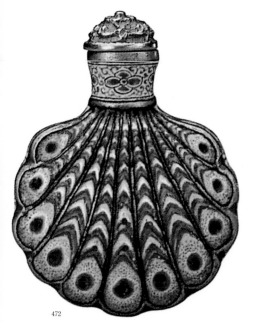

472

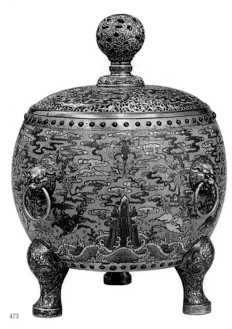

473

472. Anonymous.
Peacock-shaped snuff box, 18th century.
Enamel on copper, 4.6 x 3.7 cm.
The Palace Museum, Beijing. Chinese.

473. Anonymous.
Three-legged incense burner, Qing dynasty, 18th century.
Copper and enamel cloisonné, height: 42 cm; diameter: 36 cm.
Musée national des Arts asiatiques - Guimet, Paris. Chinese.

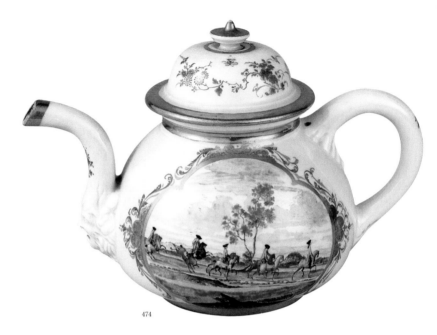

474

474. Anonymous.
Tea kettle, c. 1725-1730.
Meissen porcelain, polychrome decoration, and gold, height: 11 cm.
Musée national de la Céramique, Sèvres.

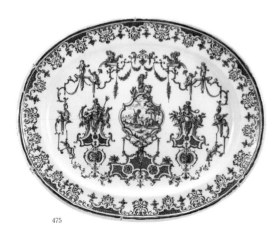

475

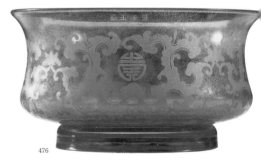

476

475. Ateliers Clérissy, French.
Large serving platter, c. 1730.
Faience, burned decoration, 61 x 48.5 cm.
Musée des Arts décoratifs, Paris.

476. Anonymous.
Blue bowl, 1723-1725.
Glass, diameter: 17.3 cm.
Asian Art Museum, San Francisco. Chinese.

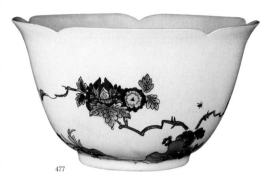

477

477. **Sèvres Manufactory**, 1740 - currently active; known at this time as the
Vincennes Manufactory, French.
Cup, second quarter of the 18th century.
Mennecy porcelain, polychrome embellishment,
height: 8.6 cm; diameter: 15.5 cm.
Musée national de la Céramique, Sèvres.

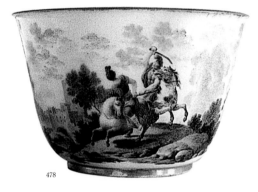

478

478. **Anonymous.**
Bowl, military battle scene of horsemen, c. 1745.
Capodimonte porcelain, height: 25 cm.

Sèvres Manufactory
(Vincennes, 1740 – currently active)

The Sèvres Manufactory, located in Sèvres, the Hauts-de-Seine
department, is one of the leading manufacturers of European
porcelain. Founded in 1740, the manufactory is currently still
open. Its current production takes into account the modern.
Sèvres was the city of ceramic in 2010 with the Musée national
de Céramique, and since 2012 the Musée national de la porce-
laine Adrien-Dubouché in Limoges. The Vicennes manufactory
was created, with the support of Louis XV and Madame de
Pompadour. Its products placed it in competition with Chantilly
and Meissen. In 1756, it relocated to Sèvres, in a building
erected close to the Bellevue Palace, following Madame de
Pompadour requests. Originally, the manufactory produced soft
paste china.

From 1800 to 1847, the production steadily increased and
gained international recognition, under the leadership of
Alexandre Brongniart.

In 1875, the manufactory once again moved, this time to a
special building, done by the French state, classified as a
historical landmark, located near Parc de Saint-Cloud. The
products are only exhibited in two galleries: the first located in
Sèvres and the second in the heart of Paris, in 1st
arrondissement, between the Louvre and the Comédie
Française. Today, the manufactory organises numerous exhibi-
tions all over the world and participates in various exhibitions
and art fairs.

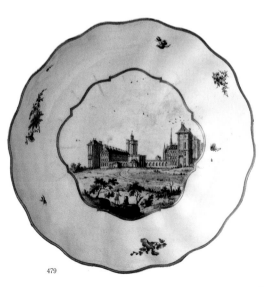

479. **Anonymous.**
Bowl, c. 1749-1753.
Vincennes porcelain, polychrome embellishment,
height: 7 cm; diameter: 24 cm.
Musée national de la Céramique, Sèvres.

479

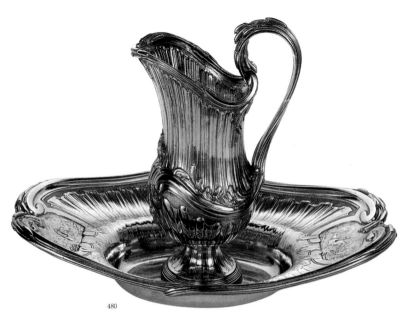

480

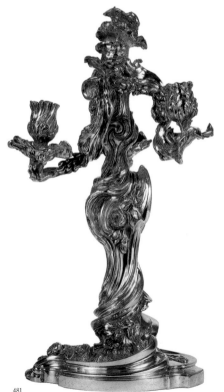

480. François-Thomas Germain, 1726-1791, French.
Ewer and basin, 1756-1758.
Silver, ewer: 27.5 x 12 x 17.8 cm; basin: 7.8 x 40.4 x 28.7 cm.
Musée des Arts décoratifs, Paris.

481. Juste-Aurèle Meissonnier and Claude Duvivier,
1695-1750 (Meissonnier) and Master in 1720 (Duvivier), French.
Candelabra, 1734-1735.
Silver, 38.5 x 21.5 cm.
Musée des Arts décoratifs, Paris. Rococo.

481

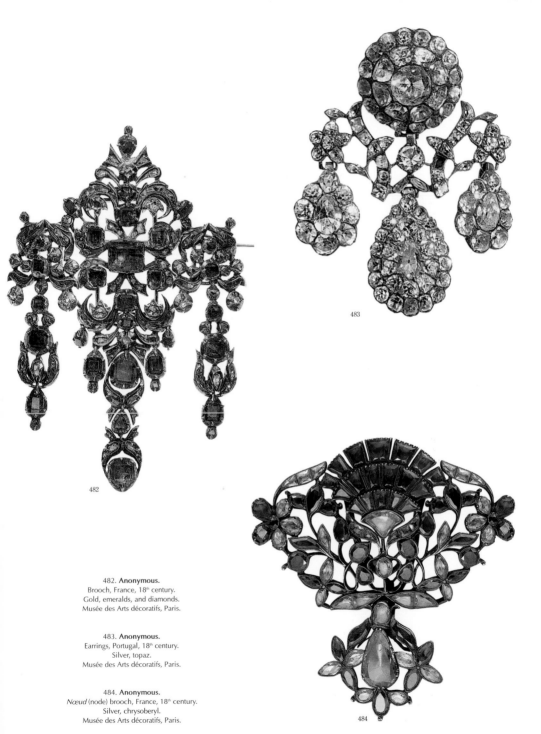

482. Anonymous.
Brooch, France, 18ᵗʰ century.
Gold, emeralds, and diamonds.
Musée des Arts décoratifs, Paris.

483. Anonymous.
Earrings, Portugal, 18ᵗʰ century.
Silver, topaz.
Musée des Arts décoratifs, Paris.

484. Anonymous.
Nœud (node) brooch, France, 18ᵗʰ century.
Silver, chrysoberyl.
Musée des Arts décoratifs, Paris.

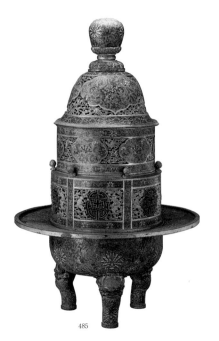

485

485. Anonymous.
Coal oven, 18th century.
Enamel cloisonné, height: 83 cm.
The Palace Museum, Beijing. Chinese.

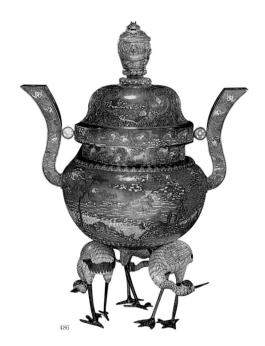

486

486. Anonymous.
Incense burner, 18th century.
Enamel, height: 101.5 cm; diameter: 55 cm.
British Museum, London. Chinese.

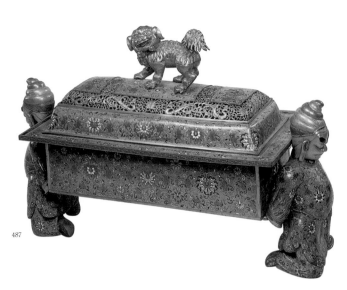

487

487. Anonymous.
Ice box, 18th century.
Enamel cloisonné, length: 117 cm.
Victoria and Albert Museum, London. Chinese.

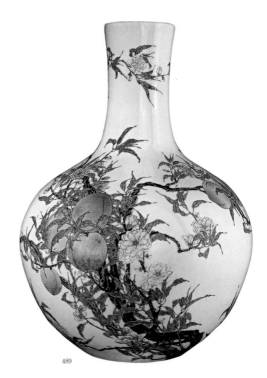

489

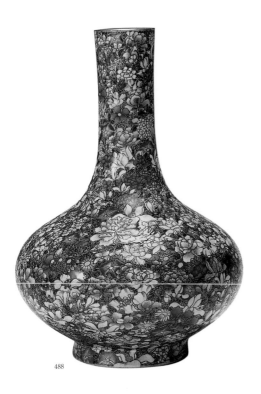

488

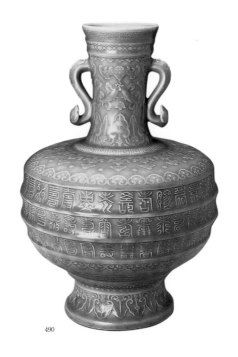

488. Anonymous.
Vase with various flowers, 18th century.
Porcelain, height: 32.4 cm.
Asian Art Museum, San Francisco. Chinese.

489. Anonymous.
Vase, 18th century.
Porcelain, height: 52 cm.
British Museum, London. Chinese.

490. Anonymous.
Celadon vase, 18th century.
Porcelain, height: 42 cm.
Baur Collection, Geneva. Chinese.

490

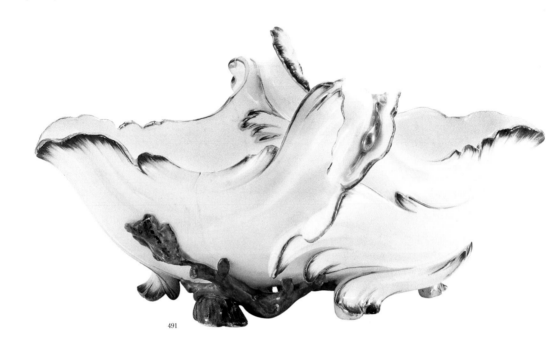

491

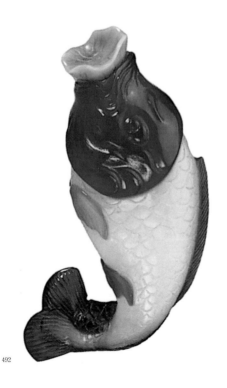

492

491. **Sèvres Manufactory**, 1740 - currently active;
known at this time as the Vincennes Manufactory, French.
Duplessis sauceboat, 1756.
Hard-paste porcelain, 26 x 19.4 cm.
Musée des Arts décoratifs, Paris.

492. **Anonymous.**
Fish-shaped snuff box, 18ᵗʰ century.
Glass, 7.5 x 3 cm.
The Palace Museum, Beijing. Chinese.

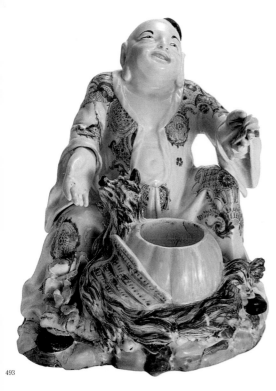

493

493. Villeroy Manufactory, 1720, French.
Magot figure, c. 1740.
Hard-paste porcelain, 20 x 21.5 cm.
Musée des Arts décoratifs, Paris.

494. Anonymous.
Seated Guandi, Qing dynasty, 18th century.
Porcelain with enamel, coated in green, 29 x 12.5 cm.
Musée national des Arts asiatiques – Guimet, Paris. Chinese.

494

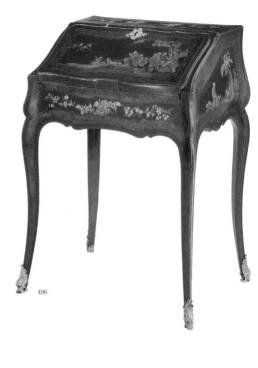

496

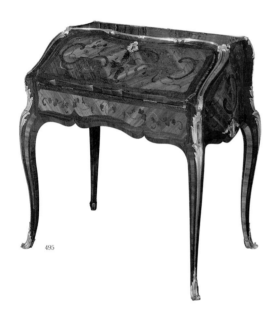

495

Adrien Faizelot Delorme
(Master 1748-1768)

Adrien Delorme, son of the cabinetmaker François Delorme, belonged to a family of crafters, as his brothers Jean-Louis and Alexis were also cabinetmakers. He became a master in 1748, and his workshop lied on Rue du Temple, similar to other manufacturers and merchants. From 1768 to 1770, he was appointed Juror of his community to replace his father. His original inlaid works show an outstanding quality, the lacquer and varnish contradict the Far East taste and secure his repute. Delorme produced tables, secretaries, but it is the curved commodes, with vibrant decoration and lacquer from China or Japan, geometric patterns or flower motifs, which assume an important place in his assembly of works. One of its decorations type consists of winding tendrils that decorate the veneer. Adrien Delorme was referred to in one of the annuals from his day as one of the adept artists to work with inlay. According to Pierre Verlet, "his works capture the boldest Rococo elements in the time of Louis XV."

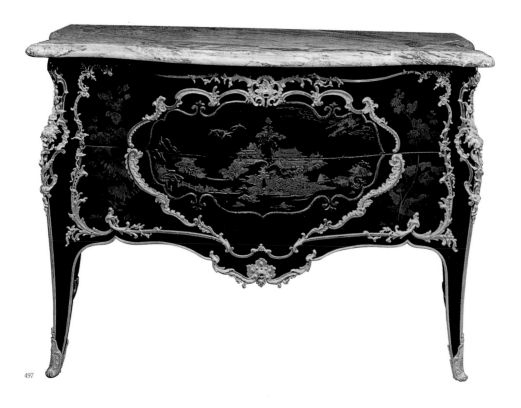

497

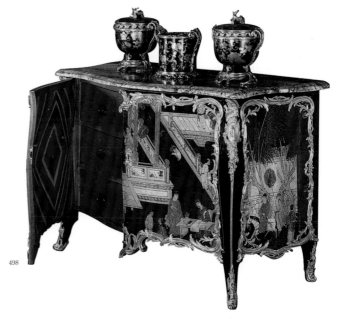

497. **Bernard II van Risen Burgh**, c. 1696-1765, French.
Commode, 1737.
Veneered in fruitwood, Japanese lacquer, vernis Martin
n oak frame, gilded bronze, Antin marble, 85 x 127 cm.
Musée du Louvre, Paris. Louis XV style.

498. **Jacques-Philippe Carel**, c. 1688-1755, French.
Commode, c. 1750.
Oak, black varnished wood, kingwood, fruit woods
and oak veneer, Coromandel lacquer, gilded bronze,
Sarrancolin marble, 93 x 146 x 69 cm.
Musée du Louvre, Paris. Louis XV style.

498

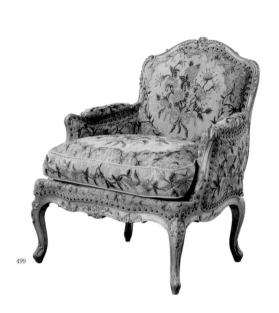

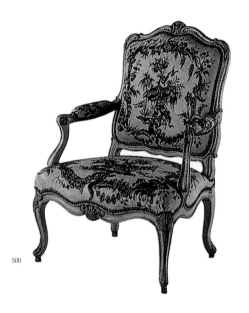

499. **Sylvain-Nicolas Blanchard**, 1723, known as Master in 1743, French.
Chair, c. 1745.
Tapestry, decorated with flower bouquets.
Archives Galerie Didier Aaron, Paris. Regency style.

500. **Jean-Baptiste Cresson**, 1720-1781, French.
The Queen's chair, c. 1755.
Carved and painted beechwood, 96 x 70 x 53 cm.
Musée des Arts décoratifs, Paris. Regency style.

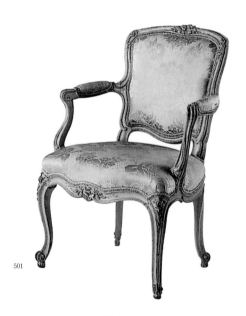

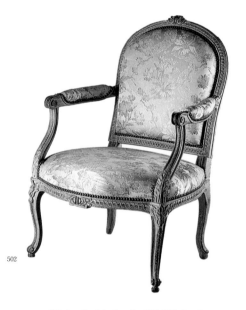

501. **Anonymous**.
Chair, c. 1750.
Carved and painted beechwood, 84 x 60 x 49 cm.
Musée des Arts décoratifs, Paris.

502. **Jean-Baptiste Gourdin**, 1723-1781, French.
The Queen's chair, c. 1770.
Moulded, carved, and painted beechwood and walnut (right arm), 96.5 x 65 x 55 c
Musée des Arts décoratifs, Paris. Regency style.

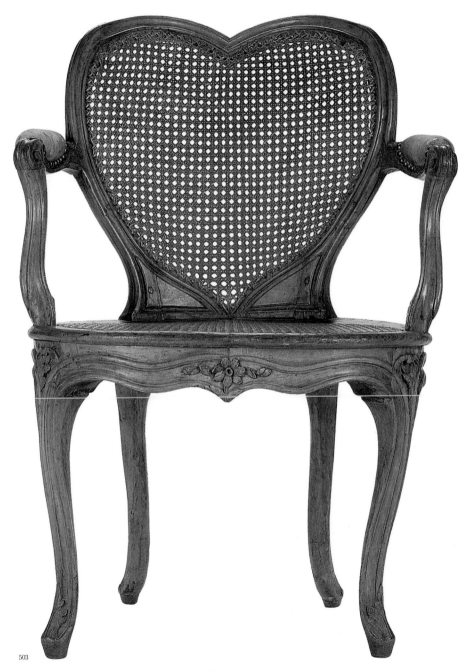

503

503. Anonymous.
Armchair with heart-shaped back, Paris, c. 1750-1760.
Beechwood, leather, and cane, 84 x 60 x 50 cm.
Musée des Arts décoratifs, Paris.

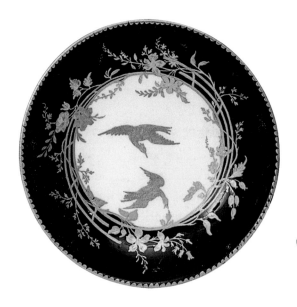

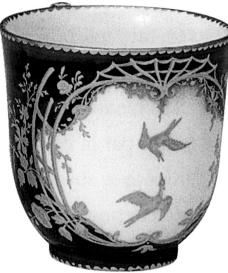

504

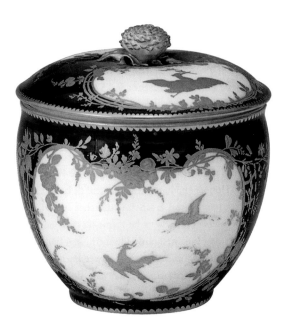

504. Anonymous.
Teacup, saucer, and sugar bowl, c. 1753-1754.
Vincennes porcelain, lapis lazuli background,
depicting birds in mid-flight and rich golden framing.
Palazzo Pitti, Florence.

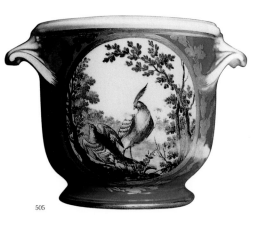
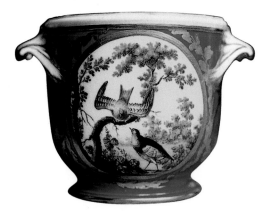

505

505. Anonymous.
Wine cooler, 1760.
Sèvres porcelain, blue background,
depicting polychrome bird reserves, 16.5 x 17.5 cm.
Palazzo del Quirinale, Rome.

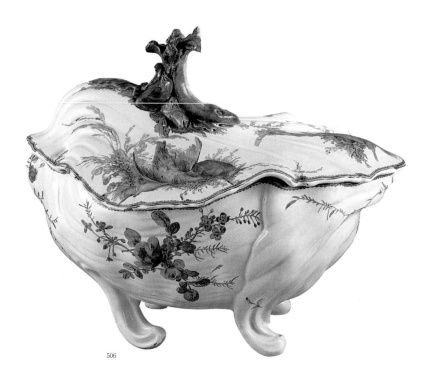

506

506. Fabrique Gaspard Robert, 1722-1799, French.
Tureen, c. 1765-1770.
Tin faience, enamel kiln-baked before decoration, 30.5 x 38.3 x 27.5 cm.
Musée des Arts décoratifs, Paris.

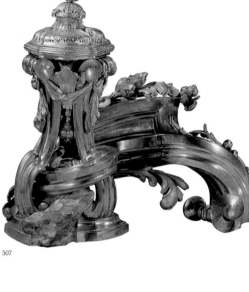

507

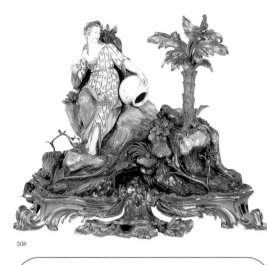

508

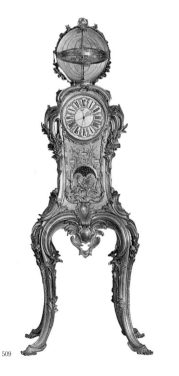

509

507. **François-Thomas Germain**, 1726-1791, French.
Fire incense burner, 1757.
Gilded bronze, 57 x 59 x 4 cm.
Musée du Louvre, Paris. Rococo.

508. **Anonymous.**
Naiad, 1756.
Hard-paste porcelain, accentuated gold, gilded bronze, 30 x 52 x 42 cm.
Musée du Louvre, Paris. Rococo.

509. **Claude-Siméon Passement**, **Claude Dauthiau**, and **Philippe Caffieri**,
1702-1769, 1730-1809, and 1725-1772, French.
Astronomical clock, 1754.
Gilded bronze, 83.2 x 53 cm. Clock Cabinet, Louis XV's living room,
Palace of Versailles, Versailles.

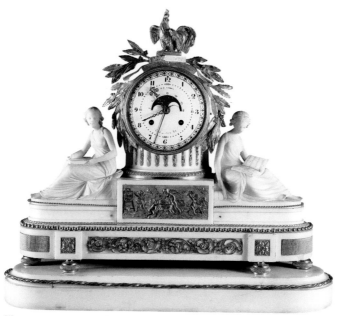

510. **F.L. Godon**, Relojero de Camara de S.M.C. and **Coteau**,
Spanish and French. Clock, last quarter of the 18th century.
White marble and gilded bronze, 57 x 68 cm.
Royal Collection, Palacio Real de Madrid, Madrid.

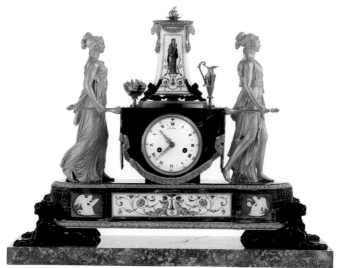

511. **Jean-Démosthène Dugourc**, **Louis-Simon Boizot**, **Pierre-Philippe Thomire**,
and **Robert Robin**, 1740-1825, 1743-1809, 1751-1843, and 1742-1799, French.
Clock, *Sacred Fire of Vesta*, 1788.
Gilded bronze and patinated bronze in black, Sèvres porcelain plate,
turquin blue marble, 50.5 x 65 x 18 cm. Musée des Arts décoratifs, Paris.

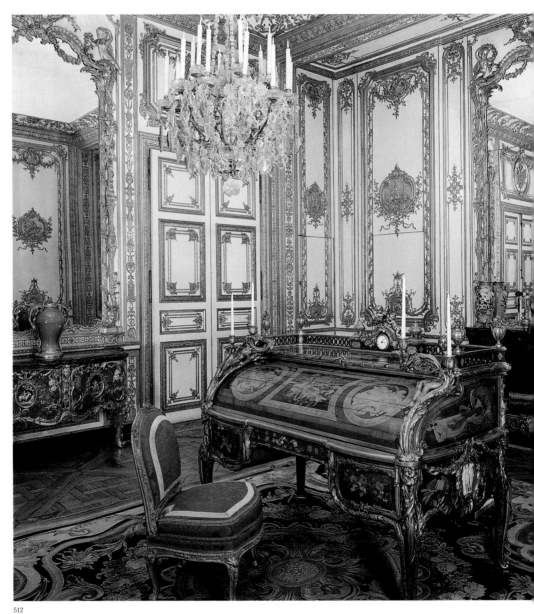

512

512. **Jean-François Oeben** and **Jean-Henri Riesener**, 1721-1763 and 1734-1806, French.
Cylinder-shaped secretary in Louis XIV's office in Versailles, 1760-1769.
Bronze and veneer in various woods, Sèvres porcelain, 147.3 x 192.5 x 105 cm.
Palace of Versailles, Versailles.

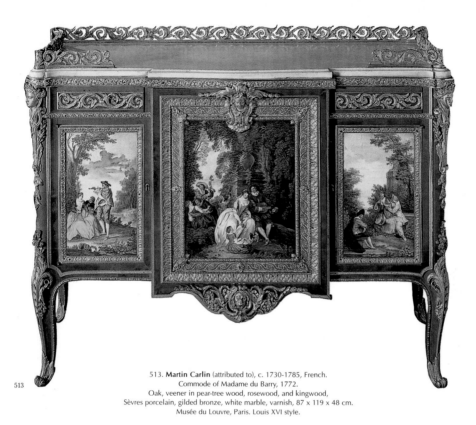

513. **Martin Carlin** (attributed to), c. 1730-1785, French.
Commode of Madame du Barry, 1772.
Oak, veener in pear-tree wood, rosewood, and kingwood,
Sèvres porcelain, gilded bronze, white marble, varnish, 87 x 119 x 48 cm.
Musée du Louvre, Paris. Louis XVI style.

513

MARTIN CARLIN
(FREIBURG IM BREISGAU, C. 1730-1785)

Martin Carlin was a cabinetmaker from Germany. He learned his craft in Paris and worked in Jean-François Oeben's workshop. He collaborated with the then-great merchants Poiriet and Daguerre. Carlin specialised in products of top quality and completed luxury furniture (commodes and secretaries), made of expensive and rare materials, belonging to the time of Louis XVI. He made posters with painted porcelain, mosaics of precious stones or lacquer.

Carlin received commissions only from the social elite, such as the royal family (Maria Antoinette), the aristocracy (Duchess of Mazarin), or the Comtesse du Barry.

His most famous pieces are those done for Bellevue Palace.

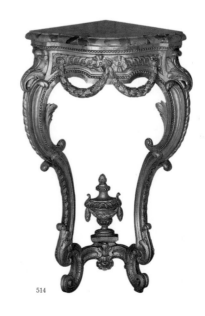

514. **Anonymous.**
Console, part of a pair, c. 1760-17709.
Carved and gilded wood.
Musée Nissim de Camondo, Paris. Louis XVI style.

514

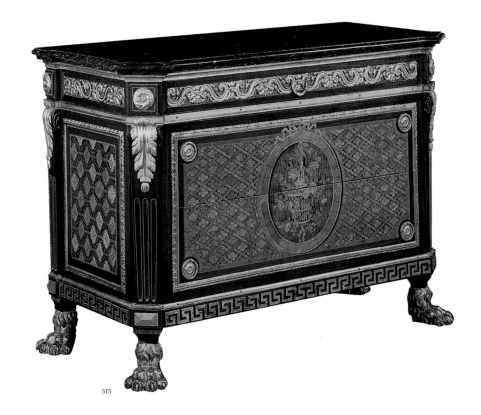

515

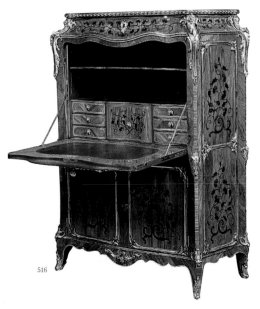

516

515. **Jean-François Leleu**, 1729-1807, French.
Commode of the Prince of Condé, 1772.
Oak frame, veneer of sycamore, rosewood and kingwood,
polychrome wood marquetry, gilded bronze, Griotte Rouge marble,
87 x 124 x 59 cm.
Musée du Louvre, Paris. Louis XVI style.

516. **Léonard Boudin**, 1735-1807, French.
Secretary with doucine moulding, c. 1760.
Rosewood inlay. Private collection.

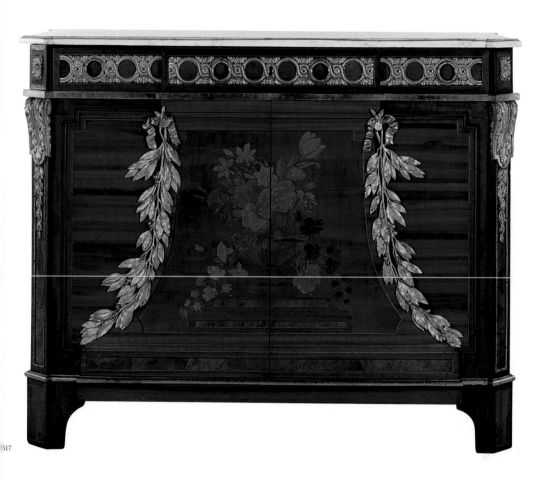

517

517. **Jean-Henri Riesener**, 1734-1806, French.
Low cabinet, c. 1775-1780.
Oak, veneer of sycamore wood, velvet, inlay, 89 x 114 cm.
Musée des Arts décoratifs, Paris. Louis XVI style.

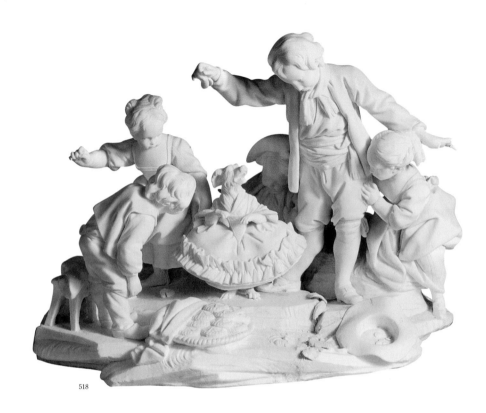

518

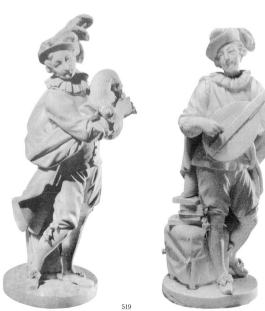

519

518. **Étienne Maurice Falconet**, 1716-1791, French.
The Dancing Dog, c. 1758-1759.
Group in soft-paste Sèvres porcelain, 22.5 x 29.2 x 20.8 cm.
Musée national de la Céramique, Sèvres. Louis XVI style.

519. **Anonymous.**
Player of the Spanish Bagpipe, 1772.
Scuplture in biscuit porcelain.
Pavlovsk Palace, St Petersburg.

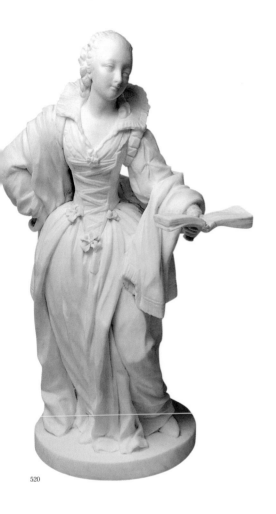

520

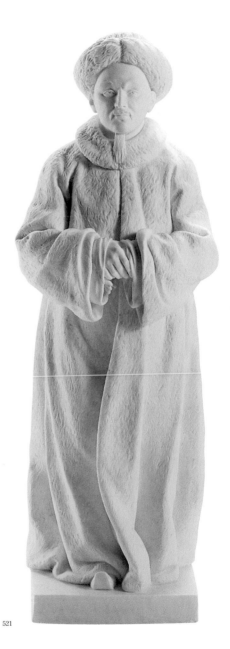

521

520. **Anonymous.**
The Soprano du Barry, 1772.
Sculpture in biscuit porcelain, height: 22.5 cm.
Musée national de la Céramique, Sèvres.

521. **Sèvres Manufactory**, 1740 - currently active, French.
Statue, *The Emperor of China*, c. 1776-1885.
Hard-paste porcelain, 40.5 x 14.5 cm.
Musée des Arts décoratifs, Paris.

522

522. **Sèvres Manufactory**, 1740 - currently active, French.
Plate from the service of Caroline of Naples, 1773.
Porcelain, diameter: 24 cm.
Musée des Arts décoratifs, Paris.

523

523. **Sèvres Manufactory**, 1740 - currently active, French.
Plate, 1773.
Porcelain, diameter: 24 cm.
Musée national de la Céramique, Sèvres.

524

524. **Pierre-Joseph Rosset**, French.
Round plate, second size, 1775.
Porcelain with gadroon, painted, height: 3.5 cm; diameter: 30 cm.
Private collection, Paris.

525

525. Anonymous.
Fruit basket, 1783.
Porcelain, height: 7.5 cm; diameter: 25.3 cm.
Museo Arqueológico Nacional, Madrid.

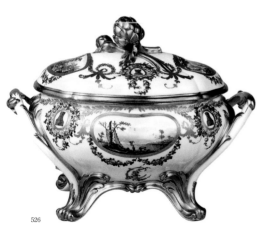

526

526. Philippe Castel, Nicolas Sisson, and **Nicolas Schradre,** French.
Terrine, 1774.
Porcelain, 25 x 33 x 20.5 cm.
Museo Arqueológico Nacional, Madrid.

527. Meissen Manufactory, 1710 - currently active, German.
Breakfast dishes, c. 1780-1790.
Box lined with leather and silk, hard-paste porcelain, polychrome enamels
and highlights, covered with gold, box: 17.5 x 38.5 x 29 cm.
Musée des Arts décoratifs, Paris.

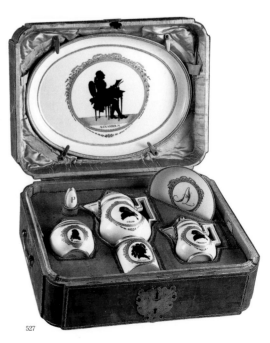

527

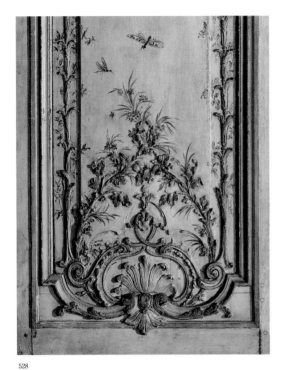

528

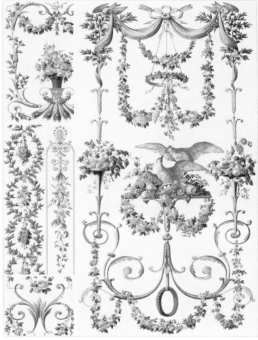

529

530

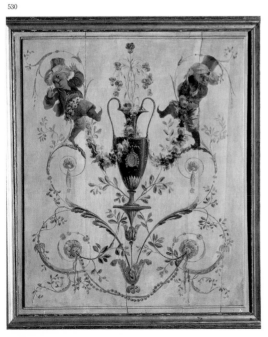

528. **Anonymous.**
Panel trim (detail), c. 1750.
Carved polychrome oak, 268 x 67 cm.
From the treasury of the Crécy-Couvé Palaces.
Musée des Arts décoratifs, Paris.

529. **Anonymous.**
Decorative flower garland and stylised foliage.
Private collection. Louis XVI style.

530. **Jean-Siméon Rousseau** (attributed to), 1747-1820, French.
Trim panel, 1782.
Oil on wood.
Musée des Arts décoratifs, Paris.

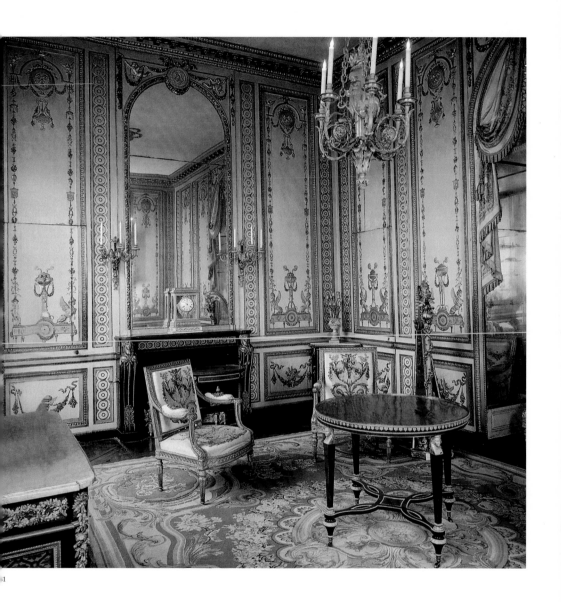

51

531. Anonymous.
The privy chamber of the queen, or the gilded privy chamber, 1783.
Palace of Versailles, Versailles.

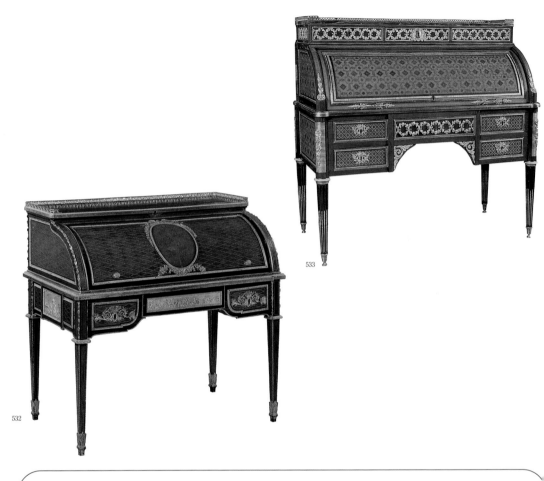

533

532

JEAN-HENRI RIESENER
(Gladbeck, 1734 – Paris, 1806)

As Marie Antoinette's favourite cabinetmaker, Jean Henri Riesener was the royal cabinetmaker for Louis XVI. After his arrival in Paris in 1755, Riesener visited Jean-François Oeben's workshop often. He completed a roll-top desk for Louis XVI and began to work in the study at the court, where he lived for ten years. Riesener quickly developed a strong reputation for his extremely-fine inlaid work, for the quality of the bronze and its elegance. His style was neo-classical with straight lines. The commissions steadily increased. The first piece that he signed was a secretary, commissioned by the king, began by Oeben and finished by Riesener in 1769.

This secretary is exhibited in a study at the Louvre, further decorated with brass work by Hervieux Duplessis and intricate inlay by Winant. His second masterpiece is a flat table, currently found at the Petit Trianon. For over ten years, Riesener was the main contractor of the royal family.

In 1755, he made the bedroom commode for Louis XVI in Versailles. Afterwards, two important pieces for Marie Antoinette: two corner cabinets and a commode made of mahogany with bronze decoration.

Despite his good reputation, his popularity sank after the French Revolution, and entered early retirement in 1800.

532. **Jean-Henri Riesener**, 1734-1806, French.
Rolltop desk of Marie Antoinette, 1784.
Oak and deal frame, veneer of sycamore, kingwood and rosewood, polychrome wood marquetry, gilded bronze, 103 x 113 x 64 cm.
Musée du Louvre, Paris. Louis XVI style.

533. **Jean-Henri Riesener**, 1734-1806, French.
Rolltop desk, Louis XVI period.
Marquetry and gilt ormolu. Louis XVI style.

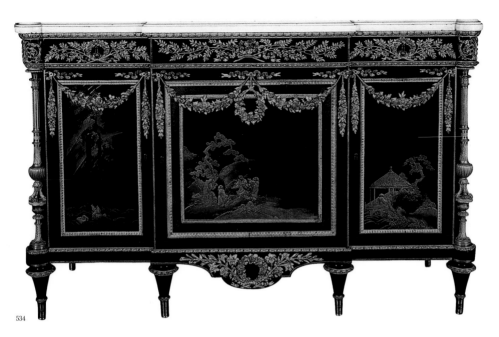

534. Martin Carlin, c. 1730-1785, French.
Commode of Madame Victoire, 1785.
Ebony, Japanese lacquer, gilded bronze, white marble, 96 x 151 x 53 cm.
Musée du Louvre, Paris. Louis XVI style.

ADAM WEISWEILER
(NEUWIED-AM-RHEIN, 1744 – PARIS, 1820)

Adam Weisweiler was a brilliant cabinetmaker of the late 18th century. He established himself in the Faubourg St Antoine, quickly developing a good standing. Specialising in dainty and charming furnishings (cabinets, tables, etc.), he soon became known for his application of porcelain from the Sèvres Manufactory and Wedgewood. His creations were beloved by nobles and by the courts of Europe. He was the main contractor for the French court, the king of Naples, and Catherine the Great, of Russia. Weisweiler strived to complete an outstanding amount of furnishings, always of excellent quality. His creations evolved through time, and after the French Revolution, he became the contractor for the imperial court.

Today, many of his works are found in various museums, such as the Louvre or the Victoria and Albert Museum in London.

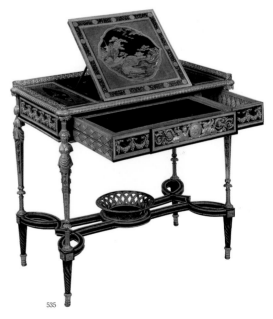

535. Adam Weisweiler, 1744-1820, French.
Writing table, belonging to Marie Antoinette, 1784.
ony, Japanese lacquer, mother-of-pearl, gilded bronze, and steel, 73.7 x 81.2 x 45.2 cm.
Musée du Louvre, Paris. Louis XVI style.

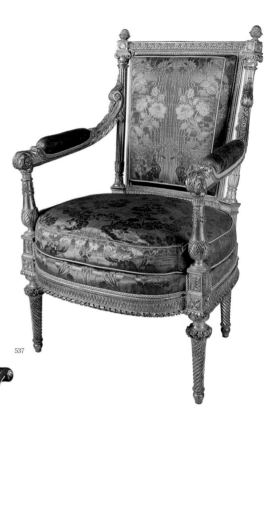

537

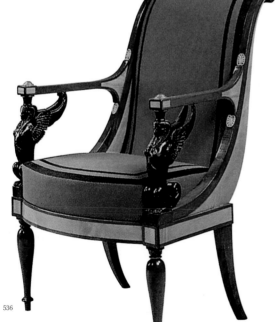

536. **Jacob Frères**, 1768-1803 and 1770-1841, French.
Chair, from a room occupied by Madame Récamier, c. 1798.
Satinwood and kingwood veneer, height: 74 cm; diameter: 75 cm.
Musée du Louvre, Paris. Louis XVI style.

537. **Jean-Baptiste-Claude Sené**, 1748-1803, French.
Chair, 1787.
Gilded beechwood, 91 x 70 x 61 cm.
Musée du Louvre, Paris.

536

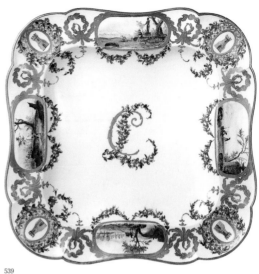

538

539

538. Jean-Louis Morin, 1732-1787, French.
Quadratic image with blue background, 18th century.
Sèvres porcelain, 15 x 15 cm.
Musée des Arts décoratifs, Paris.

539. Louis-François Lécot and François-Antoine Pfeiffer,
1741-1800 and active 1771-1800, French.
Platter, 1790. Porcelain, 28 x 28 cm.
Musée national de la Céramique, Sèvres.

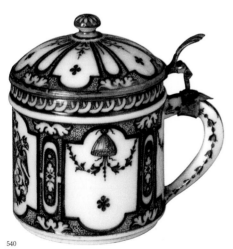

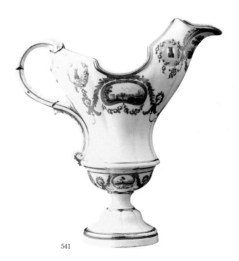

540

541

540. Sèvres Manufactory and Asselin de Villequier (decoration),
1740 - currently active, French.
Mustard pot, end of the 18th century.
Porcelain, height: 9 cm; diameter: 6.7 cm.
Musée national de la Céramique, Sèvres.

541. Sèvres Manufactory, 1740 - currently active, French.
Helmet-shaped ewer, last quarter of the 18th century.
Porcelain, height: 28.5 cm.
Musée national Adrien Dubouché, Limoges.

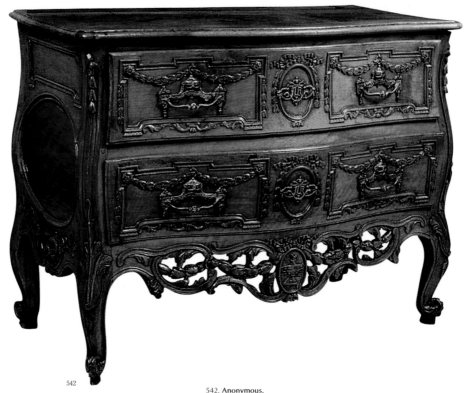

542

542. **Anonymous.**
Arles commode, end of the 18th century.
Carved wood.

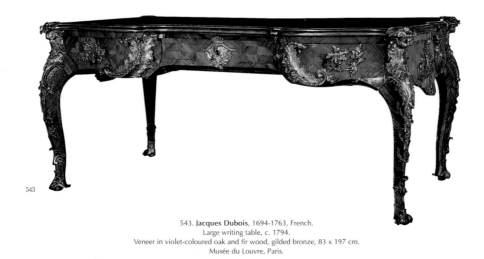

543

543. **Jacques Dubois**, 1694-1763, French.
Large writing table, c. 1794.
Veneer in violet-coloured oak and fir wood, gilded bronze, 83 x 197 cm.
Musée du Louvre, Paris.

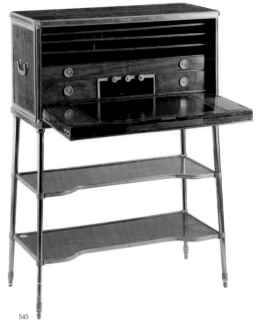

545

Georges Jacob
(Cheny, 6 July 1739 – Paris, 5 July 1814)

Georges Jacob is one of the most well-known cabinetmakers of the 18th century. Two of his sons Georges Jacob II and François-Honoré-Georges Jacob-Desmalter were also carpenters, as well as a grandson Alphonse Jacob-Desmalter. An orphan, he moved to Paris at age sixteen, where he became the apprentice to Jean-Baptiste Lerouge, a cabinetmaker. Later, he would become fellow mason at the same workshop. Specialising in seating furniture, he became a master on 4 September 1765 and opened his own workshop in 1775 on the Rue Meslée. He received commissions from the king, and Jacob was, until the end of the Ancien Regime, the official cabinetmaker to the crown. Among his employers, one finds Marie Antoinette, the king's brother, the future King Louis XVII, the Count of Artois, the Prince of Condé, and a few German princes.

Jacob was the first to apply mahogany and create new forms, inspired by the ancient Greeks and Romans. In the late 1780s, he completed a stool for artist David to use whilst painting. The Revolution deteriorated his financial situation, and on 13 August 1796, he handed over his finances to his sons, who founded La Maison Jacob-Frères. After the death of his son Georges Jacob II, he and another son, François-Honoré, opened a business, under the name 'Jacob-Desmalter et Cie', which reaped the favour of the king, completing numerous furnishings for the imperial residence. In 1813, the company went bankrupt. Georges Jacob died in ruins in his house on Rue Meslée.

544. **Georges Jacob**, 1739-1814, French.
Commode (detail), c. 1792-1795.
Mahogany, satinwood, and kingwood,
wood patinated like bronze, ivory, carved bronze, marble.
Private collection. Louis XVI style.

545. **Anonymous.**
Travel secretary, c. 1795-1800.
Mahogany, stainless steel, gilded bronze, 104 x 74 x 32 cm.
Musée des Arts décoratifs, Paris.

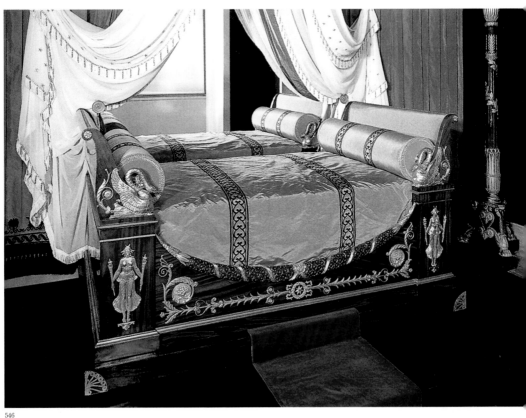

546

546. **Jacob Frères**, 1768-1803 and 1770-1841, French.
Bed of Madame Récamier, c. 1799.
Mahogany, gilded and patinated bronze, 100 x 133 x 100 cm.
Musée du Louvre, Paris. Louis XVI style.

547. **Anonymous.**
Woodwork at the lounge of the hotel Talairac, c. 1790.
Painted and gilded oak and conifer wood, mantle of cherry-red marble and gilded bron
Musée des Arts décoratifs, Paris.

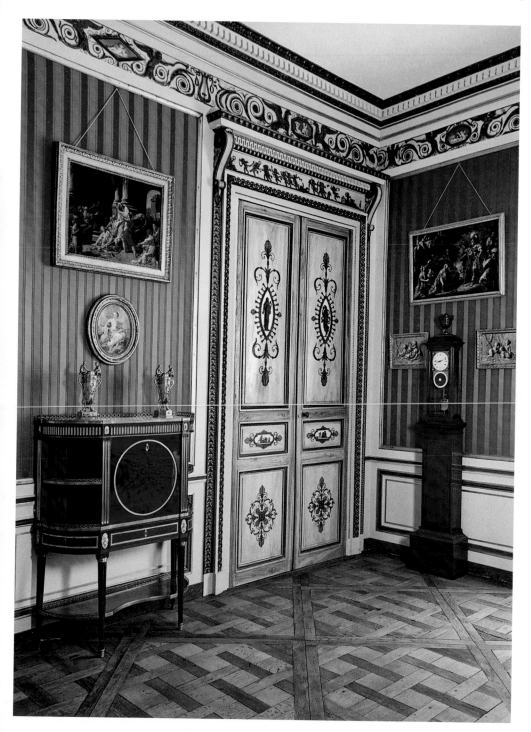

548

MODERN PERIOD

"One can argue the merits and the future of the new decorative art movement, but there is no denying it currently reigns triumphant over all Europe and in every English-speaking country outside Europe; all it needs now is management, and this is up to men of taste" (Jean Lahor, Paris 1901). Art Nouveau sprang from a major movement in the decorative arts that first appeared in Western Europe in 1892, but its birth was not quite as spontaneous as is commonly believed. Decorative ornament and furniture underwent many changes between the waning of the Empire Style around 1815 and the 1889 World Exhibition in Paris celebrating the centennial of the French Revolution. For example, there were distinct revivals of Restoration, Louis-Philippe, and Napoleon III furnishings still on display at the 1900 World Exhibition in Paris. Tradition (or rather imitation) played too large a role in the creation of these different period styles for a single trend to emerge and assume a unique mantle. Nevertheless there were some artists during this period that sought to distinguish themselves from their predecessors by expressing their own decorative ideal.

What then did the new decorative art movement stand for in 1900? In France, as elsewhere, it meant that people were tired of the usual repetitive forms and methods, the same old decorative clichés and banalities, the eternal imitation of furniture from the reigns of monarchs named Louis (Louis XIII to XVI) and furniture from the Renaissance and Gothic periods. It meant designers finally asserted the art of their time as their own. Up until 1789 (the end of the *Ancien Régime*), style had advanced by reign; this era wanted its own style. And (at least outside of France) there was a yearning for something more: to no longer be slave to foreign fashion,

taste, and art. It was an urge inherent in the era's awakening nationalism, as each country tried to assert independence in literature and in art. In short, everywhere there was a push towards a new art that was neither a servile copy of the past nor an imitation of foreign taste.

There was also a real need to recreate decorative art, simply because there had been none since the turn of the century. In each preceding era, decorative art had not merely existed; it had flourished gloriously. In the past, everything from people's clothing and weapons, right down to the slightest domestic object – from andirons, bellows, and chimney backs, to one's drinking cup – were duly decorated: each object had its own ornamentation and finishing touches, its own elegance and beauty. But the 19th century had concerned itself with little other than function; ornament, finishing touches, elegance, and beauty were superfluous. At once both grand and miserable, the 19th century was as 'deeply divided' as Pascal's human soul. The century that ended so lamentably in brutal disdain for justice among peoples had opened in complete indifference to decorative beauty and elegance, maintaining for the greater part of one hundred years a singular paralysis when it came to aesthetic feeling and taste. The return of once-abolished aesthetic feeling and taste also helped bring about Art Nouveau. France had come to see through the absurdity of the situation and was demanding imagination from its stucco and fine plaster artists, its decorators, furniture makers, and even architects, asking all these artists to show some creativity and fantasy, a little novelty and authenticity. And so there arose new decoration in response to the new needs of new generations.

The definitive trends capable of producing a new art would not materialise until the 1889 World Exhibition.

548. **Alphonse Fouquet**, **Paul Grandhomme**, and **Charles Béranger**,
1828-1911, 1851-1944, and 1816-1853, French.
The Lady of the Castle, *Bianca Cappello*, 1878.
Chased gold, enamel painted on mother-of-pearl, rose-cut diamond, 8.7 x 7 cm.
Musée des Arts décoratifs, Paris. Neo-antique style.

There the English asserted their own taste in furniture; American silversmiths Graham and Augustus Tiffany applied new ornament to items produced by their workshops; and Louis Comfort Tiffany revolutionised the art of stained glass with his glassmaking.

An elite corps of French artists and manufacturers exhibited works that likewise showed noticeable progress: Emile Gallé sent furniture of his own design and decoration, as well as coloured glass vases in which he obtained brilliant effects through firing; Clément Massier, Albert Dammouse, and Auguste Delaherche exhibited flambé stoneware in new forms and colours; and Henri Vever, Boucheron, and Lucien Falize exhibited silver and jewellery that showed new refinements. Everything was culminating into a decorative revolution. Free from the prejudice of high art, artists sought new forms of expression. In 1891, the French Societé Nationale des Beaux-Arts established a decorative arts division.

The rise of Art Nouveau was no less remarkable abroad. In England, Liberty shops, Essex wallpaper, and the workshops of Merton-Abbey and the Kelmscott-Press under the direction of William Morris (to whom Edward Burne-Jones and Walter Crane provided designs) were extremely popular.

The 1925 Exhibition contained a classification never before seen in previous exhibitions: that of furniture sets. Architects had given up composing pieces of furniture as Robert de Cotte had done, creating pieces for Versailles, Jean-François Heurtier, and Charles François Darnaudin in arranging the Louis XVI library, and Charles Percier in designing the cradle for the King of Rome. The architect limited his domain to permanent decoration later supplemented by the tapestry-maker; in this setting, the cabinetmaker would later place his pieces of furniture. Such a concept would lead to a triple failure: the stylish decorations made in advance by the architect could hardly lend themselves to the work of the tapestry-maker or to the presentation of the cabinetmakers' models. The cause of this discordance has to be sought in the generalisation of rented apartments. A permanent residence, such as the old

mansions of the 18th century, needed an ephemeral decoration, no longer suitable for a rented apartment, which hosted new tenants every three, six, or nine years. It is to the honour of some architects to have revived, at the end of the 19th century, the past tradition of designing an entire interior. Thus, at the Exposition Universelle of 1900, in the French section, furniture sets could be seen, particularly those of Plumet made in collaboration with cabinetmaker Tony Selmersheim. The first interior designers, being architects, tended to convert the furniture into permanent decoration by connecting the book-cases to the skirting boards, the divans to the book-cases, and even the tables to the divans. A particular piece of furniture thus lost its movable nature and simply became part of the architecture.

Of all the industries that are related to finery, jewellery is the one that most clearly belongs to the decorative arts. In the past, jewellers would be linked with goldsmiths' guilds. Their art had an impact on sculpture and decoration. The price and the long life span of the stones and metals give the jewels an immortality that clothing, hats, and vanity accessories lack, worn for one season and forgotten about soon after. But only seemingly so. The value of the material, far from preserving the jewels, leads them to certain destruction. Portraits and rare drawings only enable us to imagine what the tags of Anne of Austria looked like, the necklace of the Queen, the diadem of Josephine or that of Empress Eugenie. A collector of antiquarian jewels can hardly put in his showcase anything but items of minor quality and importance; all the others had become obsolete. At all times the daughters wished a new mounting for the precious stones of their mothers. Since the Revolution, more frequent breaks in tradition, and more sudden and greater displacements of private fortune accelerated these transformations. The jewellery presented by the French section was generally designed according to the 'modern' spirit, from which the Exhibition took its inspiration. The sketches that were visibly inspired by an antique style or that evoked the decorative style fashionable after 1900 had been eliminated. It was a great service rendered to the French jewellery trade, forced to find a new style.

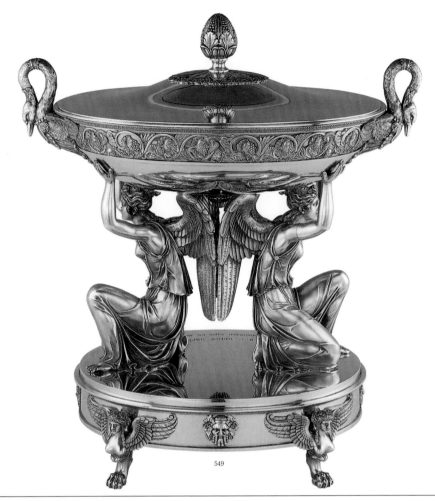

549

Jean-Baptiste-Claude Odiot
(Paris, 1763-1850)

Son of the goldsmith Jean Claude Odiot, Jean-Baptiste-Claude Odiot worked at the family workshop alongside his father until his death in December 1788. His work represents a return to the antique style and is heralded as the best of the French goldsmiths.

After the induction of a law on 15 September 1798, which forbade the export of gold or silver materials, Jean-Baptiste-Claude lost his work and enrolled in the army. He continued his goldsmithing during the imperial period, reaching the height of his fame in 1811. He obtained many commissions from the emperor and his family, such as the sceptre (found at Fontainebleau) and the coronation sword, the cradle for the King of Rome, a service for Pauline Borghese and Madame Mère, as well as furnishings and decorative items for the toilet for Empress Marie Louise, fully executed in silver-gold.

Louis XVIII bestowed upon him the National Order of the Legion of Honour during the Restoration.

His son, Charles Nicolas, who excelled in the application of Rococo-motifs, took after him, becoming the main contractor for Louis Philippe and the royal family of Orléans.

549. Jean-Baptiste-Claude Odiot, 1763-1850, French.
Soup tureen, 1819.
Bronze silver-plated with galvanoplasty, Christofle Manufacturer, 52 x 49 x 27.7 cm.
Musée des Arts décoratifs, Paris. Restoration style.

550

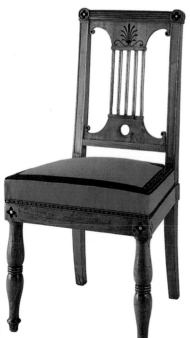

551

550. **Guillaume Martin Biennais**, 1764-1843, French.
Bed table with toiletries, c. 1800.
Mahogany, silver, gilded silver, crystal, and ivory.
Musée national du château de Malmaison, Rueil-Malmaison. Empire style.

551. **Jacob-Desmalter**, 1770-1841, French.
Chair, after 1803.
Walnut, ebony inlay, and tin.
Musée des Arts décoratifs, Paris. Empire style.

552. **Anonymous.**
Standing mirror, c. 1810.
Mahogany veneer, gilded bronze.
Musée des Arts décoratifs, Paris. Empire style.

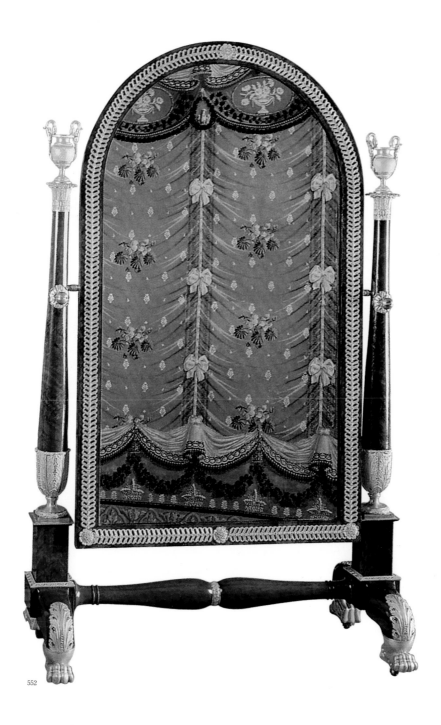

552

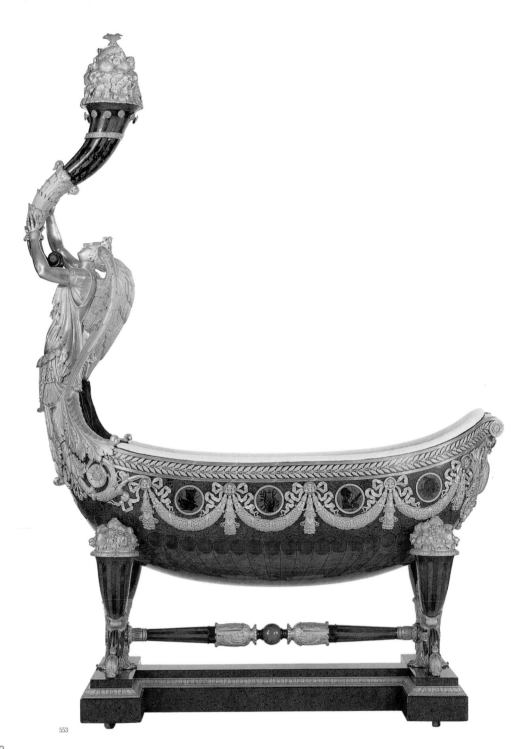

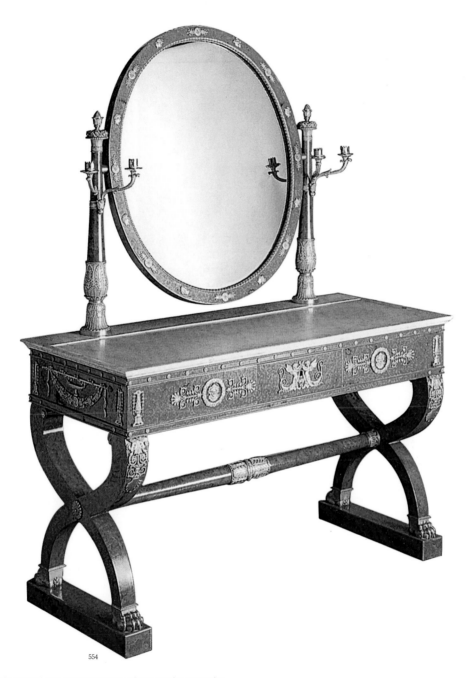

554

553. **Félix Rémond, Jean-François Denière**, and **François Thomas Matelin**,
1779 - after 1860, 1774-1866, and 1759-1815, French.
Duke of Bordeaux's ceremonial cradle, 1819.
ak, ash burl veneer and inlay, walnut and kingwood, gilded bronze, 226 x 126 x 64 cm.
Musée des Arts décoratifs, Paris. Restoration style.

554. **Félix Rémond**, 1779 - after 1860, French.
The Queen's dressing table, c. 1823.
Oak, elm burl and amboyna burl veneer, gilded bronze, white marble.
Musée des Arts décoratifs, Paris. Restoration style.

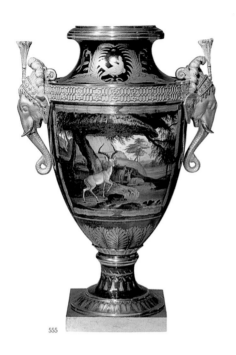

555

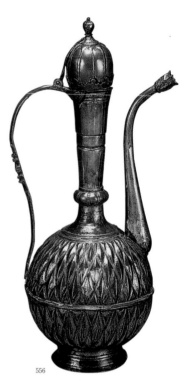

556

555. **Jean-Charles Develly**, 1783-1862, French.
'Clodion' vase, Sèvres, 1817.
Hard-paste porcelain, gilded bronze, height: 76 cm; width: 55 cm.
Musée du Louvre, Paris. Louis XVI style.

556. **Anonymous.**
'Tombak' water pitcher, Turkey, 19th century.
Gilded copper on mercury, 41 cm.
Prince Naguib Abdallah's Collection. Eastern.

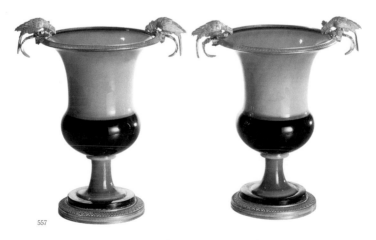

557

557. **Bercy Manufactory** (?), 1827-1867, French.
A pair of Medici vases, 1815-1830.
Handblown bicolour crystal and ormolu, height: 23.5 cm; diameter: 15 cm.
Musée des Arts décoratifs, Paris. Classicism inspired by antiquity.

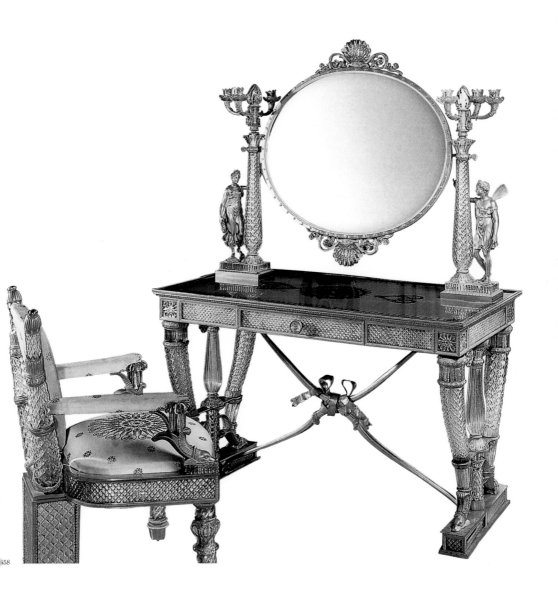

558. Anonymous.
Dressing table and chair, c. 1819.
Crystal, verre églomisé, gilded bronze, 78 x 122 x 64 cm.
Musée du Louvre, Paris. Restoration style.

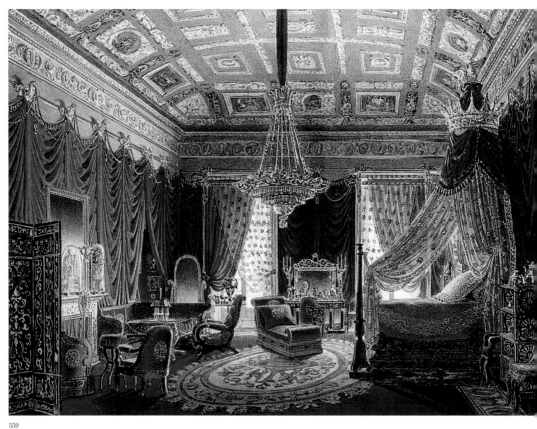

559

559. **Anonymous.**
Design for a bedroom, c. 1835.
Watercolour.
Musée des Arts décoratifs, Paris.

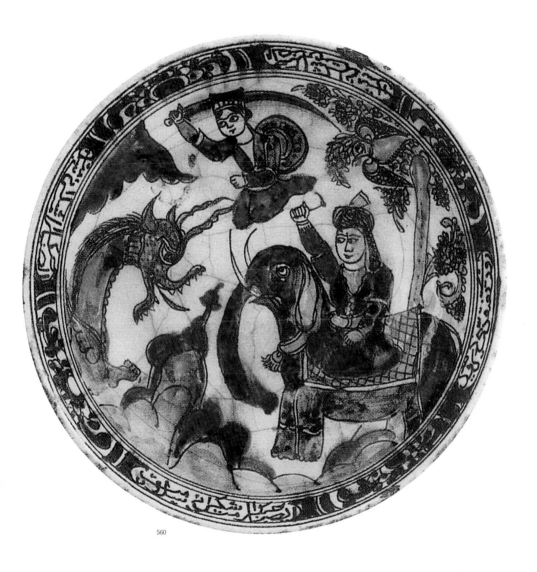

560

560. **Anonymous.**
Plate, 19th century.
Faience, decoration painted under glaze, diameter: 21.4 cm.
The State Hermitage Museum, St Petersburg. Persian.

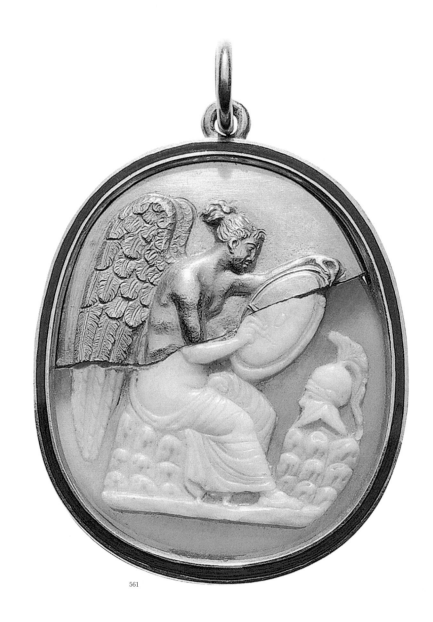

561

561. Anonymous.
Pendant, France, beginning of the 19th century.
Gold, hard-stone cameo, enamel, 4.5 x 3.2 x 4 cm.
Musée des Arts décoratifs, Paris. Restoration style.

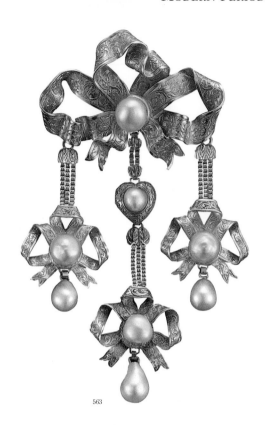

563

562

562. Anonymous.
Bracelet, France, Restoration period.
Embossed and gilded copper, coloured glass.
Musée des Arts décoratifs, Paris. Restoration style.

563. Anonymous.
Bows brooch, Paris, 1819-1838.
Gold, baroque pearls, height: 19 cm.
Musée des Arts décoratifs, Paris. Restoration style.

564. Anonymous.
Hairpin, 19th century.
Silver, glass.
Musée des Arts décoratifs, Paris. Restoration style.

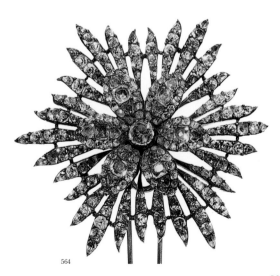

564

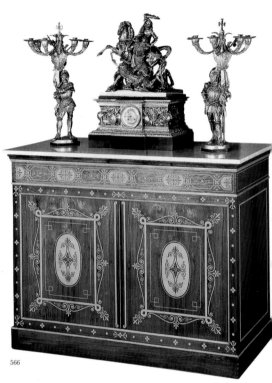

566

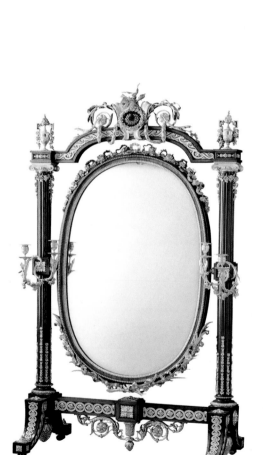

565

565. **Alexandre Georges Fourdinois**, 1799-1871, French.
Empress Eugénie's standing mirror, 19ᵗʰ century.
Mahogany and gilded bronze, 232 x 127 cm.
Musée national du château de Compiègne, Compiègne. Second Empire style.

566. **Georges-Alphonse Jacob-Desmalter**, 1799-1870, French.
Two-door library cabinet, lower part, 1832.
Veneer in palisander and rosewood, white marble, 110 x 180 cm.
Musée du Louvre, Paris. Empire style.

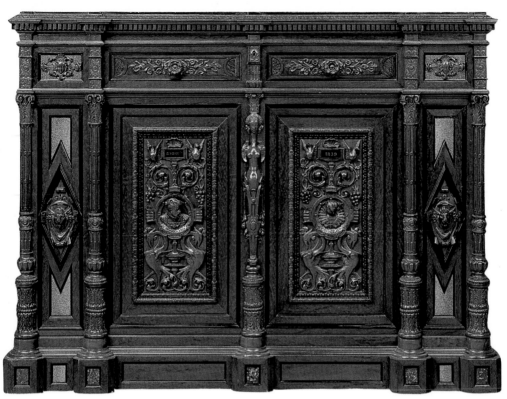

567

Guillaume Grohé
(Wintersheim, 8 February 1808-1885)

Born the son of a farmer in the Grand Duchy of Hessen, Guillaume Grohé and his brother Jean Michel moved to Paris in 1827, where he began his work as a cabinetmaker. In 1829, he began a manufacturing and purchasing firm.

A worthy follower of Boulle, Grohé was a talented artist and quickly attained a good reputation, specialising in his style of furniture.

In 1849, he received the National Order of the Legion of Honour, becoming an Officer.

Grohé was a master of modern carpentry, completing furniture for the royal house. He received commissions from King Louis Philippe, Empress Éugenie, and Napolean III. He was the main contractor to the queen of England, Madame Marguerite Pelouze, for the furnishings done at Chenonceau, and the Duke of Aumale, for the manufacture of furniture at Chantilly.

Afterwards, he participated in the World's Exhibition, acting as Vice President and Juror.

His work is currently found in several museums, such as the Louvre, the Musée du Château de Fontainebleau, the Musée Condet, and Carnavalet.

567. **Guillaume Grohé**, 1808-1885, French.
Secretary-commode, Paris, 1839.
Rosewood, ebony, end-cut palmwood, and marble, 100 x 120 cm.
Musée du Louvre, Paris. Renaissance.

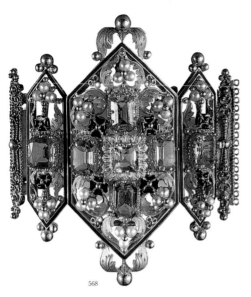

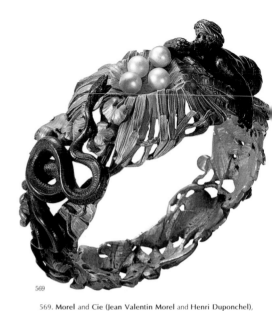

568. Anonymous.
Middle piece of a bracelet, Paris, after 1838.
Gold, topaz, pearls, and enamel, 7.5 x 6.8 cm.
Musée des Arts décoratifs, Paris.

569. Morel and **Cie (Jean Valentin Morel** and **Henri Duponchel),
Jean-Baptiste Klagmann,** and **Milleret,** 1794-1860, 1794-1868, 1810-1867, Fren
Bracelet model, 1842-1848.
Glass pearls, coated with ivory, two-tone gilt bronze, yellow and green ormolu, diameter:
Musée des Arts décoratifs, Paris.

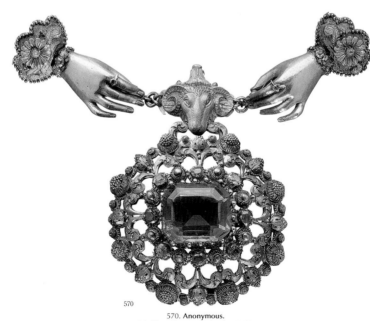

570. Anonymous.
Necklace, forepart, Paris, after 1838.
Gold of various colours, gilded silver, amethyst, rubies,
emeralds in cannetille and graineti, height: 8 cm; diameter: 4 cm.
Musée des Arts décoratifs, Paris.

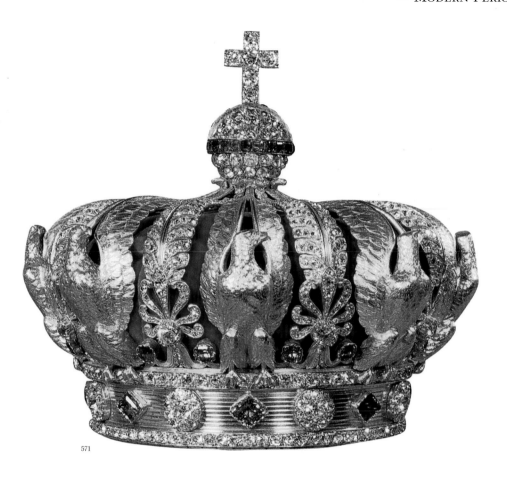

571

Alexandre-Gabriel Lemonnier
(1808-1884)

Following the World Exhibition of 1851, the jeweller Alexandre-Gabriel Lemonnier received the Medal of Council and the Legion of Honour for his works and was appointed Jeweller to the Prince-President Napoleon III. He supplied several jewels for the emperor's wedding to Eugénie. Finally, in 1853, he was appointed Jeweller to the Crown, creating two crowns for the empress. The first contained stones from the crown of Charles X, which was replaced in 1855 by a simpler crown, as the empress desired a smaller, simpler, and lighter one. It contains 2,424 diamonds and fifty-six emeralds. With this item, Lemonnier won the silver medal at the World Exhibition in 1855.

571. **Alexandre-Gabriel Lemonnier**, 1808-1884, French.
Empress Eugénie's crown, Paris, 1855.
Gold, diamonds, and emeralds, height: 13 cm; diameter: 15 cm.
Musée du Louvre, Paris. Empire style.

572

573

572. **William Morris**, 1834-1896, English.
The Red House, 1860.
Bexleyheath, London.
Arts and Crafts Movement.

573. **Philip Speakman Webb** (original idea), 1831-1915, English.
Corridor in the living quarters, 1860.
The Red House, Bexleyheath, London.
Arts and Crafts Movement.

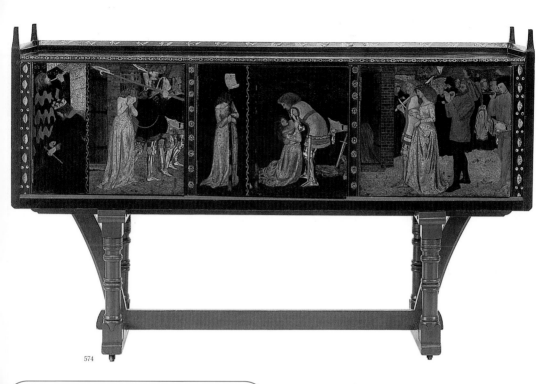

574

Philip Speakman Webb
(Oxford, 1831 – Worth, 1915)

Philip Speakman Webb was an architect and one of the leading members of the Arts and Crafts Movement. Born in Oxford on 12 January 1831, he relocated to London to work as an assistant in the office of the Gothic-Victorian architect George Edmund Street. Thereby, Webb met William Morris in 1856, who had been actively working there for nine months. The two would establish a life-long friendship and partnership. In the later 1850s, he travelled with Charles Faulkner to France. A year later, the young architect designed the Red House in Bexleyheath, Kent for his friend William Morris.

Webb participated in 1861 in the founding of the firm Morris, Marshall, Faulkner and Co.

Between 1892 and 1894, he designed and built the Standen House for London-based lawyer James Beale. Webb retired in 1901, moved from London to the countryside in Worth, West Sussex, where he lived until his death in 1915. In contrast to his friend William Morris, Webb never published anything regarding his philosophy about architecture. However, we can still see its influence in various pieces of furniture and stained-glass windows.

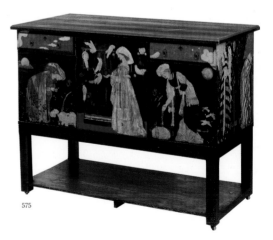

575

574. **Philipp Speakman Webb** (design), **Morris, Marshall, Faulkner & Co.** (manufacturing), 1831-1915 and 1861-1875, English. St George cabinet, 1861. Painted and gilded mahogany, pine and oak with copper mounts, 111 x 178 x 43 cm. Victoria and Albert Museum, London. Arts and Crafts Movement.

575. **Edward Burne-Jones**, 1833-1898, English. Sideboard, *Ladies and Animals*, 1860. Pine, painted with oil, with gold and silver leaf, 116.8 x 152.4 x 73.7 cm. Victoria and Albert Museum, London. Arts and Crafts Movement.

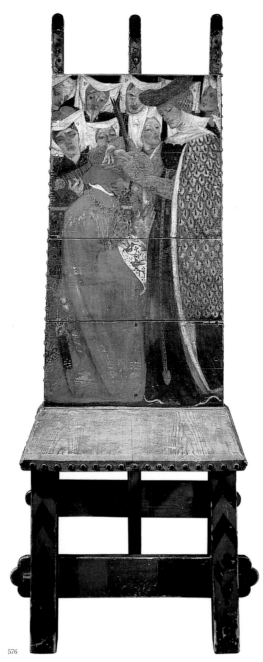

576. **William Morris, Edward Burne-Jones**, and **Dante Gabriel Rossetti**,
1834-1896, 1833-1898, and 1828-1882, English.
Chair from Red Lion Square, c. 1857.
Wood and oil painting, 90 x 40 x 40 cm.
Private collection. Arts and Crafts Movement.

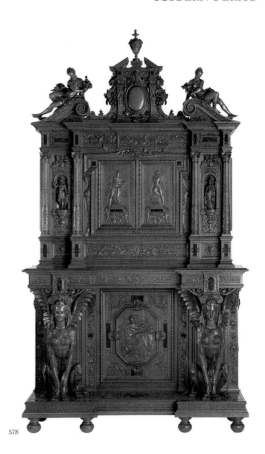

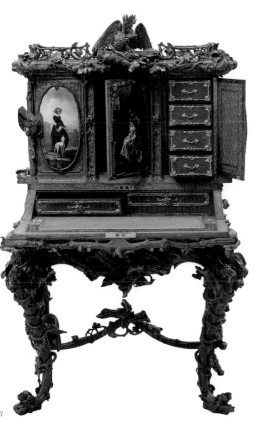

578

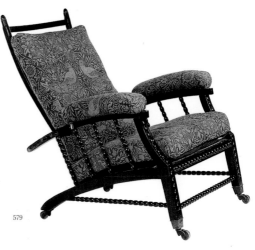

577. Alphonse Giroux and **Cie**, c. 1799-1867, French.
Empress Eugénie's *bonheur-du-jour* writing desk, 1855.
Carved linden wood, rosewood, ormolu, porcelain plates.
Musée national du château de Compiègne, Compiègne.

578. Henri Auguste Fourdinois, 1830-1907, French.
Renaissance cabinet, 1867.
Carved walnut, lapis lazuli, jasper, ivory, and silver inlay, 253 x 143 x 60 cm.
Musée des Arts décoratifs, Paris. Classicism inspired by the Renaissance.

579. Morris, Marshall, Faulkner & Co, 1861-1875, English.
Adjustable chair, c. 1866.
Mahogany, upholstered in velvet from Utrecht, 96.5 x 73.7 x 83.8 cm.
Victoria and Albert Museum, London. Arts and Crafts Movement.

579

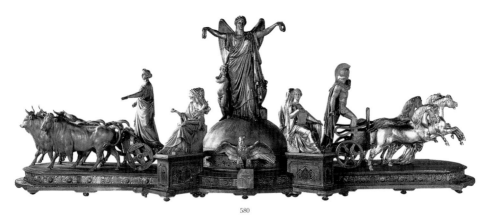

580

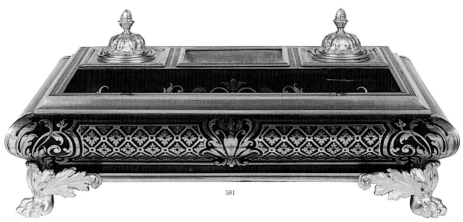

581

Henri Dasson
(Paris, 1825-1896)

Son of a shoemaker, the Paris-born Henri Dasson would quickly became the most famous cabinetmaker and bronzer of the second half of the 19th century. He successfully followed in the footsteps of the cabinetmaker Charles Winckelsen from Rue Vielle du Temple.

His furniture, decorated in bronze, inlaid, or lacquered panels reinvigorated the Louis XIV, Louis XV, and Louis XVI styles. After perfecting his craft, Dasson soon came under scrutiny of critics, receiving international recognition and great prizes, eventually becoming Legion Rider in 1883 and Officer in 1889.

The characteristic of his art comes from the originality of his creations, inspired by the 18th century, possessing much refinement and varied scenery, an exceptional quality of carving, use of varnish, Cuban mahogany, kingwood, and glass.

Henri Dasson participated in the World Exhibition of 1878, receiving the highest prize for his copy for Louis XV's desk, a masterpiece of carving. Lastly, he received the main prize at the World Exhibition in 1889.

Dasson ended his work in 1894.

580. **Christofle Manufactory, François Gilbert, Georges Diebolt,**
and Pierre-Louis Rouillard, 1816-1891, 1816-1861, and 1820-1881, French.
Table setting centrepiece, 1852-1856.
Galvanic bronze and silver-plated bronze, 100 x 292 x 105 cm.
Musée des Arts décoratifs, Paris. Neo-classiscism.

581. **Henri Dasson,** 1825-1896, French.
Inkwell, Napolean III period.
Boulle inlay and gilded bronze.
Second Empire style.

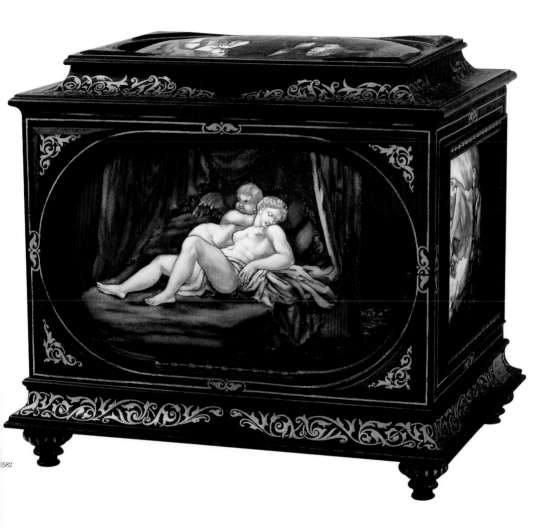

582

582. **Jacob Meyer-Heine**, 1805-1879, French.
Chest: *The Story of Psyche*, 1865.
Wood, painted enamel plates on copper, 24.5 x 27.3 cm.
Musée national de la Céramique, Sèvres. Second Empire style.

583

583. **Eugène Fontenay**, 1823-1887, French.
Earrings, 1867.
Gold, jade.
Musée des Arts décoratifs, Paris. Second Empire style.

584. **Eugène Fontenay**, 1823-1887, French.
Earring, 1867-1882.
Gold, lapis lazuli, 7.5 x 2.5 cm.
Musée des Arts décoratifs, Paris. Second Empire style.

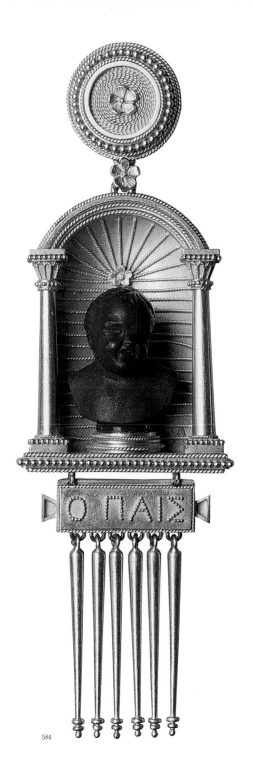

584

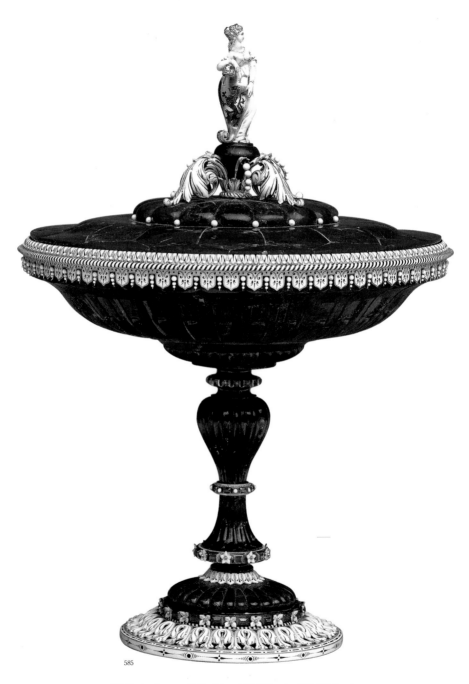

585. **Charles Duron** and **Sollier Frères**, 1814-1872 and c. 1837-1867, French.
Cup, 1867.
Gold, enamel, lapis lazuli, and precious stones, height: 21 cm.
Musée d'Orsay, Paris. Second Empire style.

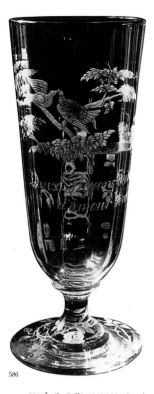

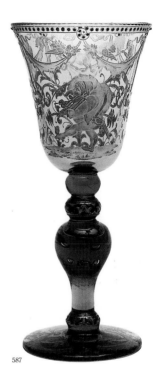

586

587

586. **Émile Gallé,** 1846-1904, French.
Vase with two doves, 1871.
Height: 16 cm.
The Bowes Museum, Barnard Castle, County Durham. Art Nouveau.

587. **Émile Gallé,** 1846-1904, French. Ceremonial glass, c. 1867-1876.
Smoked glass, wheel-engraved decoration, enamelled and gilded,
polychrome opaque enamel with gold relief, height: 23.3 cm; diameter: 10.9 cm.
Musée d'Orsay, Paris. Art Nouveau.

588. **Émile Gallé,** 1846-1904, French.
Glasses with heraldic decoration, c. 1868-1870.
Transparent glass, enamelled and gilded decoration,
polychrome opaque enamel with gold relief, height: 9.5; diameter: 5.5 cm.
Musée d'Orsay, Paris. Art Nouveau.

HAST thou longed through weary days
For the sight of one loved face
Hast thou cried aloud for rest,
Mid the pain of sundering hours
Cried aloud for sleep and death
Since the sweet unhoped for best
Was a shadow and a breath —
O, long now for no fear lowers
O'er these faint feet-kissing flowers
O, rest now; and yet in sleep
All thy longing shalt thou keep.

Thou shalt rest, and have no fear
Of a dull awaking near,
Of a life for ever blind,
Uncontent and waste and wide,
Thou shalt wake, and think it sweet
That thy love is near and kind.
Sweeter still for lips to meet;
Sweetest, that thine heart doth hide
Longing all unsatisfied
With all longings answering
Howsoever close ye cling

589

590

A BOOK OF VERSE
BY
WILLIAM MORRIS

WRITTEN IN LONDON
1870

591

589. **William Morris**, 1834-1896, English.
Detail of *Love Fulfilled*, Poem from *A Book of Verse*, 1870.
Poem was written as a gift for Georgiana Burne-Jones.
Arts and Crafts Movement.

590. **William Morris**, 1834-1896, English.
A Book of Verse, 1870.
First page.
Victoria and Albert Museum, London. Arts and Crafts Movement.

591. **William Morris**, **Charles Fairfax Murray**, **Louise Powell**, **and Graily Herw**
1834-1896, 1849-1919, 1882-1956, and 1864-1952, English.
The Story of the Valiant Frithiof, c. 1873.
Watercolour and gilding on paper, 40.1 x 53 cm.
Paul Getty Library, Wormsley. Arts and Crafts Movement.

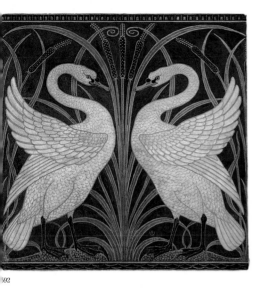

592

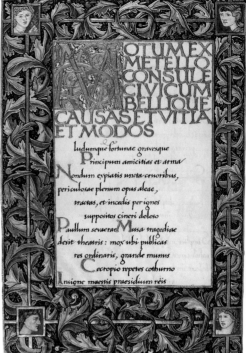

593

WALTER CRANE
(Liverpool, 1845 – Horsham, 1915)

Walter Crane was born in Liverpool in 1845. He was a British portrait, figure, and landscape painter.

He is considered one of the best illustrators of children's books and agreed with the Arts and Crafts Movement.

In January 1859, Crane began, at the age of thirteen, his three-year apprenticeship with Linton. He studied alongside him, the work of the Pre-Raphaelites Rossetti, Millais, and Burne-Jones and that of the old Italian masters. Ruskin's writing about the beauty and usefulness of art and dignity of crafters influenced him significantly.

After the completion of his apprenticeship, Crane attempted to start working. His work, from this period, consists of vignettes, landscape, and groups of people in formal attire. Crane learned to simplify the details.

In 1863, Crane met the book printer Edmund Evans, with whom he would develop a large portion of his creative work. Next, he drew a book cover for cheap, travel book for Evans. From 1865, he began to publish his own series on prize-worthy, colourful picture books, including *Sing a Song of Sixpence*, which he extended to over fifty titles over the next fifty years. His already famous illustrations influenced the appearance of children's literature in Great Britain during the 19th century. As Morris wanted to include art in the daily lives of all classes, he focused his attention on textiles, tapestries, and home decor.

Crane founded the Arts and Crafts Exhibition Society in 1888, for which he acted as President.

In 1894, he worked in the Kelmscott Press, with William Morris on the illustration for the fantasy novel *The Story of the Glittering Plain*. He wrote important books on decoration and presentation.

Walter Crane died on 1915 in Horsham, Sussex.

592. **Walter Crane**, 1845-1915, English.
Swans, design for wallpaper, 1875.
Gouache and watercolour, 53.1 x 53 cm.
Victoria and Albert Museum, London. Art Nouveau.

593. **William Morris**, 1834-1896, English.
Odes of Horace, 1874.
Manuscript.
Bodleian Library, University of Oxford, Oxford. Arts and Crafts Movement.

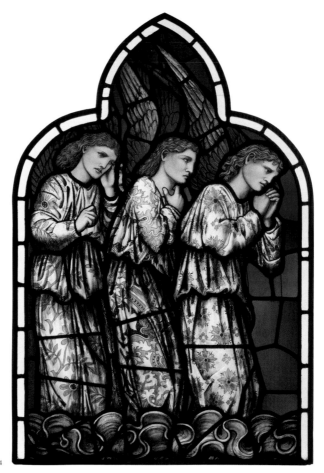

594

Edward Coley Burne-Jones
(Birmingham, 28 August 1833 – London, 17 June 1898)

Burne-Jones complete life's work presents his continuous attempt to achieve perfect beauty. Typically, Burne-Jones is considered a Pre-Raphaelite although he was not a founding member of the Pre-Raphaelite Brotherhood.

Burne-Jones' production in the second half of the 19th century closely resembled Rossetti's style. No other British artist – from Constable to Francis Bacon – enjoyed such international fame as Burne-Jones. In retrospect, his superficial portrayals and avoidance of narratives are good characteristics of the early modern style and present the first step into the abstract movement.

It is probably no wonder that Vassily Kandinsky (1866-1944), in his book *Über das Geistige in der Kunst* (*Concerning the Spiritual in Art*), describes Rossetti and Burne-Jones as forbearers of abstract art.

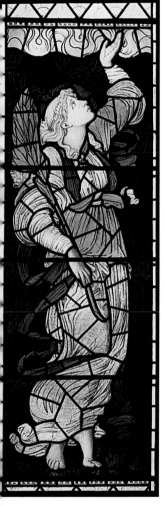
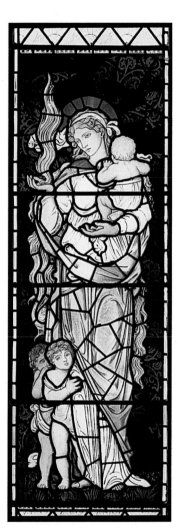
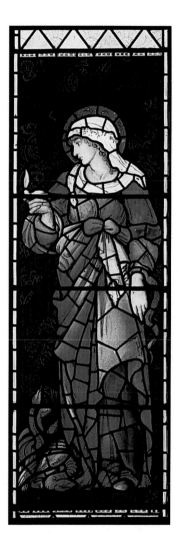

95

594. **Dante Gabriel Rossetti** or **Edward Burne-Jones** and **Morris, Marshall, Faulkner & Co.**, 1828-1882, 1833-1898, and 1861-1875, English.
Three Angels, 1870.
Reconstructed stained glass window, from the east facade
of the St James Church in Brighouse (destroyed).
Bradford Museums, Galleries & Heritage, Bradford. Arts and Crafts Movement.

595. **Edward Burne-Jones**, 1833-1898, English.
Faith, Hope, and Charity, 1889.
Stained glass window.
St Martin's Church, Brampton. Arts and Crafts Movement.

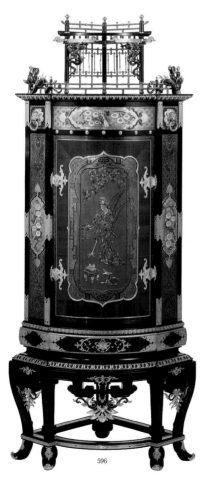

596

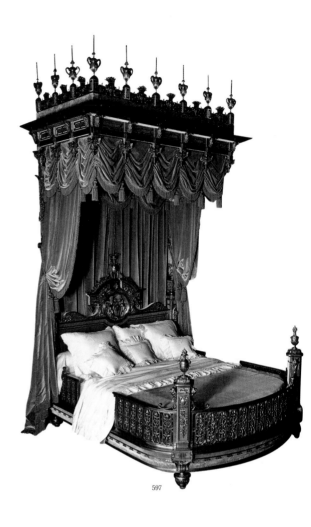

597

596. **Christofle Manufactory** and **Émile Reiber** (design),
1830 - currently active and 1826-1893, French.
Corner cabinet, 1874.
Main piece of ebony, palisander and blackened pear-tree wood, door of gilded or
patinated galvanic bronze, copper, silver, gold, enamel cloisonné, 195 x 95 x 63 cm.
Musée des Arts décoratifs, Paris. Second Empire style.

597. **Édouard Lièvre**, 1829-1886, French.
Valtesse de la Bigne's bed, 1877.
Patinated bronze, 410 x 260 x 200 cm.
Musée des Arts décoratifs, Paris. Second Empire style.

ALPHONSE FOUQUET
(1828-1911)

A famous jeweller in the 19th century born in a merchant family, Alphonse Fouquet entered a jewellery-making workshop at the age of eleven. After his apprenticeship with Renouvat, at age nineteen, he began to decorate his own jewellery with pencil and gouache on sketchpaper. Through and through, he developed his own style, eventually finishing his jewellery in leather, ribbon, decorated with flowers.

The women of the 19th century loved to wear jewellery with harmonious ornamentation and stones. Fouquet's jewellery contradicted this in a sense. The large size and the generally-framed portraits with carved figures or women or fantastic animals were done similarly to those of the 16th century. The jewellery designers of the 19th century were inspired by those of the Middle Ages and the Renaissance.

Alphonse Fouquet created numerous bracelets, brooches, necklaces, tiaras, pins, and ornate corsages.

From 1862 to 1868, he led a workshop that manufactured an innovative series of jewellery with stones such as turquoise, lapis lazuli, pearls, sapphires, and topazes.

He triumphed at the World Exhibition of 1878 with its Renaissance-inspired jewellery made in collaboration with sculptors of the time.

His son George succeeded him. He focused more on Art Nouveau style, and collaborated with Alphonse Mucha.

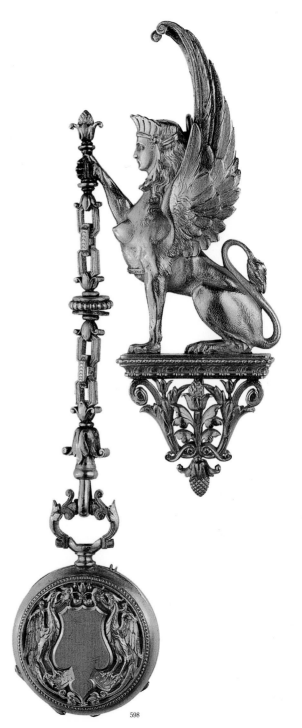

598. **Alphonse Fouquet**, 1828-1911, French.
Clock and Sphinx chatelaine, 1878.
Chased gold, 12.7 x 1.5 cm.
Musée des Arts décoratifs, Paris. Inspired by the Renaissance.

598

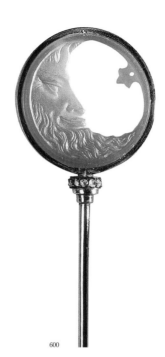

600

600. **Petit** for Frédéric Boucheron, French.
Tie pin, *The Sun*, 1880.
Gold, two-layered carnelian, silver, rose cut diamonds.
Musée des Arts décoratifs, Paris. Art Nouveau.

599

601

599. **Louis Rouvillois** for Frédéric Boucheron, French.
Tie pin, *Victory*, 1877.
Enamel on the backside, gold,
painted enamel, carnelian intaglio.
Musée des Arts décoratifs, Paris. Art Nouveau.

601. **Louis Rouvillois** for Frédéric Boucheron, French.
Tie pin with double-sided scarab, 1878.
Sapphire, carved and trimmed with gold threads and rose-cut diamonds
on silver, pin of gold, height: 8.5 cm; pin: 1.9 x 1.5 cm.
Musée des Arts décoratifs, Paris. Art Nouveau.

602

603

GAbRiEL VIARdOT
(1830-1906)

Gabriel Viardot is one of the most valued cabinetmakers of the end of the 19th century. As one of the first cabinetmakers with far-east influences, Viardot was an example for many other artists.

In the 1850s, he and his brother opened a store in Paris under the name Viardot Frères and Co. Due to Renaissance-style furniture, the two brothers earned a second class medal at the Paris World Exhibition of 1855.

In 1860, he separated from his brother and opened his own workshop. It is known that in 1875 Viardot worked daily with about ninety to hundred men and that he created a vitrine for the presentation of Clémence d'Ennery's eastern collection.

His luxurious pieces, of extraordinary quality, were the result of the substantial progress in the decorative arts area. He used ivory, pearls from Tonkin, and panel with Japanese lacquer.

His talent was frequently rewarded, hence his four medals in 1867, the silver medal in 1878, and the four gold medals from the World Exhibitions in Antwerp, Nice, and Paris.

Viardot died in 1906. His workshop continued under the leadership of his children.

602. **Maison Soufflot fils**, founded in 1867, French.
Brooch, Paris, 1878.
Rhinestones, gold setting, box in navy blue leather, 7 x 11 cm.
Musée des Arts décoratifs, Paris.

603. **Gabriel Viardot** (attributed to), 1830-1906, French.
Mirror, c. 1880.
Sycamore, glass, 175 x 120 cm.
Musée des Arts décoratifs, Paris. Art Nouveau.

604

604. **Auguste Rodin** and the **Sèvres Manufactory**, 1840-1917 and 1740 - currently active, French.
Saigon vase, *The Abduction*, 1880-1881.
Hard-paste porcelain, height: 23 cm; diameter: 13 cm.
Château-musée de Boulogne-sur-Mer, Boulogne-sur-Mer.

605

606

605. **Auguste Rodin** and the **Sèvres Manufactory**,
1840-1917 and 1740 - currently active, French.
Saigon vase, *The Elements*, 1879-1880.
Hard-paste porcelain, height: 19 cm; diameter: 10 cm.
Musée national de la Céramique, Sèvres. Inspired by the Japansese style.

606. **Sèvres Manufactory**, 1740 - currently active, French.
Blois pitcher, 1880-1883.
Hard-paste porcelain, enamel, gilded and customised decoration
from Lauth-Vogt, 42 x 27 cm.
Musée des Arts décoratifs, Paris.

607

608

607. **Auguste Rodin** and the **Sèvres Manufactory**,
1840-1917 and 1740 - currently active, French.
Plate, *Air and Water*, 1879-1880.
Hard-paste porcelain, diameter: 30 cm.
Musée national de la Céramique, Sèvres.

608. **Auguste Rodin** and the **Sèvres Manufactory**,
1840-1917 and 1740 - currently active, French.
Chinese antique vase, *Mythology*, 1880-1882.
Hard-paste porcelain, height: 35 cm; diameter: 15.5 cm.
Palais des Beaux-Arts, Lille. Inspired by the Chinese style.

609

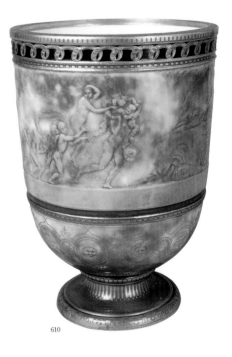

610

611

609. **Auguste Rodin** and the **Sèvres Manufactory**,
1840-1917 and 1740 - currently active, French.
Plaque, *Young Woman and Child* or *Brother and Sister*, c. 1882.
Hard-paste porcelain, 12.8 x 5.7 cm.
Musée Rodin, Paris. Neo-classicism.

610. **Auguste Rodin** and the **Sèvres Manufactory**,
1840-1917 and 1740 - currently active, French.
Jar from Pompeii *Day*, 1881-1882.
Hard-paste porcelain, height: 32 cm; diameter: 23 cm.
Musée national de la Céramique, Sèvres. Neo-classicism.

611. **Maison Soufflot fils** and **Robert**, founded in 1867, French.
Brooch, c. 1880.
Gold, silver, diamonds, stainless steel.
Musée des Arts décoratifs, Paris. Neo-classicism.

612

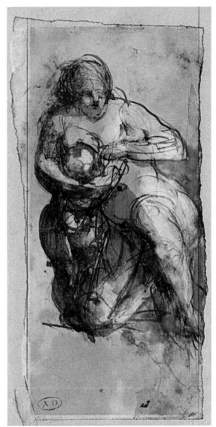

613

Auguste Rodin
(Paris, 12 November 1840 – Meudon, 17 November 1917)

French sculptor Auguste Rodin took classes at the School of Decorative Arts, also called the 'Little School.' After failing the entrance exam three times, he was unable to attend the School of Fine Art. As if in revenge against the establishment, he became one of the greatest sculptors of the century. In 1864, Rodin became a student of Carrier-Belleuse, first a master, then friend, of whom he made a bust of, almost twenty years later. In 1877, Rodin exhibited at the Cercle de Bruxelles his plaster work, the *Defeated*, then at the Salon des Artistes Français under the title of *Age of Bronze*. The work provoked a real scandal, because the modelling appeared to be alive.

Accused of moulding from a cast, Rodin was finally cleared of all suspicion, notably as a result of the support of Carrier-Belleuse, and the affair finally allowed the genius of the sculptor to be revealed to the public. Now a recognised artist, he worked in a studio, in a marble works, on the Rue de l'Université in Paris. In 1880, the state commissioned a cast of his *Age of Bronze* and a monumental door, for the future Museum of Decorative Arts. It is the beginning of public commissions which, until the death of the artist, never ceased and always ended, paradoxically, in scandal. Revolutionising sculpture by liberating the form, the work of Rodin was also marked by his admiration for Michelangelo whose non finito method he utilised in his own way, by letting his figures appear from blocks of marble in which they are kept prisoner.

612. **Auguste Rodin**, 1840-1917, French.
Pastoral from *Fenaille Album*, c. 1880-1885.
Pen and brown ink, brown wash, and white gouache, 19.3 x 13.2 cm.
Musée des Arts décoratifs, Paris. Expressionism.

613. **Auguste Rodin**, 1840-1917, French.
Woman Breastfeeding a Child from *Fenaille Album*, c. 1880-1885.
Pen and brown ink, brown wash, and white gouache, 16 x 7.6 cm.
Musée des Arts décoratifs, Paris. Expressionism.

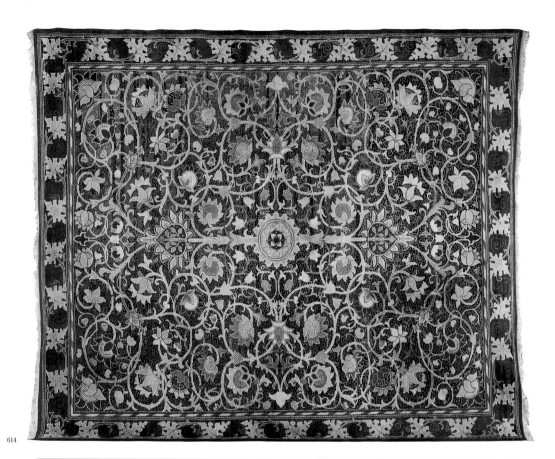

614

William Morris
(Walthamstow, 1834 – Kelmscott, 1896)

William Morris belonged to the most creative group of the Arts and Crafts Movement of Great Britain. The scope and depth of his work make him exceptional in the history of art and design. He was a revolutionary interior architect and book printer, a powerful and productive poet, a weaver, embroider, colourist, and calligrapher, and a staunch socialist and protector of historical buildings.

Starting in 1853, he studied at the Exeter College in Oxford, where he met and befriended Edward Burne-Jones.

Morris travelled in 1855, in the company of Burne-Jones, to northern France to see the gothic cathedrals.

He founded *The Oxford and Cambridge Magazine* in the beginning of 1856, and met Rossetti who encouraged him to leave architecture for paintings.

In 1861, Morris decided to found a decorative arts firm, in partnership with Peter Paul Marshall, Charles Faulkner, and Philip Speakman Webb, and artists Burne-Jones, Ford Madox Brown, and Rossetti.

In 1891, he founded Kelmscott Press (named after its original location) in Hammersmith, which publishes the *Kelmscott Chaucer*. This book was typeset by Morris and illustrated by Burne-Jones, and acts as the ideal example for Morris's objectives. It joins the beauty and usefulness of everyday objects.

Morris died in 1896 and is buried in a cemetery in Kelmscott under a simple headstone designed by Webb. His art, his ideals, and his life work pave the way for generations of artists who followed suit in his pursuit of 'the beauty of life'.

614. **William Morris**, 1834-1896, English.
Holland Park, 1883.
Hammersmith rug, 475.4 x 412.7 cm.
Private collection. Arts and Crafts Movement.

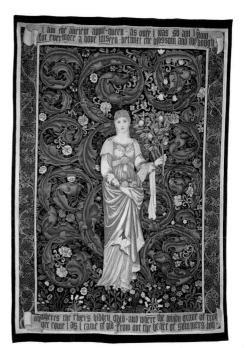

616

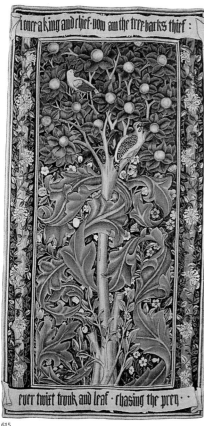

615

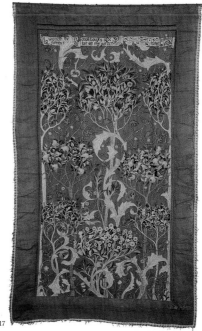

615. **William Morris**, 1834-1896, English.
The Woodpecker, 1885.
Tapestry, 307 x 156 cm.
William Morris Gallery, London. Arts and Crafts Movement.

616. **Edward Burne-Jones**, **William Morris** and **Morris & Co.**,
1833-1898, 1834-1896 and 1875-1940, English.
Pomona, 1885.
Tapestry, wool and silk on cotton weft, 300 x 210 cm.
The Whitworth Gallery, University of Manchester, Manchester.
Arts and Crafts Movement.

617. **William Morris**, 1834-1896, English.
Curtain, *The Orchard*, c. 1880-1890.
Linen.
Victoria and Albert Museum, London. Arts and Crafts Movement.

617

317

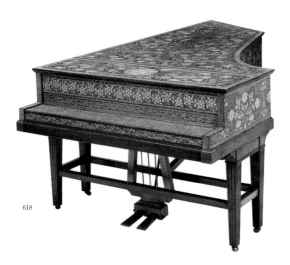

618

618. **Edward Burne-Jones** (designer), **Kate Faulkner** (decorator),
and **John Broadwood** (manufacturer), 1833-1898, dates unknown, and 1732-1812, English.
Grand piano, 1883.
Oak, stained and decorated with gold and gilded-silver gesso, 266 x 140.5 x 45.7 cm.
Victoria and Albert Museum, London. Arts and Crafts Movement.

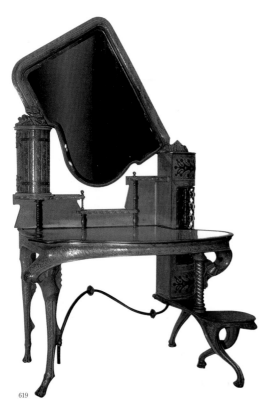

619

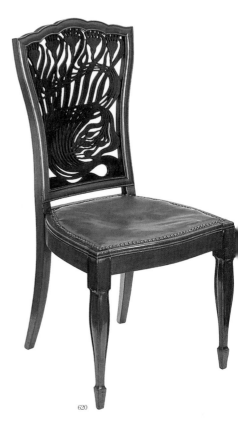

620

619. **Antoni Gaudí**, 1852-1926, Spanish.
Dressing table, c. 1895.
Wood.
The Güell Family Collection, Barcelona. Art Nouveau.

620. **Arthur Heygate Mackmurdo**, 1851-1942, English.
Chair, c. 1883.
Mahogany and leather, 97.2 x 48.5 x 47 cm.
Victoria and Albert Museum, London. Art Nouveau.

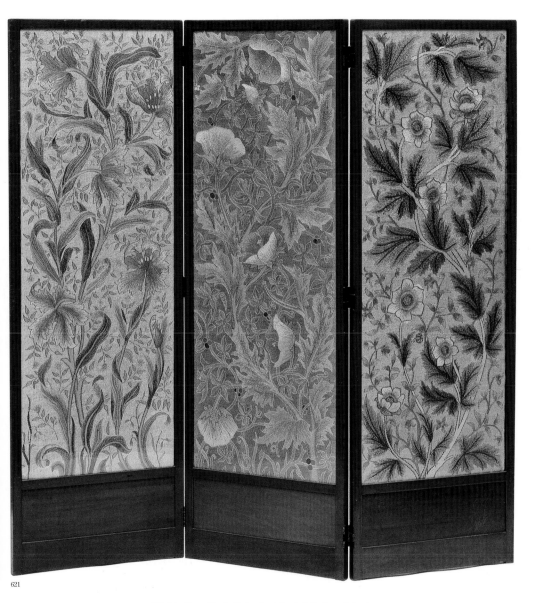

621

621. **John Henry Dearle** (designer) and **Morris & Co.** (manufacturer),
1859-1932 and 1875-1940, English.
Screen, 1885-1910.
Mahogany frame with panels of embroidered silk and satin, 162.9 x 166.2 x 2.8 cm.
Victoria and Albert Museum, London. Arts and Crafts Movement.

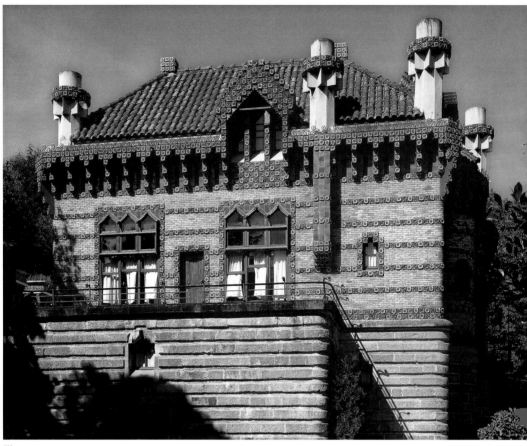

622

Antoni Gaudí
(Reus, June 1852 – Barcelona, 1926)

Antoni Gaudí I Cornet was born in Reus in June 1852. In 1870, he enrolled in the architecture school of Barcelona. In the years 1876-1877, Gaudí worked alongside Francisco de Paula del Villar on the restoration of the apse of the Montserrat monastery and published his first writing regarding architecture. The following year, he acquired his architecture diploma and designed two streetlights for the Plaza Real.

As a young architect, Gaudí would be influenced by the neo-gothic works of Viollet-le-Duc. He emancipated himself abruptly from all rigid styles, developing much originality and fantasy. Gaudí incorporated Art Nouveau principles, uniting architecture and interior design.

Gaudí undertook work for the Sagrada Família in Barcelona in 1882. Differences with the original architect brought the contract to Gaudí's hands, who modified the original plans, making it the most ambitious project he would make in his life.

In 1883, he received the commission for Casa Vicens. The work for a garden began in 1900 on a hill in Barcelona, known today as Park Güell.

In 1926 Antoni Gaudí was hit by a tram and succumbed to his injuries. He is buried in the crypt of the Sagrada Família that he left unfinished. Worthy representative of Art Nouveau, Gaudí is probably one of the artists who breaks the most radically with traditions of the past. His work, listed as World Heritage by UNESCO, was once widely criticized. However, Barcelona remains today, in the eyes of all, the work of Antoni Gaudí.

622. **Antoni Gaudí**, 1852-1926, Spanish.
El Capricho, east facade, 1883-1885.
Santander region. Art Nouveau.

623. **Antoni Gaudí**, 1852-1926, Spanish.
Casa Vicens, c. 1852-1888.
Barcelona. Art Nouveau.

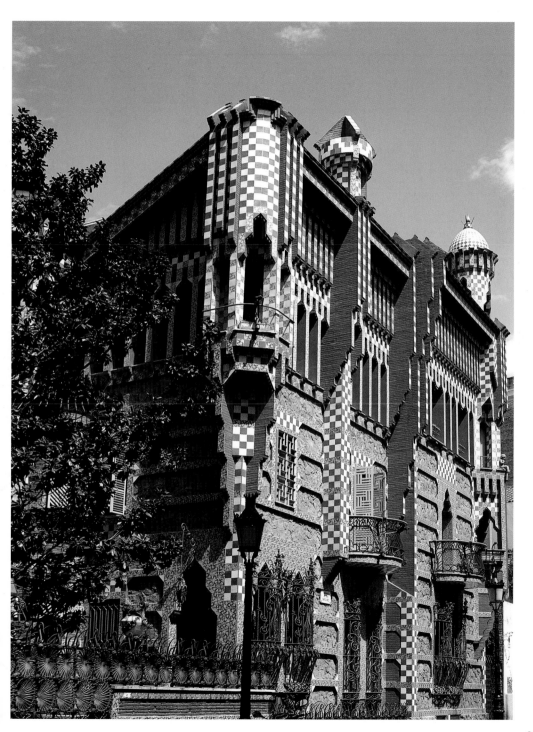

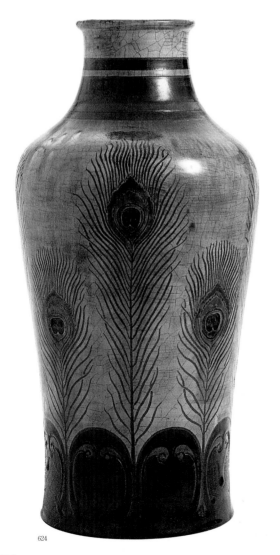

624

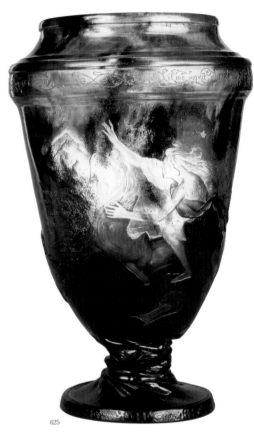

625

624. **Auguste Félix Delaherche**, 1857-1940, French.
Vase, *Peacock Feathers*, c. 1889.
Sandstone, blue enamel decoration in cobalt and green on white slip,
lead varnish, height: 42 cm.
Musée des Arts décoratifs, Paris. Art Nouveau.

625. **Émile Gallé**, 1846-1904, French.
Vase, *Orpheus*, 1888-1889.
Blow-moulded glass, processed hot, wheel-engraved, and gilded; height: 26 cm.
Musée des Arts décoratifs, Paris. Art Nouveau.

628. **Alf Wallander**, 1862-1914, Swedish.
Vase, 1897.
Porcelain.
Kunstindustrimuseet, Copenhagen. Art Nouveau.

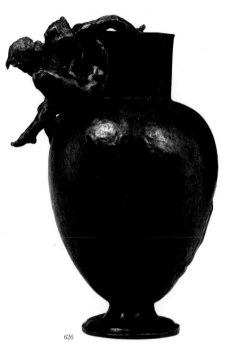

626

26. **Auguste Rodin** and **Jules Desbois**, 1840-1917 and 1851-1935, French.
Design for decorative vase, c. 1890 (?).
Bronze, 35.5 x 24 cm.
Musée Rodin, Paris. Art Nouveau.

627

627. **Émile Gallé,** 1846-1904, French.
Vase, *Autumn Nightlights*, 1891.
Multi-layered crystal, partially-hammered surface,
wheel-engraved decoration, height: 21.3 cm.
Musée d'Orsay, Paris. Art Nouveau.

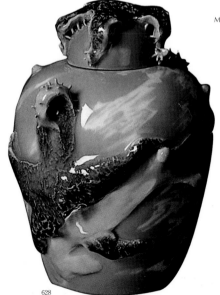

628

630

629

629. **Louis Comfort Tiffany**, 1848-1933, American.
Vase, 1892-1896.
Glass, brown and silver decoration, 9.5 x 9.5 cm.
University of Michigan Museum of Art, Ann Arbor (Michigan). Art Nouveau.

630. **Louis Comfort Tiffany**, 1848-1933, American.
Vase, 1892-1894.
Glass, silver glaze, 15 x 19 cm.
University of Michigan Museum of Art, Ann Arbor (Michigan). Art Nouveau.

Louis Comfort Tiffany
(New York, 1848-1933)

Born in the United States in 1848, Louis Comfort Tiffany was the son of Charles Tiffany, who founded his firm in September 1838 alongside John B. Young. The company Tiffany & Young would change in 1853 to Tiffany & Co., as Charles Tiffany became the sole proprietor of the firm.

In 1866, Louis Comfort studied at the National Academy of Design in New York. At the age of twenty-two, he developed an interest in glass; however, it would take another ten years before he would make serious designs for glass works. During this time he created, with great taste and extraordinary knowledge of Art Nouveau, glass objects original in form and colour and of the highest beauty, namely windows, lamps, and lampshades.

Whilst the company Tiffany & Co. fostered his passion, Louis Comfort founded his own firm in 1885, which specialised in works of glass. He developed new processes, most notably the manufacture of opaque glass (at the time, most artists relied on clear glass), and acted as a supporter of the Art and Crafts Movement begun in England by William Morris.

In 1839, Tiffany perfected a new technique for the manufacture of glass vases and glass bowls, the favrile technique, a handcrafted method for glass blowing, which produced different effects.

Bing's Maison de l'Art Nouveau in Paris exhibited Tiffany's works of glass in 1895.

In 1902, Louis Comfort Tiffany succeeded his father as head of Tiffany & Co., continuing to work with glassware. Thomas Edison later encouraged Tiffany to direct his attention toward electric lamps. From this moment on, Tiffany lamps became popular decorative and functional pieces, full of organic motifs: flowers, leaves, butterflies, and dragonflies.

Louis Comfort Tiffany died on January 1933 in New York. The company Tiffany & Co. continues to exist and has amassed a worldwide reputation for decorative pieces. The work of Louis Comfort Tiffany is still very much beloved and is in constant demand by collectors. The Metropolitan Museum of Art in New York owns many of his works, as they epitomise Art Nouveau.

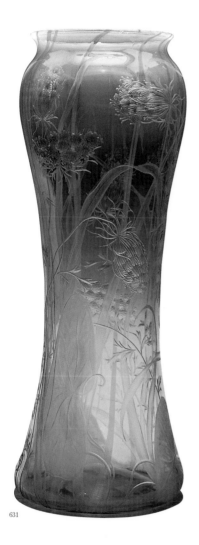

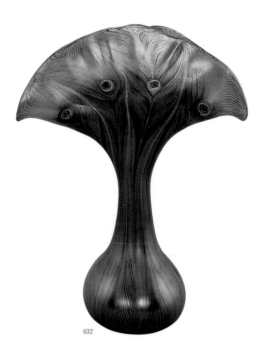

632.

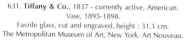
631.

631. **Tiffany & Co.**, 1837 - currently active, American.
Vase, 1895-1898.
Favrile glass, cut and engraved, height : 31.1 cm.
The Metropolitan Museum of Art, New York. Art Nouveau.

632. **Tiffany & Co.**, 1837 - currently active, American.
Vase, 1893-1896.
Favrile glass, 35.9 x 29.2 cm.
The Metropolitan Museum of Art, New York. Art Nouveau.

633. **Zsolnay Porcelain Manufacture**, 1853 - currently active, Hungarian.
Vase, 1899.
Faience, glazed porcelain.
Museum of Applied Arts, Budapest. Art Nouveau.

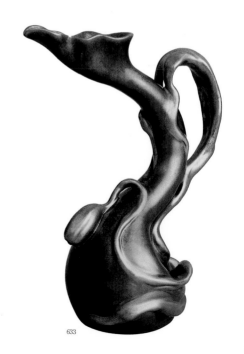

633.

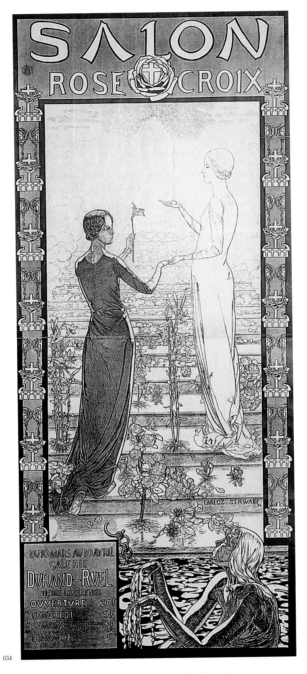

634

634. **Carlos Schwabe**, 1866-1926, Swiss, German-born.
Poster for the first Salon de la Rose + Croix, 1892.
Lithograph, 199 x 80 cm.
Private collection. Art Nouveau.

635

636

Aubrey Beardsley
(Brighton, 1872 – Menton, 1898)

Aubrey Vincent Beardsley was born in the town of Brighton in 1872. The artistic and musical aptitude of the Beardsley children was quickly recognised. Beardsley studied at a school in Bristol for four years, during which he proved his talent for drawing as seen in the caricatures of his teachers and the illustrations done for the school newspaper *Past and Present*.

Beardsley's first attempt to enter the art world originates in a meeting with the famous painter Sir Edward Burne-Jones, who advised the young artist to study at the Westminster School of Art.

In the early 1890s, Beardsley produced a series of important title images and illustrations, namely those for Sir Thomas Malorys entitled *Le Morte d'Arthur*, for which Beardsley drew over 300 illustrations, vignettes, and ornaments.

His encounter with Oscar Wilde in 1893 was crucial. Wilde's so-called scandalous piece *Salomé* was published in the French language in 1894.

To the scandalous publication by Wilde, Beardsley provided the black-and-white illustrations for Lord Alfred Douglas's English translation, which helped spread his name amongst the public.

Beardsley's fame was finally established after the publication of the first issue of *The Yellow Book*, which he completed with Henry Harland. Together with Leonard Smithers, Beardsley would later found the magazine *The Savoy*, for which Beardsley work and drew. Facing terrible health issues, Beardsley travelled to southern France, but the warm climate did not have the desired effect.

Beardsley died during the night of the 15th to the 16th of March 1898 at twenty-five years of age, either as a result of his deteriorating health, or at his own hands from world-weariness.

Despite his short career, Beardsley's innovative style has had a lasting influence on Art Nouveau.

635. **Aubrey Beardsley**, 1872-1898, English.
Poster for *The Studio*, 1893.
Lithograph, 72.5 x 47 cm.
Victoria and Albert Museum, London. Art Nouveau.

636. **Aubrey Beardsley**, 1872-1898, English.
The Toilet of Salome, illustration for Oscar Wilde's play *Salome*, 1893.
Print, ink on paper.
Private collection. Art Nouveau.

637

EUGÈNE GRASSET
(LAUSANNE, 1845 – SCEAUX, 1917)

Eugène Grasset was born in the Swiss Lausanne in 1845. He was the son of the sculptor and decorator Samuel Joseph Grasset and learned painting under the patronage of François Louis David Bocion, before undertaking architecture courses at the Swiss Federal Institute of Technology in Zurich in 1861. After completing his studies, he travelled to Egypt in 1866. In 1871, he moved to Paris, where he discovered his passion for Japanese art partially thanks to the photographs of Charles Gillot.

In 1880, he designed for Gillot furniture and a dining room. The furniture, made of oak and walnut, feature imaginative animals and figures from folk art. From 1890 to 1903, Grasset taught at the École Guérin Design. His students included, among others, Augusto Giacometti and Paul Berthon. He then designed in 1890 the poster for *Jeanne d'Arc* starring Sarah Bernhardt.

Two years later, created Gasset in his design for the poster for *Encres Marquet* his ideal woman, a true and timeless Muse. The posters, full of symbolist, Pre-Raphaelite, and Japanese influences, are the embodiment of the spirit of Art Nouveau. Its perfect union of women, art, and nature would inspire Alphonse Mucha.

In 1894 he created the poster for the *Salon des Cent*.

In 1897, he worked for two French newspapers, *Art et Décoration* and *L'Estampe et L'Affiche*.

Eugène Grasset died at Sceaux in 1917.

637. **Eugène Grasset**, 1845-1917, Swiss.
Salon des Cent (Salon of the One Hundred), 1894.
Print for a coloured poster.
Victor and Gretha Arwas Collection. Viennese Secession.

638

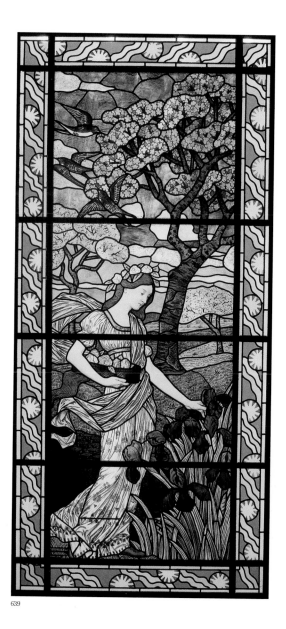

639

638. **Paul Berthon**, 1872-1909, French.
Liane de Pougy at the Folies Bergère, 1892.
Coloured lithograph, 150 x 60 cm.
Bibliothèque nationale de France, Paris. Art Nouveau.

639. **Eugène Grasset** (sketch), **Félix Gaudin** (execution),
1845-1917 and 1851-1930, Swiss and French.
Stained glass window, *Spring*, 1894.
Glass and lead, 294 x 132 cm.
Musée des Arts décoratifs, Paris. Art Nouveau.

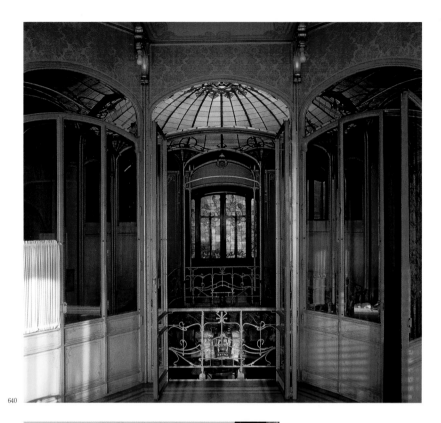

640

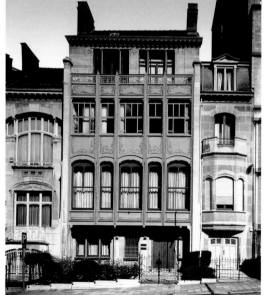

641

640. **Victor Horta**, 1861-1947, Belgian.
Hôtel van Eetvelde, interior view of the salon, 1895.
Brussels. Art Nouveau.

641. **Victor Horta**, 1861-1947, Belgian.
Hôtel van Eetvelde, façade, 1895.
Brussels. Art Nouveau.

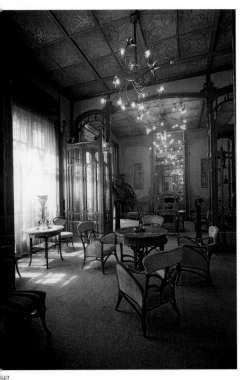

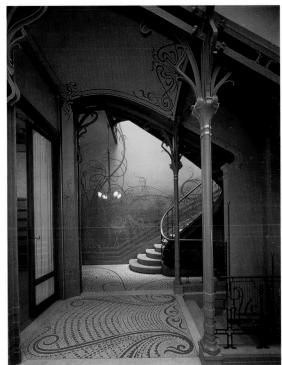

642

643

VICTOR HORTA
(Gand, 1861 – Brussels, 1947)

Victor Horta was born in Ghent in 1861. Son of a shoemaker, he enrolled at the Academy of Fine Arts in his hometown and from 1874 to 1877, he attended a school for continued education. In 1878, he made his first trip to Paris on the occasion of the World Exhibition and apprenticed with the architect and decorator Jules Debuysson. The following year, he moved to Brussels, where he became a student at the Royal Academy.

In 1884, Victor Horta presented a design for the Parliament for which he was awarded the Godecharle architecture prize. Next year he built three houses in Ghent and in 1887, he won the three-year competition launched by the Academy of Fine Arts in Brussels for the Natural History Museum.

In 1900, Victor Horta designed a mansion for the chemist Emile Tassel. This achievement, even today, exemplifies Art Nouveau. This architectural project marks the beginning of a long series of commissions that will extend into the first decade of the 20th century, houses in its majority, mainly in the Belgian capital. Among the most famous: Hotel Tassel (1893), Hotel Solvay (1894), Hotel Van Eetvelde (1895), Hotel Aubecq (1899), and Hotel Max Hallet (1902). In 1898, he made a home and workshop for himself on Rue Américaine.

But the talent of Victor Horta is also seen in public projects. In 1895 he built, for the Association of Workers and funded by Solvay, the People's House.

Horta went into exile in the United States until 1919. Upon his return, he sold his home at Rue Américaine and began working on plans for the Palais des Beaux-Arts in Brussels.

He died in 1947 at eighty-six years old.

642. **Victor Horta**, 1861-1947, Belgian.
Hôtel Solvay, view of the main salon, 1895.
Brussels. Art Nouveau.

643. **Victor Horta**, 1861-1947, Belgian.
Hôtel Tassel, great hall on the ground floor, 1893.
Brussels. Art Nouveau.

644. **Philip Speakman Webb** (original idea), 1831-1915

1893. East Grinstead, West Sussex. Arts and Crafts Movement.

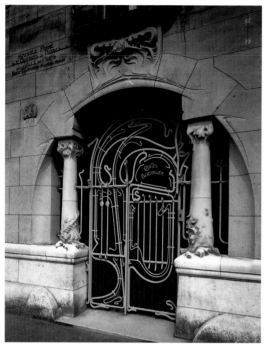

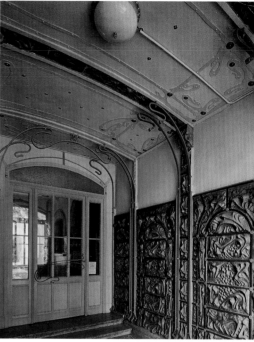

645

646

HECTOR GUIMARD
(LYON, 1867 – NEW YORK, 1942)

Hector Guimard Germain was born in Lyon in 1867. At the age of fifteen, he entered the École des arts décoratifs in Paris, and then three years later the École des beaux-arts.

In 1888 he was commissioned to build a café for live music on the banks of the Seine (which was unfortunately destroyed during the floods of 1910). In 1889, he is responsible for the pavilion of the Power Expo at the World Exhibition and is responsible for the construction of the school Sacré-Cœur.

Between 1891 and 1893, he built various private homes.

The following year he travelled to England and Belgium, where he met Victor Horta and began his conversion to Art Nouveau style. Back in France in 1895, he strived for three years on the construction of Castel Béranger. This particular architectural masterpiece entirely designed by Guimard received the first prize for the most beautiful Parisian façade in 1899.

In 1898, Hector Guimard entered the contest launched for the Paris Metro, concentrating on the conservation of the kiosks at the stations' entrances. Eventually winning, he received the commissions to design the entrances. However, his style is not yet appreciated by all.

In 1903, he participated in an international exhibition at the Grand Palais and designed a pavilion. As a modernist architect, he took into consideration the physical and economic difficulties caused by the war requiring quick and economical solutions.

In 1930, he built the country house La Guimardière using pipes as porters and decorative elements. Following the outbreak of the Second World War, the then-sick Guimard fled to the United States.

Hector Guimard died in New York in 1942.

645. **Hector Guimard**, 1867-1942, French.
Castel Béranger, main entrance, 1895-1898.
Paris. Art Nouveau.

646. **Hector Guimard**, 1867-1942, French.
Castel Béranger, detail of the vestibule
and door overlooking the courtyard, 1895-1898.
Paris. Art Nouveau.

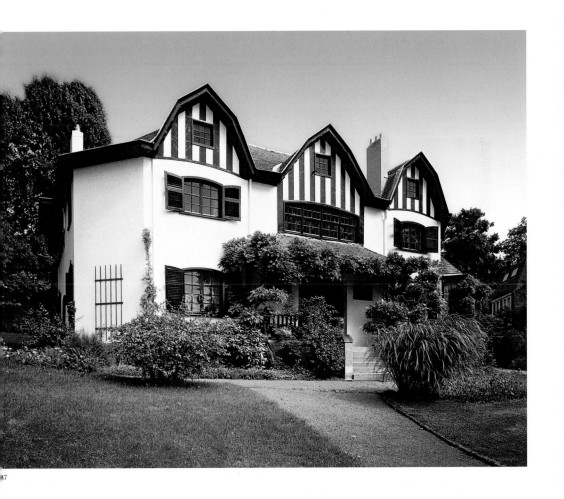

647. **Henry Van de Velde**, 1863-1957, Belgian.
Bloemenwerf, 1895.
Brussels. Art Nouveau.

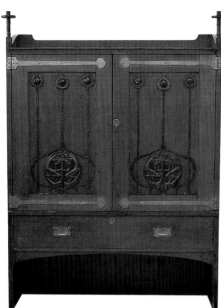

648

649

Charles Rennie Mackintosh
(Glasgow, 1868 – London, 1928)

Charles Rennie Mackintosh was born in Glasgow in 1868. He began his architectural training in his hometown and attended art and design courses at Glasgow School of Art. During his studies, he met the MacDonald sisters, Margaret (whom he would marry in 1900) and Frances.

In 1889, he joined the architectural firm Honeyman & Keppie.

The following year, he founded his own architectural office, and four years later the group *The Four* alongside the MacDonald sisters and McNair. The group soon participated in several international exhibitions. Through these exhibitions, Mackintosh's reputation began to build and the style of the group soon was dubbed the 'Glasgow style'. It was especially Mackintosh who inspired the Viennese Art Nouveau movement known as the Secession.

In 1894, Mackintosh designed his first architectural work, the corner tower of the building of the Glasgow Herald. Therefore he rejects the academic tradition of modern forms in building.

In 1897, he was responsible for the transformation of the Glasgow School of Art, a task that allowed him to assert his style. He sought to establish a synthesis between exterior architecture, interior design, and furniture. Always working with his wife, his works reflect their cooperation, his formal and straight style was enhanced by the floral and rolling shapes of Margaret.

Charles Rennie Mackintosh died at the end of 1928.

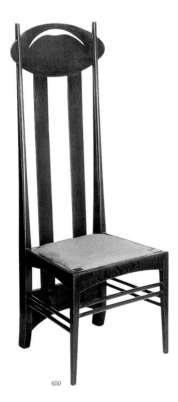

650

648. **Charles Rennie Mackintosh**, 1868-1928, Scottish.
Cabinet, 1895.
Cypress, wood, and coloured metal, 195 x 158 x 45.6 cm.
Glasgow School of Art, Glasgow. Arts and Crafts Movement.

649. **Philip Speakman Webb** (design) and **John Garrett & Son** (manufacturing,
1831-1915 and dates unknown, English.
Altar table and cloth, 1896-1899.
Oak, joined and carved, cloth embroidered with silk threads
by May Morris, 94.7 x 145.7 x 66 cm.
Victoria and Albert Museum, London. Arts and Crafts Movement.

650. **Charles Rennie Mackintosh**, 1868-1928, Scottish.
Chair, 1897-1900.
Oak, 136.5 x 50.3 x 45.5 cm.
Victoria and Albert Museum, London. Arts and Crafts Movement.

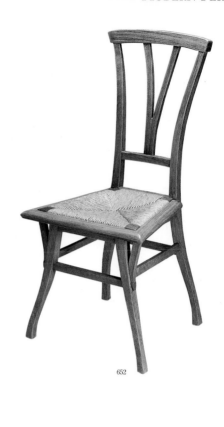

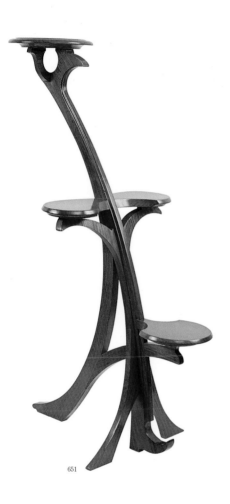

652

651

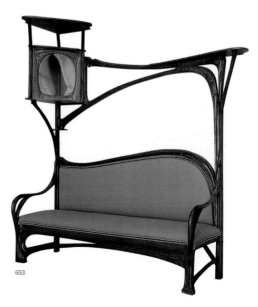

653

651. **Gustave Serrurier-Bovy**, 1858-1910, Belgian.
Pedestal, 1897.
Congolese rosewood.
Norwest Corporation, Minneapolis. Art Nouveau.

652. **Henry Van de Velde**, 1863-1957, Belgian.
Chair, c. 1895.
Wood, 94 x 44.1 x 41.7 cm.
Virginia Museum of Fine Arts, Richmond. Art Nouveau.

653. **Hector Guimard**, 1867-1942, French.
Seat for the smoking room, 1897-1898.
Jarrah, engraved metal, modern trim, 260 x 262 x 66 cm.
Musée d'Orsay, Paris. Art Nouveau.

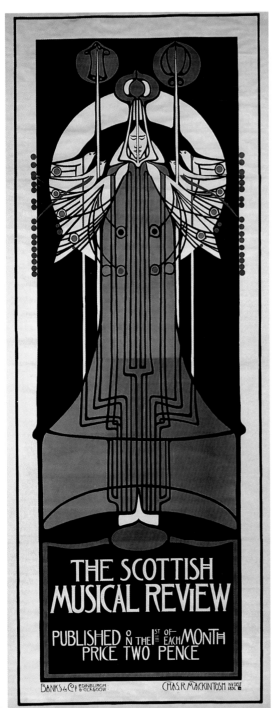

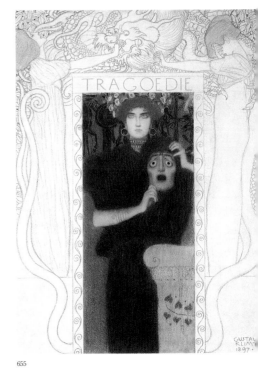

655

654. **Charles Rennie Mackintosh**, 1868-1928, Scottish.
Poster for *The Scottish Musical Review*, 1896.
Coloured lithograph, 246.4 x 94 cm.
The Museum of Modern Art, New York. Art Nouveau.

655. **Gustav Klimt**, 1862-1918, Austrian.
Final Design for the Allegory 'Tragedy', 1897.
Black chalk, wash, accents of gold and white, 42 x 31 cm.
Kunsthistorisches Museum Wien, Vienna. Viennese Secession.

656. **Alphonse Mucha**, 1860-1939, Czech.
Poster promoting the *Salon des Cents* in the *Hall de la Plume*, 1896.
Coloured lithograph, 64 x 43 cm.
Mucha Museum, Prague. Art Nouveau.

657. **Alphonse Mucha**, 1860-1939, Czech.
Poster for *Monaco – Monte-Carlo, chemin de fer P.L.M.*, 1897.
Coloured lithograph, 110.5 x 76.5 cm.
The Mucha Trust Collection. Art Nouveau.

654

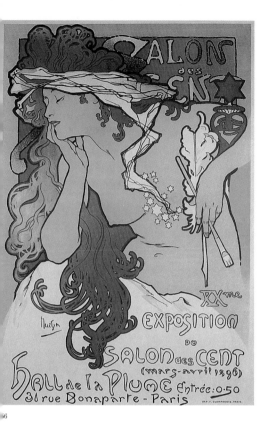

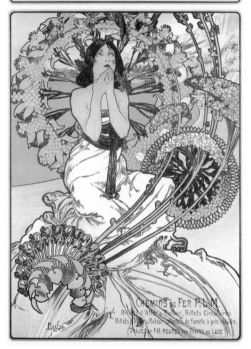

56

657

Alphonse Maria Mucha
(Ivancice, 1860 – Prague, 1939)

Alphonse Mucha was born on 14 July 1860 in Ivancice. Whilst working in an office for a living, he gave free rein to his passion for drawing.

In 1879, he became a manufacturer for theater sets for the firm Kautsky-Brioschi-Burghard. Mucha then settled in the small town of Mikulov where he met Count Khuen, who asked him to decorate a dining room in Emmahof Castle, with murals. Mucha's ambition for decorative works on a large scale originates from this first experience.

In 1888, he enrolled at the Académie Julian, where he met Sérusier, Vuillard, Bonnard, Denis, and others which will constitute the group Nabis. Mucha style would be deeply influenced by the Symbolist movement and mysticism prevailing in Paris in literary and art circles during the second half of the 1880s. Art Nouveau exploded in Paris in 1895 when Guimard built Castel Béranger, as well as when Mucha's poster of Sarah Bernhardt in the role of *Gismonda* appeared in the streets of Paris. The enormous success of this theatre poster instantly projected Mucha to the top of the Parisian artistic world and provided financial security in the form of a contract committing to work for Sarah Bernhardt for six years. A series of striking posters, *The Lady of the Camellias*, *Medea*, *La Tosca*, and *Hamlet*, emerged over the next four years.

From the success of his work for Sarah Bernhardt, Mucha received many other commissions for posters. He created an idealised feminine type, instantly recognisable, and used for all kinds of advertisements. This character was from carnal mirth the hedonistic blond or the redhead of Chéret, whose voluptuous figure, melancholy and morbid refinement stem from the Raphaelites and whose dangerous femme fatale from the end of the century.

During the late 1890s, Mucha deploys his prodigious qualities of invention in the decorative arts. He designed, as well the furniture and cutlery, storefronts, jewellery and biscuit boxes.

Mucha's career in Paris peaked with his preparations for the World Exhibition in 1900.

In 1906, he sailed for America in search of lucrative commissions for portraits.

Mucha died in 1939.

658

658. **Josef Maria Olbrich,** 1867-1908, Austrian. B

...ese Secession Exhibition, 1897-1898. Vienna. Viennese Secession.

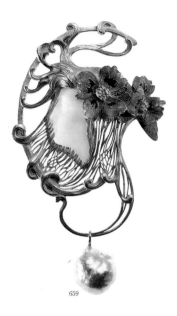

659

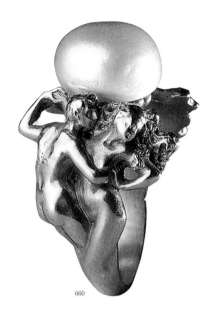

660

659. René Lalique, 1860-1945, French.
Pendant, *Head of a Woman Wearing Two Poppy Flowers*, c. 1898-1899.
Gold, white chalcedony, enamel, blister pearl pendant, 10.2 x 5.7 cm.
Musée des Arts décoratifs, Paris. Art Nouveau.

660. René Lalique, 1860-1945, French.
Ring, *Two Couples*, 1899-1901.
Cast and chased gold, pearl button, height: 2.6 cm; diameter: 2.1 cm.
Musée des Arts décoratifs, Paris. Art Nouveau.

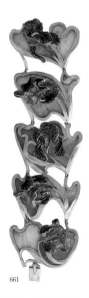

661

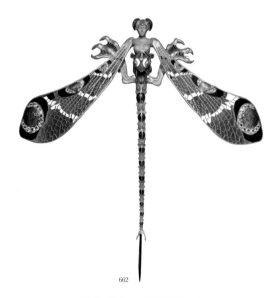

662

661. René Lalique, 1860-1945, French.
Iris bracelet, 1897.
Gold, enamel, and opal.
Private collection, New York. Art Nouveau.

662. René Lalique, 1860-1945, French.
Dragonfly-shaped brooch, 1897-1898.
Gold, enamel, chrysoprase, diamonds, and moonstone, 23 x 26.6 cm.
Calouste Gulbenkian Foundation, Lisbon. Art Nouveau.

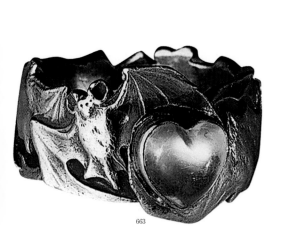

663

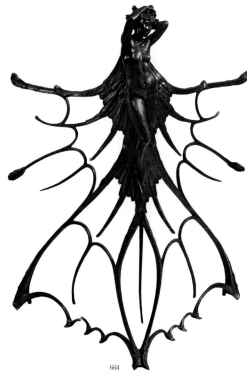

664

René Jules Lalique
(Ay, 1860 – Paris, 1945)

René Lalique was born in the small village of Ay in the Marne department in 1860. From 1876 to 1878, he apprenticed for the Parisian jeweller, Louis Aucoq. Then, from 1878 to 1880, he studied two years at the Sydenham Art College in London.

On his return to Paris, he earned his living by designing jewellery. He quickly abandoned the application of diamonds to works in order to use new materials of the time: semi-precious, horn, ivory, and glass.

In 1894, he designed costume jewellery for the actress Sarah Bernhardt which quickly thrust him into salons, such as the Salon de la Société des Artistes Français. Although an excellent sculptor, draftsman, and printmaker, he became world-known thanks to his jewellery. His reputation grew as he participated in international exhibitions in Brussels, Munich, Turin, Berlin, London, St Louis, and Liège.

In 1900, during the World Exhibition in Paris, he won the Grand Prize and was awarded the Legion of Honour. Lalique was then the most famous Art Nouveau jeweller. His fame is such that today when we talk about art jewellery, it refers to 'Lalique-style'. These works essentially show the flora and fauna, including peacock and insects. The turning point in his creation was when he ordered the creation of a perfume bottle.

After the First World War, he bought a glassware Wingen-sur-Moder in Alsace, where he began a new career, that of glassmaking, at the age of fifty-six years. After marrying the daughter of the sculptor Auguste Ledru, he had a son, Marc, who in the 1930s followed his father's footsteps. When he inherited the firm in 1945, the production changed to crystal glass.

Today, the company he founded still works.

663. **René Lalique**, 1860-1945, French.
Bat-shaped ring, 1899.
Silver, transparent blue enamel, moonstone, gold; height: 1.2 cm; diameter: 1.9 cm.
Musée des Arts décoratifs, Paris. Art Nouveau.

664. **René Lalique**, 1860-1945, French.
Winged female figure, c. 1899.
Bronze.
Private collection, New York. Art Nouveau.

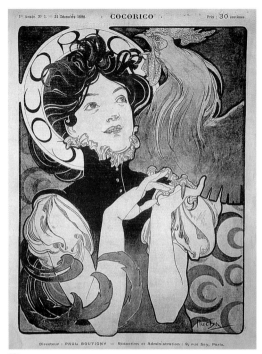

665

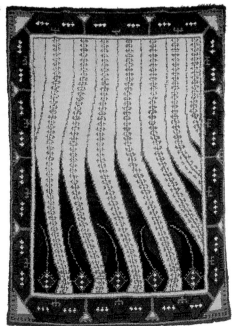

666

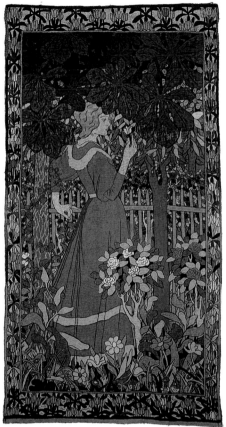

667

665. **Alphonse Mucha**, 1860-1939, Czech.
Cocorico, magazine cover, issue no. 1, December 1898.
Mucha Museum, Prague. Art Nouveau.

666. **Akseli Gallen-Kallela**, 1865-1931, Finnish.
Flame, Ryijy tapestry, 1899.
Woven wool.
Museum of Arts and Design, Helsinki. Art Nouveau.

667. **József Rippl-Rónai**, 1861-1927, Hungarian.
Woman in Red, 1898.
Embroidered tapestry.
Museum of Applied Arts, Budapest. Art Nouveau.

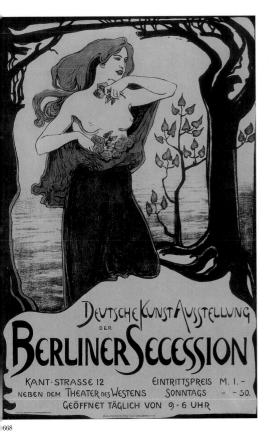

668

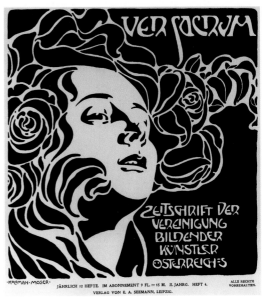

669

670

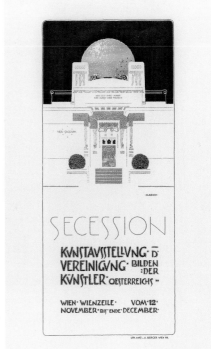

668. **Ludwing von Hofmann**, 1861-1945, German.
Poster for the first exhibition of the Berlin Secession, 1899.
Coloured lithograph.
Staatliche Museen zu Berlin, Berlin. Viennese Secession.

669. **Koloman Moser**, 1868-1918, Austrian.
Mädchenkopf (*Young Girl's Head*), design for the cover of *Ver Sacrum*, vol. 2,
no. 4, 1899.
Chinese ink on cardboard, 41 x 41 cm.
Wien Museum Karlsplatz, Vienna. Viennese Secession.

670. **Joseph Maria Olbrich**, 1867-1908, Austrian.
Poster for the 2nd exhibition of the Viennese Secession.
Lithograph, 86.2 x 51.2 cm.
Hessisches Landesmuseum, Darmstadt. Viennese Secession.

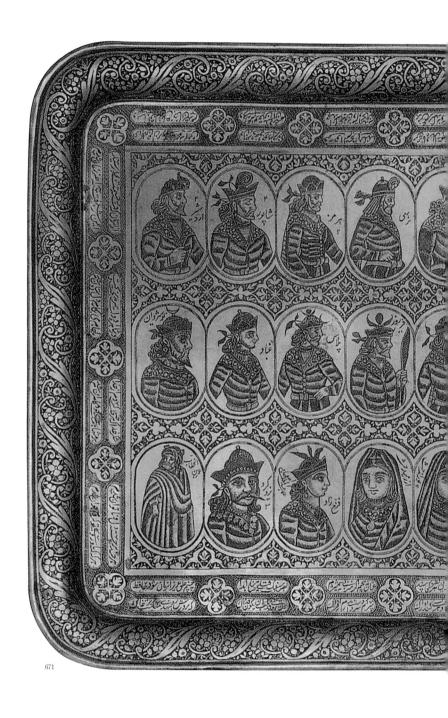

671. **Abd Al-Mutallib Isfahani**. Tablet, end of the 19th

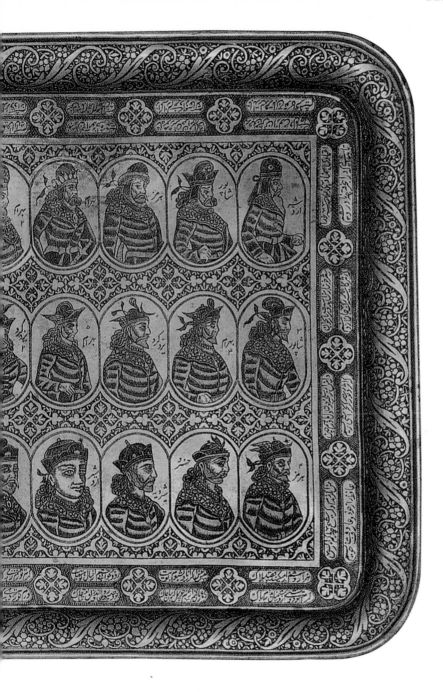

...nd engraved bronze. The State Hermitage Museum, St Petersburg. Persian.

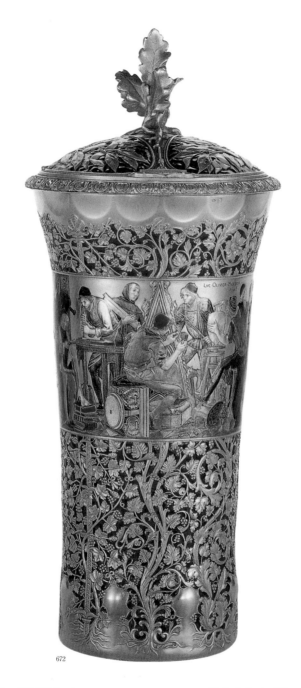

672

672. **Lucien Falize**, 1839-1897, French.
Jar, *Arts and Crafts*, 1895.
Gold and enamel, height: 22.3; diameter: 8.9 cm.
Musée des Arts décoratifs, Paris. Art Deco.

675. **Louis Comfort Tiffany**, 1848-1933, American.
Lamp, *Daffodil*, c. 1899.
Lead glass, height: 96.5 cm.
Courtesy McClelland & Lars Rachen, Ltd, New York. Art Nouveau.

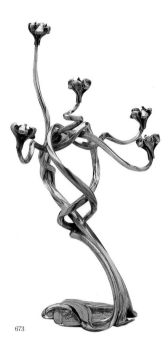

673

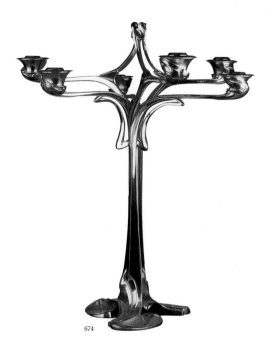

674

673. **Fernand Dubois**, 1861-1939, Belgian.
Candelabra, 1899.
Plated bronze.
Horta Museum, Brussels. Art Nouveau.

674. **Henry Van de Velde**, 1863-1957, Belgian.
Candelabra, 1898-1899.
Silver.
Musées royaux des Beaux-Arts de Belgique, Brussels. Art Nouveau.

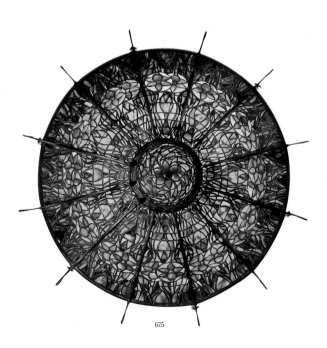

675

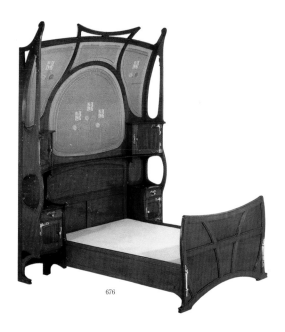

676

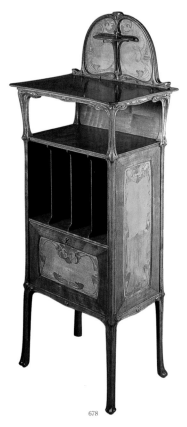

678

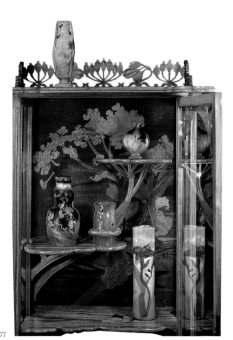

677

676. **Gustave Serrurier-Bovy,** 1858-1910, Belgian.
Bedroom furniture: bed, 1899.
Polished mahogany, brass, original silk-embroidered
and stencilled panels, with embroidery application.
Musée d'Orsay, Paris. Art Nouveau.

677. **Émile Gallé,** 1846-1904, French.
Cabinet with decoration in form of umbellifer or acanthus,
Japanese-style door and vases, c. 1900. Inlaid work and glass.
Private collection. Art Nouveau.

678. **Édouard Colonna,** 1862-1948, French.
Music cabinet, 1900. Fruit tree wood.
Made for the Art Nouveau pavilion at the World Exhibition of 1900.
Macklowe Gallery, New York. Art Nouveau.

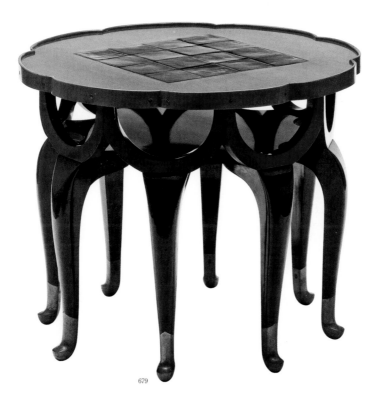

679

Adolf Loos
(Brno, 1870 – Kalksburg, 1933)

Adolf Loos was born in the city of Brno into a sculpting family. After studying at the Academy of Fine Arts in Vienna and later at the University of Technology in Dresden, Adolf Loos travelled for three years to the United States (1893-1896), where he gained artisanal and technical experience in all possible areas. Shortly before his return to Vienna, deeply influenced by his stay in the United States, he sought to establish a career as an architect in Vienna.

Adolf Loos building designed and built in 1909-1910 for the couturier Goldmann & Salatsch (das Looshaus) caused a scandal: no more columns, no frames around the windows – just patches of bare wall. And this precisely vis-à-vis the Michaelertor, a neo-baroque dome with a passage leading to the Imperial Palace in Vienna and the usual place of cabs. The Viennese were outraged. A contrast could not be more obvious. Although a railing extends around the building which optically separates the ground floor from the four upper floors, the facade was just too naked and in such bad taste according to the almost unanimous opinion of the Viennese.

Nevertheless, Loos remained faithful to its architectural design: an end to Art Nouveau. With another building, the Steiner House (1910), protected as a historic monument since 1996, he pushed the concept further. He traced the path of modern architecture in central Europe with its various villas and buildings for housing, but also with its commercial buildings and interiors. Mentioned here in particular is the Café Museum. He explained and defended this path in some writings, especially in his text *Ornament and Crime* (1908).

Adolf Loos died on 23 August 1933 in Vienna.

679. **Adolf Loos**, 1870-1933, Austrian.
Table, *Elephant trunk*, c. 1900.
Österreichisches Museum für angewandte Kunst, Vienna. Viennese Secession.

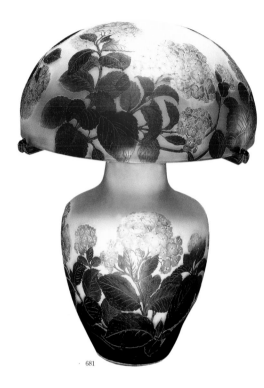

680

681

Émile Gallé
(NANCY, 1846-1904)

Émile Gallé was born in May 1846 in Nancy. At nineteen, he worked in the glassware factory Lorraine, Burgun, Schewerer, & Co. where he deepened his knowledge of glassmaking techniques and forms. Curious by nature, Emile Gallé was introduced to glassblowing. Thereafter, he travelled to London, spending long periods in the South Kensington Museum (now the Victoria and Albert Museum), and Paris. Botany enthusiast, throughout his travels he studied plants, animals, and insects which he drew carefully and later referenced in his decorative works. Back in Nancy, he began to work in 1867, with his father, for whom he designed new pieces of ceramics, furniture, and jewellery.

In 1873, he created, in the family factory, his own glassworks where he implemented the methods learned beforehand.

In 1877, he took over the management of the Gallé establishments.

In 1878, he participated in the World Exhibition held in Paris, influenced by the achievements of some contemporaries.

At the Exhibition of 1889, during which he was awarded the Grand Prize, he presented artistic glass creations, using innovative and original materials such as etched glass cameo or glass paste. He also developed new forms of glass vases, with new colours. Pioneering Art Nouveau, the Gallé style was born thereof.

These achievements were met with great success and Émile Gallé received several awards. He was appointed Officer of the Legion d'Honneur and Commander in 1900.

In 1901, he created, alongside other artists including Majorelle and Daum, the Nancy School where he became chairman. The following year, he participated at the Exhibition of Decorative Arts in Turin. The achievements of this period are recognisable by the presence of an engraved star after the signature of the master. Gallé's works were produced until 1933. The factory closed its doors in 1935.

680. **Emile Gallé**, 1846-1904, French.
King Solomon's Amphora, 1900.
Glass, height: 116 cm.
Musée de l'École de Nancy, Nancy. Art Nouveau.

681. **Emile Gallé**, 1846-1904, French.
Table lamp, *Rhododendron*, c. 1900.
Cameo glass, engraved.
Private collection. Art Nouveau.

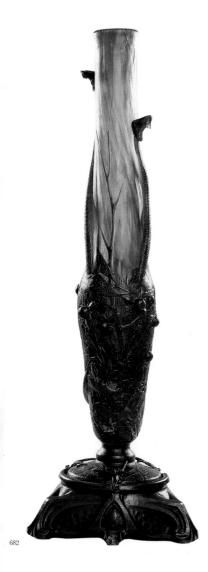

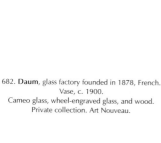

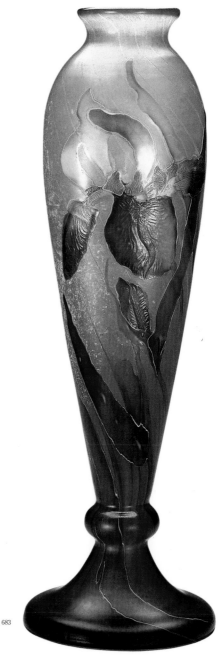

682

683

682. **Daum**, glass factory founded in 1878, French.
Vase, c. 1900.
Cameo glass, wheel-engraved glass, and wood.
Private collection. Art Nouveau.

683. **Emile Gallé**, 1846-1904, French.
Vase, *Iris*, c. 1900.
Glass, wheel-engraved glass.
Private collection, Japan. Art Nouveau.

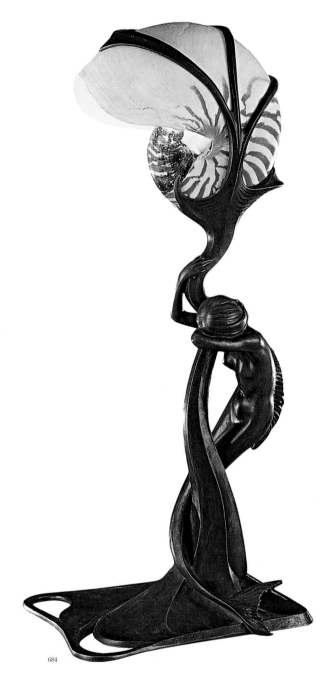

684

684. **Gustav Gurschner**, 1873-1970, Austrian.
Lamp, *Nautilus*, 1899-1900.
Bronze and nautilus shell.
Virginia Museum of Fine Arts, Richmond. Viennese Secession.

685

685. **Philippe Wolfers**, 1858-1929, Belgian.
Vase, c. 1900.
Glass and metal.
Private collection, Brussels.

686

686. **Louis Comfort Tiffany**, 1848-1933, American.
Vase, c. 1900.
Favrile glass, height: 51.1 cm.
The Museum of Modern Art, New York. Art Nouveau.

687

687. **Koloman Moser**, 1868-1918, Austrian.
Glasses, c. 1900.
Transparent and white glass, 32 x 4.5 x 4.5 cm.
Universität für angewandte Kunst Wien, Vienna. Art Nouveau.

688. **Keller Brothers**, 1878, German.
Carafe for water or wine, 1900.
Gilded silver, 26 x 18 cm.
Musée des Arts décoratifs, Paris. Art Nouveau.

688

689

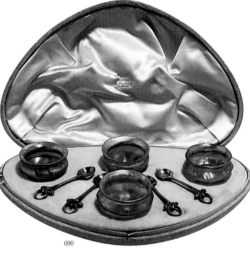

690

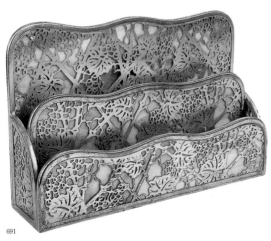

691

689. **Louis Comfort Tiffany**, 1848-1933, American.
Punch service with three ladles, 1900.
Favrile glass, gilded silver, copper, 38.8 x 61 cm.
Virginia Museum of Fine Arts, Richmond. Art Nouveau.

690. **Tiffany & Co.**, 1837 - currently active, American.
Service with four glasses and spoon within an art nouveau case, c. 1900.
Favrile glass and gilded silver.
Macklowe Gallery, New York. Art Nouveau.

691. **Louis Comfort Tiffany**, 1848-1933, American.
Document holder with three dividers, c. 1900.
Gilded bronze with lattice work and foliage and honey-coloured, marbled glass, height: 25 cm.
Private collection. Art Nouveau.

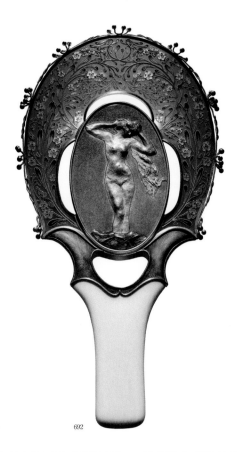

692

Félix Bracquemond
(Paris, 28 May 1833 – Sèvres, 27 October 1914)

Painter and engraver of the second half of the 19ᵗʰ century, Felix Bracquemond was a leading figure in the world of art. Producer of more than 800 engravings and precursor of Japonism in France, Bracquemond trained as a lithographer before being noticed by Joseph Guichard, a student of Ingres who took his workshop. His engravings portray landscapes, everyday scenes, or copies of works by artists such as Gustave Moreau and Camille Corot.

Bracquemond quickly befriended the Impressionists, including Manet and Degas and exhibited for the first time at the Paris Salon in 1852. In 1856, he discovered prints by artist Hokusai. Representations of insects, crustaceans, fish, flowers, and birds inspired him, making him the initiator of Japonism in France.

In 1860, he returned to the workshop of Théodore Deck, later of Eugène Rousseau, who then commissioned designs for a table service for the World Exhibition. Bracquemond used Japanese-inspired elements.

At the World Exhibition of 1867, he successfully presented his 'Rousseau' service.

In 1882, he was made a Knight of the Legion d'Honneur and Officer in 1889. Before becoming honorary member of the Société des peintres graveurs in 1890, Félix Bracquemond published the book *Du Dessin et de la couleur* in 1887.

Bracquemond played an important role in the French decorative arts and the revival of engraving.

692. **Félix Bracquemond** and **Auguste Rodin**, 1833-1914 and 1840-1917, French.
Hand mirror, c. 1900.
Gold, transparent enamel cloisonné, and ivory, 32.2 x 16.1 cm.
The Cleveland Museum of Art, Cleveland. Art Nouveau.

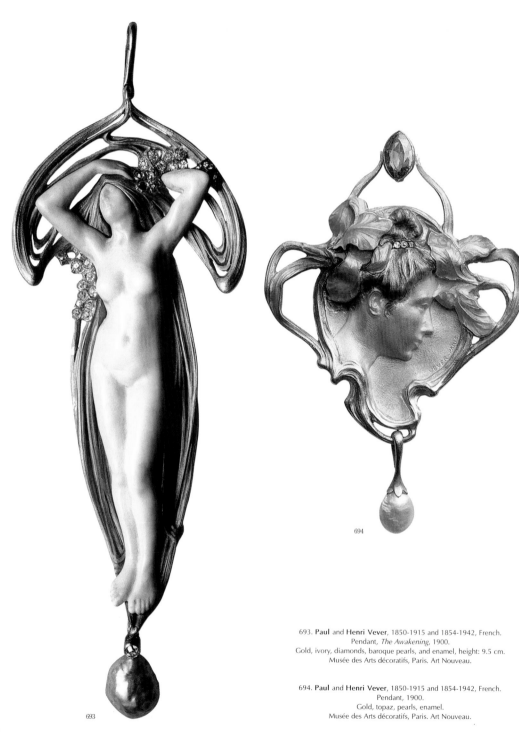

693

694

693. **Paul** and **Henri Vever**, 1850-1915 and 1854-1942, French.
Pendant, *The Awakening*, 1900.
Gold, ivory, diamonds, baroque pearls, and enamel, height: 9.5 cm.
Musée des Arts décoratifs, Paris. Art Nouveau.

694. **Paul** and **Henri Vever**, 1850-1915 and 1854-1942, French.
Pendant, 1900.
Gold, topaz, pearls, enamel.
Musée des Arts décoratifs, Paris. Art Nouveau.

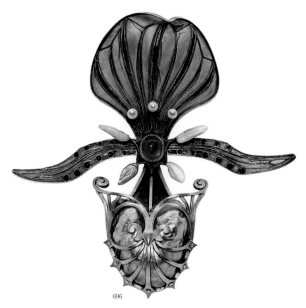

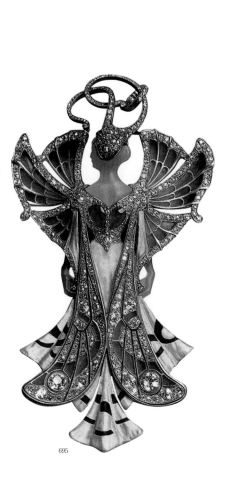

695

696

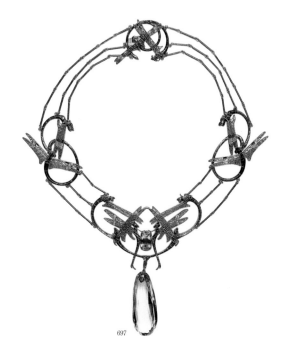

695. **Henri Vever**, 1854-1942, French.
Pendant, *Sylvia*, 1900.
Gold, agate, rubies, diamonds, and rose-cut diamonds, 12 x 6.5 cm.
Presented at the World Exhibition of 1900.
Musée des Arts décoratifs, Paris. Art Nouveau.

696. **Georges Fouquet**, 1858-1929, French.
Brooch, *Orchid*, 1900.
Gold, enamel, rubies, and pearls.
Anderson Collection. Art Nouveau.

697. **René Lalique**, 1860-1945, French.
Necklace, *Dragonfly*, c. 1900-1902.
Gold, enamel, watercolour, and diamonds.
Private collection, London. Art Nouveau.

697

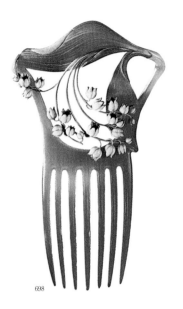

698. **René Lalique**, 1860-1945, French.
Haircomb, *Lily of the Valley*, 1900.
Gold, horn, enamel, 16 x 9.1 cm.
Musée des Arts décoratifs, Paris. Art Nouveau.

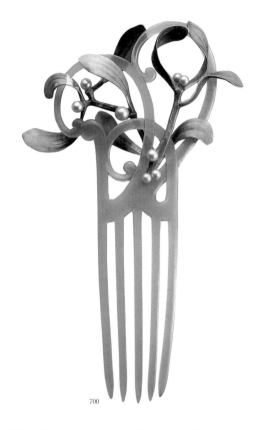

700

699

699. **Paul** and **Henri Vever**,
1850-1915 and 1854-1942, French.
Haircomb, *Daphnis and Chloe*, 1900.
Ivory, pearls, gold, enamel, 18 x 4.5 cm.
Musée des Arts décoratifs, Paris. Art Nouveau.

Henri Vever
(Metz, 16 October 1854 – Noyers, 1942)

Henri Vever came from a family of jewellers based in Metz. The House of Vever was
founded in 1821 by his grandfather Pierre-Paul Vever and was controlled by his father
Ernest in 1848.

Henri was an apprentice at Laguet Brothers around 1871 and became the craftsman.
He later undertook courses at the *Académie des Beaux-Arts*, where he studied drawing
and ornamental design. He then joined the workshop of Jean Léon Gérôme.

Vever entered the family business with his brother Paul in 1874, assuming
management during the following years. The reputation of the House of Vever continually
grew. The two brothers exhibited for the first time at the World Exhibition in Paris
and won one of two grand prizes. After this, they participated in other major exhibi-
tions such as Moscow (1891) and Chicago (1893). In their creations, wildlife or
mythical creatures are usually embellished by the use of stones, diamonds, and rubies.

In addition to creating jewellery in Art Nouveau style, Henri Vever wrote a book
on the history of jewellery, *La Bijouterie française au XIXᵉ siècle*.

700. **Paul** and **Henri Vever**, 1850-1915 and 1854-1942, French.
Haircomb, *Mistletoe*, 1900.
Gold, shell, pearls, enamel, 17.1 x 10 cm.
Musée des Arts décoratifs, Paris. Art Nouveau.

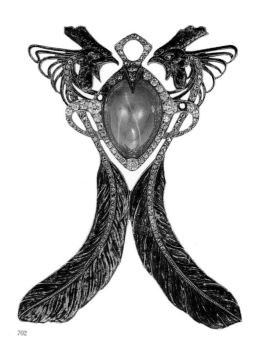

702

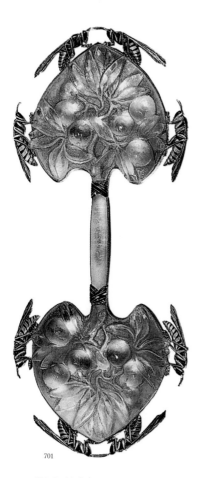

701

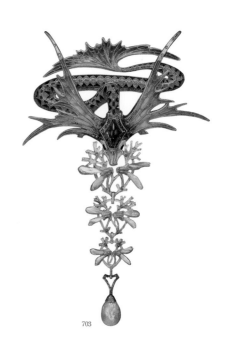

703

701. René Lalique, 1860-1945, French.
Brooch, *Blackthorn and Wasps*, 1900.
Gold, enamel, glass, 4.7 x 11.2 cm.
Musée des Arts décoratifs, Paris. Art Nouveau.

702. René Lalique, 1860-1945, French.
Pendant, *Roosters*, c. 1901-1902.
Cast and chased gold, decoration engraved on the backside. Rooster heads
and feathers of transparent enamel on gold. Surround of the central stone
and frontal feathers in gold with mounted stones. Central stone
held in place by an eyelet in the upper part, 6.9 x 5.1 cm.
Musée des Arts décoratifs, Paris. Art Nouveau.

703. Georges Fouquet, 1858-1929, French.
Brooch with *Winged Snake*, 1902.
Gold, enamel, diamonds, and pearls.
Private collection, New York. Art Nouveau.

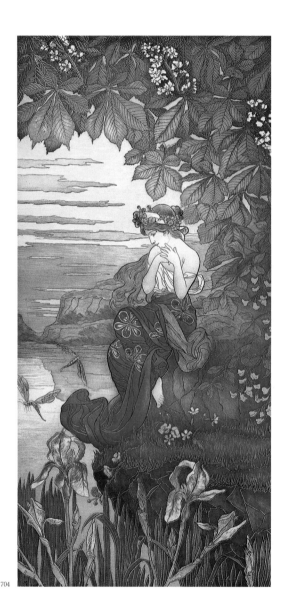

704

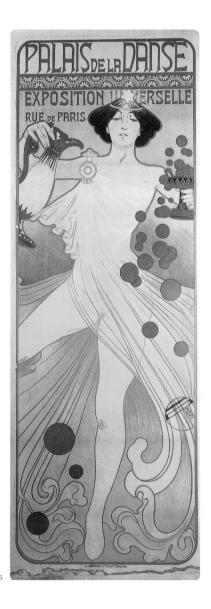

705

704. **Hippolyte Lucas**, 1854-1925, French.
At Water's Edge, 1900.
Aquatint.
Macklowe Gallery, New York. Art Nouveau.

705. **Manuel Orazi**, 1860-1934, Italian.
Dance Palace. Poster for the official dance theatre
at the World Exhibition of 1900.
Coloured lithograph. Victor and Gretha Arwas Collection. Art Nouveau.

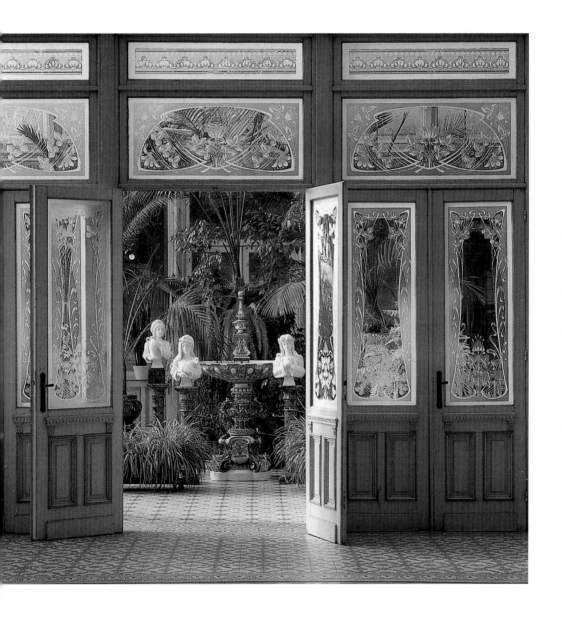

706. **Raphaël Evaldre**, dates unknown and 1862-1938, French.
Winter garden at the Ursulines Institute, c. 1900.
Wavre-Notre-Dame (Belgium). Art Nouveau.

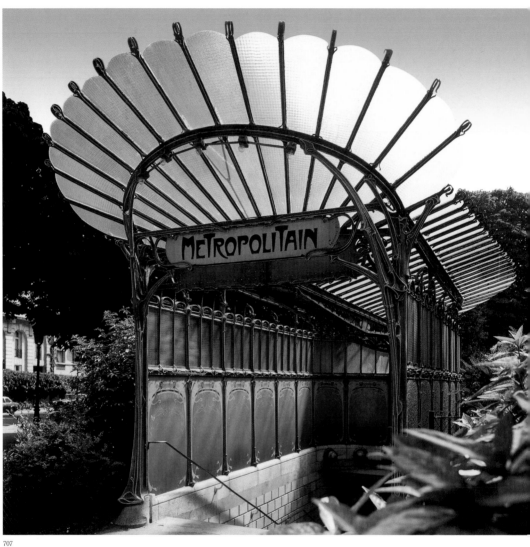

707

707. **Hector Guimard**, 1867-1942, French.
The entrance of the metro station at Porte Dauphine, c. 1900.
Paris. Art Nouveau.

708. **Georges Hoentschel**, 1855-1915, French.
Salon du bois, Paris, 1900.
Algerian plane-tree wood, glass, brass, silk wallpaper, 712 x 143 x 600 cm.
Musée des Arts décoratifs, Paris. Art Nouveau.

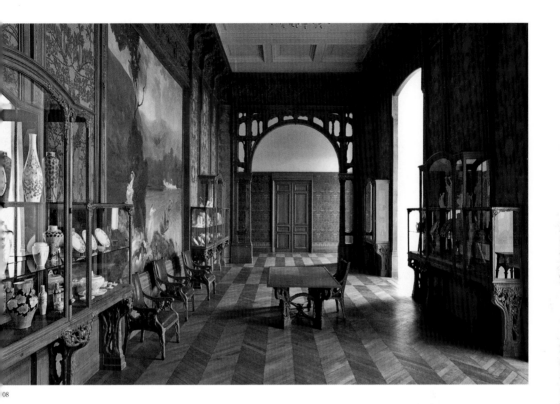

08

GEORGES HOENTSCHEL
(1855-1915)

Georges Hoentschel was a French architect, designer, ceramic artist, and collector. He designed interior rooms for the Duke of Gramont, the King of Greece, the Marquise of Ganay, and the emperor of Japan. He designed the banner for the applied arts division at the World Exhibition of Paris in 1900, as well as in St Louis in 1904. His work, especially his study of wood from 1900, is exhibited in the Musée des Arts décoratifs in Paris. Georges Hoentschel was also known as a collector in the United States, and some of his 1,800 pieces comprise the foundation of the department of Middle Ages and French 18th century art in the Metropolitan Museum of Art in New York.

Those who knew Hoentschel would describe him as "the elegance of the heart and the intelligence of taste."

Friend of Marcel Proust, Auguste Rodin, Georges Feydeau, Victor Hugo, Edgar Degas, Léopold Stevens, he was also a talented ceramic artist following Jean Carriès, with a fondness for the Impressionists, encouraging him to collect works of Monet, Manet, Turner, and Sisley.

Georges Hoentschel is buried in the Père Lachaise cemetery in Paris.

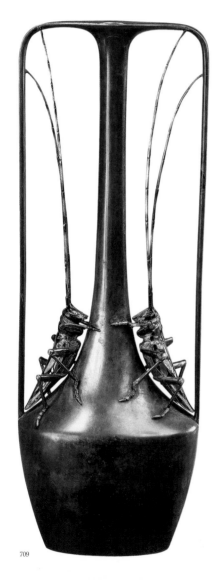

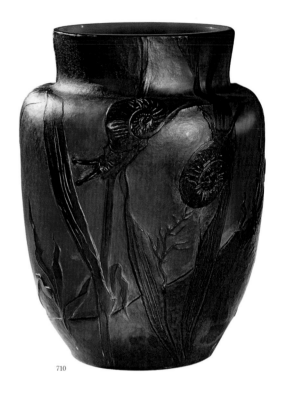

709. **Henri Vever**, 1854-1942, French.
Vase with Locusts.
Bronze and enamelled silver.
Presented at the Salon de la Société Nationale des Beaux-Arts in 1904, Paris.
Robert Zehil Collection. Art Nouveau.

710. **Imperial Glass Factory in St Petersburg** (manufacturer).
Vase, 1904.
Cased and wheel-cut glass, height: 25 cm.
Victoria and Albert Museum, London. Art Nouveau.

711. **Tiffany & Co.**, 1837 - currently active, American.
Lamp, *Wisteria*, 1902.
Bronze and glass.
Private collection. Art Nouveau.

709

710

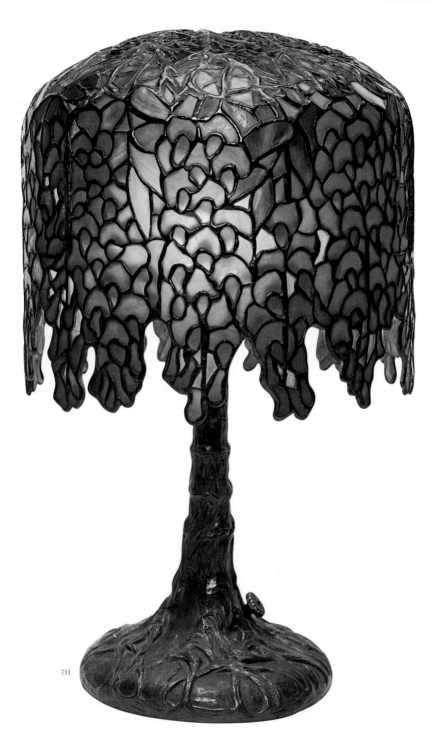

711

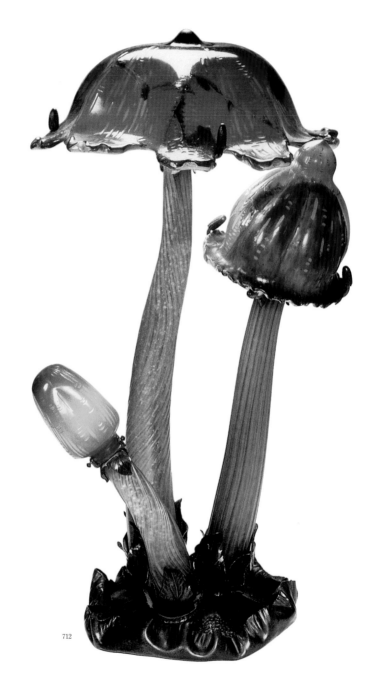

712

712. **Émile Gallé,** 1846-1904, French.
Lamp, *Mushroom*, 1902.
Triple- and double-blown glass shaped hot, height: 82 cm.
Musée de l'École de Nancy, Nancy. Art Nouveau.

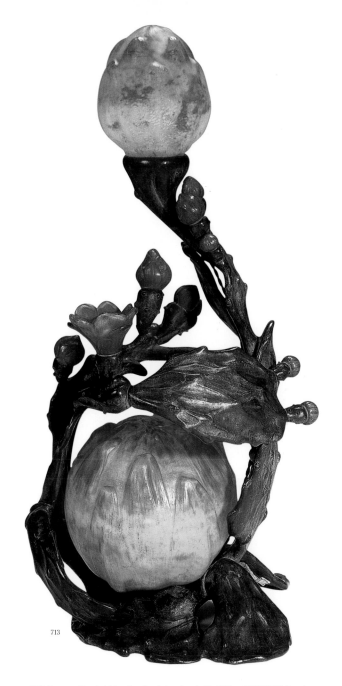

713

713. **Daum** and **Louis Majorelle**, glass factory founded in 1878 and 1859-1926, French.
Prickly Pear, 1902.
Patinated bronze and glass.
Musée de l'École de Nancy, Nancy. Art Nouveau.

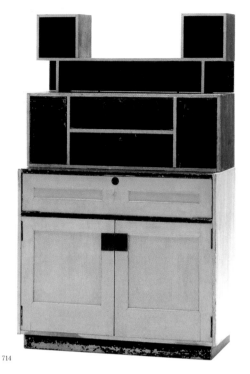

714

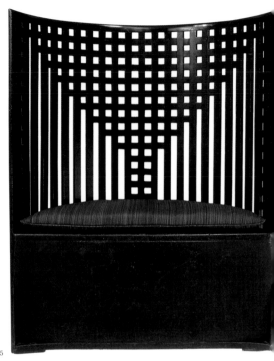

715

Koloman Moser
(Vienna, 1868-1918)

Kolosam Moser was born in Vienna in 1868. He studied painting at the Academy of Fine Arts in Vienna, and later at the University of Applied Arts in Vienna, where he was a student of Gustav Klimt. In this time, Moser also befriended the architects and decorators Joseph Maria Olbrich and Josef Hoffmann.

From the beginning of the 1890s, whilst still working as an illustrator, Moser began to develop an innovative and individual variation of Art Nouveau.

In 1897, he, with Klimt, Olbrich, and Hoffmann, founded a new alliance of artists and architects to promulgate a new aesthetic ideal, with which they revolutionised art. The result was the Vienna Secession, the proud Viennesse counterpart of Art Nouveau. Moser designed, for the house designed by Olbrich, the glass windows and the textiles, and produced furniture and various decorative objects, done primarily in glass.

In 1900, Moser organised the 6th Secession exhibition (20 January – 15 February) as an articulation of Art Nouveau, for which he worked as a set designer.

Later Moser worked in various countries (France, Germany, Switzerland, the Netherlands, and Belgium), and most specifically in the cities of Bern, Hamburg, and Paris. Moser took part, with Klimt and Josef Hoffman, of the much-celebrated project for the now famous Stoclet Palace in Brussels. He left the Secession the same year, and the Wiener Werkstätte two years later. His style changed radically, from a Belgian- and French-influenced Art Nouveau with endless dancing arches to a prosaic version of Art Nouveau with long and geometric forms.

From 1907, Moser worked exclusively as a painter.

He died in October 1918 at the age of fifty from larynx cancer.

He was fascinated by numerous aspects of art, from painting to interior decoration, from drawing to carpentry. He is therefore the embodiment of artistic production, a main tenent of Art Nouveau.

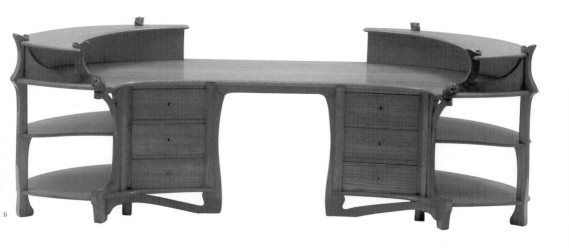

6

714. **Koloman Moser**, 1868-1918, Austrian.
Cabinet for the Moser House, 1901.
Soft wood, painted white (originally white and blue),
iron mount, 95.5 x 111 x 54 cm.
Österreichisches Museum für angewandte Kunst, Vienna.
Viennese Secession.

715. **Charles Rennie Mackintosh**, 1868-1928, Scottish.
Chair, 1904.
Oak.
Glasgow School of Art, Glasgow. Art Nouveau.

716. **Henry Van de Velde**, 1863-1957, Belgian.
Desk, 1901-1902.
Wood.
Österreichisches Museum für angewandte Kunst, Vienna.
Art Nouveau.

717. **Koloman Moser**, 1868-1918, Austrian.
Secretary and chair, 1903.
Cedar, inlay, copper, and gilding, 145.5 x 119.4 x 60 (secretary);
70 x 60 x 60 cm (chair).
Victoria and Albert Museum, London. Art Nouveau.

718. **Koloman Moser**, 1868-1918, Austrian.
Patterned cabinet, before 1904.
Rosewood and satinwood inlaid with rosewood,
maple and pearl, 138.5 x 98.8 x 49.5 cm.
Sammlung der Fondation Kamm, Kunsthaus Zug, Zug.
Viennese Secession.

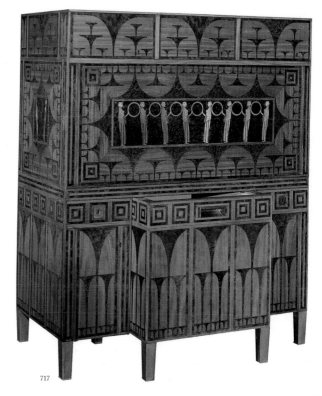

717

371

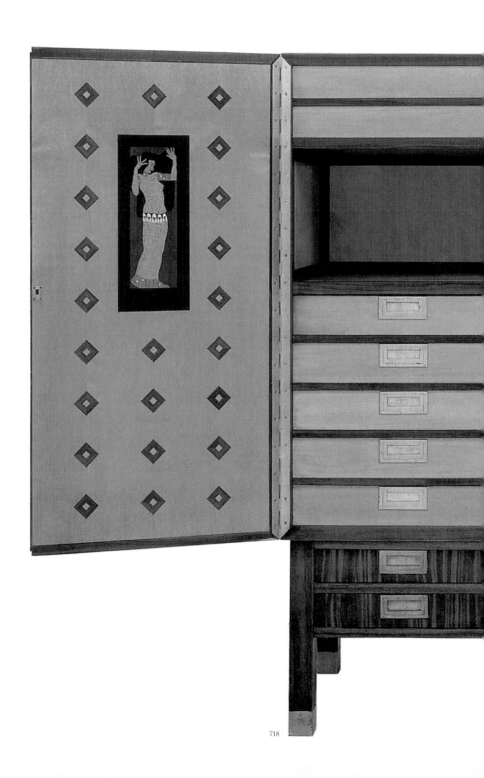

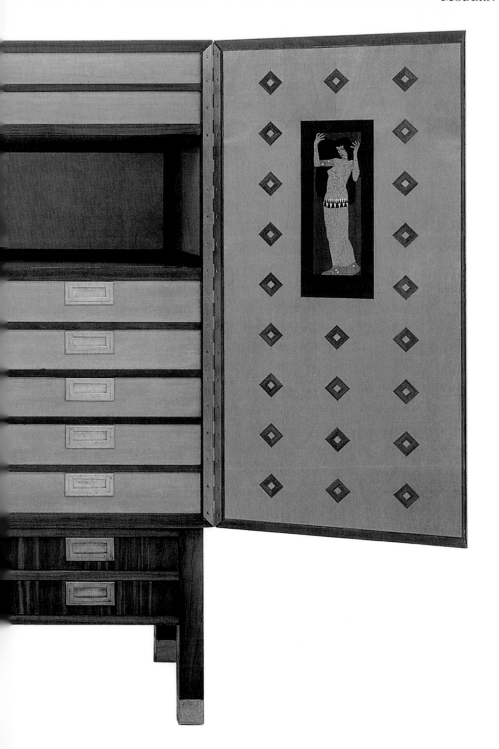

719

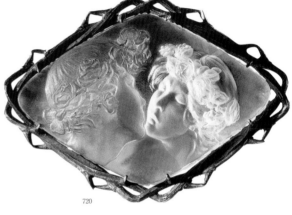

720

721

719. **Richard Riemerschmid**, 1868-1957, German.
Tankard, 1902.
Salt-glazed stoneware, cast body, with applied decoration and feet,
painted in blue, pewter lid, 14 x 15 x 11.5 cm.
Victoria and Albert Museum, London. Art Nouveau.

720. **René Lalique**, 1860-1945, French.
Brooch, *The Kiss*, c. 1904-1906.
Thorned mount: patinated and engraved silver; intaglio plate:
embossed glass relief, patinated, 4.9 x 7 cm.
Musée des Arts décoratifs, Paris. Art Nouveau.

721. **Koloman Moser**, 1868-1918, Austrian.
Pendant for children, 1904.
Enamel on silver plate, copper, 2.7 x 3 cm.
Leopold Museum, Vienna. Viennese Secession.

722

722. **Koloman Moser**, 1868-1918, Austrian.
Lamp with glass rod for the Schwestern Flöge in Vienna, 1904.
Nickel silver and glass, 37.5 x 18.5 x 18.5 cm.
Private collection. Viennese Secession.

723

724

723. **Koloman Moser**, 1868-1918, Austrian.
Fruit basket, 1904.
Silver, 5.4 x 16.4 x 16.4 cm.
Private collection. Viennese Secession.

724. **Koloman Moser**, 1868-1918, Austrian.
Vase, 1904.
Silver, 21.5 x 8.6 x 8.6 cm.
Leopold Museum, Vienna. Viennese Secession.

725

725. **Koloman Moser**, 1868-1918, Austrian.
Reliefs for local metal workshops in Vienna, Neustiftgasse 32-34, Vienna 7, 1904.
Gilded silver in a wooden frame, 15 x 14.8 cm (each piece).
Wien Museum Karlsplatz, Vienna. Viennese Secession.

726

726. **Koloman Moser**, 1868-1918, Austrian.
Reliefs for Dr Hermann Wittgenstein's living room, 1904.
Gilded copper, 22.6 x 22.5 cm (each piece).
Wien Museum Karlsplatz, Vienna. Viennese Secession.

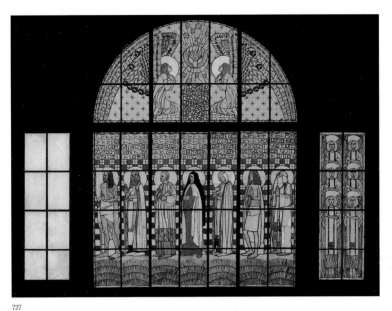

727

727. **Koloman Moser**, 1868-1918, Austrian.
Drawing for stained glass window of Am Steinhof Church, 1905-1906.
Pencil, ink, opaque colours, 86 x 114 cm.
Österreichisches Museum für angewandte Kunst, Vienna. Viennese Secession.

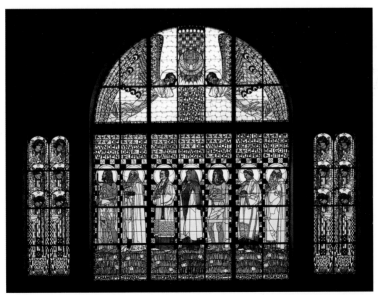

728

729. **Jacques Gruber**, 1870-1936, French.
Veranda, known as *La Salle*, 1904.
728. **Koloman Moser**, 1868-1918, Austrian.
Multi-layered glass, painted glass, American chenille glass,
Eastern window, lit by sunlight.
American iridescent stretch glass, acid etching, 243 x 344 cm.
Am Steinhof Church, Vienna. Viennese Secession.
Musée de l'École de Nancy, Nancy. Art Nouveau.

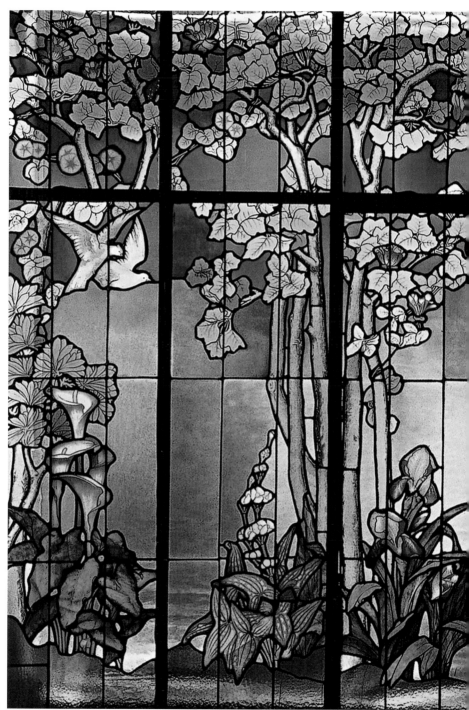

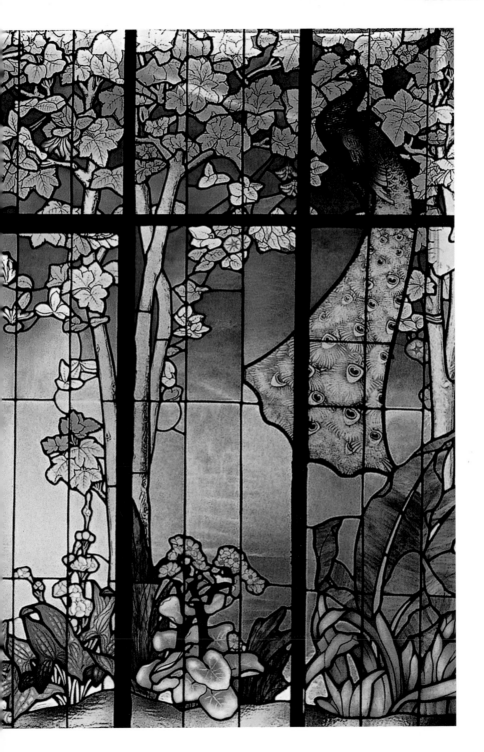

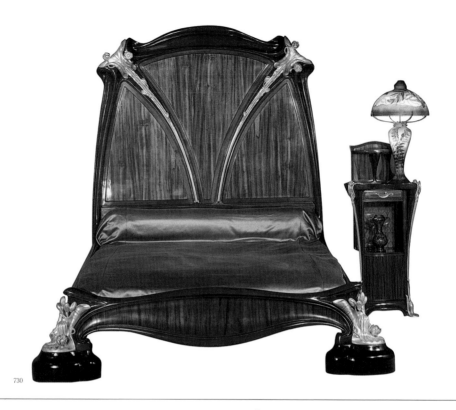

730

Louis Majorelle
(Toul, 1859 – Nancy, 1926)

Louis Majorelle was born in 1859 in Toul in the Meurthe-et-Moselle department of France. He began his art education at the École nationale supérieure d'art in Nancy and continued it in 1877 at the École nationale supérieure des Beaux-Arts in Paris. Two years later, Majorelle returned to Nancy, as his father laid on his deathbed. He inherited, with his brother, the family's furniture and porcelain manufacturing firm.

Louis Majorelle followed in his father's footsteps, in that he produced Rococo-inspired furniture to sell in France and its colonies. After Emile Gallé converted him to the principles of Art Nouveau in 1894, Majorelle would become one of the most important followers of this art style within the school at Nancy.

He would be inspired by then dominating principles of Naturalism and Symbolism. He gained much recognition for his furniture pieces, inlaid with straight-lined water lilies.

At the same time, Majorelle began to decorate furniture with metal and bronze, as a means to reinforce architecture lines or specific decorative elements. In 1898, he asked the architect Henri Sauvage to design his house in Nancy. The Villa Majorelle or Villa Jika (for the initial of his wife Jeanne Kretz) was the work of one artist for another. The house, in its architectural design, as well as its interior decor, epitomises the Art Nouveau ideals.

Majorelle's collaboration with the glass manufactory of the Daum brother resulted in an original combination of colours and shapes. His work later evolved to contain fine and easy lines, which although not part of Art Nouveau, implied the arrival of Art Deco of the 1920s.

Louis Majorelle was one of the most important and most celebrated manufacturers of Art Nouveau furniture at the time of his death in 1926. His legacy lies in his elegant but original style, which swayed in rhythm with nature.

730. **Louis Majorelle**, 1859-1926, French.
Water Lillies, 1905-1909.
Bed: mahogany and serpentwood, inlay of various woods, gilded and chased bronze.
Musée d'Orsay, Paris. Art Nouveau.

733. **Eugène Gaillard**, 1862-1933, French.
Small round table with stools, c. 1913.
Main piece of padauk, stools veneered in Madagascan palisander,
height: 71 cm; diameter: 70 cm.
Musée des Arts décoratifs, Paris. Art Nouveau.

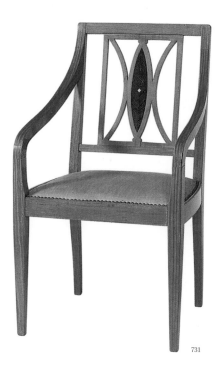

731

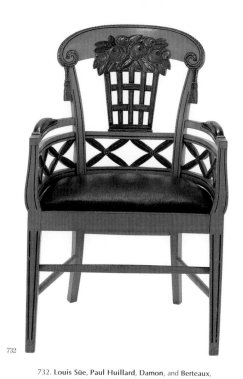

732

731. **Bruno Paul**, 1874-1968, German.
Armchair, Germany, 1905.
Beech frame with satinwood veneer, inlaid in oak,
with original raw-silk upholstery, height: 100 cm.
Victoria and Albert Museum, London.

732. **Louis Süe**, **Paul Huillard**, **Damon**, and **Berteaux**,
1875-1968 and 1875-1966, French.
Chair, 1912.
Gold beech, lacquered in green and red, arms and seat of green leather, 87 x 53 cm.
Musée des Arts décoratifs, Paris. Art Nouveau.

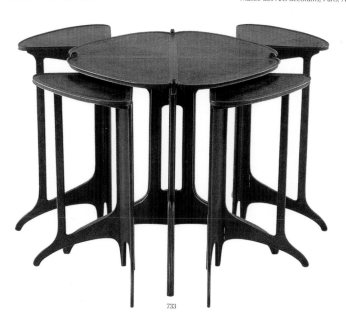

733

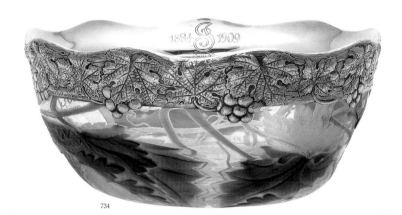

734

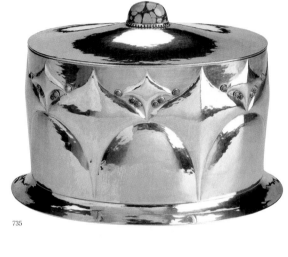

735

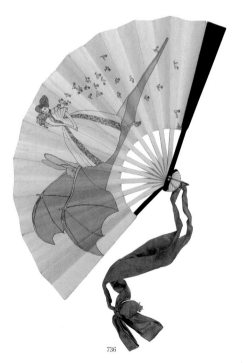

736

734. **Louis Comfort Tiffany**, 1848-1933, American.
Bowl with silver rim in grapevine pattern, 1907.
Cameo glass, sterling silver, 12 x 27.3 cm.
The Chrysler Museum of Art, Norfolk (Virginia). Art Nouveau.

735. **Koloman Moser**, 1868-1918, Austrian.
Tin with lid, 1906.
Sammlung der Fondation Kamm, Kunsthaus Zug, Zug.
Viennese Secession.

736. **Bertold Löffler**, 1874-1960, Austrian.
Torn fan for the Cabaret Fledermaus, c. 1908.
Quisquilien Sammlung, Österreichisches Theatermuseum, Vienna.
Viennese Secession.

737

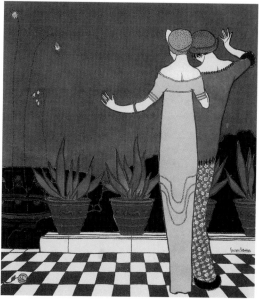

738

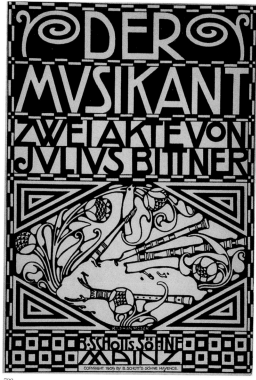

739

737. **Koloman Moser**, 1868-1918, Austrian.
Poster for a soiree of *Sonaten von Beethoven*, 1908.
Coloured lithograph, 95.3 x 31.8 cm.
Wien Museum, Vienna. Viennese Secession.

738. **Georges Lepape**, 1887-1971, French.
Plate, illustration from *Les choses de Paul Poiret vues par Georges Lepape*, 1911.
Calotype, letterpress, line block and stencil.
Victoria and Albert Museum, London.

739. **Koloman Moser**, 1868-1918, Austrian.
Cover sheet of the score of Julius Bittner's opera *Der Musikant*, 1909.
Typography, 28 x 20.5 x 3 cm.
Galerie Pabst, Munich. Viennese Secession.

740

740. **Ditha Moser**, 1883-1969, Austrian.
Tarot cards, 1908.
Coloured lithograph, 11.5 x 5.5 cm.
Universität für angewandte Kunst Wien, Vienna. Viennese Secession.

743. **Ditha Moser**, 1883-1969, Austrian.
Year 1913 Calendar, 1913.
Coloured lithograph, 13.1 x 8.3 cm.
Österreichisches Museum für angewandte Kunst, Vienna. Viennese Secession.

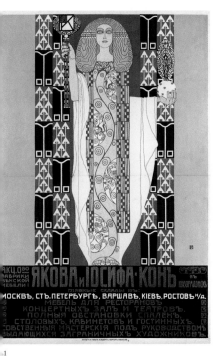

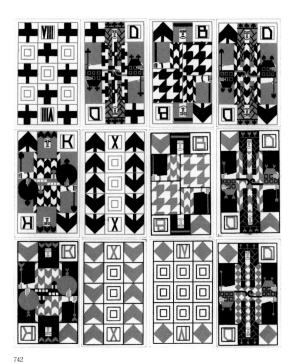

741. **Koloman Moser**, 1868-1918, Austrian.
Poster for Jacob & Josef Kohn for an auction in Russia, c. 1904.
Coloured lithograph, 94.7 x 62.6 cm.
Österreichisches Museum für angewandte Kunst, Vienna.
Viennese Secession.

742. **Ditha Moser**, 1883-1969, Austrian.
Card game Whist, 1910.
Prints on red and black cards, 8 x 5 cm.
Österreichisches Museum für angewandte Kunst, Vienna. Viennese Secession.

743

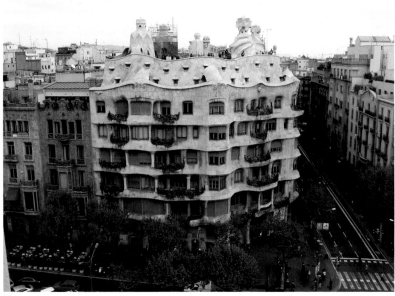

744

745

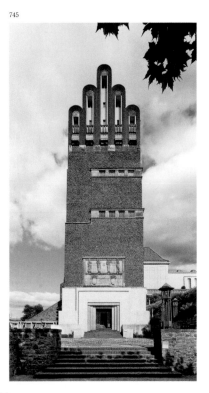

Joseph Maria Olbrich
(Opava, 1867 – Düsseldorf, 1908)

The Opava-born Joseph Maria Olbrich was a student of Otto Wagner, who opened the young student's mind and cultivated his talent. As the eldest son, his parents set a rigidly-academic plan for him. Instead he became a bricklayer before enrolling a vocational school in Vienna at age fifteen, where he enrolled in architecture courses. Four years later, he would graduate with the best possible marks.

After a temporary stay in Opava, he began his studies at the University of Applied Arts in Vienna. Otto Wagner noticed Olbrich, and hired the now mid-twenty year old at his architectural firm.

Olbrich did not limit himself as an architect, instead he designed furniture and ceramic dishware. He and another were responsible for the interior decoration of the then prestigious German liner, *SS Kronprinzessin Cecilie.*

His fame would reach the US, where he corresponded with members of the American Institute of Architects. The project list from 1900-1908 is unbelievably long, and alongside all these activities, he managed to publish on his architectural theories in *Ideen von Olbrich* (1900) and *Architektur von Olbrich.*

It is as though, with his unrest and his unbelievably many projects, he knew of his short life span. Joseph Maria Olbrich died of leukaemia on 8 August 1908 in Düsseldorf.

744. Antoni Gaudí,1852-1926, Spanish.
Casa Milà, 1905-1910. Barcelona.

745. Joseph Maria Olbrich, 1867-1908, German.
Wedding Tower in Mathildenhöhe in Darmstadt, 1908.
Photograph by Jürgen Schreiter, 2009.
Städtische Kunstsammlung Darmstadt, Mathildenhöhe Darmstadt, Darmstadt.
Viennese Secession.

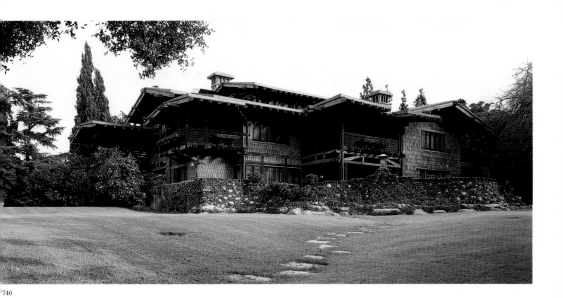

746

746. **Charles** and **Henry Greene**, 1868-1957 and 1870-1954, American.
The Gamble House, 1908-1909.
Pasadena (California). Arts and Crafts Movement.

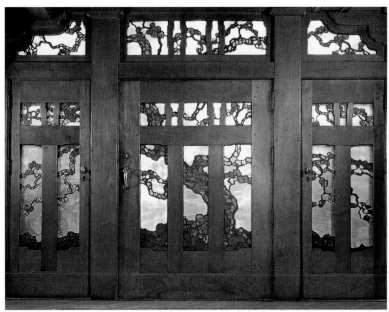

747

747. **Charles** and **Henry Greene**, 1868-1957 and 1870-1954, American.
The Gamble House, main entrance, 1908-1909.
Pasadena (California). Arts and Crafts Movement.

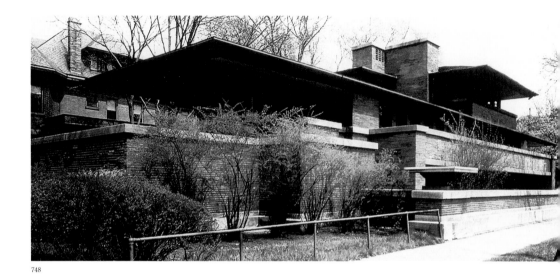

748

Frank Lloyd Wright
(Richland Center, 8 June 1867 – Phoenix, 9 April 1959)

Frank Lloyd Wright was born on 8 June 1867 in Richland Center, Wisconsin. Influenced by the English Arts and Crafts Movement, Frank Lloyd Wright, was the creator of many museums, churches, hotels, and especially many houses. He started alongside Louis H. Sullivan, the first American Art Nouveau architect who took Wright under his wing.

His first important work was his own house in Oak Park. Frank Lloyd Wright discovered Japanese architecture at the Columbian Exposition in Chicago in 1893. It was a revelation. Afterwards, he made many trips to Japan. The same year, he received his first commission, the Winslow House.

By 1897, his style asserted itself more and more with the construction of *Prairie Houses*, on which he played with the natural elements of the landscape. One of the leading examples is the Fallingwater House, built in 1934-1937, in Pennsylvania. But before was Wright's Robie House realised in 1908-1910, in Illinois, an elevated and large house.

In 1909, Frank Lloyd Wright travelled to Europe. He attended and influenced avant-garde architects in Austria, such as Gropius and Mies Van der Rohe. Upon his return in 1911, he settled in Wisconsin. During the crisis of 1929, he moved to Phoenix, and took the lead of a large agency with more than fifty workers after the Second World War.

In 1934, he began a series called *Usonian Homes* for the middle class, generally L-shaped and designed to be practical.

Frank Lloyd Wright was one of the first to integrate the interior in his architectural design. He designed more than 800 projects, half of which were realised. Wright created simple shapes, stone and wooden houses, and with geometric and bass elements. Furniture, architecture, and lifestyle should coincide.

The Guggenheim Museum in New York, opened in 1959, remains as his major work.

748. **Frank Lloyd Wright**, 1867-1959, American.
Robie House, 1908-1910.
Chicago.

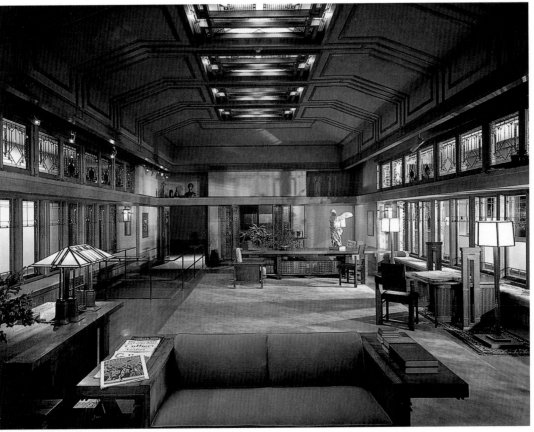

749

749. **Frank Lloyd Wright**, 1867-1959, American.
Window for the living room in *Francis W. Little House*, 1912-1915.
Lead glass, 136.5 x 288.9 cm.
The Metropolitan Museum of Art, New York.

750

751

751

750. Hector Guimard, 1867-1942, French.
Vase, c. 1910.
Patinated bronze and ceramic, height: 26 cm.
Robert Zehil Collection. Art Nouveau.

751. **Albert Dammouse**, 1848-1926, French.
Dishes, c. 1910.
Molten embossed glass, height: 8.8 and 6.5 cm.
Musée des Arts décoratifs, Paris. Art Nouveau.

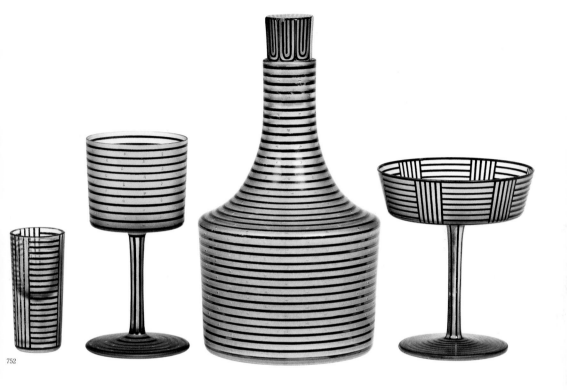

752

Josef Hoffmann
(Brinice, 15 December 1870 – Vienna, 7 May 1956)

Josef Hoffmann was an Austrian architect of the 20th century. After studying at the University of Vienna, Hoffmann went to Italy where he discovered a geometric and richly-ornate style. He was a member of the Vienna Secession in 1897, with Gustav Klimt, Koloman Moser, and Josef Olbrich, a combination of Art Nouveau and Art Deco. They completed architectural projects or furniture and were recognised for their rectilinear geometric style. He was considered the Viennese architect par excellence.

In 1903, with Olbrich, Klimt, and Moser, he founded the Wiener Werkstätte for decorative arts.

He designed not only in France but also abroad, particularly in Brussels, where he completed the Stoclet Palace, and exhibited at pavilions in Cologne, Paris, or Venice. As avant-garde architect, Robert Mallet-Stevens and Ruhlmann were great influences. Throughout his career, he combined simplicity and refinement. He was a pioneer of modernism and the Art Deco movement.

752. **Josef Hoffmann**, 1870-1956, Austrian.
Service including a shot glass, wine glass, pitcher, and flute, 1911.
Dr Ernst Ploil Collection, Vienna. Viennese Secession.

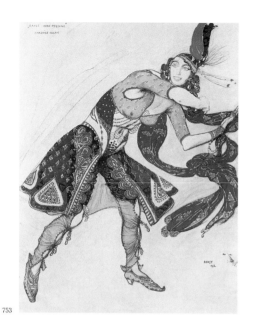

753

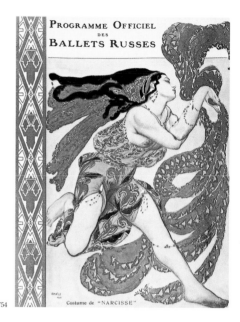

754

753. **Léon Bakst**, 1866-1924, Russian.
Costume of an Indo-Persian dancer for the ballet *Cleopatra*, 1909.
Watercolour and gold on paper, 48 x 31 cm.
Private collection, Paris.

754. **Léon Bakst**, 1866-1924, Russian.
Cover page for the official program of the Ballet Russes
(Bacchante in the production of *Narcissus*), 1911.
31 x 20 cm. Private collection.

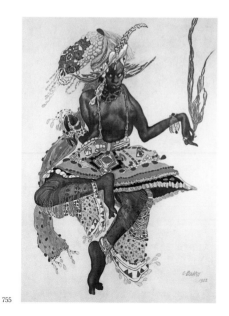

755

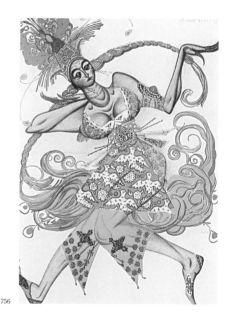

756

755. **Léon Bakst**, 1866-1924, Russian.
Costume design for the ballet *Le Dieu Bleu*, 1912.
Watercolour, graphite, accented with gold colour on paper, 43 x 28 cm.
Musée national d'Art moderne, Centre Georges-Pompidou, Paris.

756. **Léon Bakst**, 1866-1924, Russian.
Costume design for the Firebird for the ballet *The Firebird*, 1910.
Watercolour and gouache on paper. Private collection.

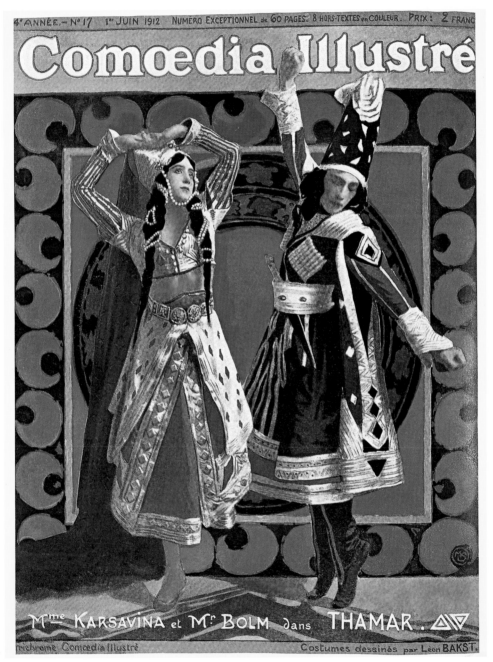

757

757. **Léon Bakst**, 1866-1924, Russian.
Cover page of the *Comœdia Illustré* (1912), 1912.
The Queen Thamar and the Prince from the ballet *Thamar*.
National Gallery of Australia, Canberra.

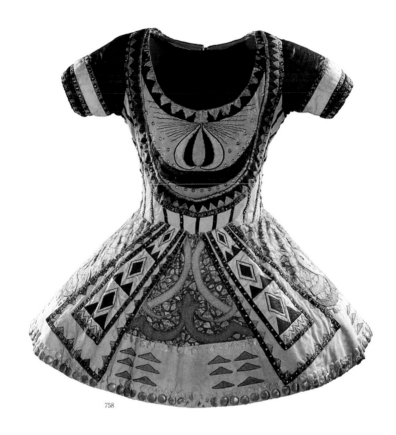

758

LÉON BAKST
(Grodno, 9 May 1866 – Paris, 27 December 1924)

Léon Baskt (born as Lev Samoilovich Rosenberg) was born on 9 May 1866 in Grodno (currently Belarus) in a middle-class Jewish family.

He studied painting at the Academy of Fine Arts in St Petersburg. Bakst began his artistic career as an illustrator for various magazines and made the acquaintance of Alexandre Benois, who introduced him to the European artistic circles. He later studied at the Académie Julian in Paris. On his return to St Petersburg in 1896, his career was gaining momentum after the publication of his first books on scenography and his portraits. In 1898, he became the co-founder, with Alexandre Benois and Serge Diaghilev, of *Mir Iskusstva* (The World of Art).

Around 1902-1903, he began his career as a designer at the Hermitage Theatre and Alexandrinsky Theatre in St Petersburg. He then received many orders from the Mariinsky Theatre. He also taught drawing at the prestigious school of painting Yelizaveta Zvantseva where he had Marc Chagall as a student and organised the Russian section of the annual art exhibition of the Salon d'Automne in Paris.

He returned to France in 1908 and worked with Serge Diaghilev to create the dance company *Les Ballets Russes*. His creations, brilliant and exotic, had a decisive influence on fashion and decorative arts. His most admired costumes are no doubt those he created for Diaghilev's ballets: *Scheherazade* (1910) and *The Afternoon of a Faun* (1912). Diaghilev appointed him Director of Arts in 1911. The lavish sets created by Bakst earned him an international reputation very quickly. Expelled from Russia due to his Jewish origins, he decided to permanently settle in Paris and in 1912 and in 1920, was the editor of *Vogue* magazine. Condé Nast persuaded him to publish one of his drawings for a cover. He died in Paris on 27 December 1924, at the age of fifty-eight.

758. **Léon Bakst**, 1866-1924, Russian.
The blue god's costume for the ballet *Le Dieu Bleu*, 1912.
Silk, satin, and sequins.
National Gallery of Australia, Canberra.

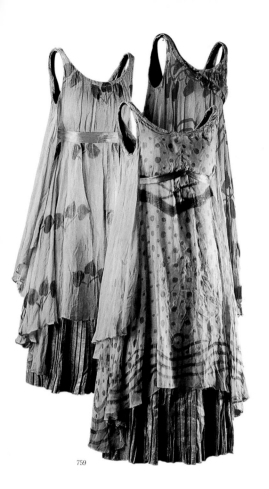

759

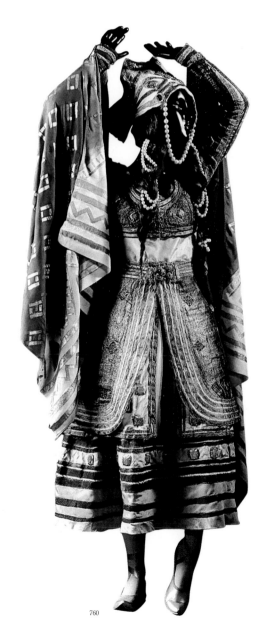

759. Léon Bakst, 1866-1924, Russian.
Nymphs' costumes for the ballet *The Afternoon of a Faun*, 1912.
Silk, lamé fabric, ribbon, and wool.
National Gallery of Australia, Canberra.

760. Léon Bakst, 1866-1924, Russian.
The Queen's costume for the ballet *Thamar*, 1912.
Silk, wool, lamé fabric, shawl, metal medallions, jewellery.
National Gallery of Australia, Canberra.

760

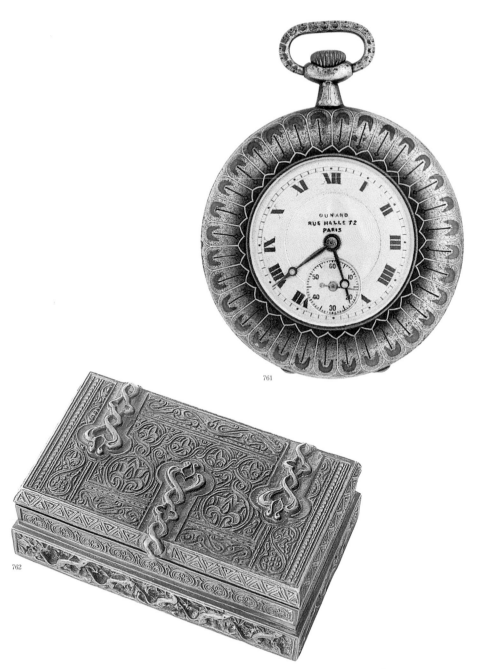

761. **Jean Dunand**, 1877-1942, French.
Pocket watch, 1914-1918.
Stainless steel coated with gold and silver, height: 6 cm; diameter: 4.5 cm.
Musée des Arts décoratifs, Paris.

762. **Louis Comfort Tiffany**, 1848-1933, American.
Venetian rectangular box, c. 1915.
Gilded bronze with sigil cover, geometric strips and rosettes. The interwoven
bands represent false hinges, height: 12.5 cm.
Private collection. Art Nouveau.

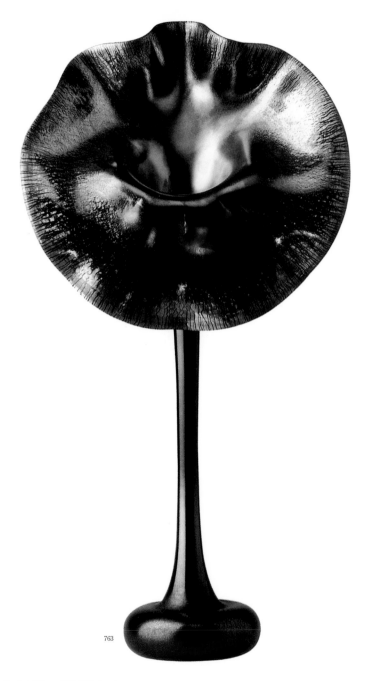

763

763. **Louis Comfort Tiffany**, 1848-1933, American.
Vase, 1913.
Favrile glass, 52.5 x 13 cm.
The Museum of Modern Art, New York.

764. **Jaap Gidding**, 1887-1955, German.
Lobby at the Pathé Tuschinski, movie theatre, 1918-1921.
Amsterdam.

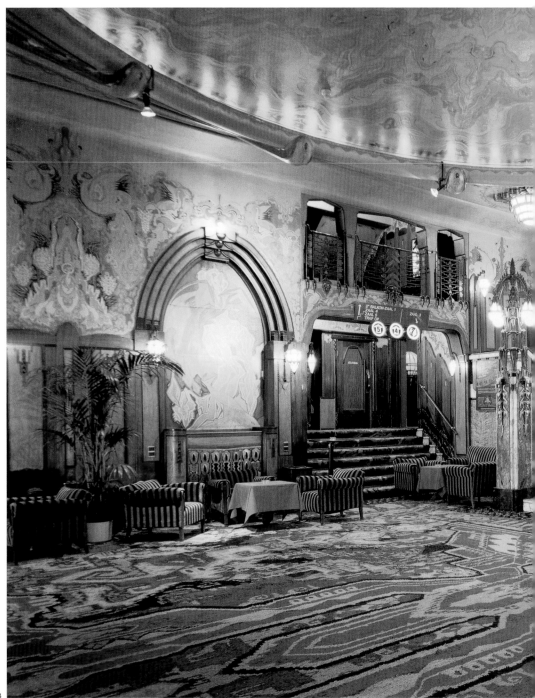

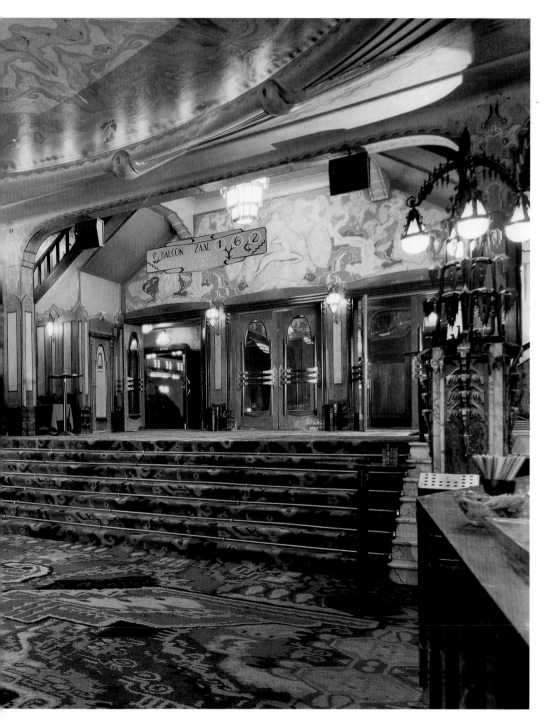

765

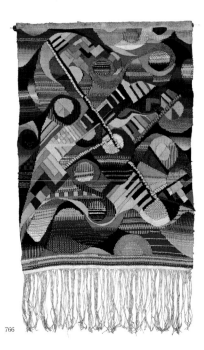

766

Sonia Delaunay
(Gradischsk, Odessa region, 14 November 1885 – Paris, 1979)

Born in Ukraine in 1888, Sofia Ilinitchna Terk came from a working class family. Adopted by her uncle, she spent her childhood in St Petersburg and travelled to Finland, Switzerland, Italy, and Germany. In 1903, she studied drawing in Karlsruhe, Germany before going to Paris with her uncle, where she studied at the Académie de la Palette. She discovers Gauguin, Bonnard, and Vuillard, and completes her first painting in 1907, *Jaune Finlandaise*. In order to stay in France, she married Wilhelm Uhde in 1908 but divorced soon thereafter. She met Robert Delaunay and assumed the name Sonia Delaunay in 1910. After the birth of her son Charles in 1911, she began her first projects, the *robes simultanées*.

During the First World War, they both sought refuge in Spain and Portugal. In 1918, she worked in Madrid with Diaghilev's *Les Ballets Russes*. During the 1920s, she focuses mainly on decorative arts and fashion, designing scarves, coats, and fabrics for apparel and furnishing, but also theatre and cinema costumes, posters, poems, and objects.

In 1925, she participated in the Exposition des Arts décoratifs and opened, at the same time, a shop with Jacques Heim. She returned to painting in the 1930s, and joined with Robert Delaunay Abstraction-Création group. The group realised murals for the pavilions for aviation and railways for the World Exhibition of 1937. In 1939, together they organised the *Salon des Réalités nouvelle* at the Galerie Charpentier.

Robert died in 1941, and Sonia moved to Grasse, where she lived with Hans and Sophie Arp until 1944. Without Robert, she continued to produce abundantly and received the Legion of Honor in 1975.

767

765. **Sonia Delaunay**, 1885-1979, French.
Illustration for Blaise Cendrars' *La prose du Transsibérien et de la Petite Jehanne de France*, 1913.
Watercolour, text imprinted on Japanese paper,
book cover with coloured parchment, 199 x 36 cm,
measurements of the closed work: 18 x 11 cm.
The Hague, Netherlands. Art Deco.

766. **Hedwig Jungnik**, German.
Rug with abstract forms, 1921-1922.
nen, cotton, wool, silver ribbons, and artificial silk, 90 x 125 cm.
Klassik Stiftung Weimar, Weimar. Bauhaus.

767. **Eileen Gray**, 1878-1976, Irish.
Rectangular rug, c. 1923.
Wool, geometric motifs in night blue and black, 154 x 128 cm.
Private collection.

768. **Anonymous.**
Shawl, c. 1925.
Handsewn velvet and silk.
Victoria and Albert Museum, London.

768

401

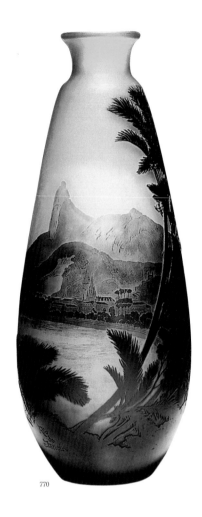

770

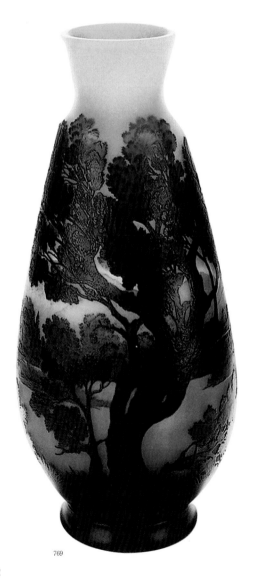

769

769. Émile Gallé, 1846-1904, French.
Vase with tree and sea motifs, 1919-1935.
Glass, height: 51 cm.
Musée de l'École de Nancy, Nancy. Art Nouveau.

770. Émile Gallé, 1846-1904, French.
Vase, depicting the Guanabara Bay in Rio, 1919-1935.
Glass, height: 46 cm.
Musée de l'École de Nancy, Nancy. Art Nouveau.

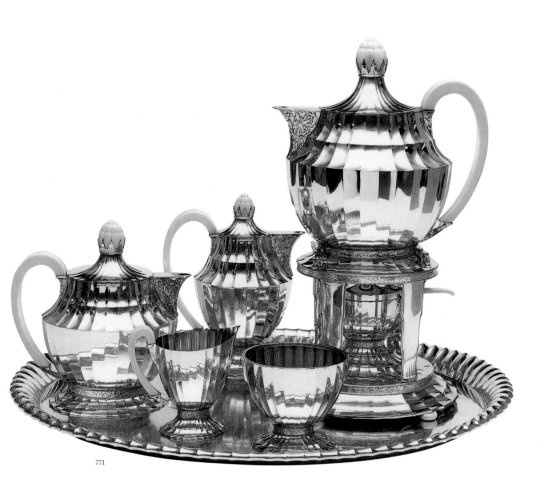

771

771. **Otto Prutscher**, 1880-1949, Austrian.
Coffee and tea service, c. 1920.
Silver and ivory, 2 x 59 x 46 cm (tray).
Victoria and Albert Museum, London.

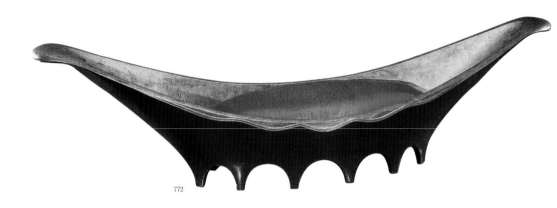

772

Eileen Gray
(Enniscorthy, 9 August 1878 – Paris, 31 October 1976)

Eileen Gray was born on 9 August 1879 in Enniscorthy, Ireland. She studied at the Slade School of Art and arrived in Paris in 1902 to take courses at the Académie Julian, as well as the Académie Colarossi. From the beginning, Gray showed a special interest in the technique of lacquer and returned to London in 1907 to further her art. She relocated permanently to Paris in 1937.

Gray's exhibition in 1913 at the Salon des Artistes décorateurs was a success. She completed decorative panels combining lacquer and rare wood with Japanese-inspired motifs, attracting the attention of art collector Jacques Doucet, who ordered the three panels including the famous screen *Le Destin*. Eileen Gray realised her own furniture for a long time for Inagaki, a Japanese craftsman and specialist in ivory and lacquer work.

In 1922, she opened her own gallery, the Galerie Jean Désert in the Faubourg Saint-Honoré and set out a number of her works: screens, curtains, carpets, mirrors, etc. The gallery would attract a chic clientele, but was abandoned in 1930.

In 1923, she designed the *Boudoir de Monte-Carlo* for the 14th Salon des Arts décoratifs. It attracted the attention of the de Stijl movement, including of its leader J.J. Oud. Grey, with Breuer, Rietveld, and Perriand pioneered steel tube furniture.

Thereafter, encouraged by the Romanian architect Jean Badovici, Eileen Gray turned to architecture. Both worked hard on the villa called *E -1027*, located in Roquebrune, for which Le Corbusier painted new mural works.

Around 1930-1932, Gray built, whilst respecting the five points of modern architecture set by Le Corbusier, her own villa *Tempe Pailla* in Castellar, in southern France. A villa with ultra-modern furniture, gadgets, consoles drawers, cupboards, etc.

After the war, well ensconced in the architectural environment, Gray continued her work. In 1973, several retrospective exhibitions were held, including at the Royal Institute of British Architects and at the Architectural League of New York.

Eileen Gray died at the age of ninety-eight years.

772. **Eileen Gray**, 1878-1976, Irish.
Lounger, c. 1919-1920.
Lacquered wood with silver leaf, 72 x 270 x 64.9 cm.
Virginia Museum of Fine Arts, Richmond.

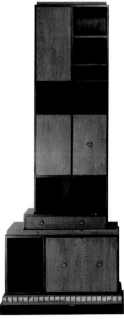
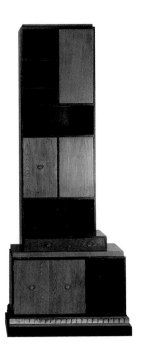

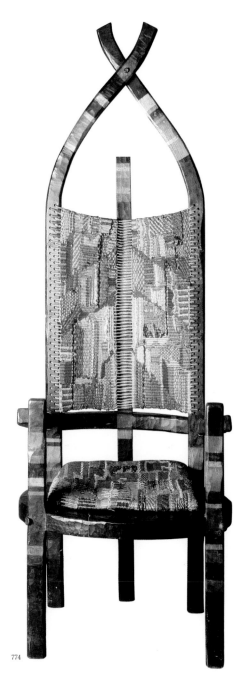

773. **Paul Theodore Frankl,** 1886-1958, Austrian.
Pair of bookshelves, 'skyscrapers' model, end of the year 1920.
California sequoia wood and veneer in nickelled stainless steel, height: 228.6 cm.
Cincinnati Art Museum, Cincinnati (Ohio).

774. **Marcel Breuer** and **Gunta Stölzl**, 1902-1981 and 1897-1983, German.
African chair, 1921.
Enamelled oak, cherry wood, hemp, wool, cotton, silk, 179.4 x 65 x 67.1 cm.
Bauhaus-Archiv Museum für Gestaltung, Berlin. Bauhaus.

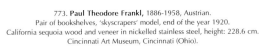

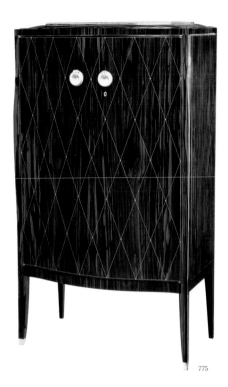
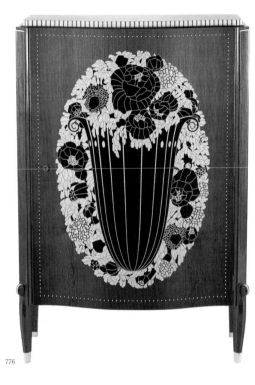

775 776

JACQUES-ÉMILE RUHLMANN
(PARIS, 28 AUGUST 1879 – PARIS, 15 NOVEMBER 1933)

Jacques-Émile Ruhlmann, son and grandson of industrialists, who owned a painting firm, was born on 28 August in Paris. After completing his military service, he began designing his own furniture and visited the shops of cabinetmakers in his neighbourhood: Gevens, Stauffacher, etc. On the death of his father in 1907, Ruhlmann took hold of the industrial firm.

He exhibited wall papers at the Salon d'Automne in 1910 and at the Salon des Artistes décorateurs, and participated in major exhibitions in France and abroad, thereby acquiring fame.

The State commissioned him for projects, and the Metropolitan Museum of Art in New York and the Egyptian Museum in Cairo acquired furniture from him. His taste for luxury, the refinement of his furniture, as well as its aesthetic usefulness and their pure form, reflect the personal style of Ruhlmann. He only used rare and refined materials, the Macassar ebony, Cuban mahogany, kingwood, amboine, and many others.

The 1925 exhibition steered Ruhlmann to the forefront of the French movement of Decorative Arts. His building 'L'Hôtel du Collectionneur' was a success. That same year, he was awarded the Legion of Honour and Officer in 1932.

Ruhlmann also completed a variety of supplies for Jacques Neubauer's shop and a piano for Pleyel. Jacques-Émile Ruhlmann died at the age of fifty-four on 15 November 1933. His company was subsequently dissolved.

775. **Jacques-Émile Ruhlmann**, 1879-1933, French.
'Cabanel' commode, c. 1921-1922.
Veneer in ivory from Macassar, glass, ivory, 133.5 x 75.5 x 39.5 cm.
Private collection.

776. **Jacques-Émile Ruhlmann**, 1879-1933, French.
'État rectangle' cabinet, c. 1922-1923.
Veneer in kingwood, ivory and ebony inlay, gilded bronze,
interior of velvet, 126.7 x 84 x 31.5 cm.
Musée des Arts décoratifs, Paris.

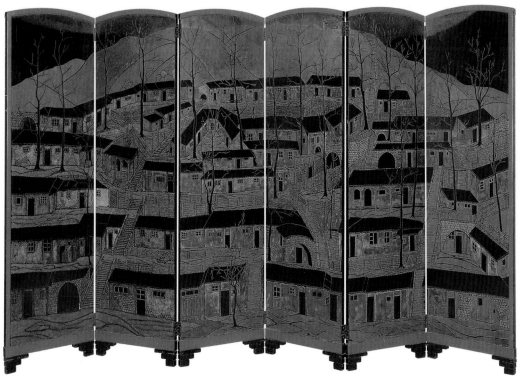

777

777. **Jean Dunand**, 1877-1942, French.
Screen, *Huts*, c. 1921.
Mahogany, lacquer, metal, six partitions, 180 x 50 cm (each).
Musée des Arts décoratifs, Paris. Art Nouveau.

778

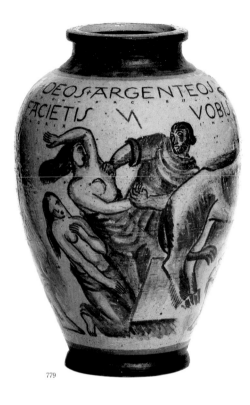

779

Adelaïde Alsop Robineau
(1865-1929)

Adelaïde Alsop Robineau was an American painter from New York. She was one of the most important ceramists of her generation. One of the few women of the American Arts and Craft Movement, she became noteworthy for making her pots from 'clay to finish'.

Adelaïde became interested in Chinese painting and married Samuel E. Robineau in 1899 in France. The same year, the couple launched *Keramic Studio* for ceramic artists and potters.

She trained at Alfred University with Charles Binns, an American potter, and was part of art academy of People's University, an institution founded by Edward Gardner in Missouri.

There is a picture of her from 1910 showing her with her famous pot *Scarab Vase*, which earned her international recognition.

778. **Adelaïde Alsop Robineau**, 1865-1929, American.
Fox and Grapes, 1922.
Pot coated with engraved and enamelled porcelain, height: 18.4 cm.
Jordan-Volpe Gallery Collection, New York. Arts and Crafts Movement.

779. **Jais Nielsen**, 1885-1961, Danish.
Vase, 1924.
Enamelled sandstone, height: 54 cm; diameter: 37 cm.
Musée des Arts décoratifs, Paris.

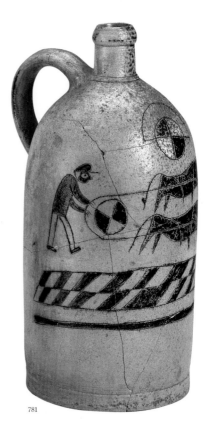

781

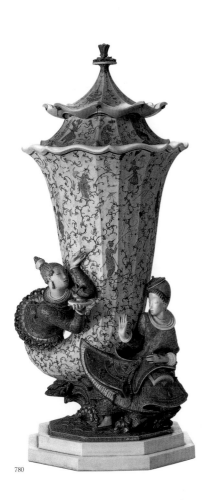

780

780. **Gerhard Henning**, 1880-1967, Swedish.
The Chinese Bride, Denmark, 1922.
Painted porcelain.
Royal Porcelain Factory, Copenhagen.

781. **Max Krehan** and **Gerhard Marcks**,
1875-1925 and 1889-1981, German.
Jar with handle, 1922.
Private collection. Bauhaus.

MAX KREHAN
(11 July 1875 – 16 October 1925)

Max Krehan was a German potter. In 1900, after obtaining the status of master potter, he entered the Krehan Pottery, led by his father in Dornburg. In 1919, when the Bauhaus in Weimar opened, its founder, Walter Gropius, established a workshop for pottery manufacture, with the intent to have it located in Weimar. Gropius proposed that Max Krehan join the Bauhaus to teach pottery, he refused for not wanting to leave his hometown. He did agree to teach students at his workshop in Dornburg, about fifteen miles from the Bauhaus. Krehan was then instructor of craftsmanship and encouraged his students to produce traditional pottery.

He died at the age of fifty in 1925.

JOSEF HARTWIG
(MUNICH, 1880-1956)

Munich-born sculptor Josef Hartwig was a member of the generation of teachers of the Bauhaus in Weimar. At the age of thirteen, Josef Hartwig began an apprenticeship in the studio of sculptor Simon Korn. There he created plaster models for architectural projects which allowed him to come into contact with famous architects such as Theodor Fischer.

Josef Hartwig then studied sculpture at the Academy of Fine Arts in Munich, led by Balthasar Schmidt from 1904 to 1906. By working as an architectural sculptor, he managed to pay for his studies and also took courses in architecture, design, and art history.

He moved to Berlin in 1910, where he worked as a sculptor for some eleven years.

In 1921, Walter Gropius called him to the Bauhaus in Weimar and made him head of the sculpture workshop of stone and wood. In this workshop, Hartwig produced plastic walls, based on projects by Oskar Schlemmer. These works, installed in the staircase of the building of the workshop, would be removed in 1928 because they were considered „useless ornaments."

Josef Hartwig also taught sculpture, geometry, and perspective at the school of art in Frankfurt.

In the following years, Hartwig worked with major artists such Gerhard Marcks, Georg Kolbe, Toni Stadler, and Richard Scheibe. In addition to sculpture, Hartwig also showed an interest in restoration. Since 1938 until the end of World War II, he worked in the restoration workshop of the Städtische Skulpturengalerie in Frankfurt am Main.

After 1945, he became master of the restoration workshop of the Frankfurt Liebieghaus.

Josef Hartwig died at the age of seventy-six years.

783. **Theodor Bogler** and **Aelteste Volkstedter Porzellanmanufaktur,**
1897-1968 and 1900 - currently active, German.
Moka pot consisting of six parts, 1923.
Klassik Stiftung Weimar, Weimar. Bauhaus.

782. **Josef Hartwig**, 1880-1956, German.
Bauhaus chess set, 1923-1924.
Solid wood (pear), cardboard, paper, 5.5 x 12.5 x 12.5 cm.
Musée national d'Art moderne, Centre Georges-Pompidou, Paris. Bauhaus.

784

784. **Eileen Gray**, 1878-1976, Irish.
Brick screen, c. 1923-1925.
Wood lacquered in black, 196.5 x 32 cm (each partition).
Private collection.

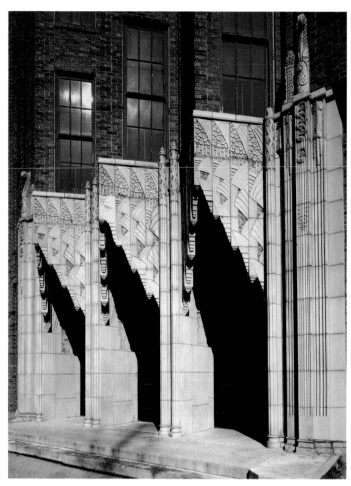

785

Francis Barry Byrne
(Chicago, 19 December 1883 – Evanston, 18 December 1967)

Son of a blacksmith, Francis Barry Byrne was forced to leave school at age fourteen, after the death of his father. Without special experience, he became an apprentice in the office of architect Frank Lloyd Wright in 1902. He remained there for five years before moving to Seattle in 1908, where he joined Andrew Willatzen who had also completed an apprenticeship with Wright. Together, they built more than fifty residential and commercial buildings. After a period of working with Wright's sons in San Diego, he was appointed Director by Walter Burley Griffin in Chicago and opened his own practice after the Second World War. From this period, he would focus exclusively on projects of religious buildings. He was the only member of the group of architects from the Prairie School to build in Europe, namely the Church of Christ the King in Cork, Ireland in 1928. He continued to accept orders until his death in 1967.

785. **Francis Barry Byrne**, 1883-1967, American.
Entrance with ceramic, St Thomas Apostle, Chicago, 1923-1925.
Chicago.

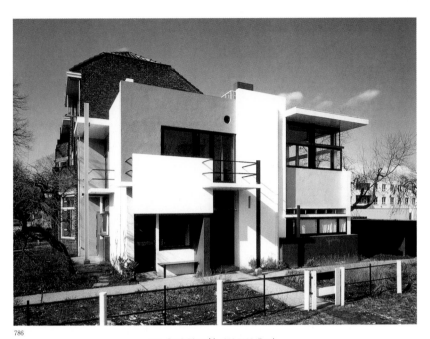

786

786. **Gerrit Rietveld**, 1888-1965, Dutch.
Rietveld Schröder House, 1924.
Utrecht. De Stijl.

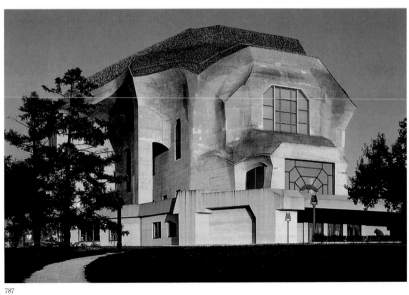

787

787. **Rudolf Steiner**, 1861-1925, Austrian.
Goetheanum, 1924-1928.
Dornach.

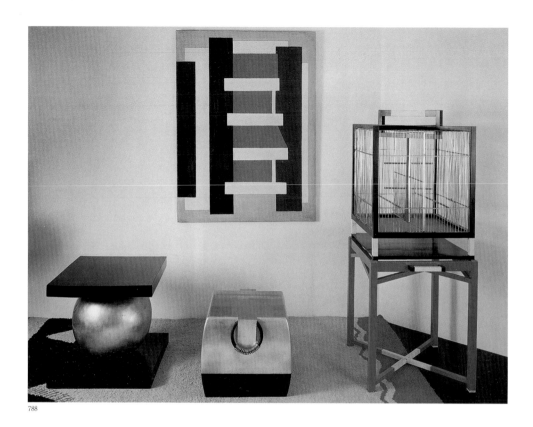

788

789

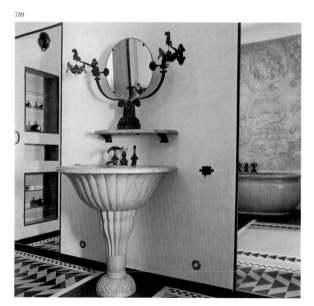

788. **Pierre Legrain**, 1889-1929, French.
Table and bench, c. 1924.
Lacquered wood, silver, black and chrome.

789. **Armand Albert Rateau**, 1882-1938, French.
Bathroom, c. 1924-1925.
Marble, bronze, glass, staff, and stucco.
Musée des Arts décoratifs, Paris.

790. **Pierre Legrain**, 1889-1929, French.
Tabouret, c. 1923.
Lacquered wood, gilded horn, 52 x 26.7 x 64.1 cm.
Virginia Museum of Fine Arts, Richmond.

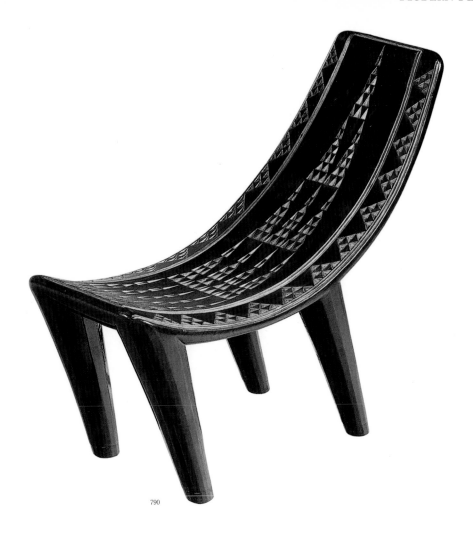

790

PIERRE LEGRAIN
(LEVALLOIS-PERRET, 10 FEBRUARY 1889-1929),

Pierre Legrain was an important artist in the movement of the decorative arts. Born in 1889, son of a rich industrialist, Pierre Legrain became interested in drawing at the age of twelve. He attended the *École des arts appliqués Germain Pilon* and joined the Paul Iribe's workshop in 1908.

He revered the art of bookbinding by Jacques Doucet, who entrusted him with the creation of bindings for his collection of manuscripts. This successful venture led him to open his own studio in 1919.

Legrain is also a furniture designer, he produced about 1,200 furniture pieces. Most of his pieces were inspired by Africa or Cubism, and were executed in exotic materials such as wood, metal, or ivory.

In 1925 he was commissioned to decorate Doucet's studio in Neuilly.

Legrain is known for his very personal geometric styles. His work shaped his virtuosity and use of rare materials, without great ornamentation. His inspiration comes undeniably from avant-garde artists of the early 20th century.

In 1929, whilst he was at the peak of his career, co-founder of the UAM (Union des artistes modernes), Pierre Legrain died at the age of forty.

Edgar Brandt
(Paris, 24 December 1880 –
Collonge-Bellerive, 8 June 1960)

Edgar Brandt was the greatest blacksmith of the early 20th century. He left the École professionnelle de Vierzon with training metalworker and is recognised for his skill and ingenuity. He finished military service in Nancy and travelled to Paris in 1902 in hopes of opening a workshop. Through his gold and silver jewellery manufacturing, Edgar exercised the modern style and received many commissions, even from the provinces. He was appreciated as a young artist. During the Exposition internationale des arts décoratifs et industriels modernes, Edgar worked as an ironworker and had his own pavilion to exhibit. On 10 December 1925, Brandt opened his gallery, the first Art Deco gallery in Paris and produces ironwork, furniture, decorative objects, and sculptures. He collaborated with Daum, Lalique, and Ruhlmann.

His fame took an international turn, as his Art Deco works reached the United States and Canada. More and more young artists began to imitate him.

Among his most famous works are the colourful ramp of the main staircase of the Town Hall in Euville, a fireplace in the lounge at the Salon Grands Voyageurs, the Gare de l'Est in Paris, and the ironwork at the CIC bank in Nancy.

The works of Edgar Brandt, long forgotten, continue to attract new attention.

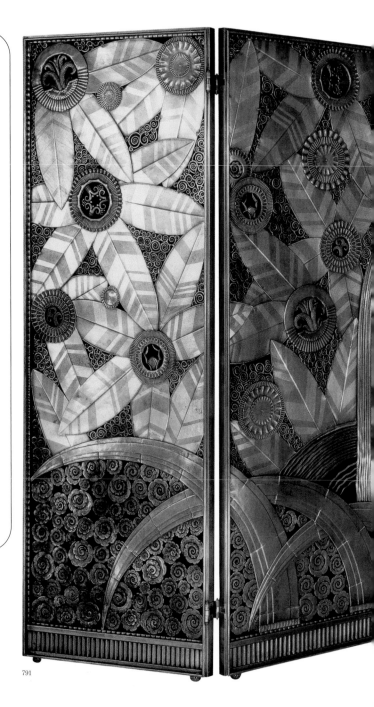

791. **Edgar Brandt**, 1880-1960, French.
Screen, *Oasis*, c. 1924.
Iron and brass, 181.6 x 63.5 cm (each partition).
Private collection, Paris. Art Deco.

791

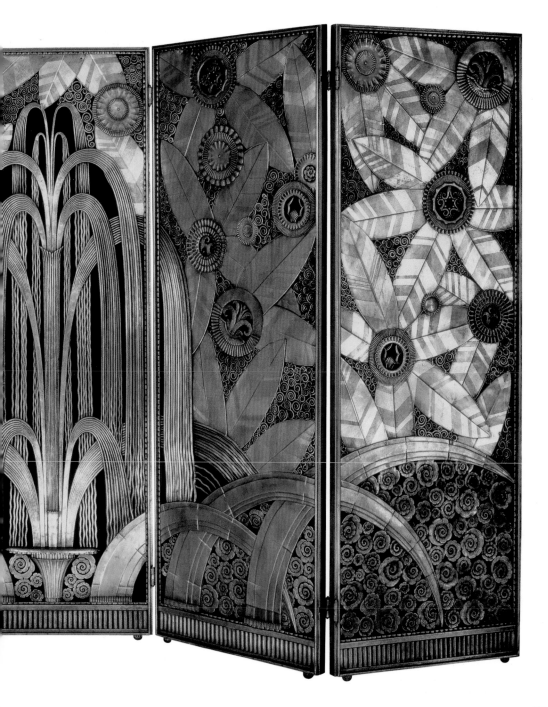

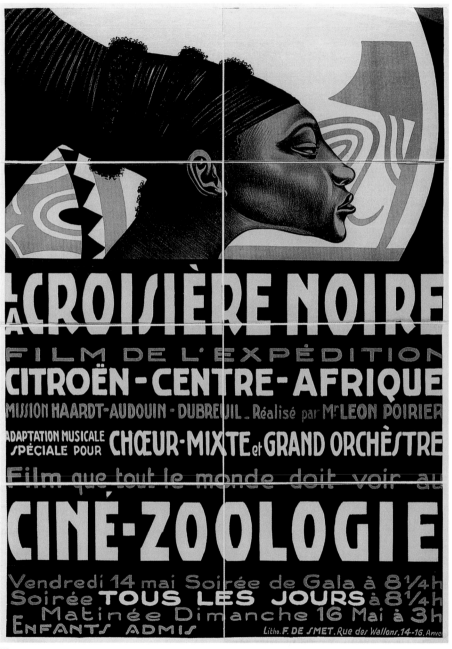

792

792. Anonymous.
Poster for *La Croisière noire*, 1925.
Coloured lithograph.
Musée du quai Branly, Paris.

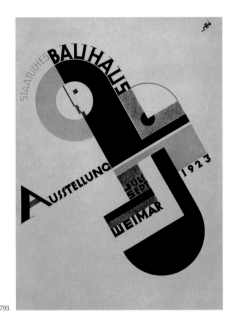

793

794

Joost Schmidt
(1893-1948)

Joost Schmidt was a typographer and sculptor. Shortly after its founding, he entered the Bauhaus in Weimar and completed his studies as a sculptor under the guidance of Johannes Itten and Oskar Schlemmer. His remarkable performance immediately attracted attention. Whilst an apprentice, he was responsible for the Bauhaus exhibition of 1923, located in the hall of the main building. Schmidt also distinguished himself in the field of graphics, as shown in the poster he created for the exhibition of the Bauhaus in Weimar.

In 1925, shortly after completing his degree in sculpting, Joost Schmidt became a teacher at the Bauhaus, being given the leadership of the sculpture studio. Schmidt also taught at the print shop.

In 1935, several years after the closure of the Bauhaus (1933), Joost Schmidt taught at the Reimann School in Berlin. In 1946, he participated in the organisation of events and exhibitions for the USA Exhibition Center and began a book on the Bauhaus.

Joost Schmidt died in 1948.

795

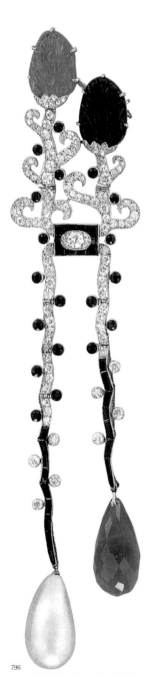

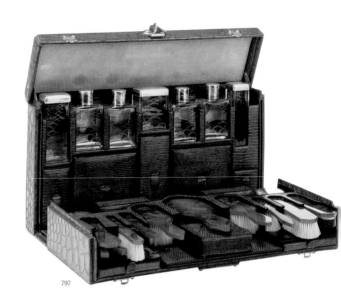

797. **Louis Vuitton**, founded in 1854, French.
Travel bag or nécessaire 'Marthe Chenal', exhibited in Paris in 1925.
Musée Louis Vuitton, Asnières.

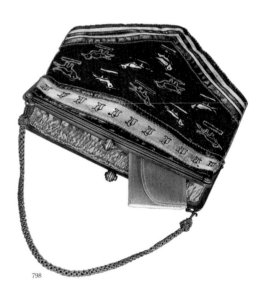

796. **Cartier**, founded in 1847, French.
Brooch, 1914.
Carved rubies and onyx, teardrop pearl, tourmaline,
diamonds, onyx, and briolette.
Private collection.

798. **Anonymous.**
Handbag with a small mirror, c. 1924.
Felt, leather, satin, brass, and tapestry.
Victoria and Albert Museum, London.

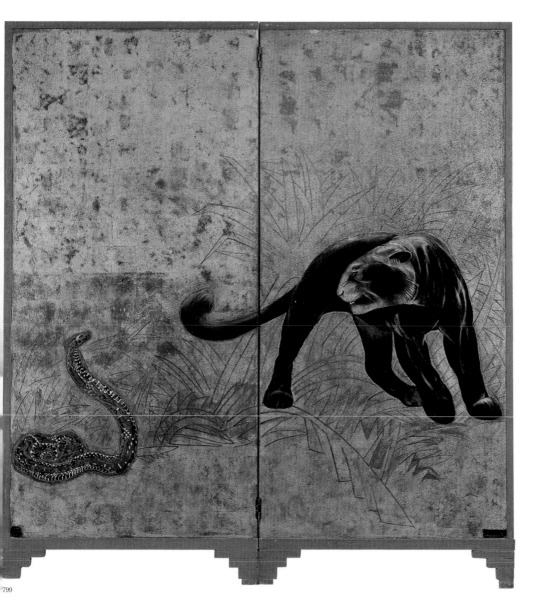

799

799. **Jean Dunand**, 1877-1942, French.
Screen with two partitions, c. 1925.
Lacquer and ivory.
Exhibited at the *Salon des Artistes décorateurs* in 1928. Art Deco.

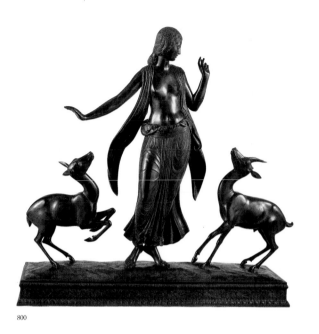

800

801

802

800. **Paul Manship**, 1885-1966, American.
Dancer and Gazelle, 1916.
Bronze, 81.9 x 88.9 x 27.9 cm.
The Metropolitan Museum of Art, New York.

801. **Carl Milles**, 1875-1955, Swedish.
Dancing Maenad, 1912.
Bronze, 71 x 50 x 10 cm.
Carl Milles Museum, Stockhlom. Art Nouveau.

802. **Paul Manship**, 1885-1966, American.
Actaeon, 1925.
Bronze, 48 x 52 cm.
Smithsonian American Art Museum, Washington, D.C.
Realism.
Photograph: Edward Owen.

803

804

Paul Manship
(Saint Paul, Minnesota, 25 December 1885 – New York, 31 January 1966)

Paul Howard Manship was born on Christmas Day in St Paul, Minnesota. He began his studies at the Institute of Arts and Sciences and continued his training in New York in 1903. Colourblind, he first attempted painting, but then turned to sculpting. In New York, he enrolled at the Art Student League and found a place in the workshop of the sculptor Solon Borglum whom Manship would always refer to as his greatest influence.

He then became apprentice to Isidore Konti, who pushed him to participate in the Prix de Rome. In 1909, at twenty-three years old, he became the youngest American sculptor to win the Prix de Rome. It was during his stay in Europe, particularly in Italy and Greece, that Manship refined his style, combining ancient Greek and Roman influences, neoclassicism, and modernism.

Returning to New York in 1912, he married Isabel McIlwaine on 1 January 1913, with whom he had four children, two of whom will become artists. The same year in February, an exhibition dedicated to him was held at the Architectural League of New York. This critical success would be the first in a long line.

Until the end of Second World War, he continued to receive commissions. He then became a member of the National Academy of Fine Arts in Buenos Aires in 1944, the Académie des Beaux-Arts in Paris in 1945, and the Academy of St Luke in Rome in 1952. He received the gold medal in sculpture from the National Institute of Arts and Letters in 1945.

After the Second World War, his works were criticised as ultra-conservative, and his popularity began to drop. He believed that contemporary sculpture expressed nothing significant, that it only directed to a self-proclaimed elite and depicted only the ideas of the artist.

However, he continued to work until his death in 1966, but his works no longer appeared in the press.

803. **Carl Milles**, 1875-1955, Swedish.
Europa and the Bull, 1923-1924.
Bronze, 78.1 x 66.7 x 33 cm.
Tate Collection, London.
Photograph: Christie's, New York.

804. **Paul Manship**, 1885-1966, American.
Diana, 1925.
Bronze, 124.4 x 109.3 cm.
Smithsonian American Art Museum, Washington, D.C. Realism.

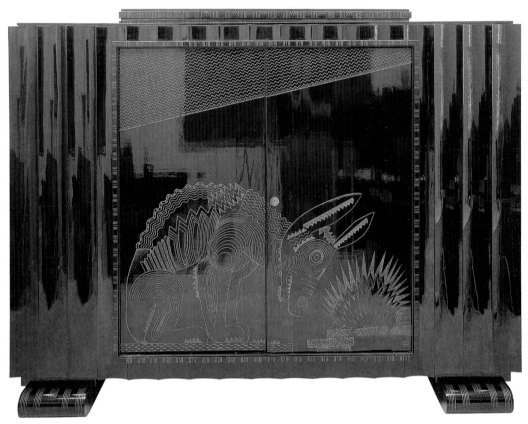

805

805. Jacques-Émile Ruhlmann, Jean Dunand, and Jean Lambert-Rucki,
1879-1933, 1877-1942, and 1888-1967, French and Polish.
Furniture, 1925.
Black lacquer and carved decorations in silver.
DeLorenzo Gallery, New York. Art Deco.

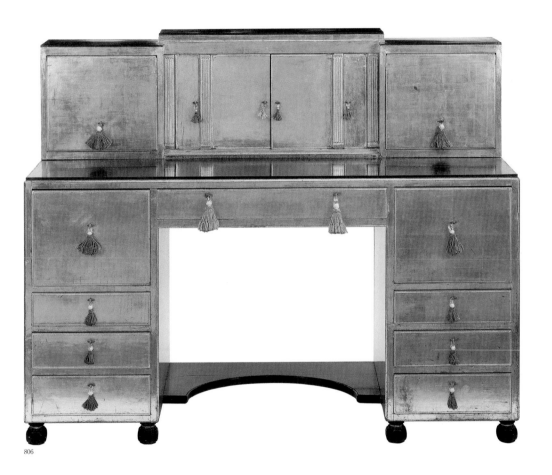

806. **Sir Edward Maufe**, 1883-1974, English.
Desk, 1925.
Mahogany carcase, with ebony writing and top surfaces,
gessoed and gilded with white gold, with haldu wood footrest and feet,
and ivory, rock crystal and silk handles, 107 x 134.3 x 53 cm.
Victoria and Albert Museum, London. Art Deco.

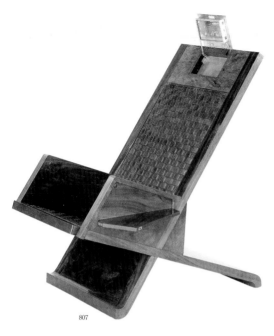

807

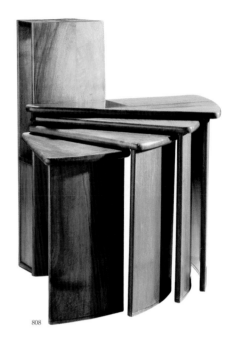

808

807. **Pierre Legrain**, 1889-1929, French.
Reading chair, c. 1925-1928.
Satin, mahogany and burl veneer, silver metal, braided leather, 115 x 59 x 45 cm.
Musée des Arts décoratifs, Paris.

808. **Pierre Chareau**, 1883-1950, French.
Telephone table 'MB152', c. 1925.
Walnut, 80 x 104 x 64 cm.
Private collection, Paris. Art Deco.

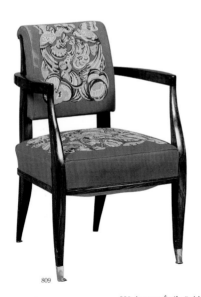

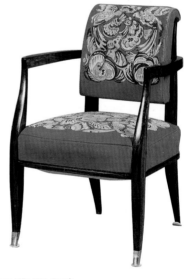

809

809. **Jacques-Émile Ruhlmann**,1879-1933, French.
Pair of armchairs, c. 1925.
Macassar ebony and bronze with Aubusson tapestry.
Private collection. Art Deco.

810

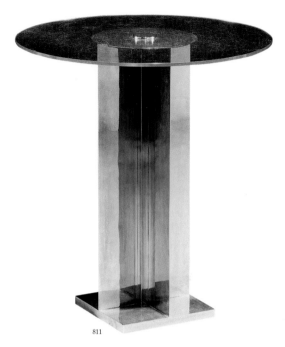

811

811. **Charlotte Perriand**, 1903-1999, French.
Small round table, 1927.
Nickelled glass and brass on four-edged base, height: 71 cm; diameter: 65 cm.
Private collection. Art Deco.

CHARLOTTE PERRIAND
(PARIS, 24 OCTOBER 1903 – 27 OCTOBER 1999)

Charlotte Perriand was a French designer and architect, born to
a father who was a tailor and a mother who was a *haute couture*
seamstress. Graduating from UCAD (Union Centrale des Arts
décoratifs), in 1927 she joined her cousin, the famous architect
Le Corbusier, and Pierre Jeanneret, and completed several metal
furniture, including highly-recognised, adjustable chair. She,
with Pierre Chareau, became a founding member of UAM
(Union des Artistes Modernes) in 1929, chaired by Robert
Mallet-Stevens. This movement aimed to exploit new materials
and new technology.

After the Second World War, Charlotte Perriand played an
important role in the creation of the Radiant City (Ville
Radieuse), designed by Le Corbusier. Her career allowed her to
travel around the world, particularly to Japan in the 1940s
where she was an industrial art advisor to the Ministry of Trade
and Industry. Her style was greatly influenced by her travels,
and Perriand turned her mind to wood. Straw, bamboo, tree
branches became elements of choice.

Charlotte Perriand died in 1999 at the age of eighty-six.

812

810. **Eileen Gray**, 1878-1976, Irish.
Dressing table, 1926-1929.
Oregon pine, plywood, cork, aluminium, glass, traces of turquoise blue, 161 x 60 x 165 cm.
Musée des Arts décoratifs, Paris. Art Deco.

812. **Eileen Gray**, 1878-1976, Irish.
'Bibendum' chair, c. 1926-1929.
Cover of ivory-coloured linen, chrome, 63 x 88 cm.
Private collection. Art Deco.

813

813. **Franz Hagenauer**, 1906-1986, Austrian.
Mirror, c. 1925.
Copper and reflective glass.
Bröhan-Museum, Berlin. Art Deco.

814

815

815. **Maison Boucheron**, founded in 1858, French.
Brooch, 1925.
Platinum, onyx, coral, and diamonds, 10.8 x 5.2 cm.
Musée des Arts décoratifs, Paris. Art Deco.

Maison Boucheron
(Paris, 1858 – currently active)

Artisan and talented artist, Frédéric Boucheron founded the House of Boucheron in 1858 in the Galerie de Valois, at Palais-Royal, before transferring to 26 Place Vendôme in 1893. The House of Boucheron has five lines of products: jewellery, fine jewellery, watches, perfumes, and glasses. Originality, mystery, sensuality, and extreme refinement characterise the famous jewellery.

The jewellery created was largely inspired by nature, which explains why gems are regularly accompanied by animals (snakes, frogs, owls, or even dragonflies). This passion for nature is still present today.

The House of Boucheron quickly gained an international reputation and won numerous awards, including a gold medal at the World Exhibition in 1867, the Grand Prix at the World Exhibition in 1878, and gold medal at the World Exhibition of Paris in 1900.

Frédéric Boucheron disappeared in 1902 leaving the family company to his son Louis. The House of Boucheron was sold in 2000.

814. **Maison Boucheron**, founded in 1858, French.
Decoration for a corsage, 1925.
Lapis lazuli, coral, jade and onyx set with rhinestones and gold,
turquoise pendant, diamonds, and platinum.
Boucheron SAS, Paris. Art Deco.

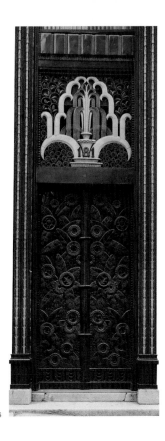

817. **René Lalique**, 1860-1945, French.
Suzanne Bathing, 1925.
Glass.
Private collection, Japan. Art Nouveau.

François Décorchemont
(Conches-en Ouche, 26 May 1880 – 19 February 1971)

The father of the French François Décorchemont was a sculptor, and so François Décorchemont became a ceramist and glassmaker. He began his training at the École nationale des Arts décoratifs. His technique of using a fine glass paste that kept the glass together and was sheer, made him internationally renowned. His style, his finesse, simple and colourful results reflected his desire to give his creations sculptural effects, and in the shapes and the lines of his designs are represented a new ornamental design concept. Décorchemont turned then to stained glass window in the 1930s. Religious iconography dominates the second part of his career, and he worked in about thirty churches.

816. **Edgar Brandt**, 1880-1960, French.
Entrance door, Madison Avenue, New York, c. 1925.
Wrought iron with bronze applications. Art Deco.

818. **François Décorchemont**, 1880-1971, French.
Large vase with two leaf-shaped handles, 1925.
Glass paste moulded by low-cast waxing; height: 24 cm; diameter with handles: 25 cm.
Musée des Arts décoratifs, Paris. Art Deco.

819

819. **Pierre Chareau**, 1883-1950, French.
Pair of sconces, 'LA272', c. 1926.
Flange and alabaster, 60 x 16 x 11 cm.
Private collection, Paris. Art Deco.

820. **Jacques-Émile Ruhlmann**, 1879-1933, French.
'Fan' wall light, c. 1925.
Alabaster and chromed bronze, 45.8 x 69.5 x 37 cm.
Private collection. Art Deco.

821. **Pierre Chareau**, 1883-1950, French.
Standard lamp, 'Religieuse SN31', c. 1927.
Indian rosewood, alabaster, wrought iron patinated black, 186.5 cm.
DeLorenzo Gallery, New York. Art Deco.

822. **Donald Deskey**, 1894-1989, American.
Table lamp, c. 1927.
Chrome and glass, 33 x 11.1 x 13.3 cm. Museum of Fine Arts, Boston.
Courtesy of the Museum of Fine Arts, Boston. Art Deco.

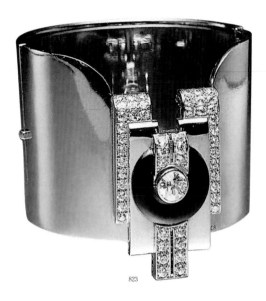

823

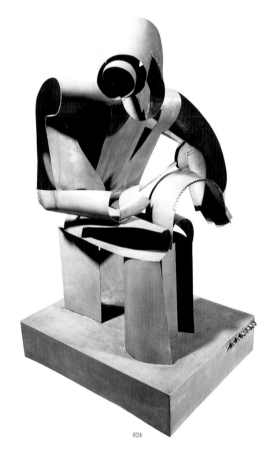

824

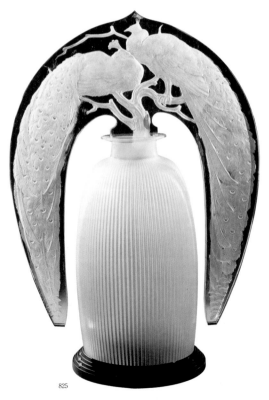

825

823. **Maison Paul** and **Raymond Templier**, 1891-1968, French.
Bracelet with brooch, c. 1925-1930.
Silver, platinum, gold, onyx, and diamonds.
Virginia Museum of Fine Arts, Richmond. Art Deco.

824. **Jan** and **Joël Martel**, 1896-1966, French.
Musical Saw Player, 1927.
Sculpture of zinc, 77.5 x 46 x 36 cm.
Private collection. Abstract art.

825. **René Lalique**, 1860-1945, French.
Lamp, 'Two Peacocks', 1920 (design).
Glass with moulded and carved decoration, on bakelite base, height: 45.1 cm.
Victoria and Albert Museum, London. Art Nouveau.

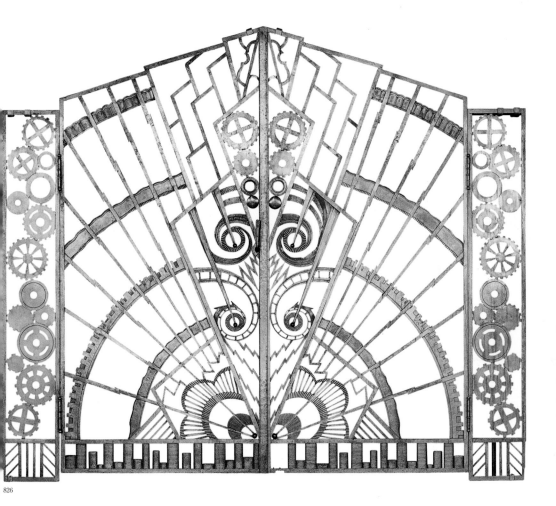

826

René Paul Chambellan
(West Hoboken, 15 September 1893 – 29 November 1955)

Sculptor, designer, and architect, Rene Paul Chambellan studied at the Académie Julian in Paris and worked in New York and New Jersey. Specialist in architectural sculpture, Chambellan made many ornate works, including the Rockefeller Center in New York for which he created a bronze door and a fountain called *La Source*, the New York State Office Building in 1929, and the Tribune Tower in Chicago in 1935. He participated in many development projects, such as town halls, banks, hospitals, shops, churches, etc. and renovated a permanent exhibition of arts and crafts decorative in Radio City building.

826. René Paul Chambellan, 1893-1955, American.
Entrance to the luxury suite of Chanin Building, New York, 1928.
Wrought iron and bronze.
Cooper-Hewitt, National Design Museum, Smithsonian Institution, New York. Art Deco.

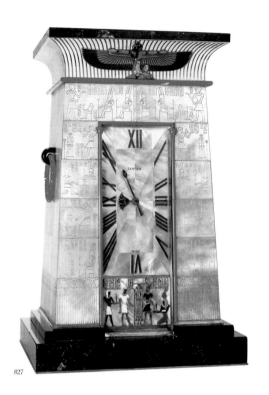

827

CARTIER
(Paris, 1847 – currently active)

Founded in 1947 by Louis-François Cartier, the company Cartier designs, manufactures, and sells jewellery and luxury watches. The family company, under the management of the son Alfred Cartier, relocated Rue de la Paix (its current address) in Paris in 1899 and was made famous by his grandson Louis Cartier. It expanded to London in 1902 and New York in 1909.

The talent of Louis-François and Alfred attracted wealthy houses and acquired them a worldwide reputation. Characterised by its know-how and inspired by cultures worldwide, the company, in the early 20ᵗʰ century, was a precursor of Art Deco jewellery, seen in its bright colours and stylised shapes.

La Maison Cartier has more than 300 shops and 5,500 employees worldwide. It now belongs to the group Richemont, headquartered in Geneva.

828

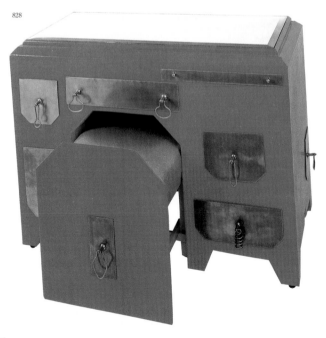

827. **Cartier**, founded in 1847, French.
'Egyptian Temple Gate' Clock, 1927.
Gold, silver-gold, ivory, coral,
enamel, lapis lazuli, carnelian, emeralds.
Cartier Collection, Geneva. Art Deco.

828. **Paul Theodore Frankl**, 1886-1958, Austrian.
'Puzzle' desk, c. 1927.
Red lacquer, silver leaf, silvered handles, height: 83.8 cm.
Art Deco.

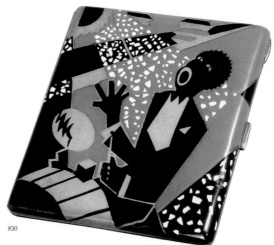

830. **Gérard Sandoz**, 1902-1995, French.
Cigarette case marked with 'Black, Starr & Frost', c. 1927.
Silver, red, black, and ecru lacquer.
Private collection. Art Deco.

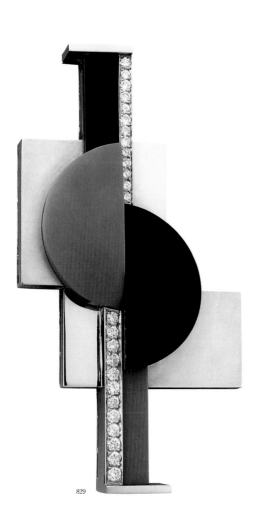

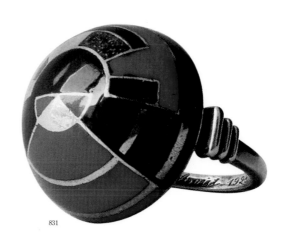

829. **Gérard Sandoz**, 1902-1995, French.
Semaphore brooch, c. 1928.
White gold, yellow gold, platinum, onyx, coral, and diamonds, 8.7 x 5 cm.
Private collection, London. Art Deco.

831. **Gérard Sandoz**, 1902-1995, French.
Ring, 1928.
Gold, silver, red, black, and ecru enamel.
Jean-Pierre Malga Collection. Art Deco.

435

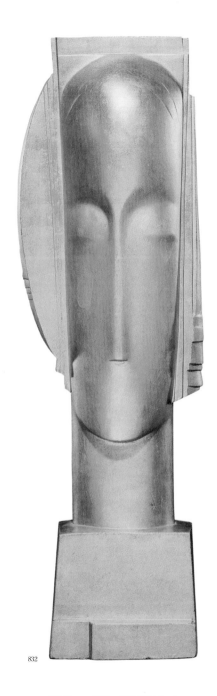

832

832. **Gustave Miklos**, 1888-1967, French.
Sun God, 1928.
Gilded plaster, 66 x 16 cm.
Private collection. Art Deco.

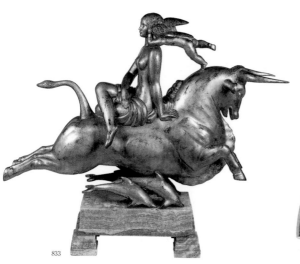

833

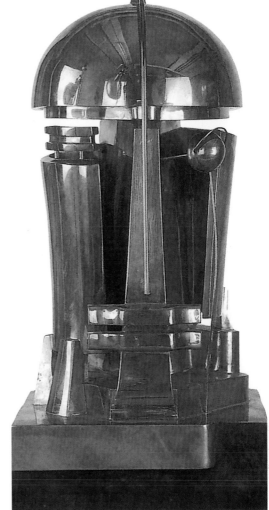

834

Rudolf Belling
(Berlin, 28 August 1886 – Krailling, 9 June 1972)

Rudolf Belling was a major supporter of modernism in Germany. After attending school in Steglitz, he received placement to learn craftsmanship. He undertook drawing classes in 1909 and worked in a workshop for sculpture. In 1911, he studied at art school in Berlin. During the First World War, he was sent to Adlershof.

In 1923, he made twenty-three sculptures, which reveal the sophisticated integration cubist and futurist principles. The head was produced by a conjoining of different geometric shapes, each having an almost mechanical precision and efficiency.

Active in the organisation to help spread the Modernism throughout German-speaking countries, Belling was labelled as a 'degenerate artist' by the Nazi regime, and was dismissed from his teaching position. He was eventually exiled and moved to New York. The Nazi regime forbade him from returning home. In 1937, he went to Turkey. In 1955, he was made a Grand Officer of the Order of Merit of the Federal Republic of Germany.

833. **Paul Manship,** 1885-1966, American.
The Rape of Europa, 1925.
Bronze.
Lionel and Geraldine Sterling Collection, USA.

834. **Rudolf Belling,** 1886-1972, German.
Sculpture 23, 1923.
Brass, 48 x 19.7 x 21.5 cm.
The Museum of Modern Art, New York. Abstract art.

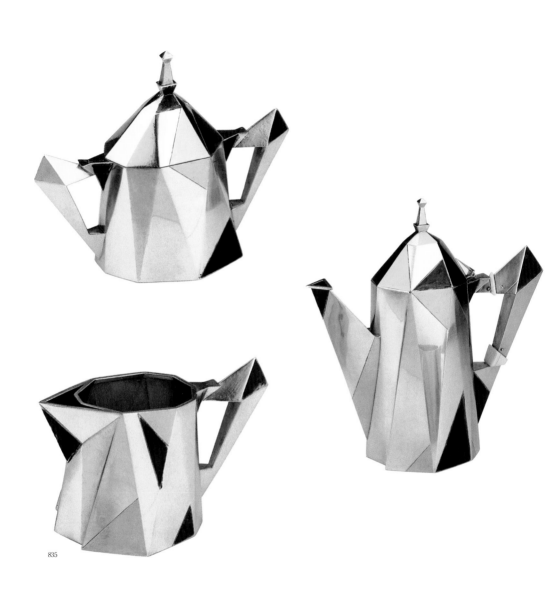

835. **Erik Magnussen**, 1884-1961, American.
Tea service: *The Lights and Shadows of Manhattan,* 1927.
Burnished silver with gold panels and oxidized grey metal.
Charles H. Carpenter Jr Collection. Art Deco.

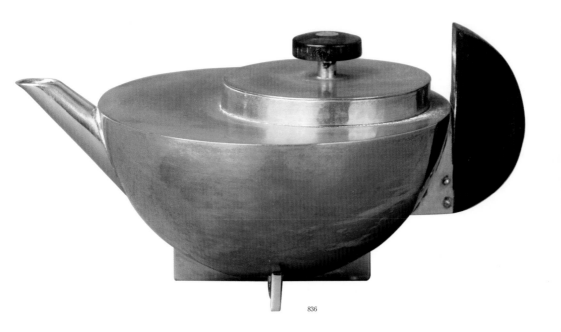

836

836. **Marianne Brandt**, 1893-1983, German.
Teapot, c. 1924.
Silver and ivory, height: 7.3 cm.
The Metropolitan Museum of Art, New York. Bauhaus.

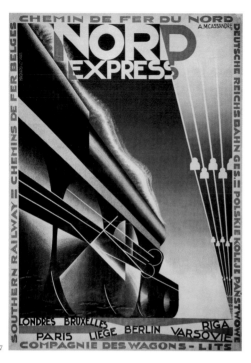

837

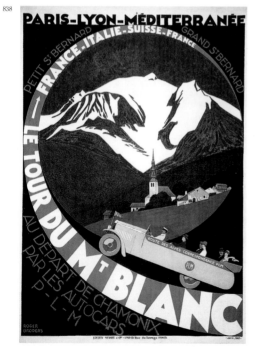

838

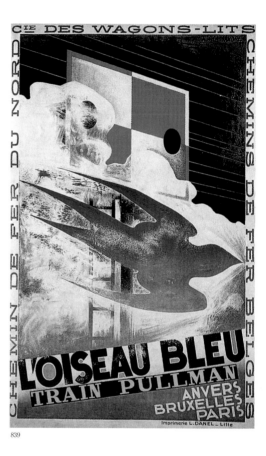

839

837. **Cassandre (Adolphe Mouron)**, 1901-1968, Ukrainian.
Poster for the *Nord Express*, 1927.
Colour lithograph, 105.4 x 75 cm.
Victoria and Albert Museum, London. Art Deco.

838. **Rogers Broders**, 1883-1953, French.
Poster for *Le Tour du mont Blanc*, 1927.
Lithograph, 101.6 x 63.5 cm.
Victoria and Albert Museum, London. Art Deco.

839. **Cassandre (Adolphe Mouron)**, 1901-1968, Ukrainian.
Poster for *L'Oiseau bleu, Train Pullman*, 1929.
Colour lithograph, 100 x 61.6 cm.
Museum of Fine Arts, Boston. Art Deco.

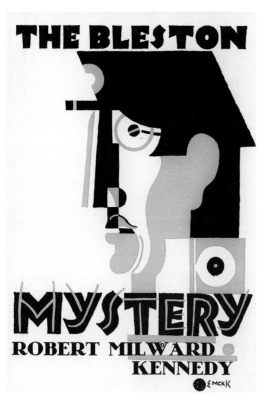

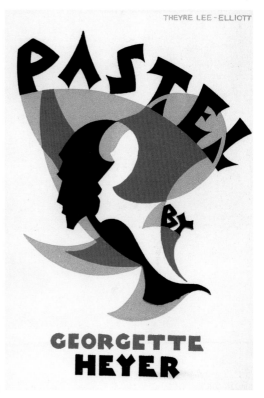

841

Cassandre (Adolphe Jean Marie Mouron)
(Charkiw, 24 January 1901 – Paris, 17 July 1968)

Adolphe Jean Marie Mouron was born in Ukraine on 24 January 1901. He studied at the École des Beaux-Arts in Paris before joining the Académie Julian. French graphic designer, poster artist, stage designer, lithographer, painter, and typographer, Cassandre grew interested in the Bauhaus movement, and would be greatly influenced by it.

In 1922, he signed his works with his artist name 'Cassandre', and made his first advertising work. "Posters offer the painter a means of connecting with the man in the street," he said.

In 1925, Cassandre received the grand prize at the Exposition internationale des Arts décoratifs for his advertisement Le Bûcheron, made for a furniture store in 1923.

In 1927, he produced posters for L' Étoile du Nord, Le Nord Express, and L'Intran.

Also decorator, Cassandre made his first theatre set in 1933 for Jean Giraudoux's Amphitryon 38. Additionally, he taught courses at the École nationale supérieure des arts décoratifs. Deeply influenced by cubism and purism, he was also inspired by the Italian Futurists. Moreover, his style was defined by simplicity and geometrical shapes, clean lines, and an emphasis on typography. He created many posters for ocean liners including that of Normandie, made in 1930.

In 1936, the Metropolitan Museum of Art in New York held a retrospective of Cassandre's posters. He then signed a contract with Harper's Bazaar and moved to the United States. Cassandra focused, thereafter, on theatre sets and painting.

In 1950, a second retrospective of his work took place at the Musée des Arts décoratifs.

Cassandre commited suicide at the age of sixty-seven, on 17 June 1968.

840. **Edward McKnight Kauffer**, 1890-1954, American.
Book cover for The Bleston Mystery by Robert Milward Kennedy, 1928.
Engraving with coloured lines.
Victoria and Albert Museum, London. Art Deco.

841. **Theyre Lee-Elliott**, 1903-1988, English.
Book cover for Pastel by Georgette Heyer, 1929.
Engraving with coloured lines.
Victoria and Albert Museum, London. Art Deco.

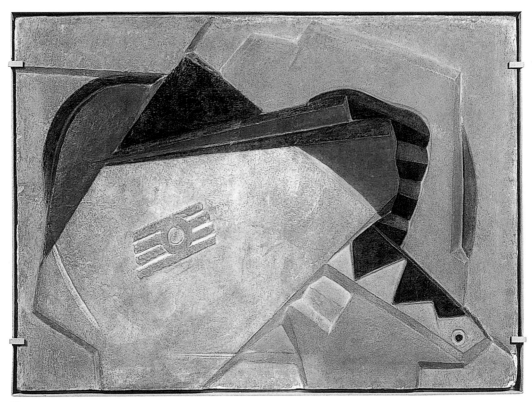

842

HENRI LAURENS
(PARIS, 1885-1954)

Henri Laurens was one of the first sculptors to operate and develop the innovations of Cubism. His early works, like many sculptures produced in the early 1900s, were strongly influenced by Rodin. He turned first to the French-Romanesque and Gothic sculpture as a means to escape the penetrating pathos of Rodin. The intimate friendship he developed with Georges Braque in 1911, the same time that analytic Cubism gave way to synthetic Cubism with the introduction of collage, helped him to make effective progress. Since one of his legs had been amputated in 1909, Laurens was exempted from military service, which ended the career of Braque. During the First World War, he expressed his new Cubist ideas in a series of sculptures entitled *Constructions*, made of wood and polychrome plaster, through which he explored typically cubist themes, such as fragmented nudes and still lifes of ordered workshops (*Bottle and Glass*, 1917 and *Guitar*, 1917-1918). At that time, Laurens, along with Picasso, Braque, Gris, and Léger, was represented by the dealer Leonce Rosenberg. Like most of them, he parted from Rosenberg at the end of the war, and for a time gave in to the dealer Daniel-Henry Kahnweiler. A token of appreciation and a sign of his status as a vogue artist, in 1924 the Russian impresario Serge Diaghilev commissioned him to decorate the stage for the ballet *Le Train bleu*, which took place on a beach in the south of France. There he met the music of Darius Milhaud, costumes of Coco Chanel, and a curtain of Picasso.

From the mid-1920s, Laurens moved away from the angular aspect of his cubist style and adopted a more gentle way, more sensual and organic, focusing on the theme of the female nude.

842. **Henri Laurens**, 1885-1954, French.
Bas-relief, 1928.
Coloured terracotta, height: 93 cm.
Lille métropole musée d'Art moderne, d'Art contemporain et d'Art brut, Villeneuve-d'Ascq. Cubism.

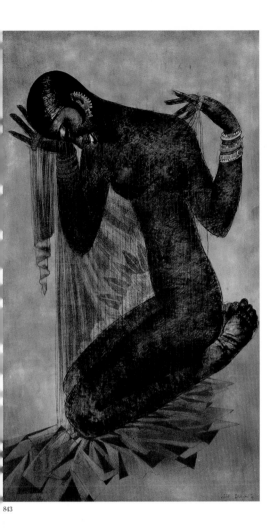

843

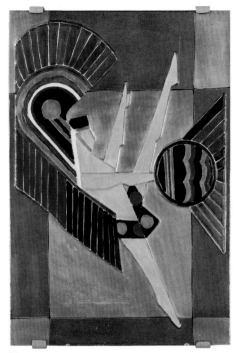

844

845

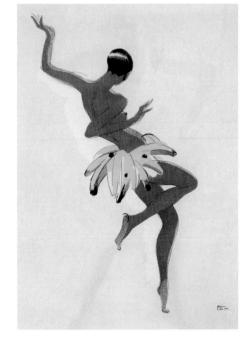

843. **Jean Dunand**, 1877-1942, French.
Panel: *Veiled Josephine Baker*, 1927.
Lacquer.
The Dunand Family Collection.

844. **Auguste Lazo**.
Tile with Mayan motif, 1928.
Sandstone.
John P. Axelrod Collection, Boston. Cubism.

845. **Paul Colin**, 1892-1985, French.
Josephine Baker, plate from *Tumulte noir*, 1927. Lithograph.

846. **William van Alen**, 1883-1953, American.
Entrance hall at the Chrysler Building, 1927-1930.
New York. Art Deco.

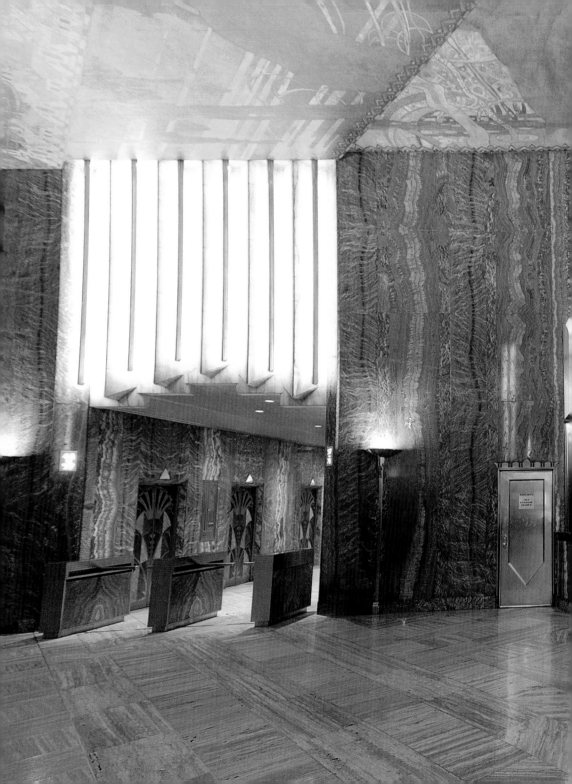

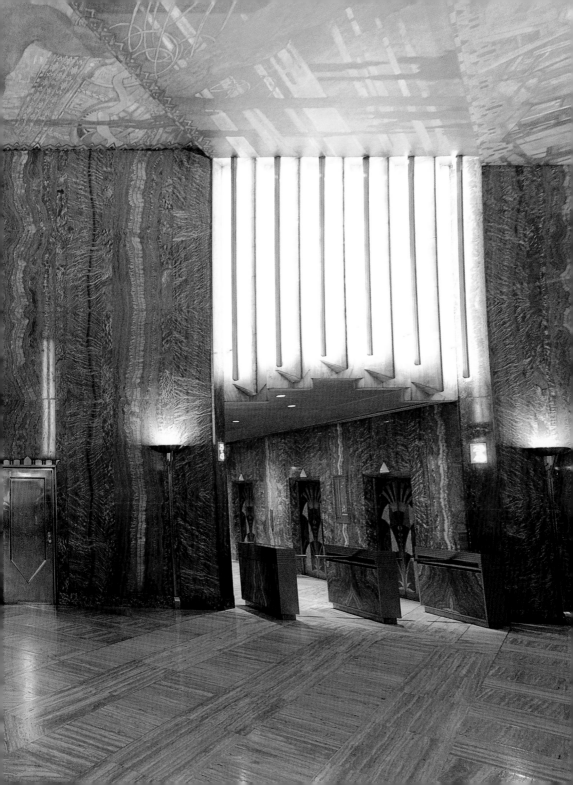

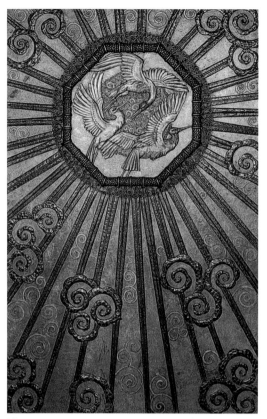

847

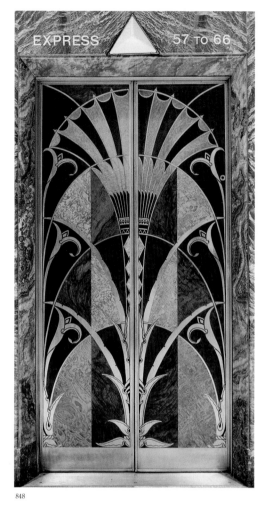

848

William van Alen
(New York, 10 August 1883 – 24 May 1953)

William van Alen was a recognised American architect having made the Chrysler Building in New York. Van Allen studied at the Pratt Institute in Brooklyn before working in the office of Clarence True. In 1911, Van Allen collaborated with H. Craig Severance to build multi-levelled shopping malls that broke with the conventional rules of material. He was subsequently contacted by Walter Chrysler to build a skyscraper in the glory of the tycoon. He wanted to have the tallest building in the world. Van Allen imagined a stainless steel spear 58.4 metres high, resting atop of the building. The first stone was laid on 19 September 1928 and the inauguration of the building took place on 27 May 1930. The title of tallest building in the world remained in force for only one year since the following year the Chrysler Building was surpassed by the Empire State Building, measuring 381 metres.

847. **Edgar Brandt**, 1880-1960, American.
Lift panel, *The Storks of Alsace*, 1928.
Lacquer, iron, bronze, and wood, 195 x 151 cm.
Victoria and Albert Museum, London. Art Deco.

848. **William van Alen**, 1883-1953, American.
Lift door, Chrysler Building, New York, 1927-1930.
Metyl-wood veneer. Art Deco.

849. **René Paul Chambellan** and **Jacques Delamarre**,
1893-1955 and 1906-1986, American.
Frieze in the Chanin Building, 1929.
Repoussé copper. Art Deco.

850. **Heinsbergen Decorating Company (Anthony Heinsbergen)**,
1894-1988, American.
Design for the ceiling at the Pantages Theater, Los Angeles, c. 1929.
Watercolour on paper. Art Deco.

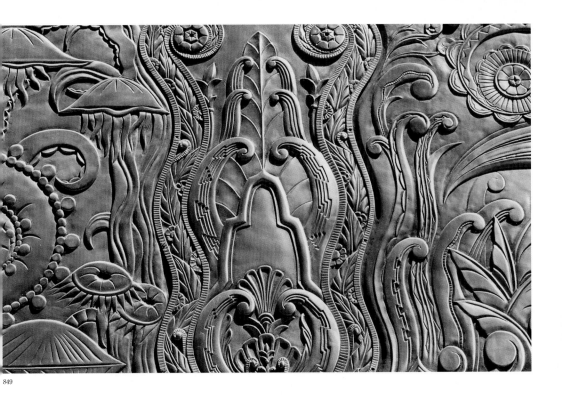

849

850

851

Le Corbusier
(La Chaux-de-Fonds, 6 October 1887 – Roquebrune-Cap-Martin, 27 August 1965)

The architect, painter, and sculptor Charles-Édouard Jeanneret-Gris was born in Switzerland. He studied at his local art school before completing his training with August Perret between 1908-1909. At the age of fifteen, he completed his first graphic work, for which he was distinguished at the exhibition of decorative arts in Turin in 1902.

After travelling through Italy, Austria, southern Germany, and eastern France, Le Corbusier met Eugène Grasset, from whom he learned the characteristics of technical drawing for reinforced concrete engineering. He then worked as designer at Peter Behrens's architectural firm.

In 1917, he moved to Paris. Perret introduced him to Amédée Ozenfant, who in turn introduced him to oil painting. Together, they would develop the foundation of Purism. In their opinion, art should awaken the spirit of austerity and should condemn opulence. This aspect would resurface in the works of Le Corbusier. In 1920, Le Corbusier, together with poet Paul Dermée and Ozenfant, founded the magazine *L'Esprit Nouveau*, where he signed under his pseudonym Le Corbusier for the first time. In 1922, he built his first house in Paris, and then that of Amédée Ozenfant.

Later, he merged with his father Pierre Jeanneret and founded an agency in Paris. He designed numerous villa and workshops, including the Villa Stein in 1927 and the Villa Savoye in 1929. In the late 1920s, he designed furniture, and he founded the Union des Artistes Modernes (UAM). In the 1930s, protected by the economy, he participated in various international competitions, making an international name for himself. He devoted himself to the study of the urban planning of North Africa, Brazil, Argentina, etc.

After the war, he reconstructed the city centre in Marseille and the Notre Dame du Haut in Ronchamp with changes to a less-harmonious style than that of previous years. As promoter of modernity, Le Corbusier defines the history of architecture and the 20th century.

851. **Le Corbusier**, 1887-1965, French.
Villa Savoye, 1928-1929.
Poissy-sur-Seine. Purism.

852. **Frank Lloyd Wright**, 1867-1959, American.
Falling Water, 1934-1937.
Pennsylvania.

853

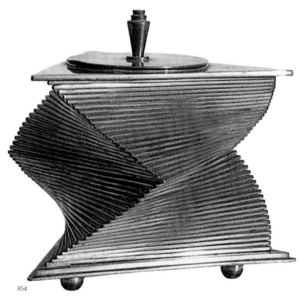

854

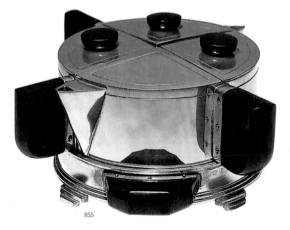

855

853. **Maurice Marinot,** 1882-1960, French.
Small bottle, *The Golden Parrot,* 1928.
Handblown glass, shaped hot, metallic bubbles, and coloured interlayers
between three layers of transparent glass, 15.5 x 12 cm.
Musée des Arts décoratifs, Paris.

854. **Otar,** American.
Inkwell, c. 1928.
Copper and brass, height: 11.4 cm.
Mitchell Wolfson Jr Collection, Miami Dade Community College, Miami.

855. **Gilbert Rohde,** 1894-1944, American.
Tea service, c. 1928.
Tin plated with silver and blackened wood, height: 6.9 cm;
diameter of the tray: 19.7 cm.
Miles J. Lourie Collection. Art Deco.

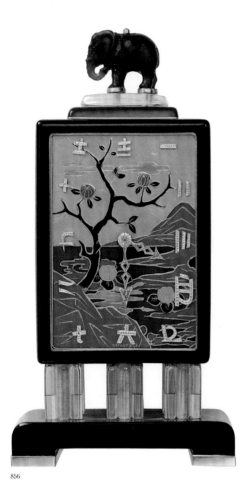

856

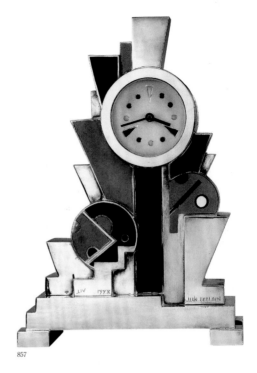

857

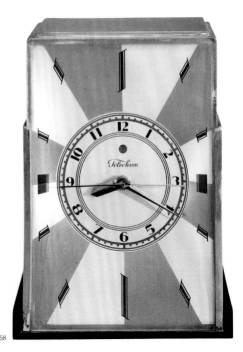

858

856. **Tiffany & Co.**, 1837 - currently active, American.
Desk clock.
Silver, jade, quartz, black onyx, and enamel, signed, height: 12.7 cm.
Location unknown. Art Deco.

857. **Jean Goulden**, 1878-1946, French.
Clock, 1928.
Silvered bronze and enamel.
Stephen E. Kelly Collection. Art Deco.

858. **Paul Theodore Frankl**, 1886-1958, Austrian.
Clock, 1928-1929.
Polished and burnished silver.
Art Institute of Chicago, Chicago. Art Deco.

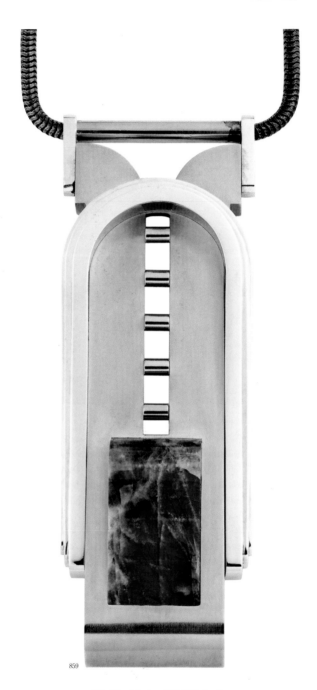

859

859. Gérard Sandoz, 1902-1995, French.
Pendant with chain, c. 1929.
Pink gold, white gold, yellow gold, silver, and labradorite, 10.3 x 3.6 cm.
Private collection. Art Deco.

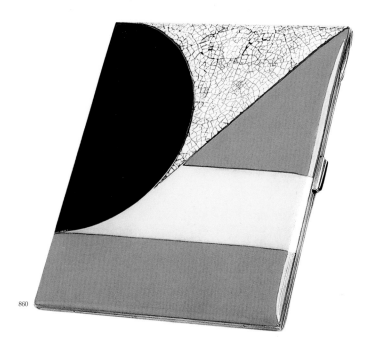

860

RAYMOND TEMPLIER
(PARIS, 21 April 1891-1968)

Raymond Templier, the son and grandson of jewellers, whose family name also is 'jewellery sculptor', was one of the greatest Art Deco artists. From 1909 to 1912, he studied at the École Nationale Supérieure des Arts Décoratifs. Soon after his graduation, he participated in various exhibitions, in particular in the salon Artistes Décorateurs of 1911, the Salon d'Automne, and the Tuileries.

In 1929, Raymond Templier, with Robert Mallet-Stevens, Jean Puiforcat, and Pierre Chareau, founded the Union des Artistes Modernes (UAM). He was the first to incorporate a strict style, with slender shapes, geometric lines, and used innovative materials, like black-lacquered silver, typical for the new Art Deco style, to which critics and buyers responded to well.

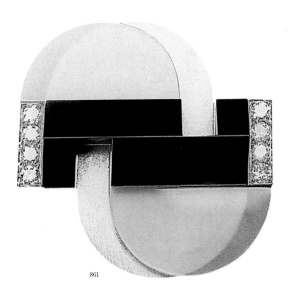

861

860. **Raymond Templier**, 1891-1968, French.
Cigarette case, 1928.
Silver, eggshell, and lacquer, enamel interior.
Bröhan-Museum, Berlin. Art Deco.

861. **Raymond Templier**, 1891-1968, French.
Brooch, 1929.
Platinum, onyx, frosted crystal, diamonds, 4.5 x 4.5 cm.
Musée des Arts décoratifs, Paris. Art Deco.

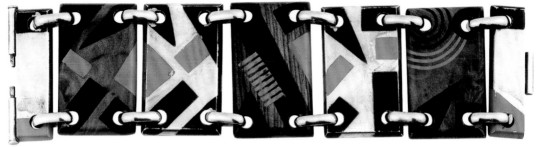

862

JEAN DUNAND
(LANCY, 20 MAY 1877 – PARIS, 7 JUNE 1942)

Jean Dunand was born on 20 May 1877 in Lancy, Switzerland. His father was a gold smelter for watchmaking.

In 1891, he entered a sculpture class in the school for industrial design in Geneva. In 1896, he received a stipend to travel to Paris, where he was an apprentice to the sculptor Jean Dampt, who taught him to sculpt in different materials, such as plaster, bronze, stone, and ivory. Jean Dunand would be chosen by Dampt as one of three students to visit his estate in Touraine, to further learn about sculpting.

Dunand presented at the World Exhibition as a Swiss artist, and won the gold medal for his sculpture *Quo Vadis*.

From 1903 to 1906, he collaborated with Dampt to design the mansion of the Viscountess of Béarn and realized sculptures for panelling, door frames, and furniture.

He turned completely to the decorative arts in 1905. Dunand discovered Japanese lacquer craftsmanship, attracted to its brilliance and vibrant colours. He learned this technique from the Japanese Sougawara, who worked with Eileen Gray.

In August 1914, he enrolled as a volunteer to the French Red Cross. Upon his return, still fascinated by lacquer, Dunand continued his research and experiences and also participated in many fairs and exhibitions gaining fame. His style evolved into simple, geometric shapes.

On 1 November 1919, he was made Chevalier of the Legion of Honour.

In 1923, he accentuated his geometric designs with contrasting colours, Japanese red on black.

In collaboration with the coachbuilder Henri Labourdette, he realised interiors for limousines, using lacquer and eggshell.

In 1927, Dunand participated in the decoration of the liner *Île de France* and in 1928 designed the programme for Josephine Baker's first 'farewell', done for her audience. He then worked on the interior design of the steamer *L'Atlantique*, whose theme was revolved around the fauna and flora of tropical regions. The boat burned and all lacquers by Dunand were destroyed.

Jean Dunand died on 7 June 1942 at the age of sixty-five.

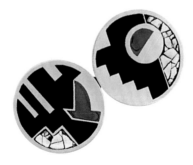

863

862. **Jean Dunand**, 1877-1942, French.
Bracelet, c. 1930.
Rosewood, cedar burl, nickel, and lacquer, 4.2 x 17.2 cm.
Mrs Eva Chow Collection. Art Deco.

863. **Gérard Sandoz**, 1902-1995, French.
Cuff links, c. 1929.
Silver, red, black, and eggshell lacquer.
Historical Design, New York. Art Deco.

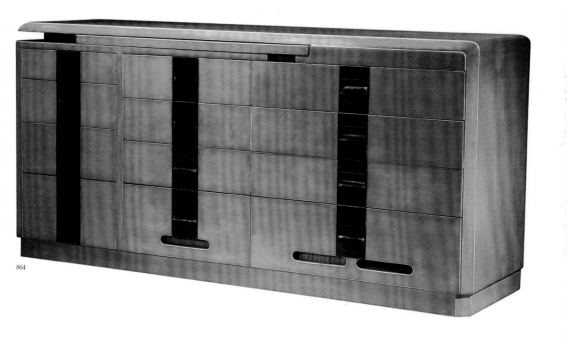

864

864. **Jean Dunand**, 1877-1942, French.
Commode, 1928.
Lacquered wood and black lacquer, 85 x 170.2 x 84.5 cm.
Private collection. Art Deco.

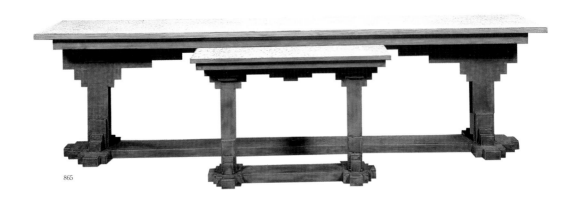

865

865. **Jean Dunand**, 1877-1942, French.
Large and small sideboard, commissioned by Templeton Crocker, c. 1928.
Lacquered wood.
Peter and Sandra Brant Collection. Art Deco.

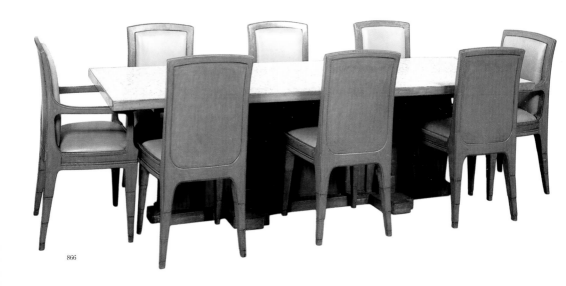

866

866. **Jean Dunand**, 1877-1942, French.
Dining room table with eight chairs, commissioned by Templeton Crocker, c. 1928.
Lacquered wood and eggshell.
Peter and Sandra Brant Collection. Art Deco.

Robert Mallet-Stevens
(Paris, 4 March 1886 – Paris, 8 February 1945)

Robert Mallet-Stevens was born 4 March 1886 in Paris. Architect, designer, teacher, he was one of the key figures of modern architecture. By 1905, he studied at the École Spéciale d'Architecture.

Mallet-Stevens mainly drew architectural designs and interior designs and undergoes for many years, the influence of Josef Hoffmann. After the war, he created a number of private residences, theatres, cinemas, offices, and public gardens. In 1923-1924, Mallet-Stevens realised sets for Marcel l'Herbier's movie *L'Inhumaine*.

As regards to the field of architecture, Villa Paul Poiret and Villa des Frères Martel remain two of his major works. Robert Mallet-Stevens created furniture in simple shapes, without ornament, using mostly wood and metal. Lighting played an important role in his interiors.

In 1929, he became president of the Union des Artistes Modernes (UAM) which united avant-garde designers and architects.

Appointed Director of Fine Arts in Lille in 1930, he then took part in the exhibition in Brussels in 1935 and at the Universal Exhibition of 1937, where he received numerous commissions.

During the occupation, he took refuge in western France and died in Paris in 1945, after a long illness.

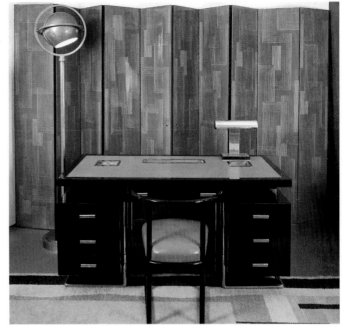

867

867. **Robert Mallet-Stevens**, 1886-1945, French.
Desk with leather surface with built-in, nickelled pencil cases, c. 1928
and chair of lacquered stainless steel tubes by Labormétal, c. 1929. Art Deco.

868. **Robert Mallet-Stevens**, 1886-1945, French.
Dressing table, 1929-1932.
Sycamore and aluminium veneer, 110 x 113 cm.
Private collection. Art Deco.

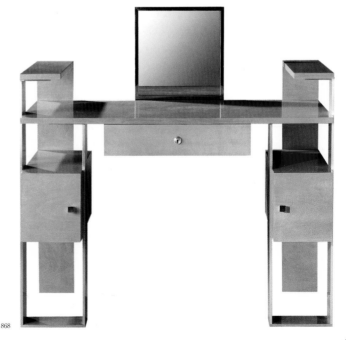

868

869

869. Heinsbergen Decorating Company (Anthony Heinsbergen), 1894-1988, American. Two designs for the orname

antages Theater, Los Angeles, c. 1929. Watercolour on paper. Upper part of the frieze mounted on the safety curtain by the proscenium. Art Deco.

870

William F. Lamb
(Brooklyn, 21 November 1883 – 8 September 1952)

Born in Brooklyn in 1883 and of Scottish origin, William Frederick Lamb, son of an architect, studied architecture at Columbia University in New York, and graduated from the École des Beaux-Arts in Paris in 1911. The same year, he joined the architectural firm Carrère & Hastings, where he met the man who would become his partner: Richard H. Shreve. Together they founded Shreve & Lamb and Shreve, Lamb & Harmon in 1929. Following a commission from John J. Raskob, Lamb drew plans for what will remain for decades the tallest skyscraper in world. On 1 May 1931, the Empire State Building was completed. He participated in the realisation of many other skyscrapers such as 14 Wall Street, headquarters for *Forbes* magazine, and 500 Fifth Avenue.

870. **Raymond Hood,** 1881-1934, American.
Entrance of the McGraw-Hill building, New York, 1930. Art Deco.

871. **Robert S. Degolyer** and **Charles L. Morgan**, 1890-1947 (Morgan), American.
Entrance of the apartment complex 'Powhatan', Chicago, 1929. Art Deco.

872. **William F. Lamb**, 1883-1952, American.
Empire State Building, New York, 1929-1930. Art Deco.

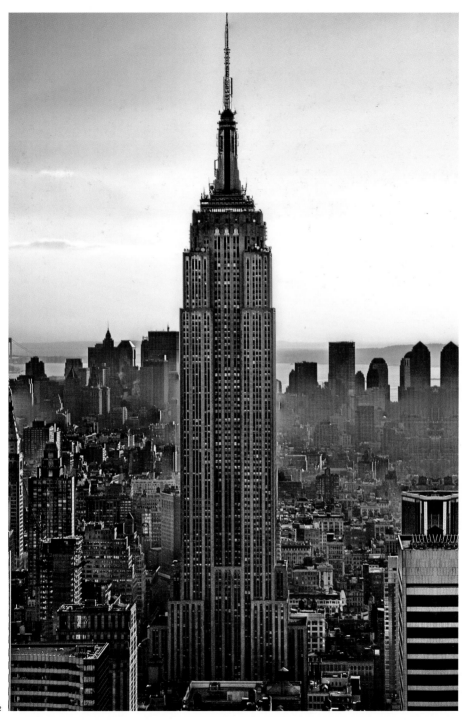

872

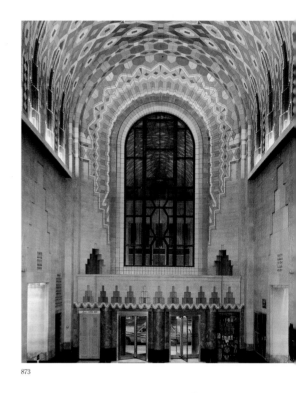

873

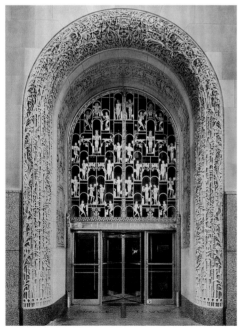

874

873. **Wirt Rowland, Smith, Hinchman & Grylls Associates Inc.**
and **Thomas di Lorenzo**, 1878-1946 (Rowland), American.
Main foyer at the Guardian Building, Detroit, 1929.
Black marble from Belgium and red marble from Numidia, Mankato stone,
and Rookwood ceramic. Art Deco.

874. **Rubush & Hunter**, American.
Vestibule at the Circle Tower, Indianapolis, 1929-1930.
Chiselled hot stones and bronze doors. Art Deco.

875. **Anonymous.**
Swimming pool, 1929-1944.
Umaid Bhawan Palace, Jodhpur. Art Deco.

876. **Anonymous.**
The Maharajah's bathroom, beginning of the year 1930.
Umaid Bhawan Palace, Jodhpur. Art Deco.

877. **Anonymous.**
The Maharajah's bedroom, 1931-1940.
New Palace, Morvi. Art Deco.

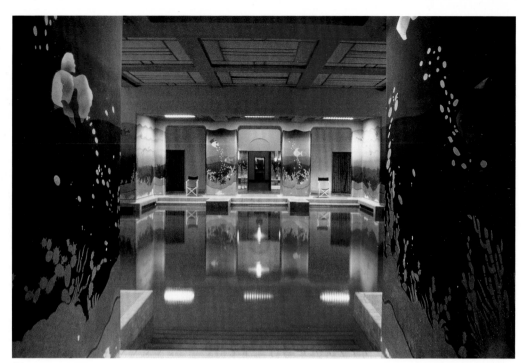

875

876

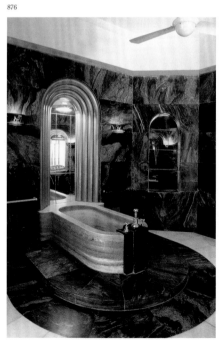

877

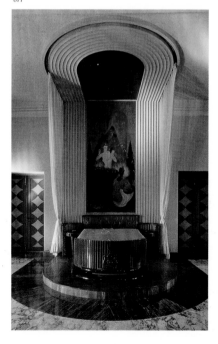

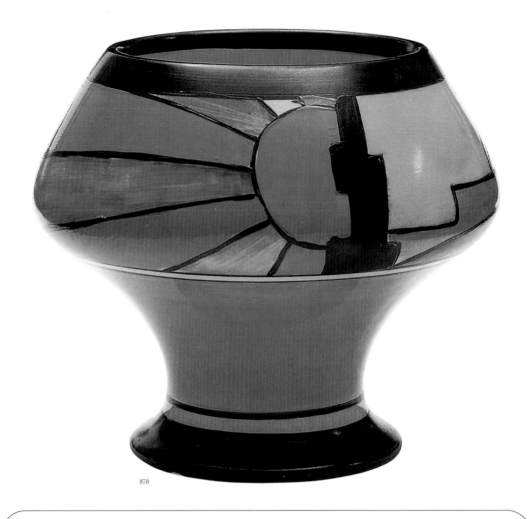

878

Clarisse Cliff
(Tunstall, 20 January 1899 – 23 October 1972)

Queen of decorative art, Clarisse Cliff was an active English ceramist between 1922 and 1963. Born into a working class family, she began to work from the age of thirteen years in the pottery industry. She was gilder at first and then began to paint by hand. In 1916, she joined the factory AJ Wilkinson's Royal Stattfordshire Pottery. Her talent did not go unnoticed. She attended evening classes at the Burslem School of Art and learned sculpture at the Royal College of Art in London. Clarisse Cliff was the first woman to mass produce her own hand-painted creations. Cliff ceramics are defined by very bright colours with designs never seen before, a stark contrast with those of the time, done in traditional, white porcelain. Described as fantastic or bizarre, works by Cliff surprised the audience because of their communicative joy and explosive colours. She later became artistic director, and her production explodes. Unfortunately after the war, production decreases and Clarisse Cliff retired in 1963. Eleven years later, she died sitting in her garden, listening to the radio. Clarisse Cliff works are now highly sought after.

878. **Clarice Cliff**, 1899-1972, English.
Vase, *Sunray*, c. 1929.
Stoneware painted with enamels.
Victoria and Albert Museum, London. Art Deco.

880

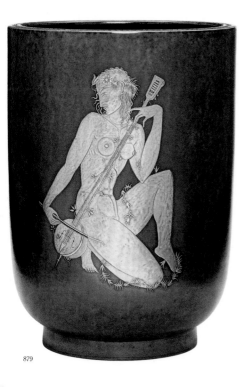

879

879. **Wilhelm Kage**, 1889-1960, Swedish.
Silvered vase, Sweden, c. 1930.
Silver-coated sandstone, height: 20.4 cm.
Victoria and Albert Museum, London.

880. **Rockwood Pottery Company** and **Wilhelmine Rehm**,
founded in 1880 and 1899-1967, American.
Vase, 1930.
Height: 16.5 cm.
John P. Axelrod Collection. Art Deco.

881. **Thelma Frazier Winter**, 1908-1977, American.
Octagonal plate, 1930.
Diameter: 33.1 cm.
Martin Eidelberg Collection. Art Deco.

881

882. **Jean Fouquet**, 1899-1984, French.
Pendant, c. 1930.
White gold, yellow gold, and citrine, 8 x 7 cm.
Private collection, Paris. Art Deco.

883. **Robert Lallemant**, 1902-1954, French.
Ball vase, c. 1930.
Enamelled ceramic, height: 16 cm.
Private collection. Art Deco.

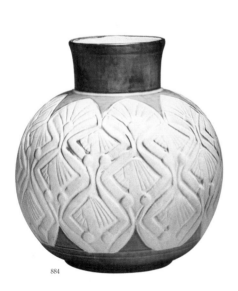

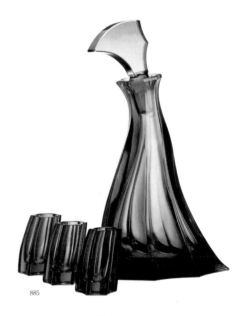

884. **Thelma Frazier Winter**, 1908-1977, American.
Vase, *Amazon*, 1930.
Grey enamel, white relief, height: 25.4 cm.
Cowan Pottery Museum, Rocky River (Ohio). Art Deco.

885. **Anonymous.**
Liquor service, Czech Republic, c. 1930.
Dark smoked glass.
Museum of Decorative Arts, Prague. Art Deco.

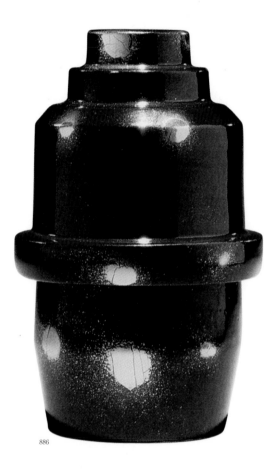

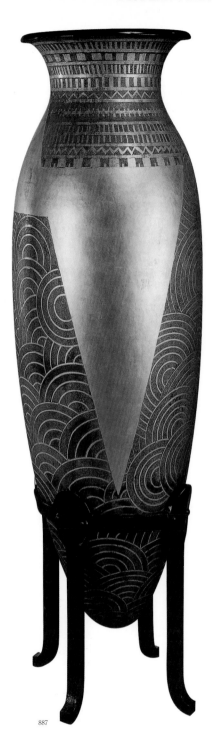

886. **Robert Lallemant,** 1902-1954, French.
Roll vase, c. 1930.
Emanelled ceramic, decorated with golden cloud-shaped dots, height: 17 cm.
Private collection. Art Deco.

887. **Jean Dunand,** 1877-1942, French.
Vase, 1931.
Lacquered brass.
Musée d'Art moderne de la Ville de Paris, Paris. Art Deco.

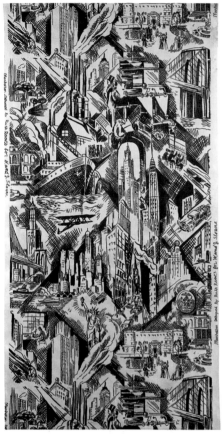

888

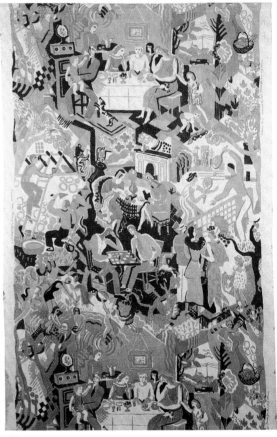

889

888. **Ruth Reeves**, 1892-1966, American.
Hanging: *Manhattan*, 1930.
Printed cotton voile, length: 87 cm.
Victoria and Albert Museum, London. Art Deco.

889. **Ruth Reeves**, 1892-1966, American.
The American Scene, 1930.
Block-printed cotton, plain weave; lined with cotton, plain weave, 215.9 x 106.7 cm.
Museum of Fine Arts, Boston. Art Deco.

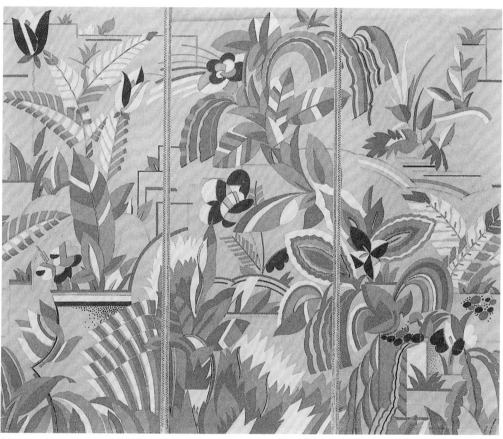

890

890. **Charles Follot Manufactory** and **Henri Stéphany**, founded in 1859 and 1880-1934, French.
Wallpaper, '*Décor floral*', 1930.
Wallpaper done with rotary printing press, 186 x 75 cm.
Musée des Arts décoratifs, Paris. Art Deco.

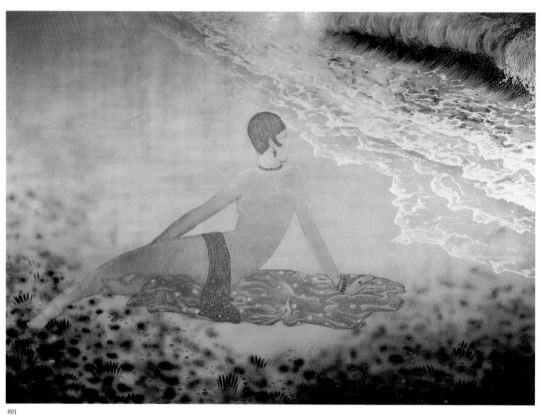

891

891. **Jean Dunand**, 1877-1942, French.
Lacquered panel and gold leaf, 1930.

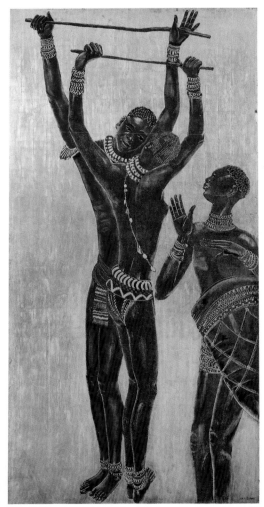

892

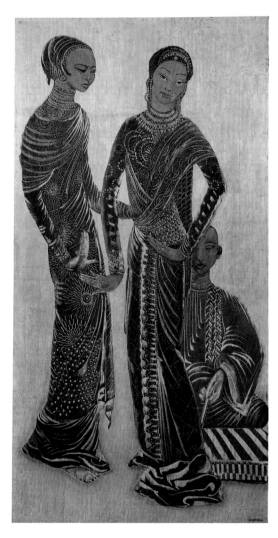

892. **Jean Dunand**,1877-1942, French.
The People of Africa (Cameroon) and *The People of Asia (Indochina)*, 1930.
Lacquered aluminium panels.
Musée du quai Branly, Paris.

893

894

895

893. **Ivan da Silva Bruhns**, 1881-1980, French.
Rugs (manufactured by the Savigny Workshop), c. 1930.
Wool.
Galerie Camoin Demachy, Paris.

894. **Hélène Henry**, 1891-1965, French.
Aubusson tapestry, c. 1930.
Wool, 276 x 196 cm.
Private collection.

895. **Fernant Léger**, 1881-1955, French.
'Paris' tapestry, c. 1930.
Wool, 236.7 x 126.4 cm.
Private collection.

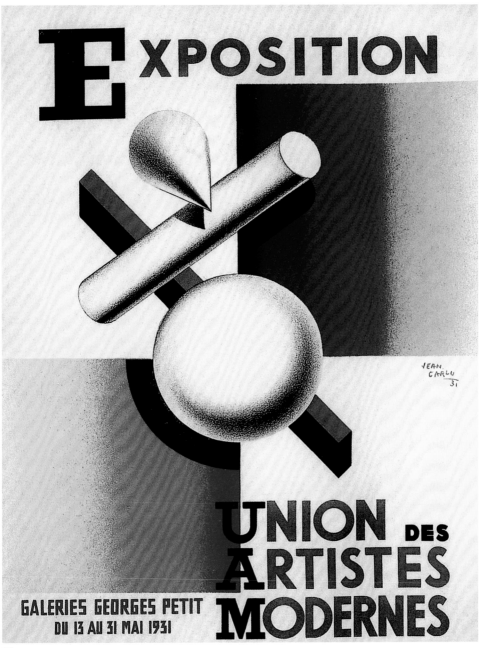

896

896. **Jean Carlu**, 1900-1997, French.
Poster for the second exhibition of *Union des artistes modernes* at the Galerie Georges Petit, 1930.
Colour lithograph.
Musée des Arts décoratifs, Paris. Art Deco.

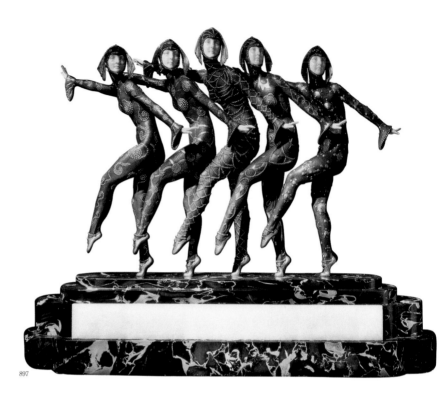

897

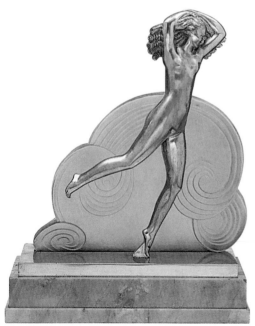

898

897. **Demetre Chiparus**, 1886-1947, Romanian.
Les Girls, c. 1930.
Bronze and ivory.
Private collection.

898. **Raoul-Eugène Lamourdedieu**, 1877-1953, French.
Lamp, c. 1930.
Bronze, marble, and glass, 42.8 x 35 cm.
Victoria and Albert Museum, London.

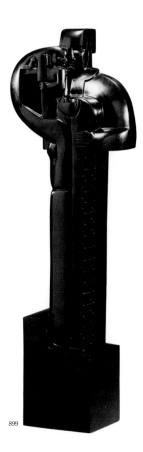

899

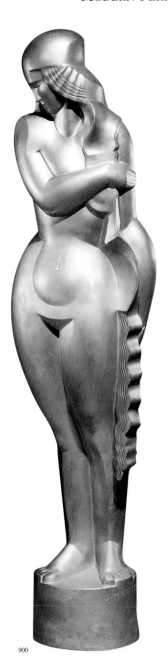

Joël and Jan Martel
(Nantes, 5 March 1896 – 16 March and 26 September 1966)

Martel twin brothers were born in Nantes in 1896. Sculptors, they also realised memorials, decorative bas-reliefs for public buildings and even a baptismal font, which they would sign with their family name. In 1925, they were discovered at the Internationale des Arts décoratifs et industriels modernes by Robert Mallet-Stevens, after he saw their cubist trees for the tourist pavilion. They built a studio house in Paris that was classified as a historical monument in 1990. They also contributed to the Union des Artistes Modernes, a group of French architects and decorators. Throughout their careers, they remained attached to their regional traditions, and would even create a folk group that recorded more than one hundred and fifty popular songs.

900

899. **Jan and Joël Martel**, 1896-1966, French.
The Holy Trinity, c. 1930.
Bronze over black patina, height: 105.5 cm.
Private collection.

900. **Jan and Joël Martel**, 1896-1966, French.
Nude, c. 1930.
Sculpture of silvered Lakarmé, height: 200 cm.
Private collection.

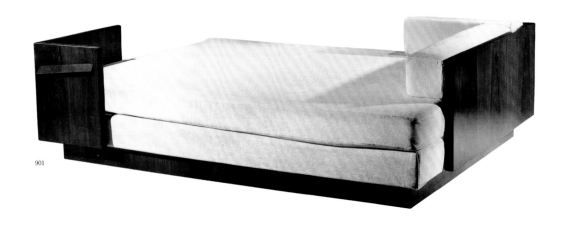

901. **Pierre Chareau**, 1883-1950, French.
Double bed, c. 1930.
Palisander from Rio and wrought iron, patinated black, 59 x 205 x 190 cm.
Galerie L'Arc en Seine, Paris. Art Deco.

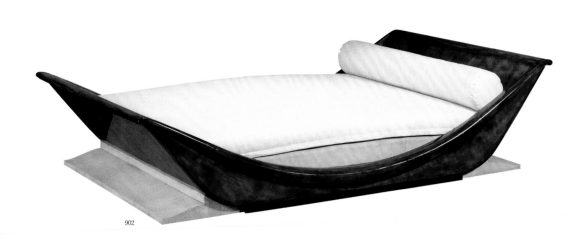

902. **Jean Dunand**, 1877-1942, French.
Bed, 1930s.
Wood and lacquer.
Private collection.

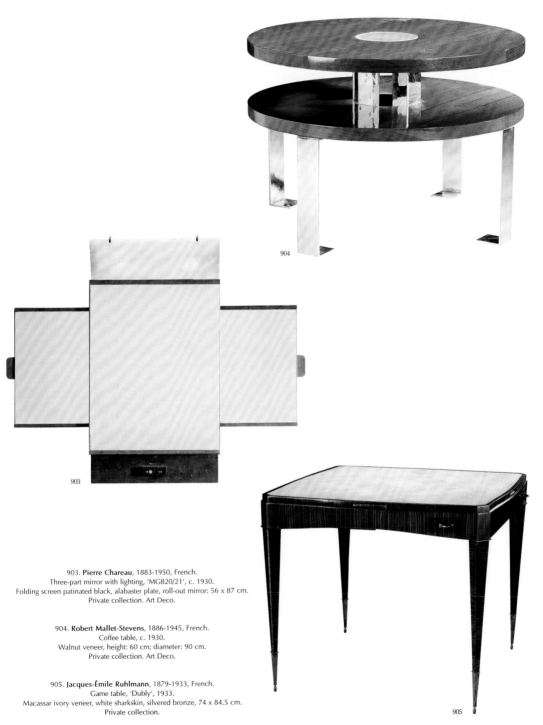

903. **Pierre Chareau**, 1883-1950, French.
Three-part mirror with lighting, 'MG820/21', c. 1930.
Folding screen patinated black, alabaster plate, roll-out mirror: 56 x 87 cm.
Private collection. Art Deco.

904. **Robert Mallet-Stevens**, 1886-1945, French.
Coffee table, c. 1930.
Walnut veneer, height: 60 cm; diameter: 90 cm.
Private collection. Art Deco.

905. **Jacques-Émile Ruhlmann**, 1879-1933, French.
Game table, 'Dubly', 1933.
Macassar ivory veneer, white sharkskin, silvered bronze, 74 x 84.5 cm.
Private collection.

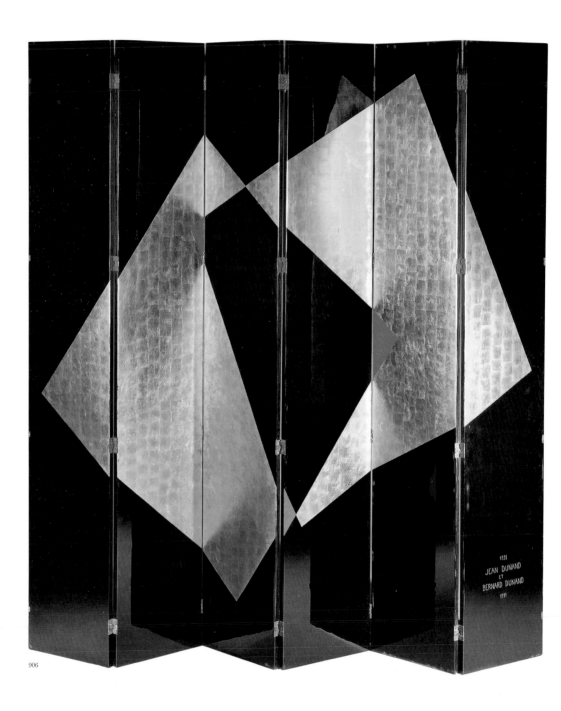

906

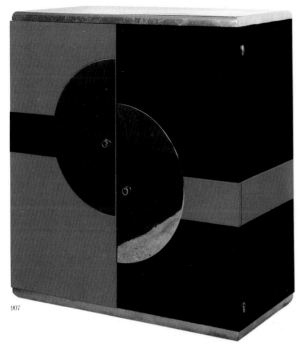

907

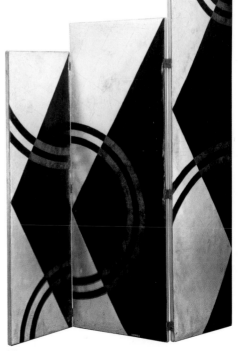

906. Jean Dunand, 1877-1942, French.
Screen, 1931.
Black chinese lacquer, gold leaf, and red lacquer, 298 x 54 cm (each partition).
Private collection. Art Deco.

907. Paul Theodore Frankl, 1886-1958, Austrian.
Cabinet for men, c. 1930.
Red wood and black lacquer inlaid with silver and gold plated round shapes,
silver leaf on upper part and gold leaf on the base, mahogany interior.
Cincinnati Art Museum, Cincinnati (Ohio). Art Deco.

908. Donald Deskey, 1894-1989, American.
Screen, c. 1930.
Wood, canvas, metal fittings, aluminum leaf, and paint, 194.3 x 148.6 cm.
Museum of Fine Arts, Boston. Art Deco.

908

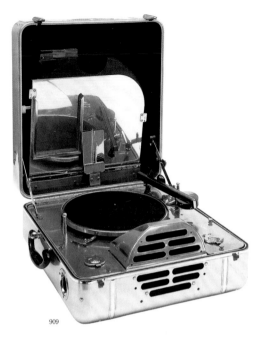

909

909. **John Vassos**, 1898-1985, American.
Portable phonograph, Victor Special model, 1930.
Metal and plastic.
Victoria and Albert Museum, London.

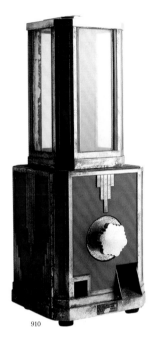

910

910. **Stewart & McGuire**, American.
Nut vending machine, end of 1930.
Height: 48.3 cm.
Ronald and Norma Keno Collection.

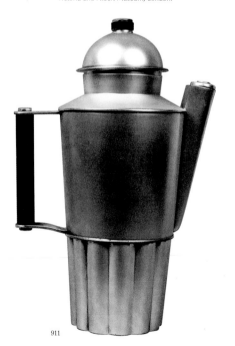

911

KEM WEBER
(BERLIN, 1889-1963)

Designer and architect, Karl Emanuel Martin Weber was born in 1889. He began by attending Eduard Schultz's cabinetmaking workshop, and then enrolled at the School of Decorative Arts, where he studied with Bruno Paul. He travelled to San Francisco in 1915 to oversee the German pavilion at the Panama Pacific International Exposition. He then moved to Santa Barbara, where he taught art and opened a workshop. He became an American citizen in 1924. Weber then worked in industrial design and established his design studio in Los Angeles in 1927. Many projects are controlled by him, including film sets.

Two of his works are particularly renowned: the clock *Zephyr*, made around 1934 and found at the Metropolitan Museum in New York, considered a work of 'Streamline Moderne', a popular style, inspired by the aesthetics of Art Deco that burgeoned in the 1920s. The second famous piece being the chair *Airline*, made to furnish Disney studios.

Kem Weber is also recognised as the architect of the Walt Disney Studios complex in Burbank, California.

911. **Kem Weber**, 1889-1963, German.
Coffee pot, c. 1930.
Plated silver and rosewood, height: 26.7 cm.
Alan Moss Collection.

912

912. **Peter Müller-Munk**, 1907-1967, American.
Water pitcher, *Normandie*, 1935.
Chrome-plated brass, 30.5 x 7.6 x 23.8 cm.
The Metropolitan Museum of Art, New York.

913

913. **Norman Bel Geddes**, 1893-1958, American.
Cocktail service, *Manhattan*, 1937.
Chrome-plated brass, shaker: 33 x 8.3 cm; cups: 11.4 x 6.4 cm; tray: 36.8 x 29.2 cm.
The Metropolitan Museum of Art, New York.

914

914. **Peter Müller-Munk**, 1907-1967, American.
Kettle on stand with burner, 1931.
Silver and ivory, kettle: 14.9 x 26.7 x 9.5 cm; tray: 2.5 x 62.9 x 34.9 cm.
The Metropolitan Museum of Art, New York.

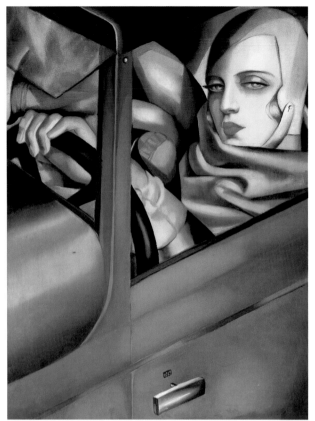

915

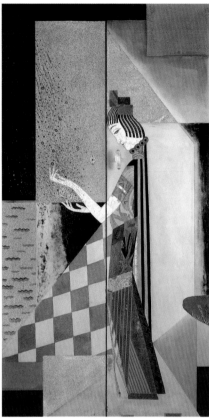

916

Tamara de Lempicka
(Warsaw, 16 May 1898 – Cuernavaca, 18 March 1980)

Tamara de Lempicka is the most famous Polish Art Deco painter of the period. She was born into a wealthy bourgeois Polish family. Tamara discovered her passion for art in 1911 during a trip to Italy with her grandmother. In 1917, Bolsheviks came into power in Russia following the revolution and established a new regime. Tamara and her husband Tadeusz managed to flee the country and lived in Paris for twenty years.

In 1920, she took painting lessons with Maurice Denis and André Lhote and chose to name Tamara de Lempicka. She started to develop a style that was fashionable, trendy, as well as erotic and revealed her creations to the public for the first time at the Salon d'Automne in Paris in 1922. Lempicka's name was also listed as a presenter at the exhibition at the Bottega di Poesia in Milan in 1925, and the first world exhibition of Art Deco held in Paris. German fashion magazine *Die Dame* ordered one of her most famous works, an self-portrait entitled *Tamara in the Green Bugatti*.

The artist received commissions from the Boucard family and painted a portrait of her husband Tadeusz, shortly before their divorce that same year. She met Baron Raoul Kuffner and moved into a luxury apartment on the Rue Méchain, designed by modern architect Robert Mallet-Stevens. Her work and creativity suffered from Hitler's rise to power and the ensuing serious realities, and the stock market crash on Wall Street. She entered a long period of depression. In 1939, Lempicka and Kuffner departed to the United States and settled in Los Angeles. Lempicka continued to paint and was easily seduced by the sensual world and attracting high society of Hollywood. They then moved to New York. Her new life in the high society of New York was reflected in her work. Her figurative paintings and experiences with abstract impressionism aroused little interest. Her career began to falter. Tamara de Lempicka began to sink slowly in the dark.

In 1962, following the death of Baron Kuffner, she moved to Houston with her daughter and son.

In 1973, a retrospective exhibition was devoted to her at the Galerie du Luxembourg, an exhibition that was a great success. Having found fame once again, she moved with her daughter in 1974 to Cuernavaca, Mexico, where she spent the rest of her life, constantly marred by her inability to live in peace with her family and others.

Tamara de Lempicka died on 18 March 1980.

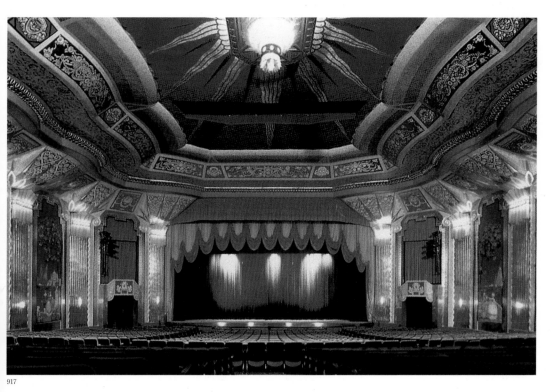

917

917. **Rapp & Rapp Architects**, American.
Auditorium for the Paramount Theater, 1931.
Aurora (Illinois).
Courtesy of Paramount Arts Center. Art Deco.

915. **Tamara de Lempicka**, 1898-1980, Polish
Self-Portrait in the Green Bugatti, 1929.
Oil on wood panel, 35 x 27 cm.
Private collection. Art Deco.

916. **Jean Dunand**, 1877-1942, French.
Proposed panels for a pair of lacquered doors, c. 1930.
Art Deco.

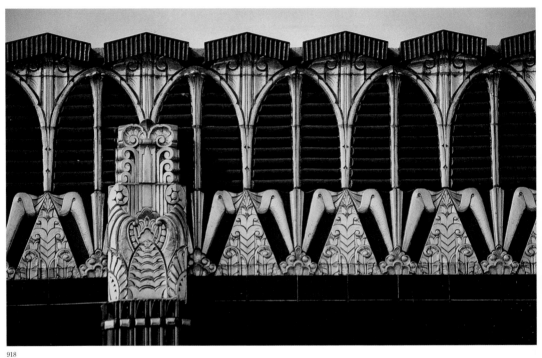

918

918. **Arthur E. Harvey**, 1884-1971, American.
Detail of clay coating, enamelled and blackened, 1931.
Crocker Citizens National Bank, now Spring Arts Tower, Los Angeles.
Art Deco.

919. **K. M. Vitzthum & J. J. Burns architects**, American.
Reception at the Field Building, Chicago, c. 1930.
Chicago.

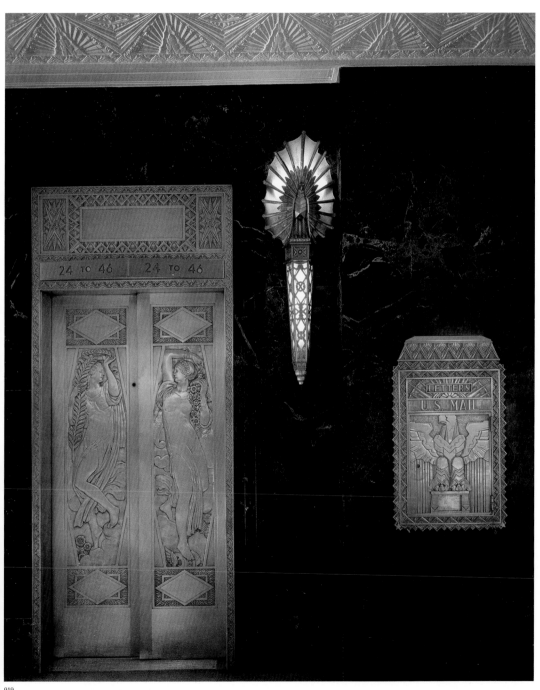

919

920

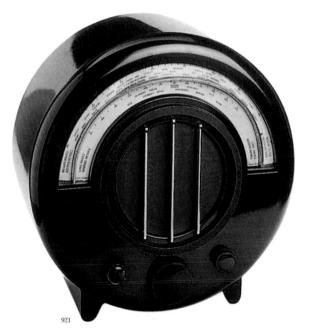

921

920. **Jean Desprès**, 1889-1980, French.
Brooch, c. 1932.
Silver, lacquer, painted and engraved varnish, 5.9 x 3.1 cm.
Musée des Arts décoratifs, Paris. Art Deco.

921. **Wells Coates**, 1895-1958, Canadian.
Ekco AD-65, radio, 1932.
Bakelite, 39.5 x 40.5 x 21 cm.
Victoria and Albert Museum, London.

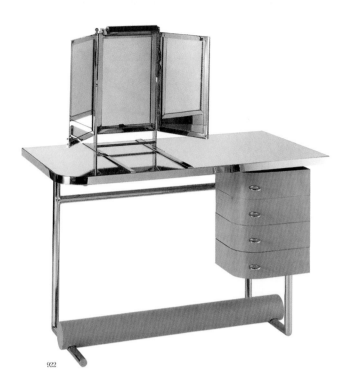

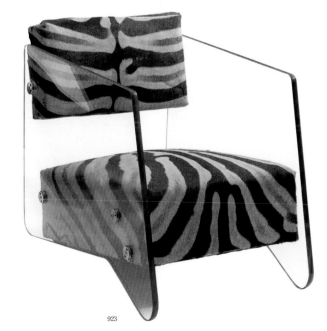

922. **René Herbst**, 1891-1982, French.
Dressing table, 1931.
Chromed stainless steel, glass, lacquer, three-part mirror,
built-in lamp, 71.5 x 109 x 60 cm.
Musée des Arts décoratifs, Paris. Art Deco.

923. **Denham Maclaren**, 1903-1989, English.
Chair, Great Britain, c. 1930.
Glass and zebra print, 68 x 57 x 85 cm.
Victoria and Albert Museum, London.

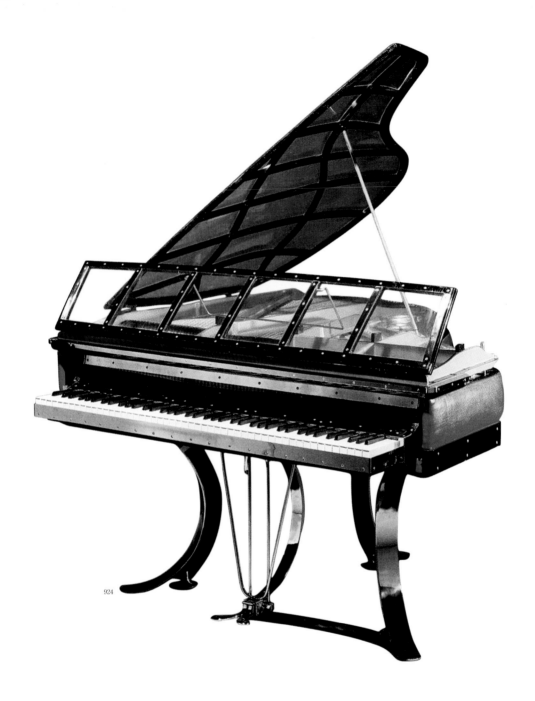

924. **Poul Henningsen**, 1894-1967, Danish.
Baby grand piano, *Mira Flygel*, c. 1931.
Chrome metal, golden lacquer, red leather, black-lacquered wood, keys of ivory and ebony, 94 x 141.5 cm.
Private collection.

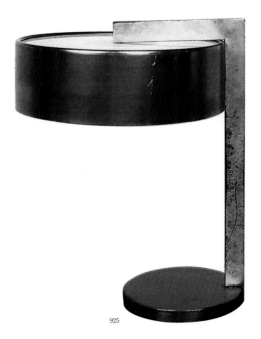

925

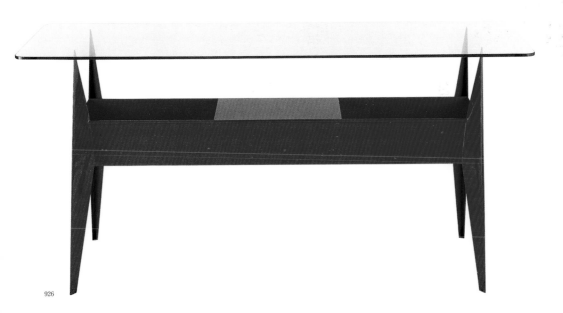

926

925. **Kurt Umen**, 1901-1997, American.
Table lamp with detachable lampshade, 1934.
Copper and chrome.
Allan Moss Associates Ltd Collection.

926. **André Hermant**, 1908-1978, French.
Library table, 1937.
Painted sheet steel, glass, 92 x 200 x 65 cm.
Musée des Arts décoratifs, Paris.

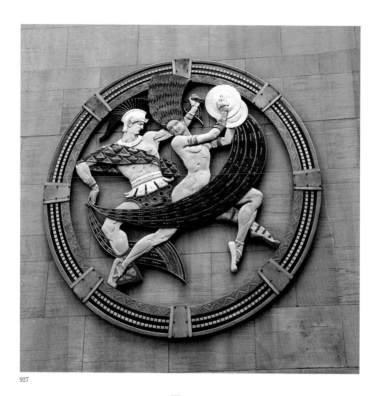

927

928

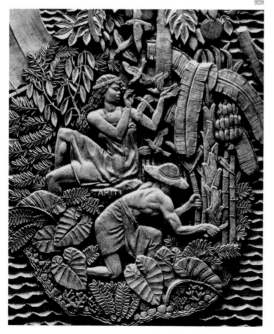

927. **Hildreth Meiere**, 1892-1961, American.
Dance, art deco rondel, 1932.
Metal.
Radio City Music Hall facade, Rockefeller Center, New York. Art Deco.

928. **Alfred Janniot**, 1889-1969, French.
Tahiti, 1931.
Plate from the bas-relief for Jean Charbonneaux's musée des Colonies.
Sculptural decoration for the musée des Colonies, palais de la Porte Dorée. Art Deco.

929. **Rayner Hoff**, 1894-1937, English.
Sacrifice, 1934.
Bronze.
Central sculpture in the Hall of Silence, ANZAC Memorial, Sydney.

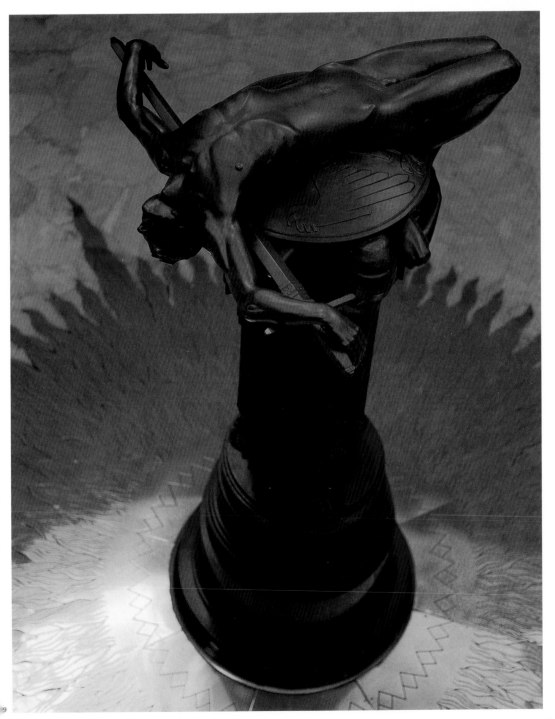

930

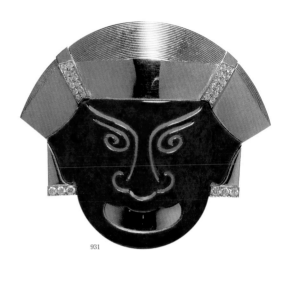

931

930. Anonymous.
Pair of ear clips, 'Crest' or 'Helmet', 1931-1934.
White gold, platinum, sapphire, and lacquer.
Primavera Gallery, New York. Art Deco.

931. Georges Fouquet, 1858-1929, French.
Brooch, 1931.
White gold, blue enamel, and diamonds.
Private collection. Art Deco.

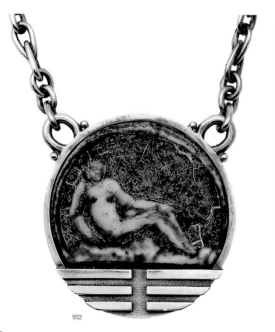

932

Jean Mayodon
(Sèvres, 1893 – Paris, 1967)

Jean Mayodon lived his childhood in the arts since his father was an amateur painter and sculptor. He entered in the Bracquemond workshop, where he met Rodin, Monet, Gauguin, and the dancer Isadora Duncan, whose dancing he portrayed on his vases. He produced a ceramic with figural decoration in the ancient taste. Antiquity was depicted by round newts, sirens, dancers, gods and heroes.

Mayodon lived and worked most of his life in his workshop in Sèvres. In 1919, he exhibited twenty polychrome ceramics at the Musée Galliera.

During the 1930s, he became interested in architectural decorating and realised monumental works (decorative panels, sculptures, fountains, fireplaces). He was knighted Legion of Honour in 1931 and officer in 1954 and became director of the Sèvres Manufactory from 1940 to 1942. His works show an undeniable technical quality.

932. Jean Mayodon, 1893-1967, French.
Brooch, c. 1938.
Silver and gold, enamelled ceramic.
Private collection.

934

933

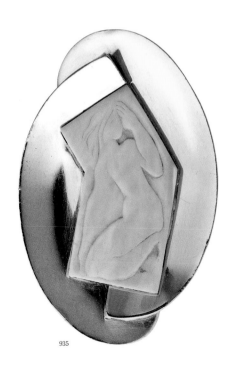

933. **Jean Lambert Rucki, Maison Georges Fouquet**, and **Charles Girard**,
1888-1967 (Rucki) and 1895-1936 (Fouquet), Polish and French.
Clip, 1937.
Gold, 6.5 x 6 cm.
Musée des Arts décoratifs, Paris.

934. **Jean Fouquet**, 1899-1984, French.
Clip, 1937.
Gold, lacquer, diamonds with old brilliant cut, 6.2 x 3.9 cm.
Musée des Arts décoratifs, Paris.

935. **Raymond Templier** and **Joseph Csaky**,
1891-1968 and 1888-1971, French and Hungarian.
Pendant, *Kneeling Woman*, 1940.
Gold, silver, and ivory.
Mme Cheska Vallois Collection, Paris.

935

936

936. **Air King Product Company**, American.
Radio, *Air King* model, 1934.
Red coating with inscription: 'Air King Product Co B'klyn N.Y. USA', height: 10.5 cm.
Private collection.

937

938

937. **Kem Weber**, 1889-1963, German.
Zephyr, electronic clock, c. 1934.
Brass and bakelite, 8.3 x 20.3 x 7.9 cm.
The Metropolitan Museum of Art, New York. Streamline Moderne.

938. **Walter Dorwin Teague**, 1883-1960, American.
Camera *KodakBantam Special*, 1933-1936.
Chromed metal branded 'Kodal Bantam Special, made in USA
Eastman Kodak Company, Rochester, N.Y.', height: 7.6 cm.
Mitchell Wolfson Jr Collection, The Wolfsonian-Florida International
University, Miami Beach.

939. **Ronson Company**, American.
Lighter, *Touch Tip*, 1935.
Enamelled copper, height: 8.9 cm.
Mitchell Wolfson Jr Collection, The Wolfsonian-Florida International
University, Miami Beach. Streamline Moderne.

939

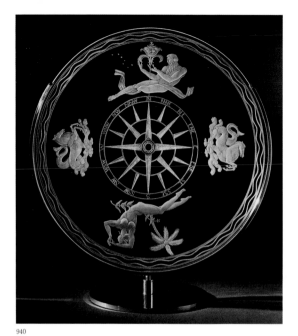

940

941

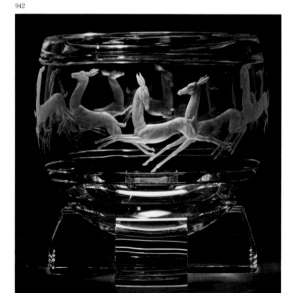

942

940. **Sidney Biehler Waugh**, 1904-1963, American.
Mariner's Bowl, 1935.
Glass, 5.7 x 39.4 cm.
Brooklyn Museum, New York.

941. **Séraphin Soudbinine**, 1867-1944, French, born in Russia.
Bottle, c. 1935.
Enamelled porcelain, height: 28.5 cm; diameter: 12 cm.
Musée des Arts décoratifs, Paris.

942. **Sidney Biehler Waugh**, 1904-1963, American.
'Gazelle' bowl, 1935.
Glass, 18.4 x 17.8 cm.
The Metropolitan Museum of Art, New York.

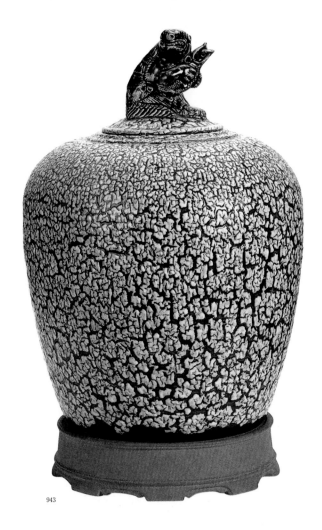

943

Séraphin Soudbinine
(Nizhny Novgorod, 1867-1944)

Of Russian origin, Seraphim Soudbinine remained in Rodin's studio for ten years. He discovered in 1923, during a trip to the United States with the painter Sorine, a collection of ceramics from the Far East at the Metropolitan Museum in New York. On his return to France, he gave up sculpture and devoted himself to ceramics. After years of work, Soudbinine became master in the field and opened his studio in Rue Broca in Paris, destroyed during the Second World War. Soudbinine also worked at the Sèvres Manufactory. His inspiration came from the East, from China to Korea. Robustness, ruggedness, and refinement, matt and glazed stoneware are characteristic of the sculptor's art.

 This covered pot was donated by the artist to the Musée des Arts décoratifs in Paris. The animal carved on the lid recalls the influence of oriental art.

943. **Séraphin Soudbinine**, 1867-1944, French, born in Russia.
Pot with cover, 1935.
Enamelled sandstone, height: 44.2 cm; diameter: 31 cm.
Musée des Arts décoratifs, Paris.

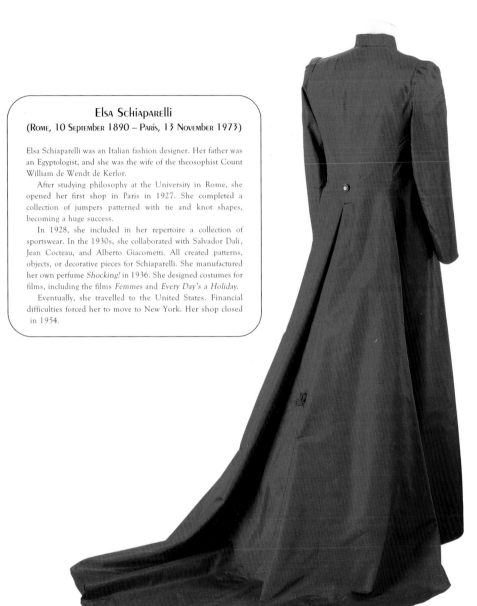

Elsa Schiaparelli
(Rome, 10 September 1890 – Paris, 13 November 1973)

Elsa Schiaparelli was an Italian fashion designer. Her father was
an Egyptologist, and she was the wife of the theosophist Count
William de Wendt de Kerlor.

After studying philosophy at the University in Rome, she
opened her first shop in Paris in 1927. She completed a
collection of jumpers patterned with tie and knot shapes,
becoming a huge success.

In 1928, she included in her repertoire a collection of
sportswear. In the 1930s, she collaborated with Salvador Dalí,
Jean Cocteau, and Alberto Giacometti. All created patterns,
objects, or decorative pieces for Schiaparelli. She manufactured
her own perfume *Shocking!* in 1936. She designed costumes for
films, including the films *Femmes* and *Every Day's a Holiday*.

Eventually, she travelled to the United States. Financial
difficulties forced her to move to New York. Her shop closed
in 1954.

944

944. **Elsa Schiaparelli**, 1890-1973, Italian.
Evening coat, 1939.
Scarlet taffeta.
Victoria and Albert Museum, London.

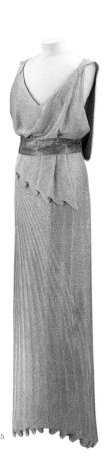

945

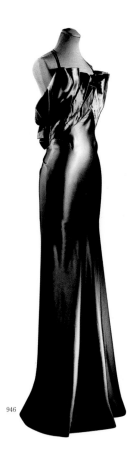

946

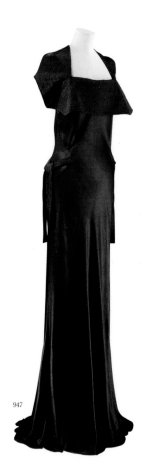

947

JEANNE LANVIN
(PARIS, 1 JANUARY 1867 – PARIS, 6 JULY 1946)

Jeanne Lanvin was a well-known French seamstress. At age thirteen, she began to work at a hat shop, and trained as a seamstress and milliner. In 1885, she opened her own fashion workshop in Faubourg Saint-Honoré and her first shop in 1889. The birth of her daughter Marie-Blanche, for whom she designed much clothing, inspired her to start a collection for children. Her fashion is known for, above all, its elegance and quality. Jeanne Lanvin had four favourite colours: Lanvin blue, Velasquez green, Polignac pink, and black.

Later, she designed cloth and perfumes (beginning with the perfume *Arpège*), as well as a sportswear collection.

Following Jeanne Lanvin's death in 1946, her daughter Margaret assumed control of the company, bought by L'Oréal in 1990. Lanvin fashion house was famous for its ¨chic à la française¨.

945. **Jean Patou**, 1880-1936, French.
Evening gown, 1932-1934.
Tulle with pearls.
Victoria and Albert Museum, London.

946. **Charles James**, 1906-1978, American.
Evening gown, 1937.
Black satin decorated with silk ribbon.
Victoria and Albert Museum, London.

947. **Jeanne Lanvin**, 1867-1946, French.
Evening gown, 1935.
Mauve-coloured satin.
Victoria and Albert Museum, London.

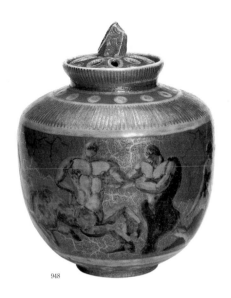

948

949

950

948. **Jean Mayodon**, 1893-1967, French.
Vase with top, c. 1937.
Faience, height: 34 cm; diameter: 27.5 cm.
Musée des Arts décoratifs, Paris.

950. **Anne Dangar**, 1885-1951, Australian, born in Ireland.
Plate with the Virgin Mary and Christ Child, c. 1937.
Faience, diameter: 47 cm.
Musée des Arts décoratifs, Paris.

949. **Jean Besnard**, 1889-1958, French.
Plate, 1937.
Faience, partially enamelled; height: 6 cm; diameter: 32.5 cm.
Musée des Arts décoratifs, Paris.

951

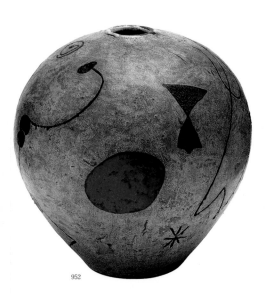

952

Raoul Dufy
(Le Havre, 1877 – Forcalquier, 1953)

The French artist was born in Le Havre in 1877. At the beginning of his career, he was significantly influenced by the Fauve movement and his colourful works with bold contours reflect this approach. He attended the École des Beaux-Arts in Le Havre where he met Othon Friesz. In later years, his forms became geometric, the space structured – clear signs of Cubism. Later, he developed a very personalised style with easy lines, light colours, and strong ornamental character. He enjoyed painting flowers, fashionable tennis courts, views of the French Riviera, and elegant parties. Raoul Dufy died in 1953.

951. **Émile Decoeur**, 1876-1953, French.
Bowl, 1938.
Cast sandstone, enamelled, monogrammed in the impression in the base,
height: 5.9 cm; diameter: 11.1 cm.
Musée des Arts décoratifs, Paris.

952. **Joan Miró**, 1893-1983, Spanish.
Vase, 1941.
Enamelled sandstone, height: 28.5; diameter: 29 cm.
Musée des Arts décoratifs, Paris.

953. **Raoul Dufy**, 1877-1953, French.
Vase with Bathers on a Black Background, 1938.
Enamelled faience, height: 23.5 cm; diameter: 23 cm.
Musée des Arts décoratifs, Paris.

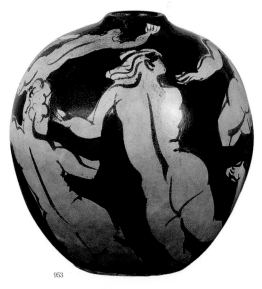

953

954

954. **Gilbert Poillerat**, 1902-1988, French.
Table, 1943.
Table legs of wrought iron, moulded tabletop, 73 x 288 x 110 cm.
Musée des Arts décoratifs, Paris.

955

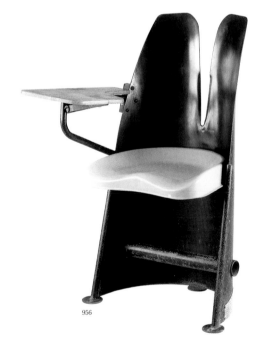

956

955. **René Coulon**, 1908-1997, French.
Chair, 1938.
Polished glass surface, bent and tempered, leather seat, 86 x 59 x 56 cm.
Musée des Arts décoratifs, Paris.

956. **Jean Prouvé**, 1901-1984, French.
Amphitheatre chair, 1952.
Metal, wood, and aluminium, 92 x 70 x 60 cm.
Musée des Arts décoratifs, Paris.

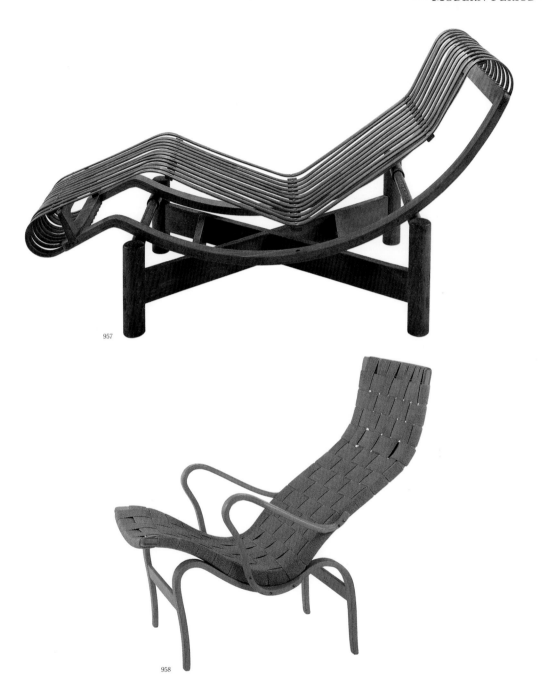

957

958

957. **Charlotte Perriand**, 1903-1999, French.
Lounger made of bamboo, 1941.
Unique model, 74 x 140 x 52 cm.
Musée des Arts décoratifs, Paris.

958. **Bruno Mathsson**, 1907-1988, Swedish.
'Pernilla' chair, 1943.
Birch, webbing of vegetable fibres, 90 x 71 x 102 cm.
Musée des Arts décoratifs, Paris.

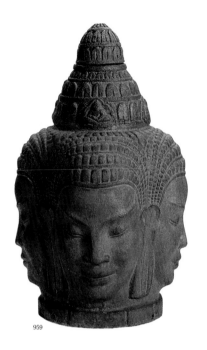

959

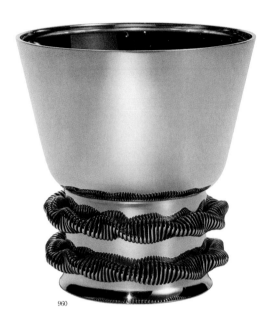

960

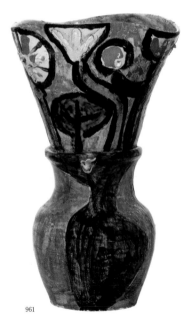

961

959. **Georges Serré**, 1889-1956, French.
Buddha's head, c. 1937.
Sandstone; height: 49.6 cm; diameter: 25.6 cm.
Musée des Arts décoratifs, Paris.

960. **Jean Émile Puiforcat**, 1897-1945, French.
Vase, 1945.
Silver; height: 16 cm; diameter: 15.5 cm.
Musée des Arts décoratifs, Paris.

961. **Pablo Picasso**, 1881-1973, Spanish.
Vase with flowers, 1948.
Faience engobed and enamelled; height: 56 cm; diameter: 33.5 cm.
Musée des Arts décoratifs, Paris. Cubism.

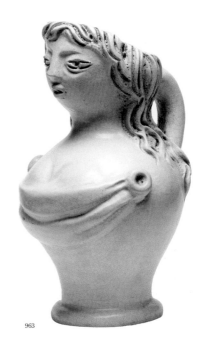

963

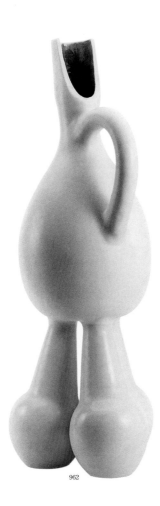

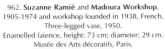

962

962. **Suzanne Ramié** and **Madoura Workshop**,
1905-1974 and workshop founded in 1938, French.
Three-legged vase, 1950.
Enamelled faience, height: 73 cm; diameter: 29 cm.
Musée des Arts décoratifs, Paris.

963. **Georges Jouves**, 1910-1964, French.
Woman jug, c. 1946.
Enamelled faience, 43.5 x 32 x 25.5 cm.
Musée des Arts décoratifs, Paris.

964. **Odette Lepeltier**, 1914-2006, French.
Motherhood, c. 1947.
Enamelled faience, height: 40.4 cm.
Musée des Arts décoratifs, Paris.

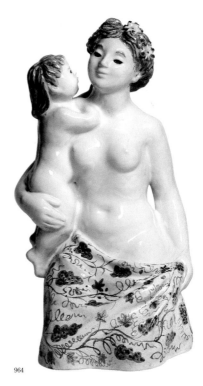

964

965

966

967

967. **Jorn Utzon, Hall, Todd** and **Littlemore**, 1918-2008 (Utzon),
Sydney Opera House, 1957-1973.
Sydney.

965. **Frank Lloyd Wright**, 1867-1959, American.
Guggenheim Museum, 1943-1959.
New York.

966. **Le Corbusier**, 1887-1965, Swiss.
Notre Dame du Haut, 1950-1955.
Ronchamp.

968

969

970

968. Jean Royère, 1902-1981, French.
'Liane' lamp, c. 1950-1955.
Metal tube, original lampshade in Rhodoid, 250 x 240 cm.
Musée des Arts décoratifs, Paris.

969. Viviana Torun, 1927-2004, Swedish.
Necklace, *Body Sculpture*, 1951-1958.
Silver, rutile quartz, glass, 20 x 10 cm.
Musée des Arts décoratifs, Paris.

970. Alexander Calder, 1898-1976, American.
Brooch, c. 1955.
Hammered silver, 13 x 9.5 cm.
Musée des Arts décoratifs, Paris.

971

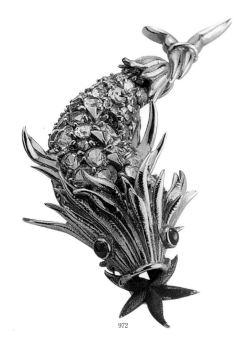

972

JEAN LURÇAT
(BRUYÈRES, 1 July 1892 – SAINT-PAUL-DE-VENCE, 6 JANUARY 1966)

The painter Jean Lurçat was a creator of tapestries, as well as ceramics. In 1912, he and his brother André moved to Paris. He enrolled at the Académie Colarossi and later learned at the workshop of the graphic designer Bernard Naudin. There, he discovers Matisse and Cézanne. Subsequently, he became a painting apprentice to the fresco painter Jean-Paler Lafitte. In 1917, Jean Lurçat, under the patronage of his mother, completed his first canvas. Afterwards, he took many trips to Berlin, Rome, Naples, and Palermo, eventually settling in Paris, where he exhibited at the Salon des Indépendants. He was the first, in 20th century tapestry, to unite architecture with contemporary art.

In the late 1930s, Lurçat entered the workshop of Louis Delachenal in Sèvres. Jean Lurçat had a deeply-personalised style with stark colour contrast and vivid motifs, also seen in his tapestries. In the last years of his life, he worked in the famed porcelain manufactory Haviland & Co. in Limoges, and he completed models of great finesse. He was one of the most important actors in the revitalisation of the art of the 20th century.

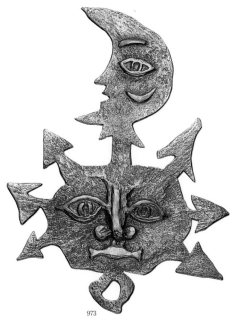

973

971. **Line Vautrin**, 1913-1997, French.
Necklace, *Leapfrog*, 1950-1955.
Gilded bronze, enamel, length: 24 cm; diameter: 13 cm.
Musée des Arts décoratifs, Paris.

972. **Jean Schlumberger**, 1907-1987, French.
Clip, *Fish*, 1956.
Gold, amethyst, rubies, aquamarine, red lacquer, 6.4 x 4.6 cm.
Musée des Arts décoratifs, Paris. Art Deco.

973. **Jean Lurçat**, 1892-1966, French.
Pendant, *Face of the Moon*, 1959-1960.
Hammered 24-carat gold, 9.5 x 6.5 cm.
Musée des Arts décoratifs, Paris. Art Deco.

974

975

976

974. **Jean Schlumberger**, 1907-1987, French.
Hat part, c. 1938.
Gilded metal, coral, enamel, 17 x 4 cm.
Musée des Arts décoratifs, Paris.

975. **Saara Hopea-Untracht**, 1925-1984, Finnish.
Ring, 1960.
Silver, spheres of white coral, 3.3 x 2.6 cm.
Musée des Arts décoratifs, Paris.

976. **Georges Braque**, 1882-1963, French.
Clip, *Hera*, c. 1962.
Figure in gold, waves in sapphire over platinum, 4.3 x 6 cm.
Musée des Arts décoratifs, Paris. Cubism.

977

ROGER TALLON
(Paris, 6 March 1929 – 20 October 2011)

Born in Paris in 1929, the designer Roger Tallon made an international career for himself and is regarded a pioneer of industrial design in France. After his studies in engineering, Tallon joined an office for technical and aesthetic studies Technès, founded by the father of industrial design Jacques Viénot. Before Roger Tallon assumed control of the company in the wake of Viénot's death in 1959, he taught at the art school in Paris, where he offered the first courses in design throughout all of France. In 1963, he went even further, in that he founded a department of design at the École Nationale Supérieure des Arts Décoratifs in Paris. At the same time, he met with avant-garde artists and collaborated with his friends Yves Klein, Arman, or Caesar. As explorer and designer, he produced more than 400 projects between 1953 and 1973, such as the portable TV *Télévia P111*, a slide projector for Kodak, and a graphic system for the magazine *Art Press*. Roger Tallon quickly designed objects for all areas, such as the coral-red train car for SNCF, the funicular railway in Montmartre, and the Eurostar project. With good reason, he received in 1992 the title Commandeur des Arts et des Lettres. Before his death in 2011, he bequeathed his complete archive to the Musée des Arts décoratifs in Paris. Besides an impressive career, Roger Tallon established the job of industrial designer.

977. **Roger Tallon**, 1929-2011, French.
Service '3T', 1967.
Ceramic porcelain made by Raynaud porcelain; crystal glass made by Daum;
stainless steel cutlery made by Ravinet d'Enfert.
Musée des Arts décoratifs, Paris.

978

979

Jean Dubuffet
(Le Havre, 1901 – Paris, 1985)

The French sculptor Jean Dubuffet was born into a family of wine dealers. After completing a night course at the art school in Le Havre, he travelled to Paris in 1918, where enrolled at the Académie Julian, discontinuing his studies just six months later. In 1924, he stopped painting for the next eight years, in order to continue his father's shop.

He finally decides in 1942, after several interruptions, to focus entirely on painting. His work was exhibited in Paris, New York, and Basel and caused much controversy. In 1965, he began to make sculptures out of foamed polystyrene and painted with vinyl. Starting in 1969, he received more commissions for public work, such as *The Group of Four Trees* at the One Chase Manhattan Plaza in New York in 1969 and the sculpture *La Tour Aux Figures* for the French state, located in the city of Île Saint-Germain since 1983. Jean Dubuffet considered these monumental sculptures as cell proliferation, a continuation in the space between place, figure, and object. In those given three-dimensional space, he allowed his graphics to escape from the sheet and invade monumental elements in the surrounding.

979. **Jean Lurçat**, 1892-1966, French.
Baroque vase, c. 1960.
Enamelled faience, height: 38.5 cm; diameter: 31 cm.
Musée des Arts décoratifs, Paris.

978. **Jean Dubuffet**, 1901-1985, French.
Paysage portatif (*Portable Landscape*), 1968.
Transferred onto polyester, 80 x 130 x 75 cm.

980.

980. **Gabriel-Sébastien Simonet**, known as **Sébastien**, 1909-1990, French.
Tree with Branches, c. 1960.
Terracotta, partially engobed, base of wood, height: 33.5 cm; length: 31 cm.
Musée des Arts décoratifs, Paris.

981.

982.

981. **Jean** and **Jacqueline Lerat**, 1913-1992 and born 1920, French.
Anthropomorphic vase, 1974.
Sandstone, burned wood, 45 x 30 cm.
Musée des Arts décoratifs, Paris. Expressionism.

982. **Gilbert Portanier**, born 1926.
Vase, 1964.
Red terracotta, enamelled and engobed; height: 95 cm.
Musée des Arts décoratifs, Paris.

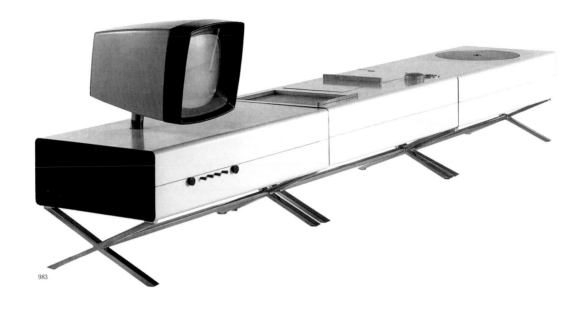

983

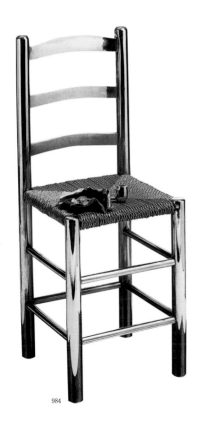

984

983. **Antoine Phlippon** and **Jacqueline Lecoq**,
1930-1995 and born 1932, French.
TV cabinet, turntable and bar, 1959.
Post-formed formica, polished brass, chrome steel,
120 x 60 cm (each component).
Musée des Arts décoratifs, Paris.

984. **Clive Barker**, born 1952, American.
Van Gogh's Chair, 1966.
Chromed stainless steel, height: 86.4 cm.
Sir Paul McCartney Collection.

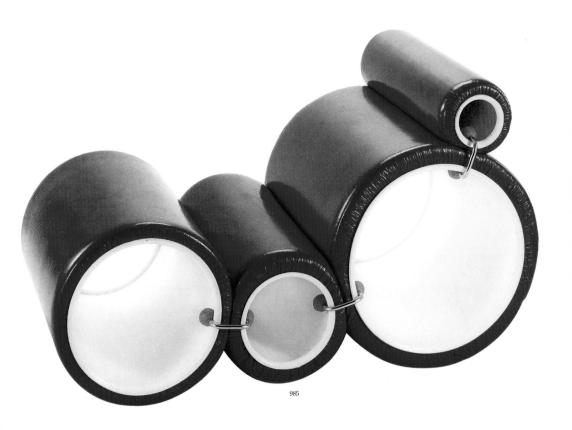

985

985. **Joe Colombo**, 1930-1971, Italian.
Tube Chair, Italy, 1969.
Four PVC cylinders, coated with red Arex Lasckina Softalon,
six metal seals with twelve rubber balls, original cover, 60 x 47 cm.
Musée des Arts décoratifs, Paris.

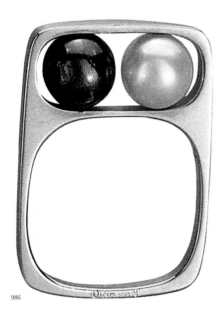

986

986. **Jean Dinh Van**, born 1927, French.
Ring, 1966.
Gold, pearls, 2.5 x 1.2 cm.
Musée des Arts décoratifs, Paris.

987

988

988. **Mutsuo Yanagihara**, born 1934, Japanese.
Vase, 1985.
Enamelled sandstone, height: 43.5 cm; width: 7 cm.
Musée des Arts décoratifs, Paris.

JEAN DINH VAN
(born 11 September 1927)

JeanVan Dinh has a Vietnamese father and a French mother. In 1950, he began his studies of applied arts and jewellery making in Paris and joined Cartier, where he learned the craft of jewellery. His work is influenced by Chinese symbols. In 1965, he founded his own studio and completed in 1967, the famous ring with two pearls, signed by Pierre Cardin and currently found at the Musée des Arts décoratifs. Recognised worldwide, Dinh Van collaborates with Cartier and signs his rings 'Cartier-Dinh Van'. In the late 1970s, he opened new stores on Madison Avenue and in Geneva and Brussels. In 2008, he opened another on Champs-Elysées in Paris. In the early 2010s, he established the brand *Pi Independent* in collaboration with the Italian designer Lapo Elkann. Many jewellery pieces by Dinh Van are exhibited at the Musée des Arts décoratifs.

987. **Jean Dinh Van**, born 1927, French.
Pendant, *Razor Blade*, 1972.
Gold, 4.5 x 2.3 cm.
Musée des Arts décoratifs, Paris.

989

989. **Richard Meitner**, born 1949, Dutch.
Vases, *Violation du fond* (*Breaching the Depths*), 1984.
Handblown glass, enamelled and painted wood, 65 x 100 x 10 cm.
Musée des Arts décoratifs, Paris.

991

990

990. **Ettore Sottsass**, 1917-2007, Italian.
Vase from the series *Yantra*, 1969.
Enamelled faience, height: 43 cm; width: 25 cm.
Musée des Arts décoratifs, Paris. Minimalism.

991. **Henri Gargat**, born 1928, French.
Bracelet, 1984.
Brushed aluminium, gold, diameter: 10 cm.
Musée des Arts décoratifs, Paris.

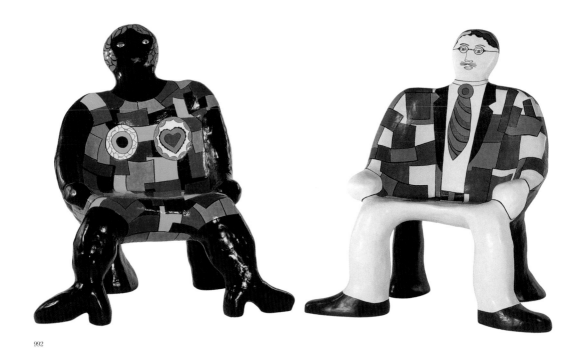

992

Niki de Saint Phalle
(Paris, 1930 – San Diego, California, 2002)

The French sculptor Niki de Saint Phalle spent her childhood in New York. A self-taught artist, she began painting in 1950. In 1952, she returned to Paris, and after 1960, lived with the sculptor Jean Tinguely. In 1961, she began to create her shot-reliefs, artworks where she used a shotgun to pierce suspended paint cans located over an assembly of different materials found in relief; whilst emptying these bags, the paint would finish the work. Her first solo exposition took place at the Alexander Iolas's Gallery in New York in 1961. During this time, she joined the New Realist group in Paris and began creating slightly more conventional sculptures, many of them made to express a political intention. She later began making extremely large artworks, including *She* from 1966, showing a woman lying down with entrails including film projections, installations and machines that can be seen through a small opening between her legs. Later in her career, Saint Phalle wrote plays, directed films, created architectural projects, and continued to sculpt. A large retrospective of her work was organised in Munich in 1987.

992. **Niki de Saint Phalle**, 1930-2002, French.
Chairs, *Clarice* and *Charley*, 1981-1982.
Painted polyester resin, *Clarice*: 121 x 113 x 84 cm; *Charley* : 121 x 120 x 80 cm.
Musée des Arts décoratifs, Paris. New Realism.

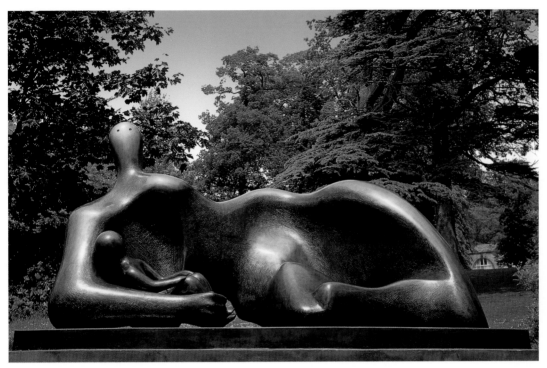

993

HENRY MOORE
(Castleford, Yorkshire, 1898 – Hertfordshire, 1986)

The British sculptor Henry Moore is considered one of the most important sculptors of the 20th century. His bronze and stone sculptures constitute the major 20th-century manifestation of the humanist tradition in sculpture. The son of a Yorkshire coal miner, he was enabled to study at the Royal College of Art by a rehabilitation grant after being wounded in the First World War. His early works were strongly influenced by the Mayan sculpture he saw in a Paris museum. From around 1931 onwards, he experimented with abstract art, combining abstract shapes with human figures, at times leaving the human figure behind altogether. Much of his work is monumental, and he is particularly well-known for a series of reclining nudes. These female figures, echoing the forms of mountains, valleys, cliffs and caves, extended and enriched the landscape tradition which he embraced as part of his English artistic heritage.

993. **Henry Moore**, 1898-1986, English.
Lying Woman with Child, 1983.
Bronze, 139.7 x 265.4 x 144.8 cm.
Yorkshire Sculpture Park, Wakefield. Abstract art.

994

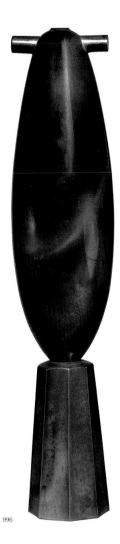

996

995

994. **Kimpei Nakamura**, born 1935, Japanese.
Sculpture, 1985.
Porcelain, partially enamelled, gold application, 42.5 x 35 cm.
Musée des Arts décoratifs, Paris.

995. **Wayne Fischer**, born 1953, American.
Vase, 1997.
Enamelled porcelain, 53 x 36 x 35 cm.
Musée des Arts décoratifs, Paris.

996. **Pierre Bayle**, 1945-2004, French.
Alabaster, 1985-1987.
Engobed and burned terracotta, height: 58 cm; width: 13.5 cm.
Musée des Arts décoratifs, Paris.

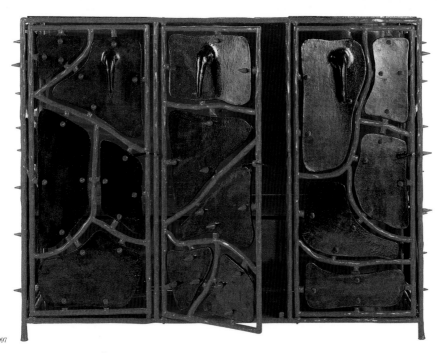

997

997. **Élisabeth Garouste** and **Mattia Bonetti,** born 1949 and 1952, French and Swedish.
Cabinet, *Hell,* 1998.
Wrought iron and enamelled terracotta, 103 x 135 x 48 cm.
Musée des Arts décoratifs, Paris.

998

999

998. **Alison Britton,** born 1948, English.
Green Striped Pot, 1999.
Enamelled faience, height: 48 cm; width: 27 cm.
Musée des Arts décoratifs, Paris.

999. **Shiro Kuramata,** 1934-1991, Japanese.
Acrylic Stool, Japan, 1990.
Acrylic, aluminum, feathers, finished in colourful alumina, 54 x 33 cm; diameter: 33 cm.
Musée des Arts décoratifs, Paris.

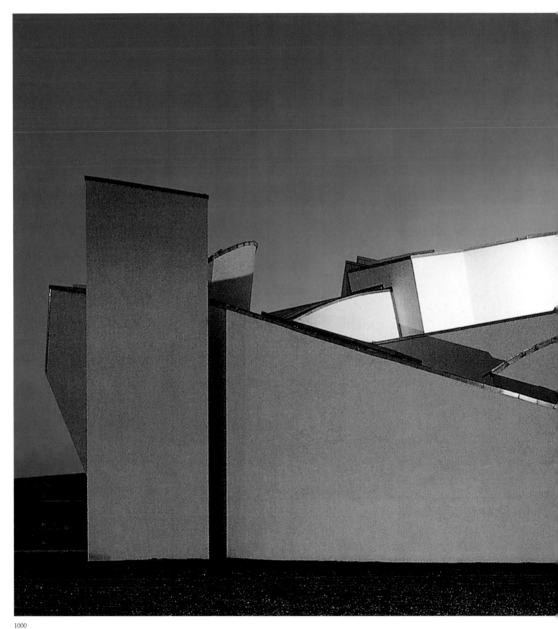

1000

1000. **Frank Gehry**, born 1929, Canadian-Ameri

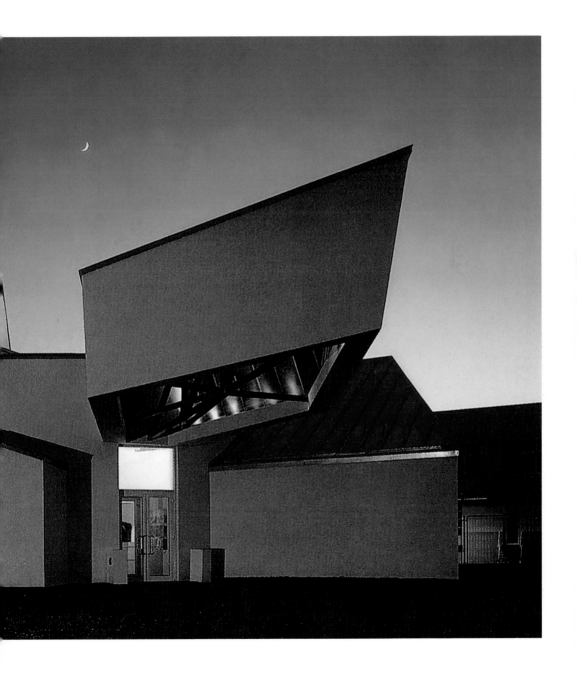

Design Museum, 1987-1989. Weil am Rhein.

CHRONOLOGY

	PREHISTORY	
	3,000,000 BCE - 400,000 BCE	**400,000 BCE - 3000 BCE**
IBERIAN PENINSULA	800,000 BCE: First Neanderthal men (Spain)	15,500-13,500 BCE: Rock paintings in the Altamira cave
ITALY		
FRANCE	1,800,000 BCE: First tools attestation (pebbles) 400,000 BCE: Fire harnessing	25,000-23,000 BCE: Venus of Lespugue 21,000 BCE: Venus of Brassempouy 18,000-15,000 BCE: Rock paintings of Lascaux 4000 BCE: Beginnings of the megalithic civilisation
BRITISH ISLES		
CENTRAL EUROPE (GERMANY INCLUDED)		23,000 BCE: *Venus of Willendorf*
FLANDERS (BELGIUM, NETHERLANDS)		
GREECE		3200-2700 BCE: The Cyclades civilisation
AFRICA	3,000,000 BCE: First men's appearance in Eastern and Southern Africa	4000 BCE: Sahara desert's dryness, migrations towards Western Africa 3300 BCE: First handwritings' appearance in Egypt
AMERICAS		
RUSSIA		

<table>
<thead>
<tr><th colspan="3" align="center">ANTIQUITY</th></tr>
<tr><th></th><th align="center">3000 BCE - 0</th><th align="center">0-476 CE</th></tr>
</thead>
<tbody>
<tr>
<td>IBERIAN PENINSULA</td>
<td>1000 BCE: Beginnings of the Iron Age
2nd-1st centuries BCE: Roman conquest</td>
<td></td>
</tr>
<tr>
<td>ITALY</td>
<td>800 BCE: Beginnings of the Etruscan civilisation in Tuscany
753 BCE: Foundation of Rome
3rd-2nd centuries BCE: Punic wars
44 BCE: Julius Caesar's murder
31 BCE: Actium battle. Birth of the Roman Empire</td>
<td>64: Great fire of Rome and first Christians persecutions led by Nero
79: Vesuvius eruption, destruction of Pompei and Herculaneum
293: Diocletian installs the Triumvirate, dividing the Empire's government between Eastern and Western
410: The sack of Rome by the Visigoths
476: Fall of the Western Roman Empire</td>
</tr>
<tr>
<td>FRANCE</td>
<td>600 BCE: Founding of Marseille, first mention of Gaul
58-51 BCE: Gallic wars. Vercingetorix's defeat</td>
<td>406: Beginnings of the great invasions in Gaul, because of the Rhine's frost</td>
</tr>
<tr>
<td>BRITISH ISLES</td>
<td></td>
<td></td>
</tr>
<tr>
<td>CENTRAL EUROPE (GERMANY INCLUDED)</td>
<td>2nd millennium BCE: Appearance of the Germanic peoples</td>
<td>9: Teutoburg battle, victory of the Germanic tribes over the Romans</td>
</tr>
<tr>
<td>FLANDERS (BELGIUM, NETHERLANDS)</td>
<td></td>
<td></td>
</tr>
<tr>
<td>GREECE</td>
<td>2700-1200 BCE: Minoan civilisation in Crete
800 BCE: Increasing of the trade with the Near East, then with Italy
800-510 BCE: Archaic period
750 BCE: Beginnings of the Greek colonisation towards the West
561 BCE: Pisistratus becomes a tyrant of Athens. Autocracy in all the greek cities
510-323 BCE: Classical Greece
508 BCE: Cleisthenes installs democracy in Athens
490-479 BCE: Greco-Persian wars
323-146 BCE: Hellenistic Greece</td>
<td>1st century CE: Beginnings of Christianity
330: Founding of Constantinople</td>
</tr>
<tr>
<td></td>
<td colspan="2" align="center">146 BCE-330 CE: Roman Period</td>
</tr>
<tr>
<td>AFRICA</td>
<td>3100-343 BCE: Pharaonic Egypt
814 BCE: The Phoenicians found Carthage
332 BCE: Alexander the Great enters in Egypt
331 BCE: Founding of Alexandria
146: Destruction of Carthage by the Romans
30 BCE: Egypt goes under the Roman rule</td>
<td>2nd-3rd centuries: Christianity expands through North Africa
429: Arrival of the Vandals in Africa</td>
</tr>
<tr>
<td>AMERICAS</td>
<td></td>
<td></td>
</tr>
<tr>
<td>RUSSIA</td>
<td></td>
<td></td>
</tr>
</tbody>
</table>

	476-1200	1200-1299
IBERIAN PENINSULA	542: Great bubonic plague 711: Beginnings of the Muslim conquest 756: Abd al-Rahman founds the Umayyad Emirate in Cordoba 596: Toledo becomes the capital of the Visigothic kingdom	1200: Introduction of the Arabic numerals in Europe 1212: The combined armies of Aragon and Castile defeat the Almohads at the Battle of Las Navas de Tolosa 1238: The Moors set their last refuge in Granada
ITALY	756: Pepin the Short delivers Rome besieged by the Lombards 962-973: Otto the first is crowned in Rome, first emperor of the Holy Roman Empire	c. 1200: The compass arrives in Europe for purpose of navigation c. 1200: The paper arrives in Europe 1204: Sack of Constantinople by the Crusaders 1209: Foundation of Franciscan and Domenican monastic orders preaching against heresy and praising poverty and charity 1215: Lateran Council 1271: Marco Polo reaches China 1276: First paper mill set in Italy
FRANCE	481: Clovis becomes king of the Franks 496: Clovis becomes a convert to Christianity 511-751: Merovingian dynasty 732: Charles Martel defeats the Muslim army in Poitiers 751-987: Carolingian dynasty 800: Charlemagne is crowned emperor 987: Hughes Capet, first king of the Capetian dynasty 987-1328: Capetian dynasty 1066: Conquest of England by William, Duke of Normandy 1095: First crusade	1233: Pope Gregory IX starts the Papal Inquisition. Extirpation of the Cathars in southern France 1226-1270: King St Louis of France (Louis IX), last crusade
	1180-1223: King Philip Augustus II of France. Building of the Louvre	
BRITISH ISLES		1215: King John forced to sign the Magna Carta
CENTRAL EUROPE (INCLUDING GERMANY)	843: Treaty of Verdun, division of the Carolingian empire into three kingdoms 919-936: Henry I the Fowler, King of Germany 962: Creation of the Holy Roman Empire 1122: Concordat of Worms 1138-1152: Conrad III of Germany. Hohenstaufen dynasty	1260: Albert the Great writes a major book on botanical studies
FLANDERS (BELGIUM, NETHERLANDS)		1214: Philip Augustus of France wins the Battle of Bouvines. Starts a long period of French control
GREECE	1054: Definitive schism between the Orthodox Church and the Roman Catholic Church 1185: Storming of Salonica by the Normans	
AFRICA	634: Omar I unifies Arabia and starts the first Muslim conquest (Hijra) 7th century: North Africa conquest by Arabs 800: Introduction of the Arabic numerals	
AMERICAS		
RUSSIA	862: Arrival of the Viking king Rourik, fondator of the first russian dynasty 989: The emperor Vladimir converts Russians to Christianity 1157-1327: Vladimir-Suzdal principality	1207: The Mongols spread xylography in Eastern Europe 1223: Invasion of Russia by Mongols 1242: Alexander Nevsky begins to unify Russia

	MIDDLE AGES	
	1300-1349	**1350-1399**
IBERIAN PENINSULA	1309: First portulan (navigation map)	1385: Victory of Juan I of Portugal over the Castilians
	1232-1492: The Nasrid dynasty rules Granada	
ITALY	1308: Dante writes the *Divine Comedy*. Flourishing of vernacular literature 1348: The plague (known as the Black Death) arrives in Europe	1378: Two popes are elected, one in Italy, one in France. Beginning of the Great Schism
	1349-1353: Boccaccio writes the *Decameron*	
FRANCE	1309: Avignon becomes residence of Pope Clement V 1320-1330: Endemic wars and development of sea trade	1378: Two popes are elected, one in Italy, one in France. Beginning of the Great Schism
	1309-1423: Avignon becomes residence of Pope Clement V 1328-1589: House of Valois 1337-1453: England and France start the Hundred Years' War	
BRITISH ISLES	1346: Canon powder arrives in Europe and is used for the first time at the battle of Crecy	1382: John Wycliffe finishes translating the Latin Bible into English
	1337-1453: England and France start the Hundred Years' War	
CENTRAL EUROPE (INCLUDING GERMANY)	1310: Experiments on reflection and refraction of light	1356: Emperor Charles IV issues the Golden Bull. Prague becomes centre of learning and culture
FLANDERS (BELGIUM, NETHERLANDS)		1369: Marriage of Philip the Bold, Duke of Burgundy, to Margaret of Flanders, beginning of Burgundian rule in the Low Countries
GREECE	14th century: Beginnings of the Ottoman Greece	
AFRICA		
AMERICAS		
RUSSIA		

RENAISSANCE

	1400-1449	1450-1499
IBERIAN PENINSULA	15ᵗʰ c. - 16ᵗʰ c.: Navigation with caravels	1456: The Portuguese discover the Cape Verde 1469: Reign of the Catholic Monarchs (Ferdinand of Aragon and Isabella of Castille) 1478: Sixtus IV issues the Bull establishing the Spanish Inquisition 1492: Moors driven out of Spain. End of 800 years of Islamic presence in Spain. Columbus reaches the New World 1498: Vasco da Gama arrives in India
ITALY	1407: Bank of St George established in Genoa as the first public bank 1413: Brunelleschi invents the pictorial perspective	1453: Turkish conquest of Constantinople
FRANCE	1429: Saint Joan of Arc leads the French to victory against the English 1431: Joan of Arc is burned alive in Rouen 1328-1589: Valois dynasty	
BRITISH ISLES		1455: War of the Roses 1485-1509: Reign of Henry VII Tudor, King of England
CENTRAL EUROPE (INCLUDING GERMANY)	1445: Invention of the moveable type (first printer)	1456: Gutenberg produces the first printed Bible 1493: Maximilian I establishes the Habsburg family as a major international power Late 15ᵗʰ century: Invention of the art of etching (with Daniel Hopfer)
FLANDERS (BELGIUM, NETHERLANDS)		
GREECE		
AFRICA	Mid 15ᵗʰ century: Beginning of the slave trade by the Europeans	
AMERICAS		1492: Columbus reaches the New World
RUSSIA		1480: Ivan III Vasilevich frees Russia from Mongol domination

	1500-1549	1550-1599
	RENAISSANCE	

	1500-1549	1550-1599
IBERIAN PENINSULA	1500: First Portuguese explorers disembark in Brazil 1506: Hernán Cortés, conquistador, arrives in the New World 1513: Pacific Ocean discovered by Vasco Nuñez de Balboa 1520: Magellan sails across the Pacific Ocean 1521: Hernán Cortés defeats the Aztecs. A 300 year colonial period starts 1543: First scientific study of human anatomy (Andreas Vesalius) 1549: Francis Xavier establishes the first Christian mission in Japan	1571: Battle of Lepanto, Ottomans defeated by the Venetian and the Spanish 1588: Spanish Armada defeated by England. End of Spanish commercial supremacy
	1516-1555: Charles V, Holy Roman Emperor	
ITALY	1494-1559: Italian wars 1527: Sack of Rome by the troops of Charles V 1530: End of the Florence Republic (1500-1530). Under the reign of Cosimo de' Medici, Tuscany acquires the title of Grand Duchy 1545-1563: Council of Trent Counter-Reformation	
FRANCE	1515-1547: Francis I, King of France 1515: Battle of Marignan, victory of Francis I against the Swiss	1552: Ambroise Paré practices the first vessel ligature 1562-1598: Wars of Religion 1572: St Bartholomew's Day massacre: massive killings of Protestants in France during the night of St Bartholomew 1598: Edict of Nantes proclaimed by French King Henry IV End of the Wars of Religion
	1328-1589: Valois dynasty 1494-1559: Italian wars 1589-1792: House of Bourbon	
BRITISH ISLES	1485-1509: Reign of Henry VII Tudor, King of England 1533: Henry VIII is excommunicated by the Pope	1553-1558: Reign of Marie Tudor, Queen of England. Return to Catholicism 1558-1603: Elizabeth I, Queen of England. Protestantism established in the Church of England
CENTRAL EUROPE (INCLUDING GERMANY)	1508-1519: Reign of Maximilan I, emperor of the Holy Roman Empire. Spreads the Habsburgs' reign to Burgundy, the Netherlands, Franche-Comté, Hungary and Bohemia 1517: Martin Luther posts his 95 theses: Protestant Revolt and beginning of the Reformation 1519-1555: Reign of Charles V, emperor of the Holy Roman Empire 1529: Turkish invasions, Siege of Vienna 1543: Copernican Revolution with the theory of heliocentrism	1560: Spreading of Calvinism
FLANDERS (BELGIUM; NETHERLANDS)	1508-1519: Reign of Maximilan I, emperor of the Holy Roman Empire. Spreads the Habsburgs' reign to Burgundy, the Netherlands, Franche-Comté, Hungary and Bohemia	1568: General revolt in the Netherlands 1581: Creation of the Dutch Republic (Independence of the Northern provinces from Spain)
	1519-1555: Reign of Charles V, emperor of the Holy Roman Empire	
GREECE		
AFRICA		
AMERICAS	1500: First Portuguese explorers disembark in Brazil 1506: Hernán Cortés, conquistador, arrives in the New World 1521: The conquistador Hernán Cortés defeats the Aztecs 1531-1534: Pizarro conquers the Inca Empire	1588: Spanish Armada defeated by England. End of Spanish commercial Supremacy
RUSSIA	1533-1584: Ivan IV of Russia (Ivan the Terrible) first ruler of Russia to assume the title of tsar	

BAROQUE		
	1600-1649	**1650-1699**
IBERIAN PENINSULA	1598-1621: Philip III rules Spain, Naples, Sicily, Southern Netherlands and Portugal 1621: Victories against the French and Dutch 1648: Defeat of Spain against France, peace of Westphalia, concession of the Flanders' territories	
ITALY	1610: Galileo Galilei first uses the telescope 1616: Galileo forbidden by the Church to further scientific work 1644: Evangelista Torricelli invents the barometer	
FRANCE	1610-1643: Louis XIII, King of France 1618-1648: The Thirty Years War 1648: Defeat of Spain against France, peace of Westphalia, concession of the Flanders' territories	1661-1715: Louis XIV, King of France. Castle of Versailles transformed 1685: Revocation of the Edict of Nantes (Protestantism declared illegal in France)
BRITISH ISLES	1600: Founding of the British East India Company 1640-1660: English Revolution led by Oliver Cromwell (1599-1658)	1666: Great fire of London 1687: Isaac Newton's theories of the law of motion and principle of gravity 1698: Invention of the steam engine by Thomas Savery
CENTRAL EUROPE (INCLUDING GERMANY)	1619-1637: Reign of Ferdinand II, emperor of the Holy Roman Empire	
FLANDERS (BELGIUM; NETHERLANDS)	1608: Hans Lippershey invents the telescope 1625: Dutch settle in Manhattan and establish New York	1672-1678: Intruding of Louis XIV's army in the Netherlands
GREECE		
AFRICA		
AMERICAS	1607-1675: British colonisation of North America 1624: Dutch set in Manhattan and establish New York	1681: King Charles II of England grants a land charter to William Penn for the area that now includes Pennsylvania
RUSSIA		

BAROQUE		
	1700-1749	**1750-1799**
IBERIAN PENINSULA	1701-1714: War of the Spanish Succession and Treaty of Utrecht	
ITALY	1709 and 1748: Discovery of the ruins of Herculaneum and Pompeii	
FRANCE		1756-1763: Seven Years War 1763: Treaty of Paris. France ceded Canada and all its territory east of the Mississippi River to England 1770: Nicolas-Joseph Cugnot built the first automobile 1783: First flight in hot air balloon 1789: Lavoisier publishes studies of chemistry 1789: Beginning of the French Revolution 1792-1804: First Republic established 1793-1794: Reign of Terror led by Robespierre 1793: Louis XVI executed. Opening of the Musée du Louvre 1798-1799: Expedition of Bonaparte in Egypt
BRITISH ISLES	1707: Acts of Union merges the Kingdom of England and the Kingdom of Scotland in the "United Kingdom."	1768-1779: James Cook explores the Pacific 1768: The Royal Academy is founded, with the painter Joshua Reynolds 1780-1810: First Industrial Revolution in England 1788: Colonisation of Australia by the United Kingdom
CENTRAL EUROPE (INCLUDING GERMANY)	1738: Vienna Treaty. End of the war of Polish Succession 1741: Beginning of the Austrian War of Succession	1796: Aloys Senefelder invents lithography
FLANDERS (BELGIUM; NETHERLANDS)		1794: Southern Netherlands conquered by the French
GREECE		
AFRICA		1794: In France, the Convention forbids slavery
AMERICAS	Early 18th century: Benjamin Franklin invents the bifocal lens and performs studies on electricity	1763: Treaty of Paris. France cedes Canada and all its territory east of the Mississippi River to England 1775: American war of Independence 1776: Official founding of the United States, declaration of Independence from Great Britain 1789: Election of George Washington
RUSSIA	1703: Foundation of St Petersburg 1721-1725: Reign of Peter I of Russia, first emperor of the Russian Empire	1762-1796: Catherine II, Empress of Russia

	MODERN TIMES				
	1800-1810	1811-1820	1821-1830	1831-1840	1841-1850
IBERIAN PENINSULA	1810-1826: The Spanish colonies of America, except for Cuba and Puerto Rico, gained their independence				
ITALY					
FRANCE	1802: Treaty of Amiens (end of the wars with France) 1804: Napoleon I crowned emperor	1814: Abdication of Napoleon defeated by the armies of Britain, Russia and Austria. Louis XVIII ascends the throne	1822: Champollion deciphers hieroglyphs	1839: Nicéphore Niepce and Louis Daguerre invent the daguerreotype (early process of photography)	1848: Napoleon III is sa~ Emperor of the 2ⁿᵈ Empir
BRITISH ISLES		1811-1820: Regency period. Flowering of the arts and literature 1815: George Stephenson invents the railroad locomotive		1834: A furnace destroys most of Westminster Palace 1837-1901: Reign of Victoria I, Queen of the United Kingdom of Great Britain and Ireland	
CENTRAL EUROPE (INCLUDING GERMANY)	1806: Dissolution of the Holy Roman Empire				
FLANDERS (BELGIUM; NETHERLANDS)		1815: Defeat of the French army against Prussia and England at Waterloo		1831: Belgian independence from the Netherlands	
GREECE			1821: Beginning of the Greek Independence War 1830: Creation of the first Greek independent state		
AFRICA	1802: Slavery is reestablished by Napoleon			1833: Slavery is abolished in the British colonies 1880-1881: First Boer War	1848: Slavery is abolish~ a second time in the French colonies
AMERICAS	1803: Louisiana sold to the United States by Napoleon	1812: War with Great Britain	1823: Monroe Doctrine	1834: Thomas Davenport makes the first electric motor commercially successful	1848: James W. Marsha~ discovers Gold in Calif~
	1810-1826: The Spanish colonies of America, except for Cuba and Puerto Rico, conquered their independence				
RUSSIA	1801: Assassination of Tsar Paul I. Alexander I is brought to power	1812: Napoleon invades Russia	1825-1855: Nicolas I, Tsar of Russia, enforces military discipline, censorship and traditions of the Orthodox Church		

1851-1860	1861-1870	1871-1880	1881-1890	1891-1900
	1861: Italian Kingdom is proclaimed. Victor-Emmanuel II is crowned			
1856: Crimean War, d Kingdom and France re war on Russia	1869: Charles Cros invents a process for colour photography (based on three colours)	1871: Repression of the Commune in Paris	1885: First use of vaccine for rabies invented by Louis Pasteur	1895: August and Louis Lumière invent the first motion-picture projector
	1870: French defeated by Prussia. Fall of Second Empire			1898: Marie Curie discovers radium

1871-1914: Expansion of French Colonial Empire (Indochina and Africa)

1875-1940: Third Republic

| 1856: Crimean War, d Kingdom and France re war on Russia | 1867: Publication of the first volume of Karl Marx's *Capital* | | | |
| Publication of in's *Origin of Species* | | | | |

1837-1901: Victoria, Queen of Great Britain. India under control of the British Empire (1857-1947)

| | 1867: Bismarck becomes Chancellor of the North German Confederation | 1871: Proclamation of the German Empire
1877: Heinrich Hertz discovers electromagnetic radiation, first radio emission | 1890-1900: Discovery of psychoanalysis by Sigmund Freud in Vienna | |

1888-1918: Reign of William II, German emperor and King of Prussia

			1884-1885: Partition of Africa between the colonial powers during the Berlin Conference	1899-1902: Second Boer War
Election of Abraham In	1862: Emancipation Proclamation (end of slavery)	1876: Alexander Graham Bell invents the telephone	1890: Halifax is the first city to be totally lit up with electricity	1897: New York Journal publishes the first comic strip
	1861-1865: American Civil War	1879: First incandescent lamp (Thomas Alva Edison and Joseph Wilson Swan)		1898: Spanish-American War
	1868: Christopher Latham Sholes develops the typing machine			

1848-1896: Gold rushes toward West America

| 1856: Crimean War, d Kingdom and France re war on Russia | 1860s: Russian populist movement (the narodniki) | | | |
| | 1861: Emancipation of the serfs | | | |

1855-1881: Tsar Alexander II of Russia

	1900-1910	1911-1920	1921-1930	1931-1940
IBERIAN PENINSULA		1914-1918: First World War		1931: Attempted coup by Fra 1936-1939: Spanish Civil War 1939-1945: Second World W
ITALY		1914-1918: First World War 1915: Vittorio Emanuel III declares war on Austria-Hungary	1922-1943: Mussolini leads Italy, creation of a fascist state 1922: Benito Mussolini's march on Rome. Creation of the U.S.S.R. 1929: Lateran Treaties, creation of the State of Vatican	1939-1945: Second World W
FRANCE	1907: Louis Lumière develops a process for colour photography 1908: First cartoon shown (invention of cellulos)	1914-1918: First World War 1919: Treaty of Versailles (official end of First World War)		1939-1945: Second World W
BRITISH ISLES	1903: Woman's right to vote	1914-1918: First World War	1925: John Baird invents the television	1939-1945: Second World W
CENTRAL EUROPE (INCLUDING GERMANY)	1888-1918: Reign of William II, German emperor and King of Prussia	1912-1913: Balkan Wars 1914: Assassination of the Archduke Franz Ferdinand and his wife the Duchess of Hohenberg at Sarajevo 1914-1918: First World War 1915: Einstein works out the theory of relativity 1916: Freud. *Introduction to Psychoanalysis*	1925-1926: Heisenberg and Schrödinger's theories of quantum mechanics 1919-1933: Weimar Republic	1933-1945: Hitler, Chancello of Germany
FLANDERS (BELGIUM; NETHERLANDS)		1914-1918: First World War		1939-1945: Second World W
GREECE		1912-1913: Balkan Wars		
AFRICA		1914-1918: Germany loses its colonies		
AMERICAS	1900: First flight on a biplane of Wilbur and Orville Wright 1910: Dunwoody and Pickard invent the crystal detector (used for receiving radio broadcast)	1914: Henry Ford mechanises mass-production. Inauguration of the Panama canal 1917: USA enters the First World War		1939-1945: Second World W
RUSSIA	1904-1905: Russo-Japanese War. Rivalry for dominance in Korea and Manchuria	1914-1918: First World War 1917: Russian Revolutions. Abdication of Tzar Nicolas II	1922-1953: Stalin General Secretary of the Communist Party of the Soviet Union	1939-1945: Second World W

Modern Times

1941-1950	1951-1960	1961-1970	1971-1980	1981-1990	1991-2000
			1975: Death of Franco. Restoration of the Spanish monarchy		
5: Execution of ...ssolini. End of fascist state					
5-1960: Conflicts and Decolonisation. Algeria (1945-1947), ...ochina (1946-1954), Africa (1956-1960), Maghreb (1954-1962)	1958: Fifth Republic	1969: First trial flight of the Concord between France and Great Britain			
7: India gains its ...ependence from the ...sh Empire	1953: James Watson and Francis Crick discover the structure of DNA — 1955: First radio telescope in Jodrell Bank		1973: First babies born through in-vitro fertilisation		
1947-1991: Cold War					
9-1945: Second World		1961: Erection of the Berlin Wall		1989: Fall of the Berlin Wall	
6-1949: Civil War				1981: Greece enters the EU	
8: South Africa under ...theid	1951: Independence of Libya — 1956: Independence of Morocco and Tunisia — 1960: Almost all French colonies take their independence	1962: Algerian Independence	1974-1975: end of the Portuguese colonies		1994: Genocide in Rwanda — 1994: Nelson Mandela is elected in South Africa
4: Attack on Pearl ...bor by the Japanese — 2: First nuclear fission ...ab — 4: First computer at the ...versity of Pennsylvania — 5: Atomic bombing of ...shima	1950-1953: War of Korea — 1951: First nuclear reactor — 1960: Theodore Maiman invents the laser — 1960: First satellite for telecommunication created by the NASA	1969: Neil Armstrong and Edwin Aldrin walk on the moon	1972-1976: Vietnam War — 1973: Oil Crisis. Military Coup in Chile	1981: First space shuttle launched by the United States	
5: Yalta Conference	1953: Khrushchev, leader of Soviet Union, starts de-Stalinisation — 1957: Sputnik, first satellite launched	1961: First cosmonaute, Yuri Gagarin orbits around the planet		1989: Collapse of Communism	

LEGEND

PREHISTORY

Paleolithic

Neolithic

Ancient Egypt

Ancient Greece

ANTIQUITY

Ancient Egypt

Ancient Greece

Ancient Rome

MIDDLE AGES

Byzantine

Gothic

Romanesque

RENAISSANCE

Byzantine

Renaissance

High Renaissance

Mannerism

BAROQUE

Baroque

Neo-classicism

Rococo

Romanticism

MODERN ERA

Arts & Crafts

Naïve Art

Art Nouveau

Pre-Raphaelite Brotherhood

Barbizon School

Hudson River School

Impressionism

Naturalism

Neo-classicism

Post-Impressionism

Realism

Romanticism

Symbolism

Abstract Art

American Scene

Art Deco

Art Informel

Minimal Art

Art Nouveau

Arte Povera

Ashcan School

Bauhaus

Camden Town group

COBRA

Constructivism

Cubism

Dada

Expressionism

Abstract Expressionism

Fauvism

Figuration Libre

Futurism

New Realism

Pop Art

Post-Impressionism

Rayonnism

Regionalism

Social Realism

Surrealism

Symbolism

Glossary

Abstract Art
International, 20th century.
Artistic style started in 1910. Involves the renunciation of naturalistic representations, and creates art without references to figurative reality. The term is also used to describe different movements of Abstraction, such as those of Geometric Abstraction, Abstract Expressionism, and Lyrical Abstraction.

Aiguière
(French for water jug) a name for a water container, in the time from the Middle Ages to the Baroque period.

Alabaster
Name applied to two distinct mineral substances, the one a hydrous sulphate of lime and the other a carbonate lime. The former is the alabaster of the present day, the latter is generally the alabaster of the ancients. The two kinds are readily distinguished from each other by their relative hardness (the ancient alabaster being harder than the modern one). Highly esteemed in the ancient times, it was used for perfume bottles, sculptures and even sarcophagi.

Aluminium
Most abundant metal in the earth's crust where it always occurs in combination, malleable, ductile, light, with high resistance to oxidation. It has a bluish silver-white colour.

Armature
Iron skeleton with stout bars for the arms and legs fixed in the pose of the future figure.

Art Deco
International art style from the early 1920s, a style in design, sculpture, painting, and architecture.

Art Nouveau
International, late 19th century and beginning of the 20th.
Painting characterised by decorative motifs, with shapes inspired by vegetation, sinuous curves, simple compositions, and a denial of volume. Style influencing painting, sculpture, architecture, and design.

Arts and Crafts Movement
Reform movement from England, starting around 1860. It can be seen as the English counterpart to the French Art Nouveau.

Baptismal font
Vessel used in churches to hold the water for the Christian baptism. Located in a baptistery (separate hall or chapel where baptisms occur), baptismal fonts belong to a period when adults were baptised by immersion.

Baroque
Europe, 17th and first half of the 18th century.
In opposition to intellectualism and the coldness of mannerism, Baroque has a more immediate iconography. Characterised by dramatic light effects, dynamic movements, contrasting forms, and optical illusions. A style found in furniture, architecture, and sculpture.

Byzantine
European style from the 5th to the 15th century. The style derived from a frontal representation of identified Paleo-Christian iconography.

Cabinet
Furniture piece, luxury closet composed of many drawers; but also depository for various types of precious objects (curiosity cabinet).

Cameo
Term applied to engraved works executed in relief on hard or precious stones.

Ceramic
Objects made of clay and burned in the oven at high temperature, such as stoneware or clay jugs. Porcelain objects are also considered ceramic pieces.

Classicism
Europe, 17th century.
Style aiming for an ideal of beauty inspired by Greco-Roman Antiquity. Carracci developed it in Italy, while it was imported to France by Poussin and Le Lorrain. Emphasises the perfection of the drawing and the superiority of historic painting.

Clay
Fine-grained, almost impalpable substance, very soft, more or less coherent when dry, plastic and retentive of water when wet. It consists essentially of hydrous aluminium silicate with various impurities. Modelled to make a sculpture, it can also be used for casts.

Crater
A special jar used in Ancient Greece to mix water and wine.

Enamel
An opaque or glassy substance applied to metals or ceramic.

Expressionism
Germanic countries, early 20th century.
Works of a great expressivity, characterised by thick outlines, strong colours, anatomic and spatial distortions. Associated with the *Der Blaue Reiter* and *Die Brücke* groups.

Gothic
Europe, from 13th to early 16th century.
Style characterised by an organisation of space and more dynamic representations. An international gothic style of great ornamental wealth emerged in Burgundy, Bohemia, and Italy (14th-15th century).

Gypsum
An abundant mineral consisting of hydrated sulfate, mostly white or colourless, grainy to lumpy. The Romans discovered that through heating, the resulting substance could be mixed with water to harden and make plaster.

Hammered work
Plates of bronze hammered over a wooden core, rudely cut into the required shape, giving shape and strengthening the thin metal.

Ivory
Term confined to the material deriving from the tusk of the elephant.

Lapis lazuli
Jewellery stone composed of a blue-glazed mineral mixture, used for over 7,000 years in jewellery-making, as well as in the decoration of mosaics and sculptures.

Limestone
Sedimentary rock, composed mainly of calcite and aragonite. Used frequently as building material for its easy malleability.

Low relief (basso relieve)
The relief is wholly attached and may scarcely rise above the surface, or it may exceed in projection to about a half the proportionate depth (or thickness) of the figure or object represented.

Mannerism
Europe, 1525-1600.
Elegant and refined style, dominated by secular subjects, complex compositions, long, muscular and stylised bodies, captured in complex poses, and having an abundance of precious details.

Marble
Term applied to any limestone or dolomite which is sufficiently close in texture to admit of being polished. Famous quality marbles are Pentelic marble in Ancient Greek sculptures or Carrara marble from the Renaissance period until now.

Metalwork
Gold, silver, and bronze worked in several different ways, for example: moulded into a certain shape then adorned through hammer and embossing (repoussé).

Minimalism
USA, late 1960s.
Based on a reduction of historic content and expressive in a minimum degree. Geometric and tall, simplified forms.

Modelling
1. In painting and sculpting, the object or person used as an example.
2. Preliminary sculpture made in malleable material (wax, clay, plaster).

Mosaic
A picture or pattern composed by arranging small (and coloured) pieces of stone or glass. Mosaics were used during the Roman period, the Middle Ages, and in particular during the Byzantine period, and would be further developed by Art Nouveau artists.

Naturalism
Europe, 1880-1900.
Extension of realism, Naturalism praises an even more realistic approach of nature.

Portal
In architecture, the word "portal" designates an elevated structure serving as a façade or as a main entrance to a large building in front of the door. It often takes the form of a splay in front of the main doors of an edifice, forming an overhanging shelter. The portal is built around the doors themselves. This distinguishes it from a porch, which extends outward from the building. The portal is the frame of the door and the arch which extends from it, either corbelled or supported by buttresses or columns.

Realism
France, middle of the 19th century.
The rendering of everyday characters, subjects and events in a manner close to reality, in contrast to classical, idealised forms. It inspired Corot, Millet and the Barbizon School of painters.

Renaissance
Europe, c. 1400-1520.
Period of great creative and intellectual activity, breaking away from the restrictions of Byzantine Art. Study of anatomy and perspective through an appreciation and understanding of the natural world.

Retable
A frame or shelf enclosing decorated panels above and behind an altar.

Rococo
Europe, 1700-1770.
An exuberant style which began in France, characterised by great displays of ornamentation; tumultuous compositions; light, delicate colours; and curving forms.

Sandstone
Consolidated sand rock built up of sand grains held together by a cementing substance.

Sarcophagus
Name given to a coffin in stone, which, on account of its caustic qualities, according to Pliny, consumed the body forty days; also by the Greeks to a sepulchral chest, in stone or other material, which was more or less enriched with ornaments and sculptures.

Secretary
A writing desk with shelves on top. There are several shapes and types of secretaries.

Sideboard
Furniture piece with cupboards and drawers, placed along a wall and used for storing dishes, glasses, and table linen. Developed during the Renaissance.

Terracotta
Originally used to define clay sculptures 'sun-dried' only. Can also be used to define fired clay. This word comes from the Italian 'terra cotta', literally 'baked earth'.

Vienna Secession
Austrian art movement that arose from the coalition of several avant-garde artists at the end of the 19th century. This Art Nouveau movement is more geometric in style. The leader is Gustav Klimt.

Wood
Solid compact or fibrous substance forming the trunk, branches an droots of voluminous plants. Lighter and more malleable than stone, it was often used for sculptures of small scale or in regions where sculptural stone was not easy to find.

LIST OF ILLUSTRATIONS